ROBERT

DOISNEAUPARIS

Flammarion

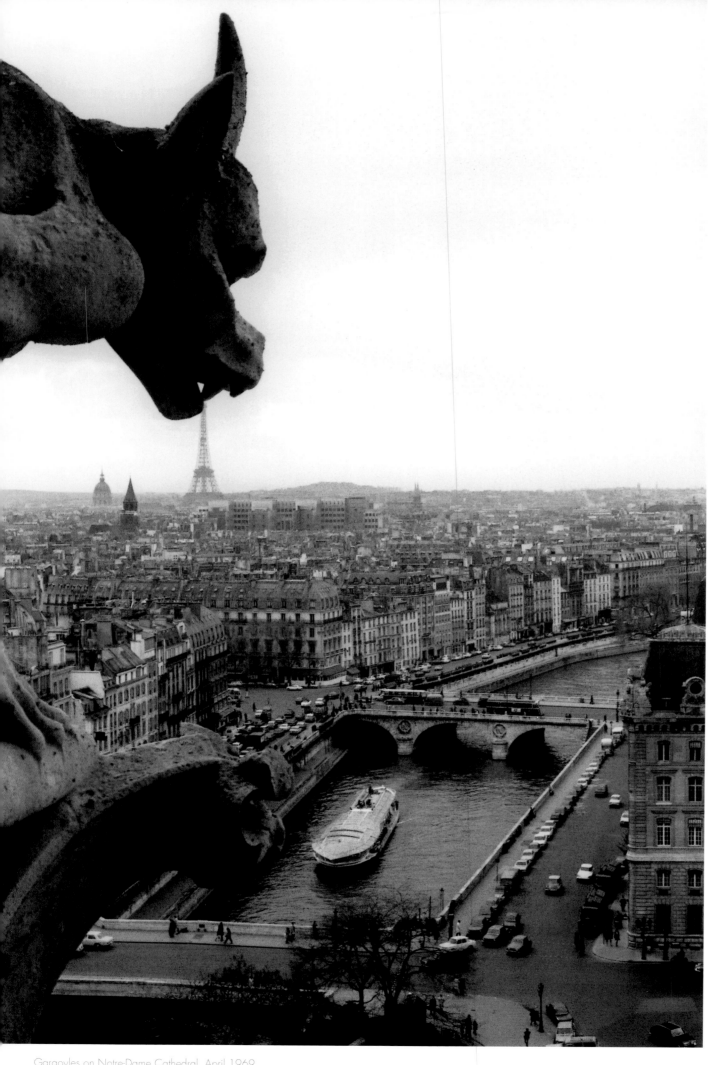

Gargoyles on Notre-Dame Cathedral, April 1969

" I remember Paris with caps and bowler hats, Paris in the days of upheaval, humiliation, collaboration, Paris with its whores and its secrets, Paris defended by barricades, Paris wild with joy—and now we have a car-packed, scheme-laden, jogger-happy Paris. "

"By constantly rubbing against the street fixtures, Parisians have given the place a special patina. I myself have polished the city's furnishings so often that, for the first time in my life, I feel a vague sense of ownership.

I'd nevertheless like to remain one of those rare, broad-minded owners who always leaves the door wide open."

" I now readily admit that in the days when I was trying my hand at life, leaving a record of Paris for future generations was the least of my worries.

If I had assigned myself such a mission, I might have collected millions of images, methodically, but it would have cost me countless days without pleasure.

No, my behavior was completely unpremeditated. The morning light was enough to get me going, without rhyme or reason.

Was it really reasonable to love whatever I happened to see?

I never asked myself that question. Nor do I regret it, because once you start taking your alarm clock apart you no longer know what time it is.

For half a century I pounded the cobblestones, then asphalt, of Paris, wandering up and down the city. This activity required no special physical prowess, Paris not being Los Angeles, thank heavens, and traveling on foot not considered a sign of poverty here.

The few images that now rise to the surface of the flow of time, bobbing together like corks on a swirling stream, are those taken on time stolen from my employers.

Breaking the rules strikes me as a vital activity, and I must say I enjoyed indulging in it.

So when the aging delinquent I've become sees serious folks like curators and librarians make a big fuss over these pictures taken in illegal conditions, I get a jubilant thrill.

A word about curators, while I'm at it—they're either all good or all bad. When they're good, their cleverness almost invites a hoax, which may explain why museums hold so many forgeries. Personally, I think it's more sporting to reserve that treatment for bad curators. They're the ones who lay claim to all the vanity due to the makers of the artworks that they've simply pirated.

This is not a typically French phenomenon, it's equally true in other countries—an observation that doesn't really get me very far.

Long-distance trips, for that matter, have always disturbed me. I can't stand the natives' scornful looks. I'm ashamed. In Paris *I'm* the native, I blend into the masses. I'm part of the scenery: an average Frenchman, of average height, with no distinguishing marks.

Well, except maybe the camera. But there are loads of them, and I don't go around in a showy fashion, camera around my neck like a label.

No, I move quietly along with the flock, invisibly.

One day, though, I wanted to see my home town the way tourist groups see it. So I climbed on a bus—a whale with a PA system—determined to swallow all the glitzy stuff seen by people in a hurry.

Before the vehicle had even begun to move, I learned that I was living in a dangerous city.

'Ladies and gentlemen, for security reasons we ask you to remain together at all times, at every stop. If not, management declines all responsibility for the consequences.'

A warning whose effect was to produce trembling little clusters in the night.

So I saw the guillotine in a cellar in the Latin Quarter, followed by the sizzling scene in the Bastille (where a lass of easy virtue and slit skirt climbed on the lap of a Presbyterian elder from a middling-sized town in Ohio).

In Montmartre I saw second-rate Paris girlies drop their bras, and tall, boa-feathered beauties on the Champs-Élysées, before finding myself dumped on the sidewalk once again, numbed by the consumption of so much entertainment stripped of its time-consuming preliminaries.

The day after that particular outing, I luxuriated in stillness. In a city where everything is constantly in motion, it's not easy to fight the herd instinct.

Just try planting yourself someplace, motionless, not for a few minutes, but for a full hour or two.

Once you're a statue—without pedestal— it's strange how you attract all those people lost in the movement.

'Do you happen to have a corkscrew?'... 'Do you speak French?'... 'Have you seen a little white dog with a red leash, by any chance?'

My replies are always impeccably polite, even though it annoys me to be disturbed. It takes a minimum of concentration to see things properly.

Seeing sometimes means constructing a little theater with the materials at hand, and then awaiting the arrival of actors.

Which actors?

I don't know, but I wait.

I just keep hoping and believing real hard—and damned if they don't finish by showing up.

Then the scene has to be set in a flash. A picture, if it's going to be legible, has to take the form of one those icons used since the dawn of time by priests and, more recently, by traffic signs.

If all this seems slightly obscure to you, that's deliberate—I'm trying to show just how tricky photography can be.

After all these private confessions, let's resume our stroll.

I always make a point of varying my route, to avoid falling into lazy if comfortable habits.

From experience, I know that the show is always livelier on the poorer outskirts of town.

These settings testify to mankind's struggle. They're full of nobility, because everyday acts are carried out simply, and the faces of people who have to rise early in the morning can be very moving—what a lesson in vitality we get from young women heroically putting on makeup at dawn every day before rushing to the metro. It's enough to melt your heart.

In contrast, I don't much like the ritzy neighborhoods, where rebel barricades have never been erected.

Life there is invisible, hidden away like contraband.

Shut outside, I think of young Baroness Haussmann, wife of the famous urban redeveloper, who smirked, 'How strange! Every time my husband buys a building, the demolition team arrives!'

Nowadays a lot of demolition is going on again. But I refuse to weep over the ruins. Beauty only really moves us if it's fleeting.

So the bulldozers are merely delivering certificates of authenticity, that's all.

I've seen my private landmarks vanish one by one—the heart-shaped paving in front of the Institut de France, the crucifix in front of the gas-storage tanks on rue de l'Évangile—but what bothers me most is the confiscation of my personal oases.

My magnetic spots have a strictly personal appeal—in short, they're for private use only. I mean, at one spot I once perceived a silhouette so harmoniously balanced that it immediately became a dazzling totem, one I've been seeking ever since; at another spot, a friend gave me a wave of his hand—the last—before disappearing around the corner forever.

So you see, that's of no interest to you.

And Paris seems to me to be increasingly populated by ghosts.

'How can you say that? It has always been full of them.'

Maybe. But I'm not interested in other peoples' ghosts.

Robert Doisneau, October 23, 1984

[PARIS

BY SURPRISE

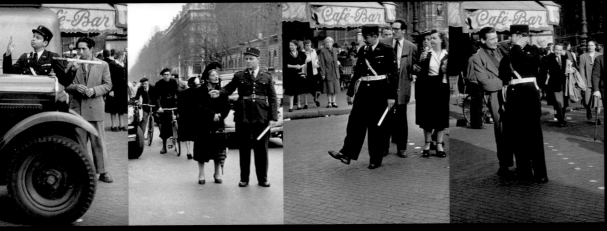

PARKS AND GARDENS, PEDESTRIAN BALLET, URBAN FLIRTATION, BISTROS

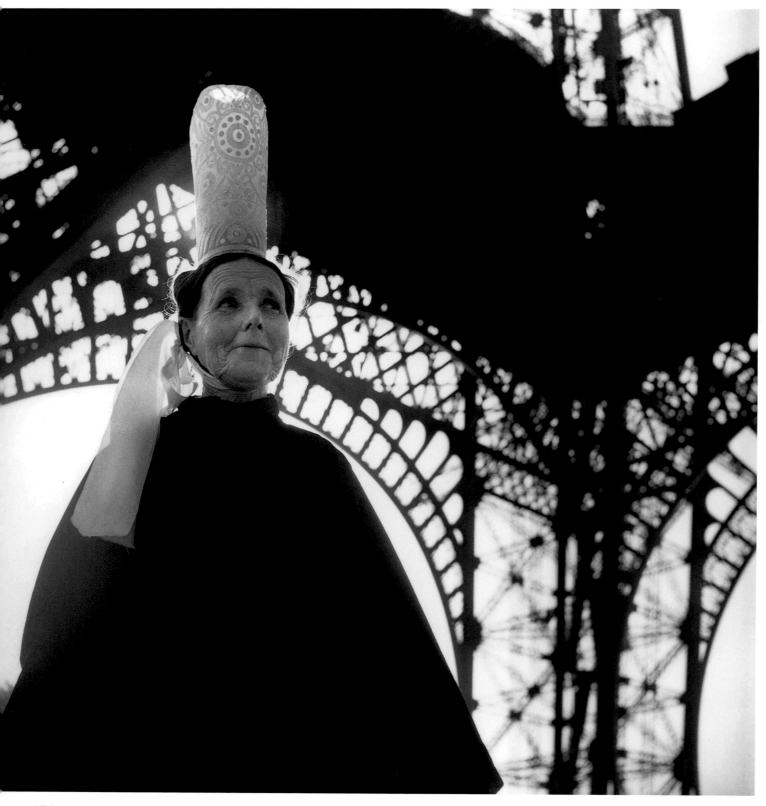

Eiffel Tower and Breton woman, 1950

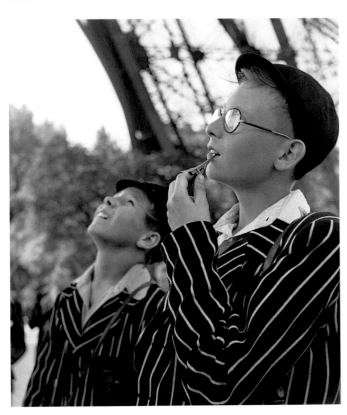

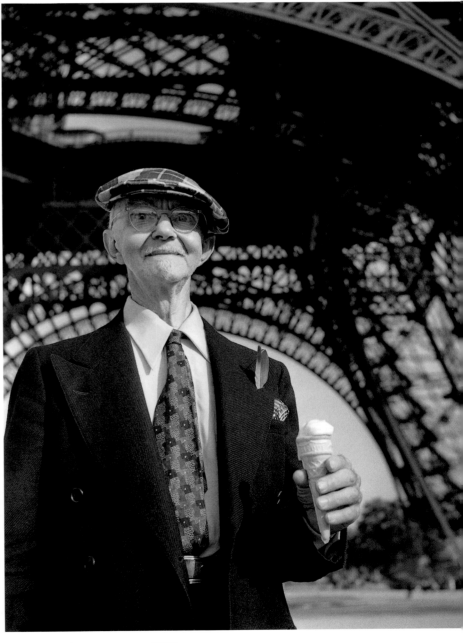

> " Going up the Eiffel Tower offers a panoramic view of Paris, which itself is no longer recognizable, since it lacks the all-important silhouette of the Eiffel Tower. "

English schoolboys, August 1950

Retired American tourist, 1950

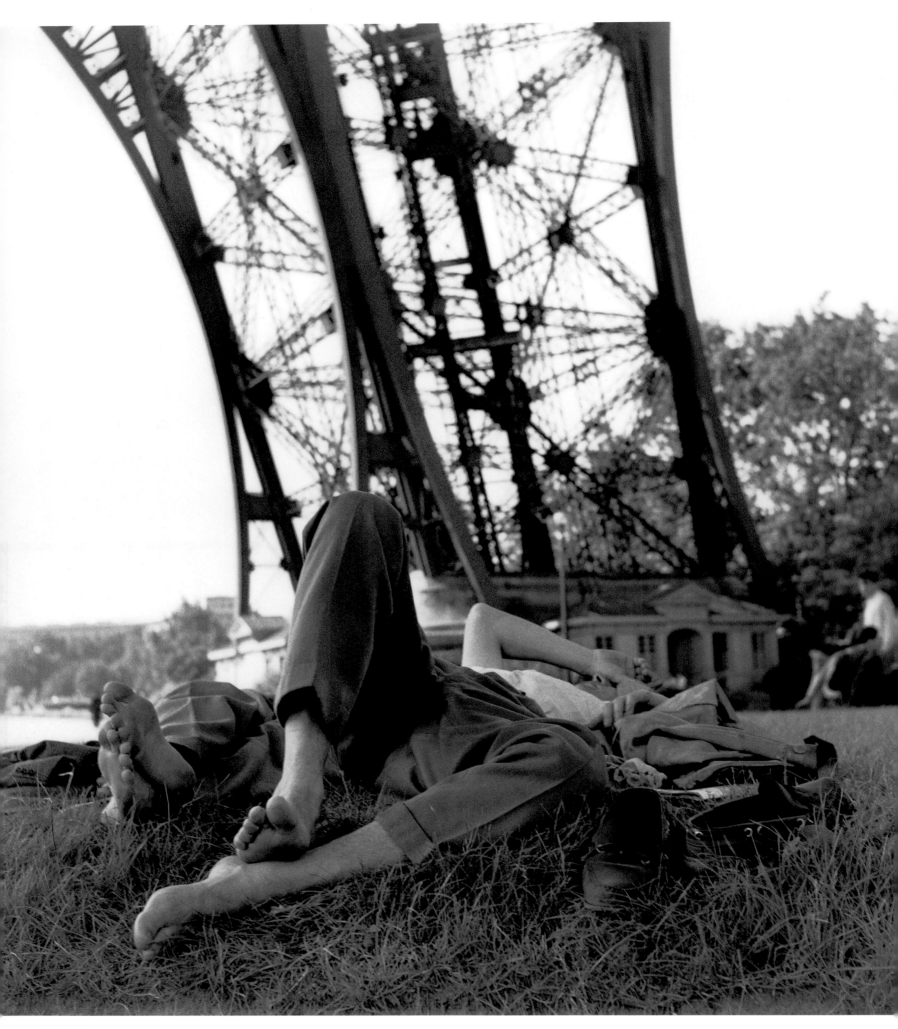

July 1950

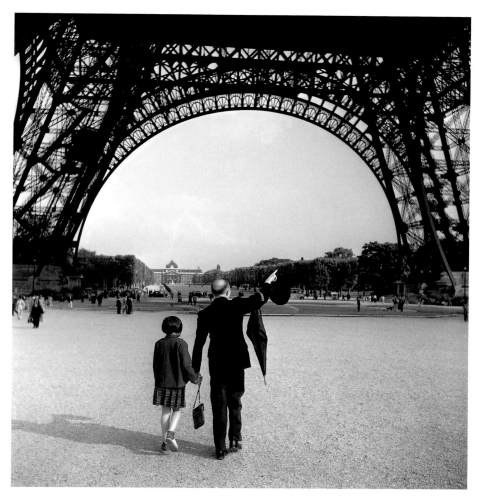

Black Jacket in the Sunshine, 1950

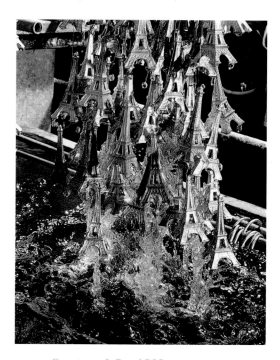

Coursinoux & Co., 1955

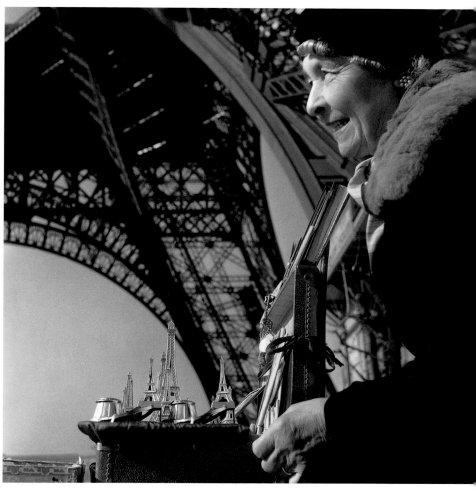

Souvenirs of Paris, 1946

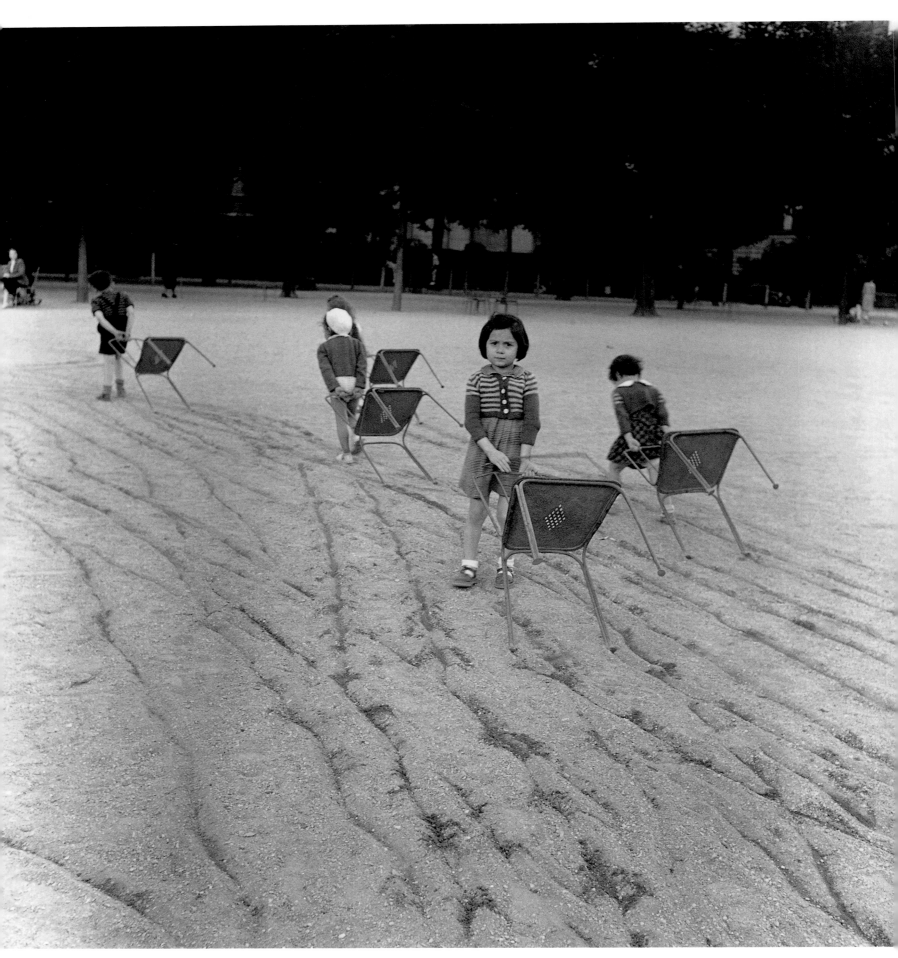

Luxembourg Gardens, 1951

“ Empty park chairs—still warm—arranged in pairs, groups, or singly: they inevitably make you wonder who has been sitting in them.

An accurate guess is very hard to make. So an urgent need arose for serious research into this crucial question of modern citizenry's relationship to park chairs—research that required the aid of photography. ”

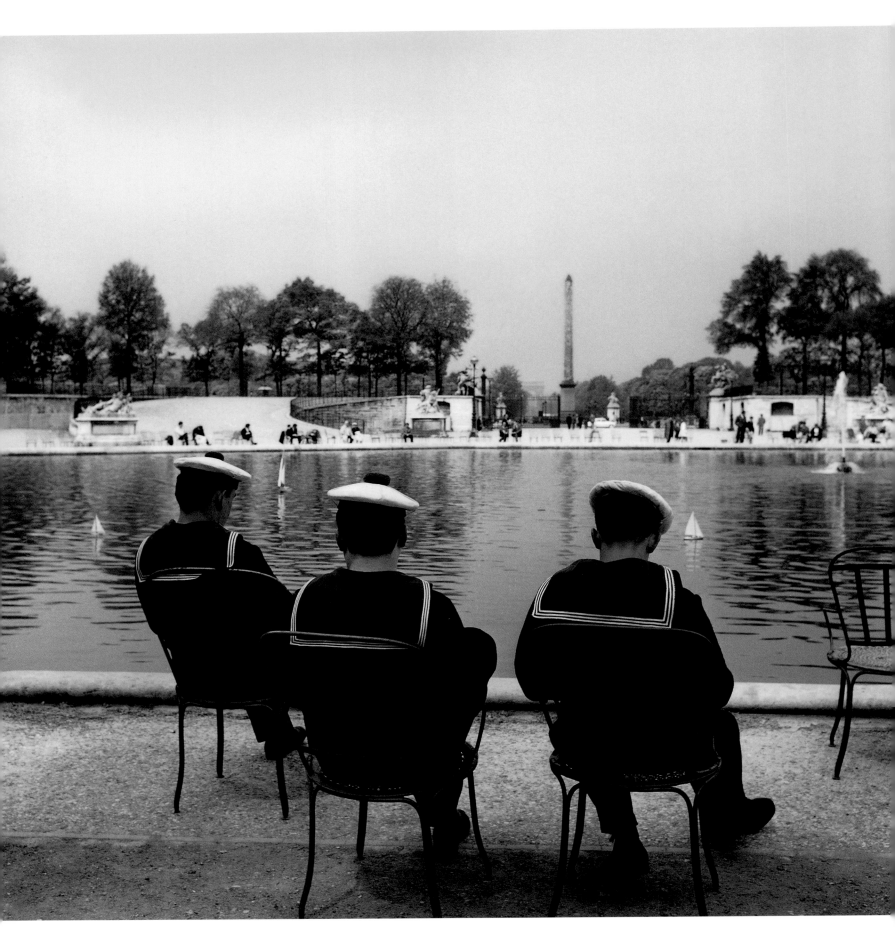

Tuileries Gardens, April 1959

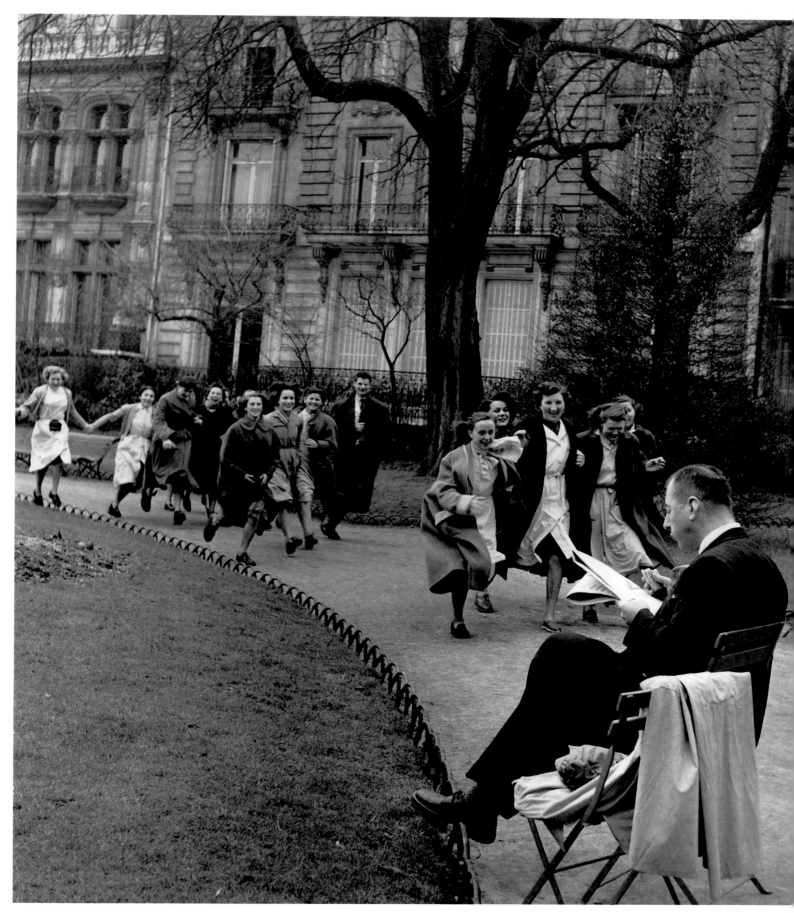

Parc Monceau, 1953

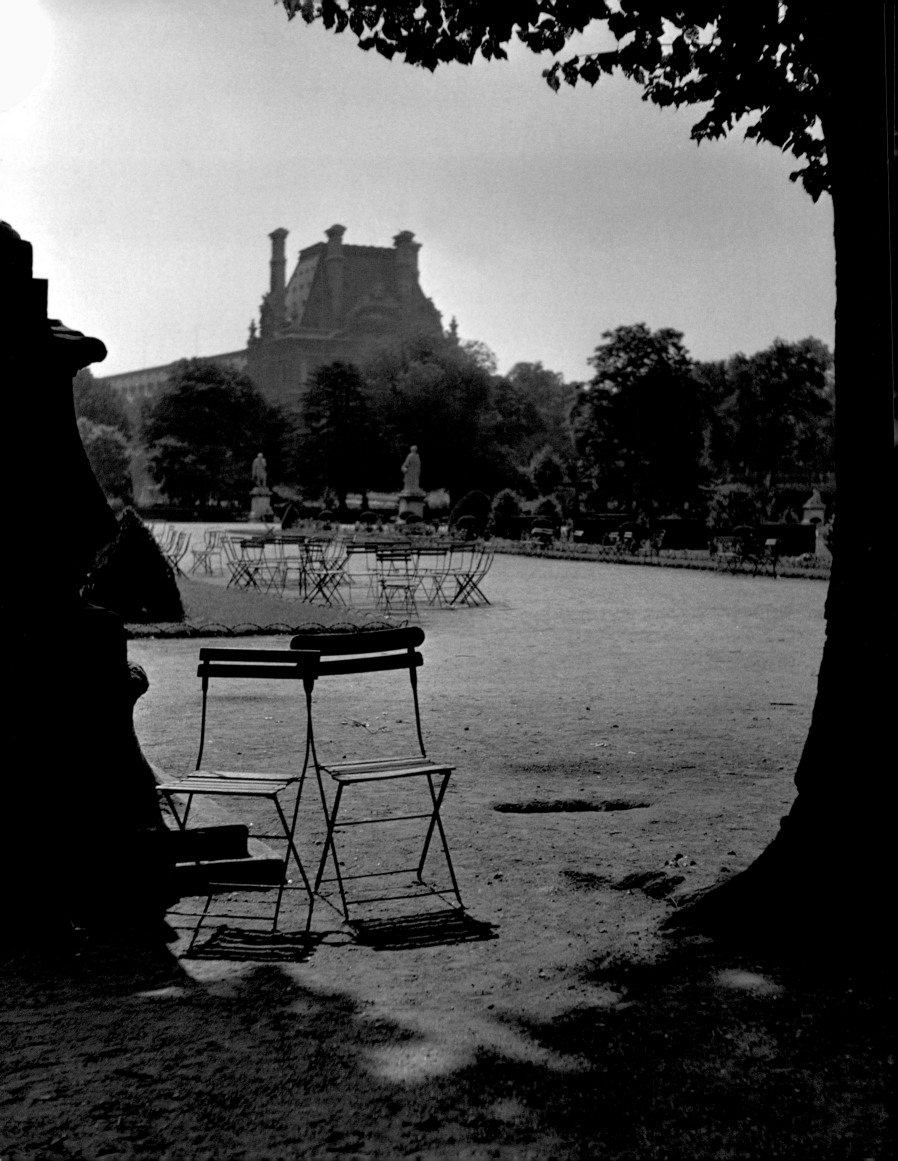

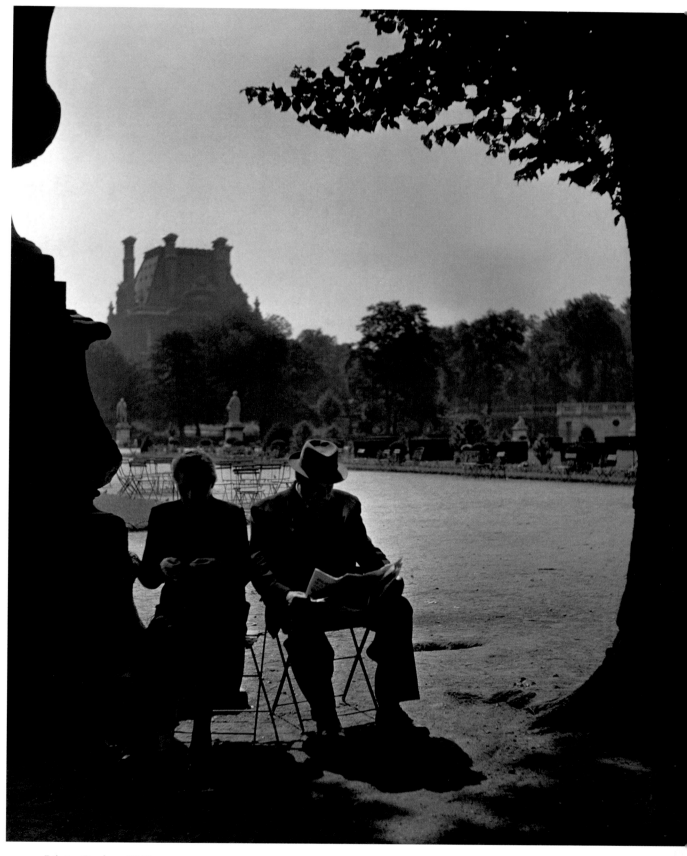

Tuileries Gardens, 1951

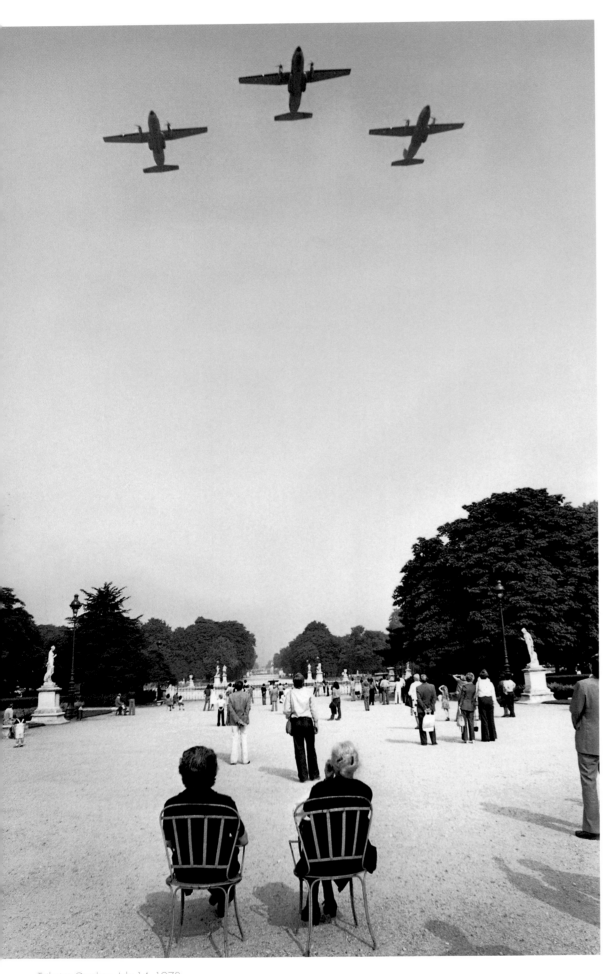

Tuileries Gardens, July 14, 1978

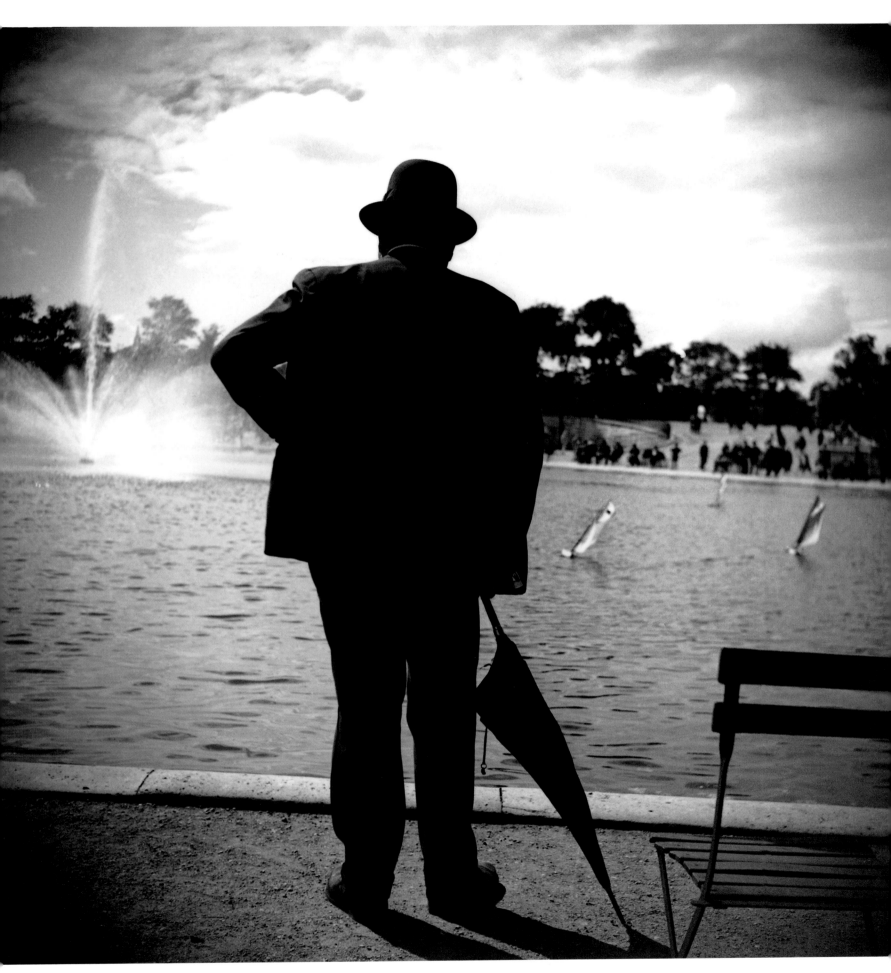

Circa 1932

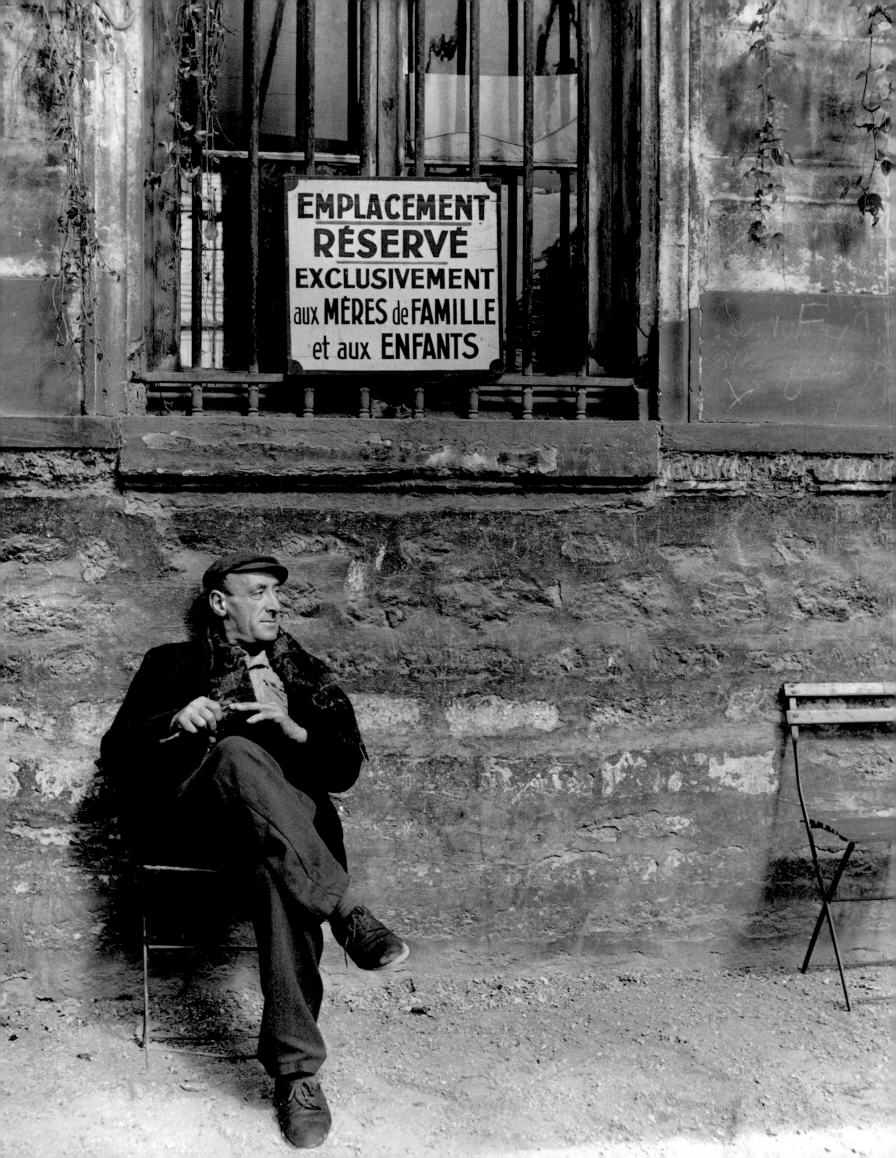

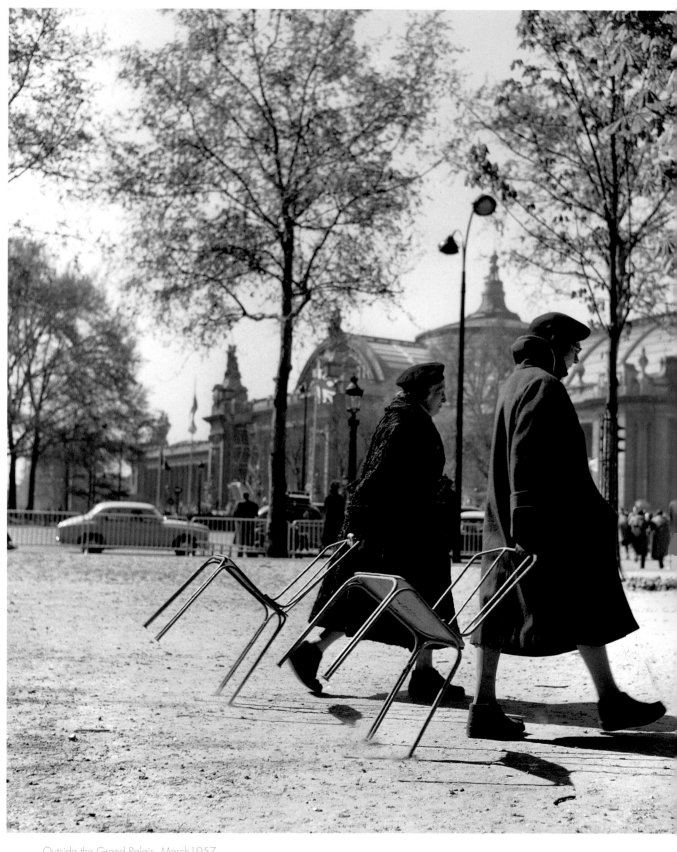

Outside the Grand Palais, March 1957

FACING PAGE: Jardin des Plantes, May 1951

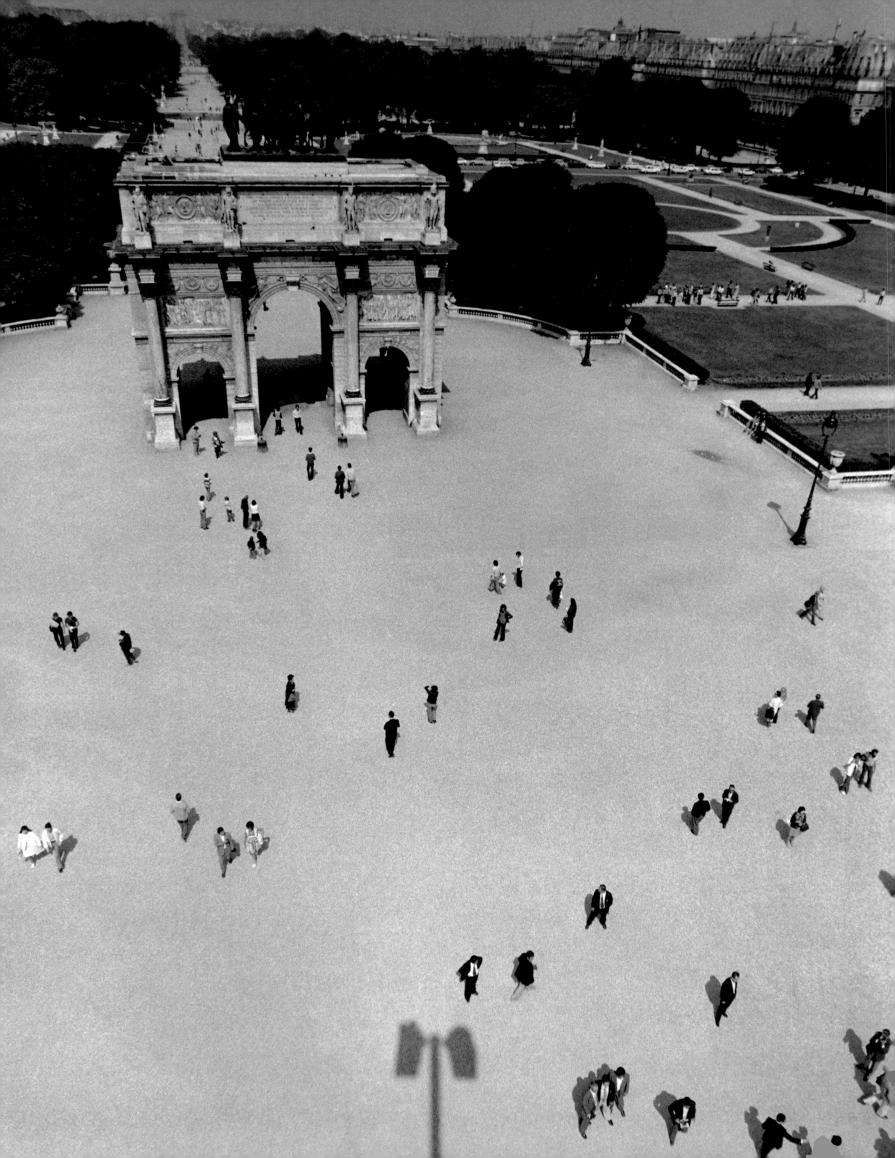

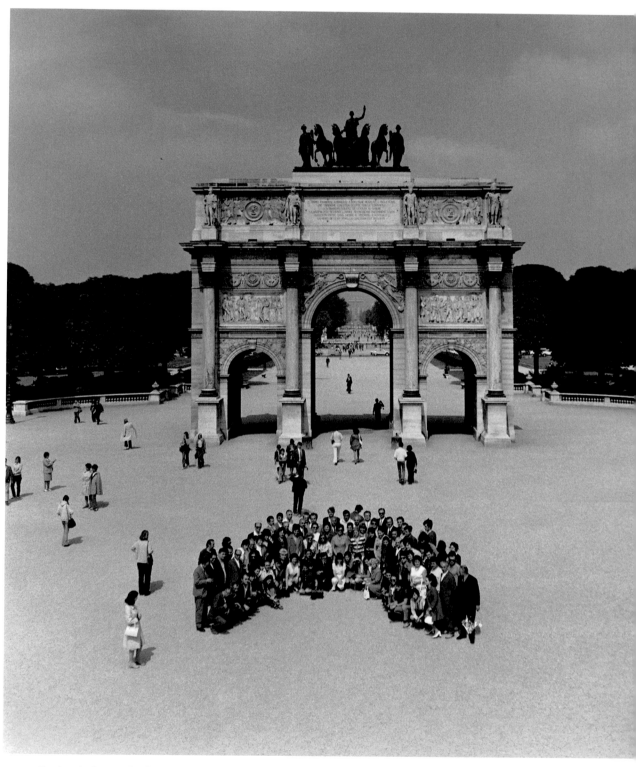

The Arc du Carrousel, 1972

CAVALIER PIGEONS, 1954

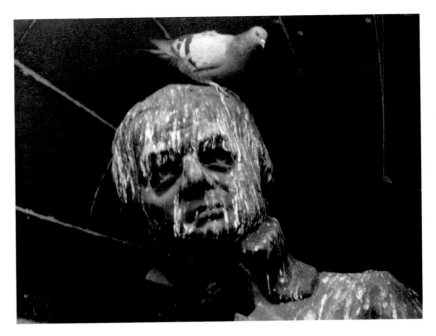

Lazare Carnot

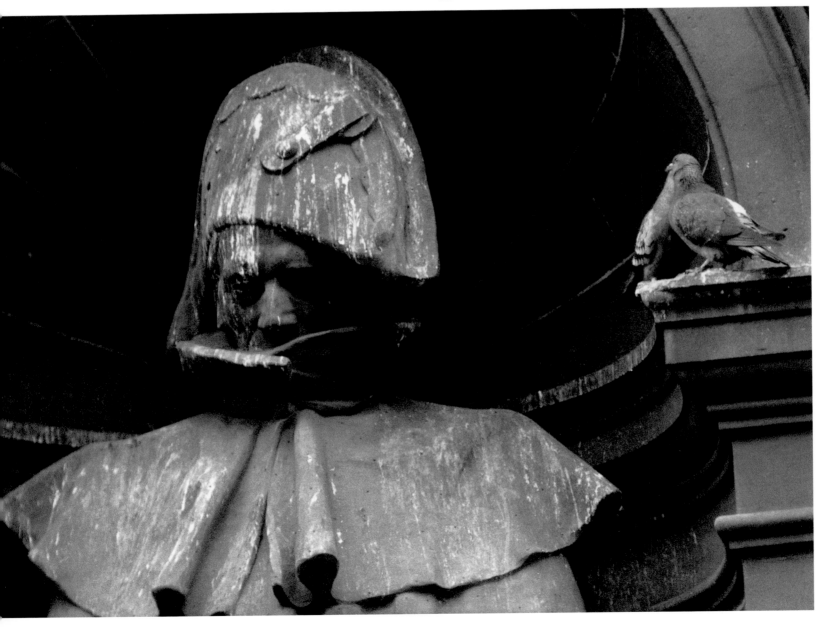

Jean-Nicolas Pache

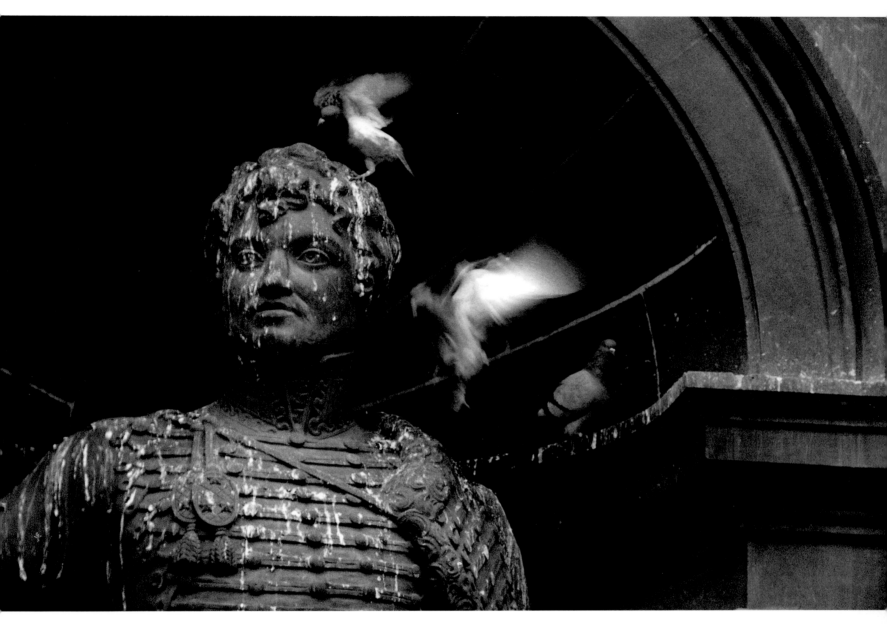

Joachim Murat

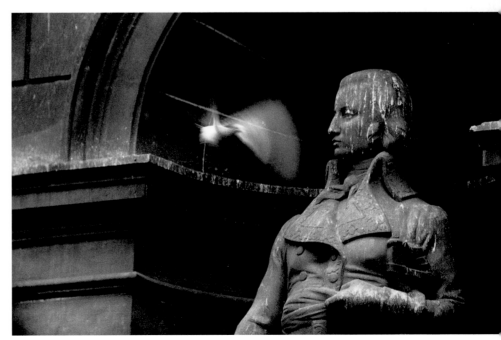

Jean-Baptiste Jourdan

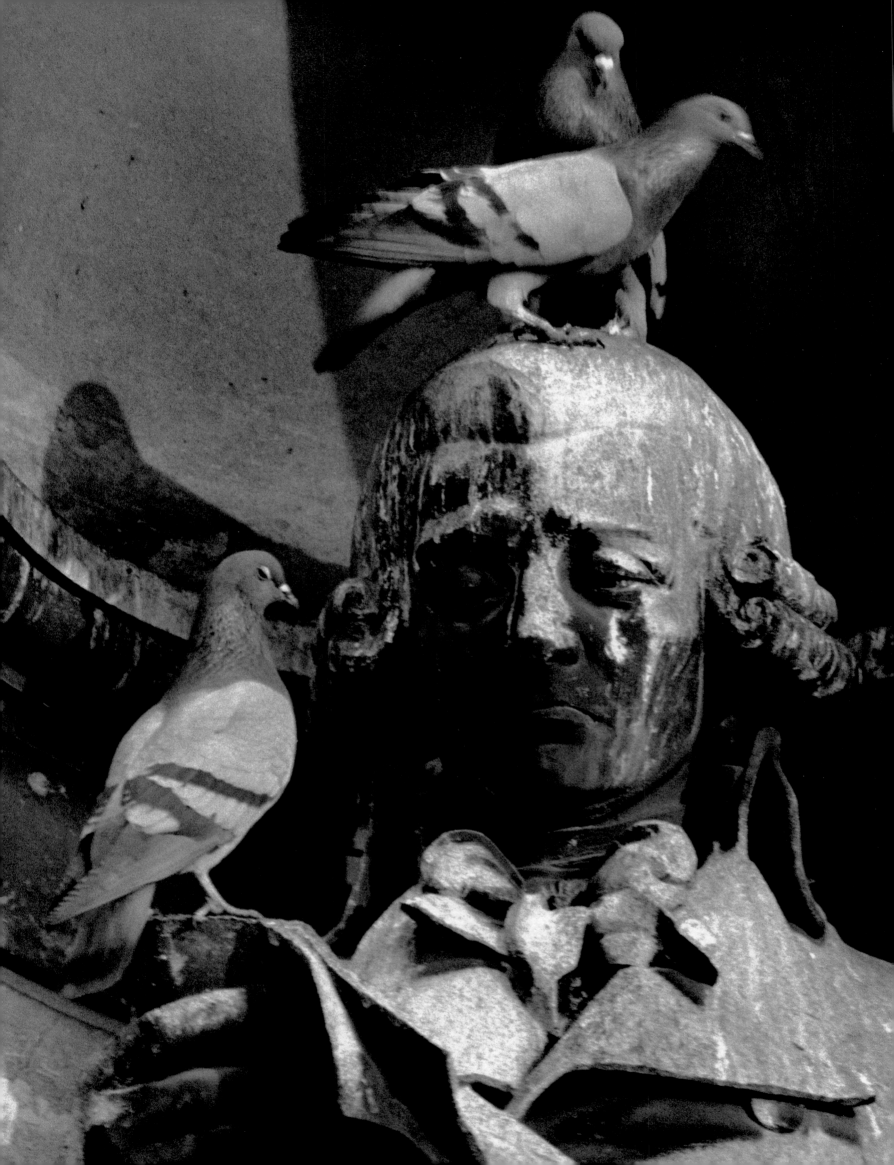

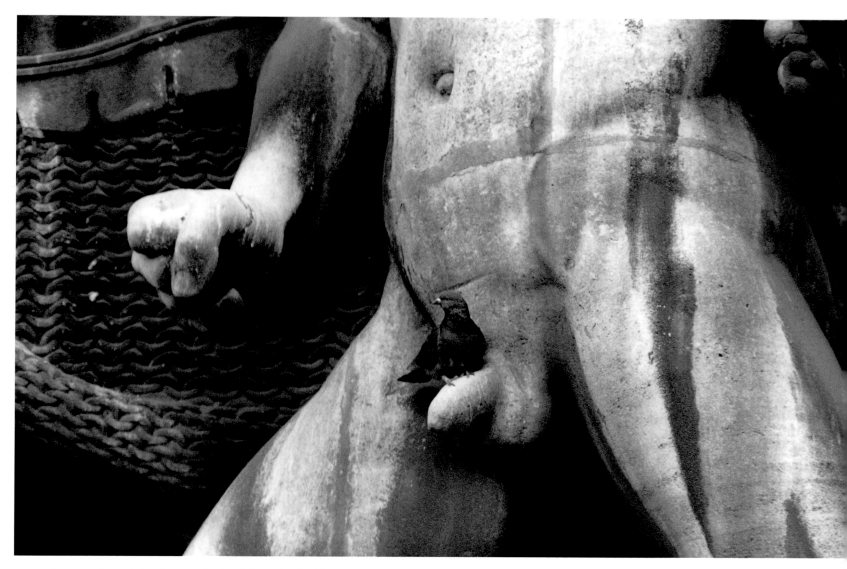

Fragment of the relief sculpture on the Arc de Triomphe, 1954

FACING PAGE: Marcel Moncey

Colette at Palais Royal, 1953

Colette at Palais Royal, just in front of Le Grand Véfour restaurant where she has been meeting with fellow members of the Académie Goncourt to discuss not only the candidates for the Goncourt literary prize but also the quality of Véfour's shrimp bisque. She is surrounded by the cast and crew of Claude Autant-Lara's *Game of Love,* based on her novel *The Ripening Seed.* Left to right: Max Douy (sets), Madame Autant-Lara (assistant to the director), cast members Edwige Feuillière, Nicole Berger, and Pierre Beck, plus Jean Aurench (screenplay), Pierre Bost (screenplay), René Cloérec (music), and Claude Autant-Lara. As our photographer, Robert Doisneau, took out his camera, all the pigeons in the park came running. Not to be immortalized, but to greet their great literary friend Colette, whose famous blue lamp they see glowing at bedtime every night, like a star, in her window overlooking the Palais Royal courtyard.

Claude Brulé, *Album du Figaro,* December 1954

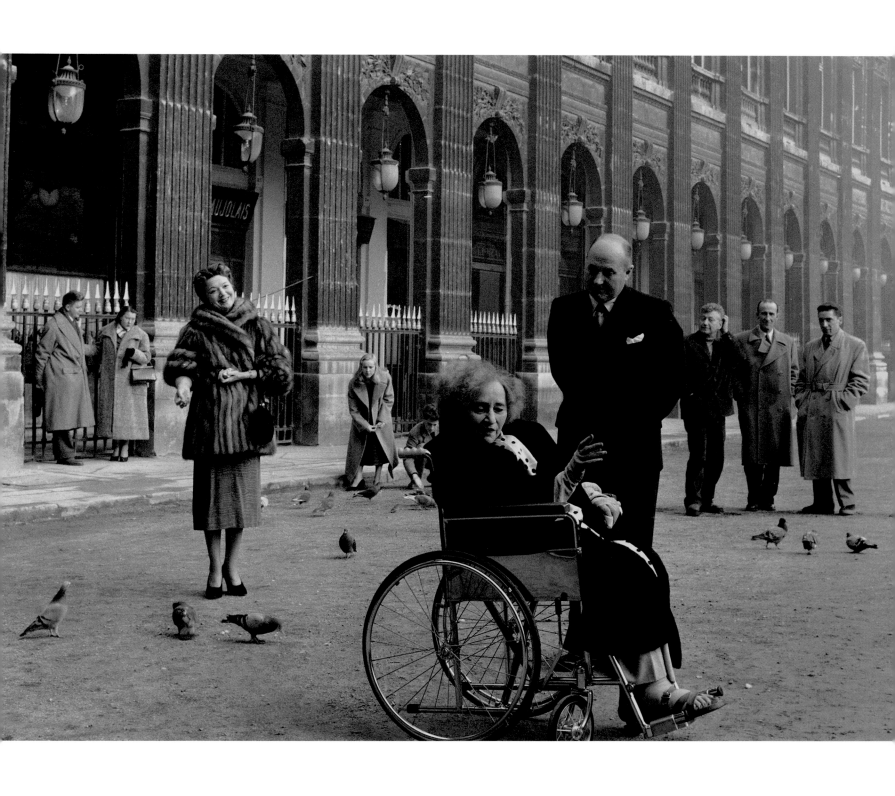

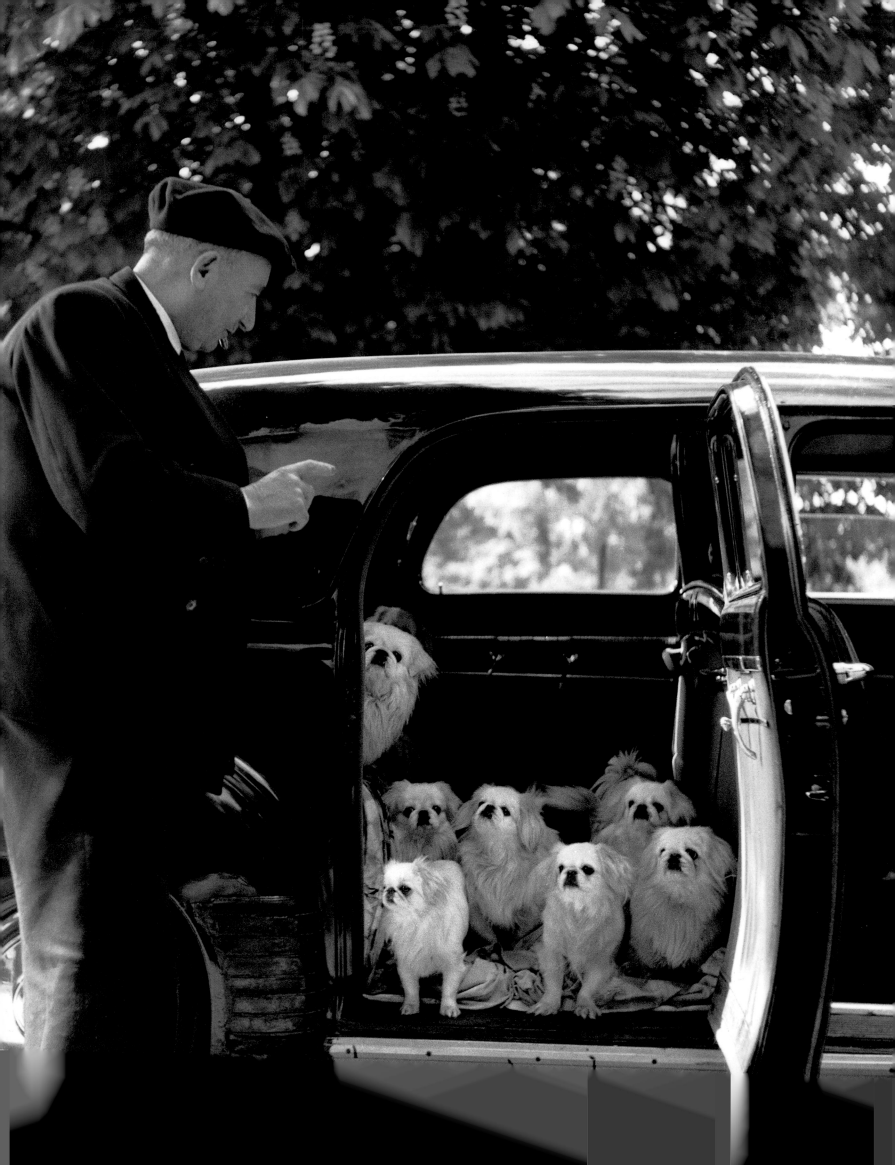

Bois de Boulogne

Tuileries Gardens, 1954

FACING PAGE: *The Marquis de Cuevas's Dogs*, Bois de Boulogne, 1953

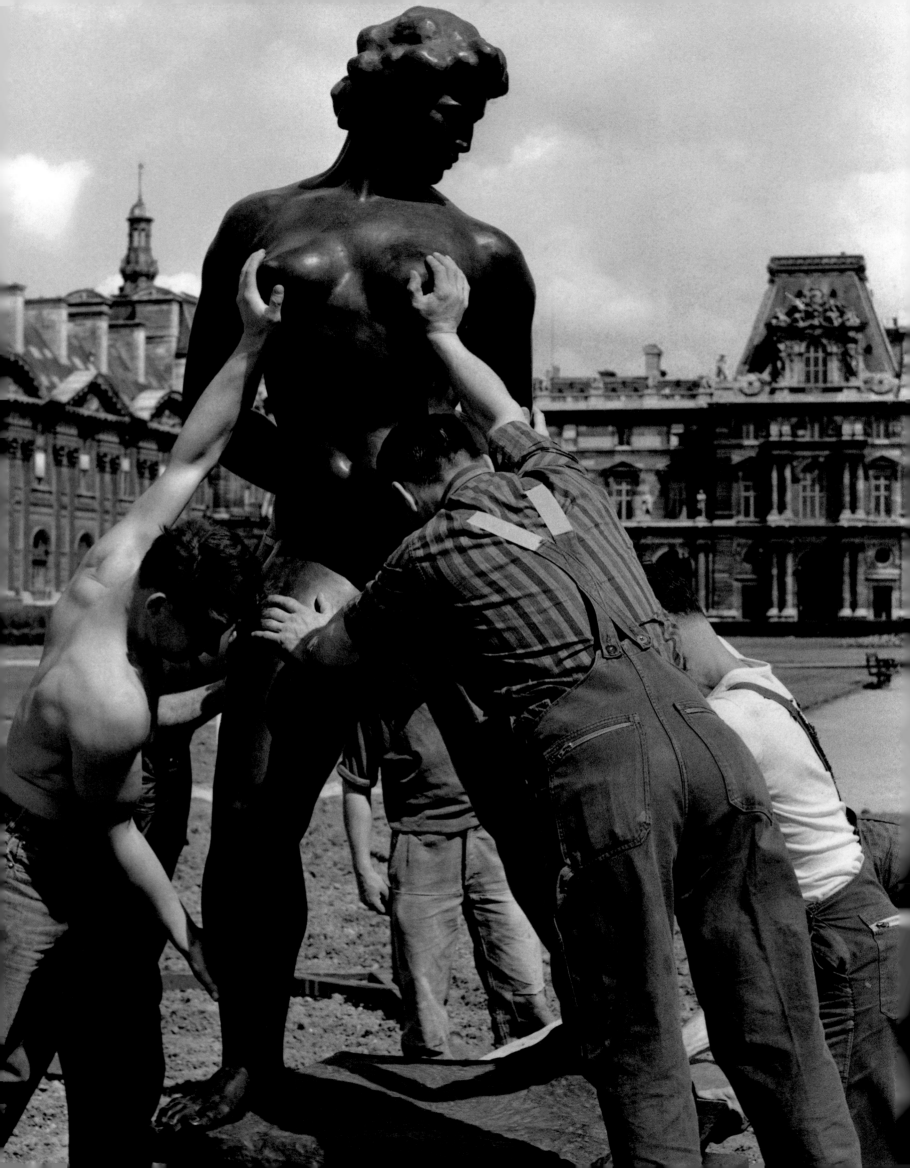

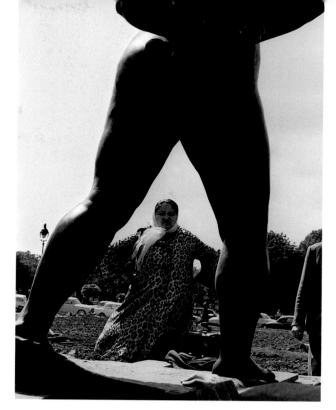

Dina Vierny [Maillol's companion] in bronze and in the flesh

Facing page: *Venus Gone Bust*, 1964

Workers install Maillol's statues in the Tuileries Gardens
on June 29, 1964

" One morning I had an appointment with a clutch of advertising peo-
ple who were preparing a campaign to launch new washbasins in
polystyrene—or was it polyester?

As usual, I was late, and as I was crossing the Tuileries I was held
up by a van marked 'Gougeon: Fine Art Movers.'

Once I saw the statues by Maillol, the washbasins completely
slipped my mind.

It must have been about that time that the advertising agency
stopped returning my calls. "

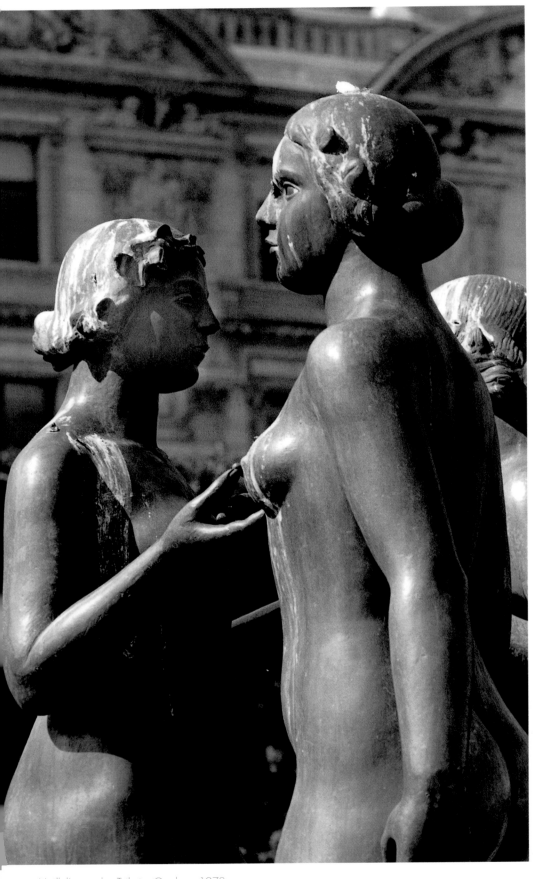

Maillol's nymphs, Tuileries Gardens, 1972

FACING PAGE: Helicopters, Tuileries Gardens, 1972

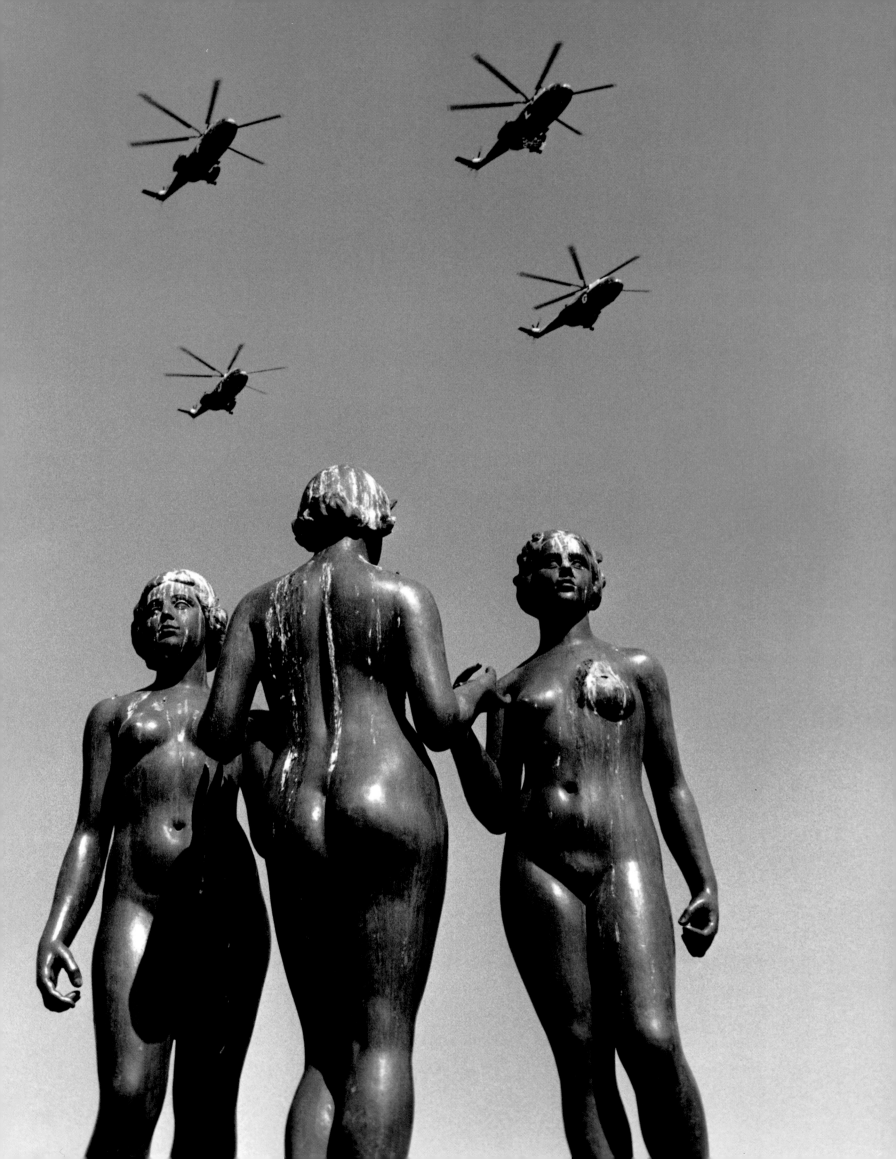

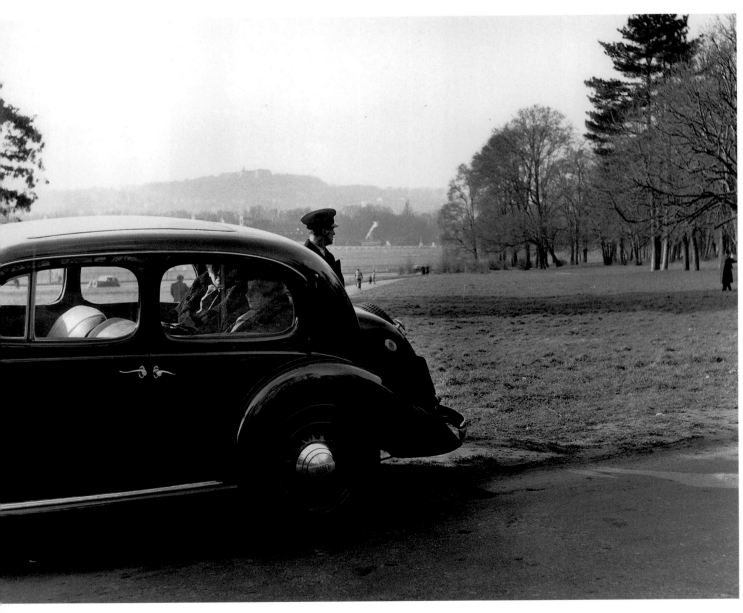

Sheltered from inclement weather, two ladies get some fresh air in the Bois de Boulogne, 1953

FACING PAGE: West face of the Arc de Triomphe, beneath *Resisting the Coalition* by Antoine Etex, 1974

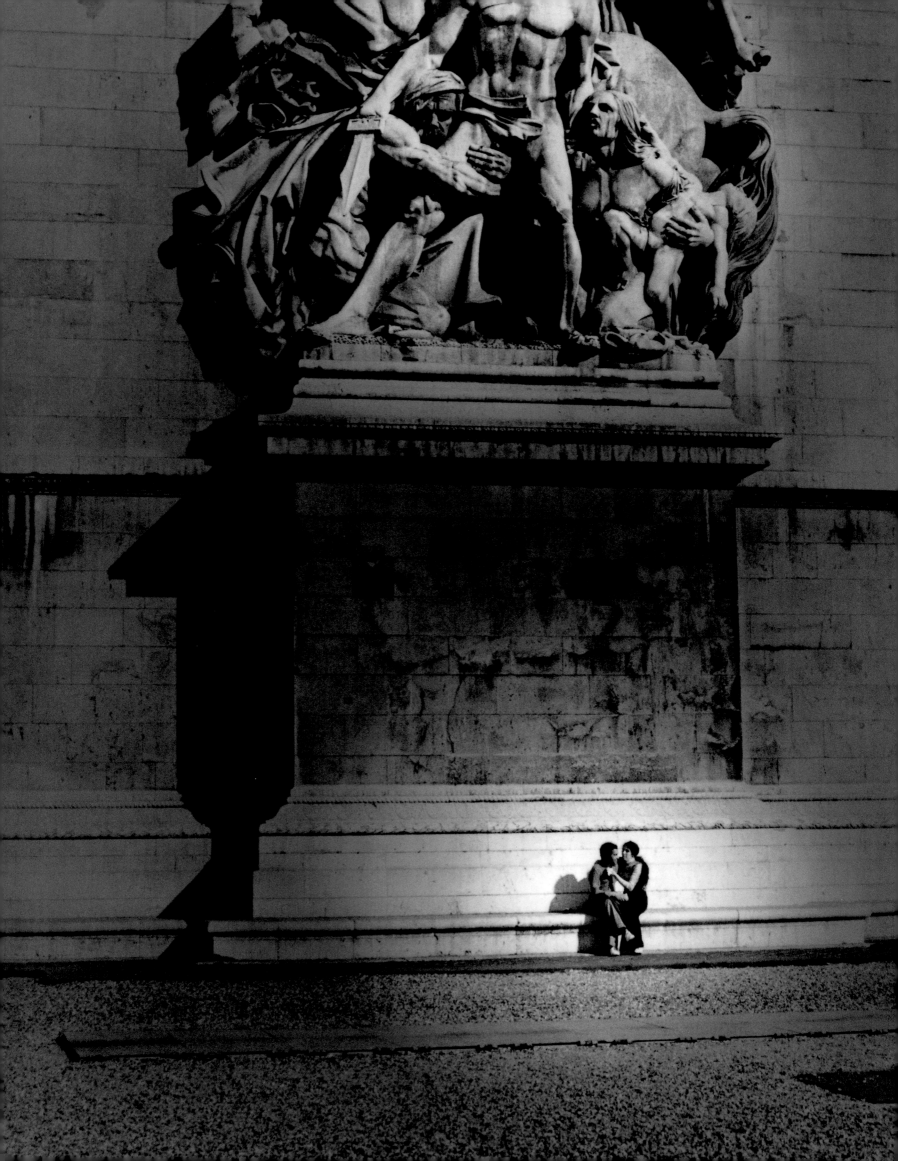

THE SIMPLE TALE OF A PARIS STREET URCHIN AND DUTIFUL SOLDIER

I was born at 89 rue d'Assas, in Dr. Stéphane Tarnier's clinic.

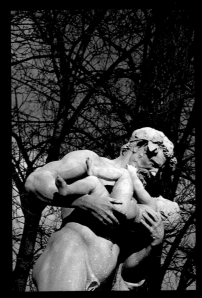

My father rushed in, took me in his arms, and set me in my cradle. After wiping a tear from his leathery cheek, he left without a word. We didn't hear from him for a long time after that.

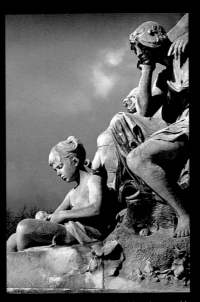

Like many poor kids, I studied hard. I quickly learned how to read and write, and I soon caught measles, mumps, and whooping cough.

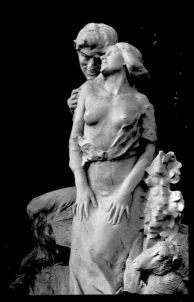

Our games were innocent, our joys simple. Virginie helped me discover the marvels of nature.

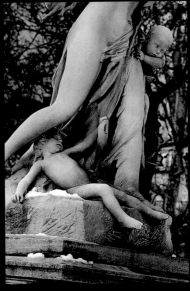

Plagued by dark forebodings, my mother clasped me to her breast and suddenly left the clinic, despite the good doctor's rebukes.

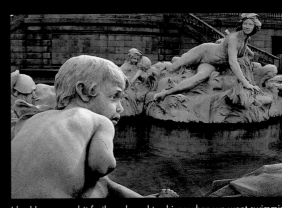

I had become a bit frail, and used to shiver when we went swimming on Sundays. My mother thought I looked too pale, and decided to send me to live with friends on a farm outside Paris.

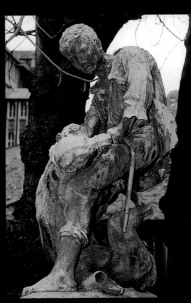

One day an unfortunate incident occurred. Jealous of being excluded from our games, Virginie's dog bit me on the thigh. The wound wasn't deep, but the froth on the dog's muzzle spurred my adoptive parents to put me back on the train for Paris.

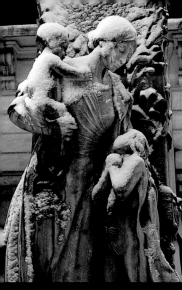

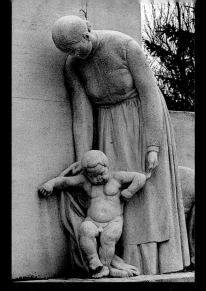

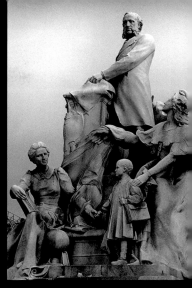

hen came the cold weather. My mother, older brother, and I went through hard times. t's no exaggeration to say that my mother, brother, and I were in desperate straits.

My first steps were a great joy to my saintly mother.

When it was time to go to school, she regis tered me in the free public school run by Monsieur Jules (a strict but fair man).

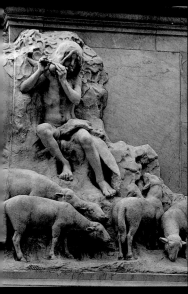

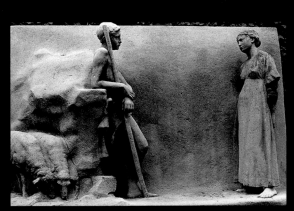

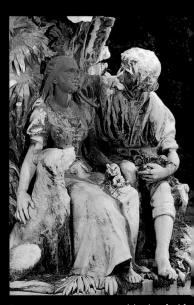

he folks at the farm welcomed me like a son. made myself useful by keeping the sheep, laying a little flute.

There I met Virginie, a shepherdess my age.

Every evening, accompanied by her faithfu dog, Virginie would come to sit by me. brought her the first flowers of spring.

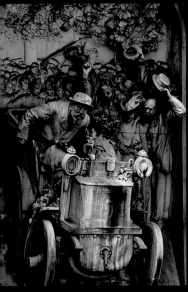

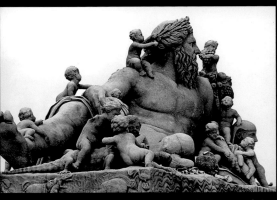

hen came the gloom of illness. But my recov ery was hastened by good news. My father, having become a famous race-car driver, wanted to flee the adoring crowds. My

But the welcoming kisses couldn't mask reality for long. My father had returned with so many new little brothers that I began to feel too big for such a small house. So my mother was pleased when I told her I was joining the armed forces.

On the advice of elders, I decided to make it a career. their influential wake, I found a job with a future in th Gendarmerie, where I could become a secretary, chauffeu skin diver, or typist—and, with my superiors' approvo

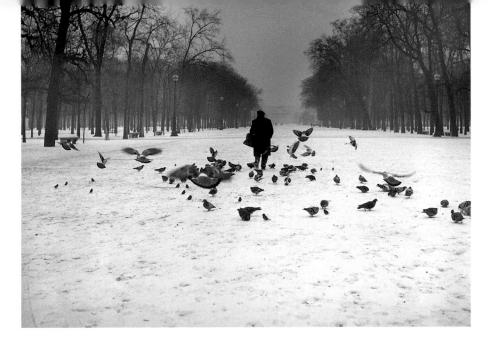

Tuileries Gardens, 1951

FACING PAGE: *Horses of Ice*, Fontaine de l'Observatoire, 1983

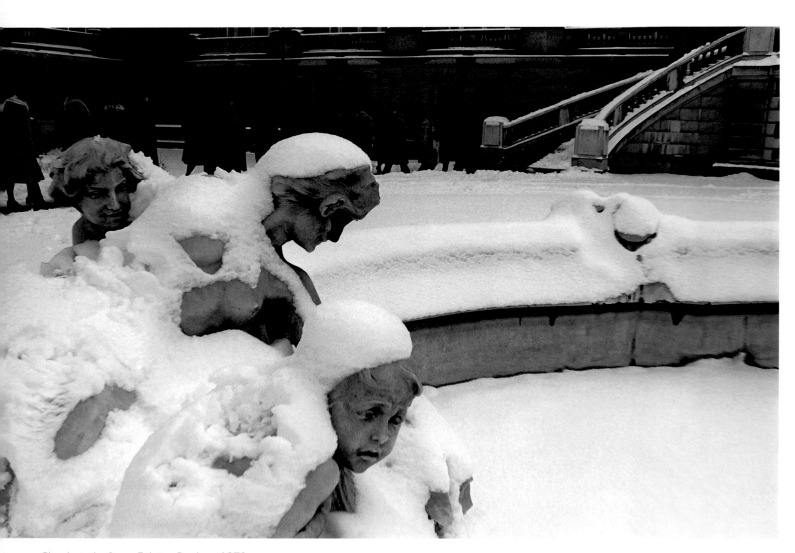

Cherubs in the Snow, Tuileries Gardens, 1978

FOLLOWING PAGES: *Three Small Children in White*, Monceau Park, 1971

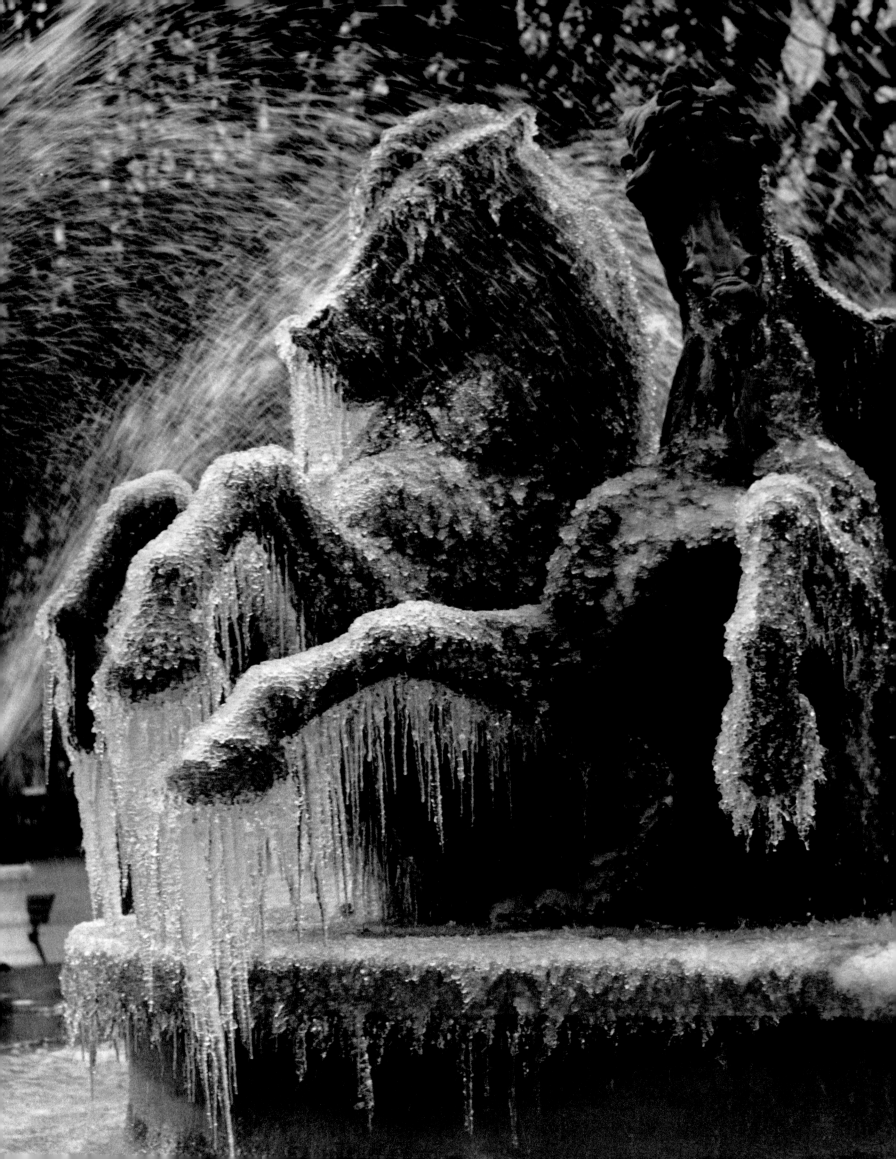

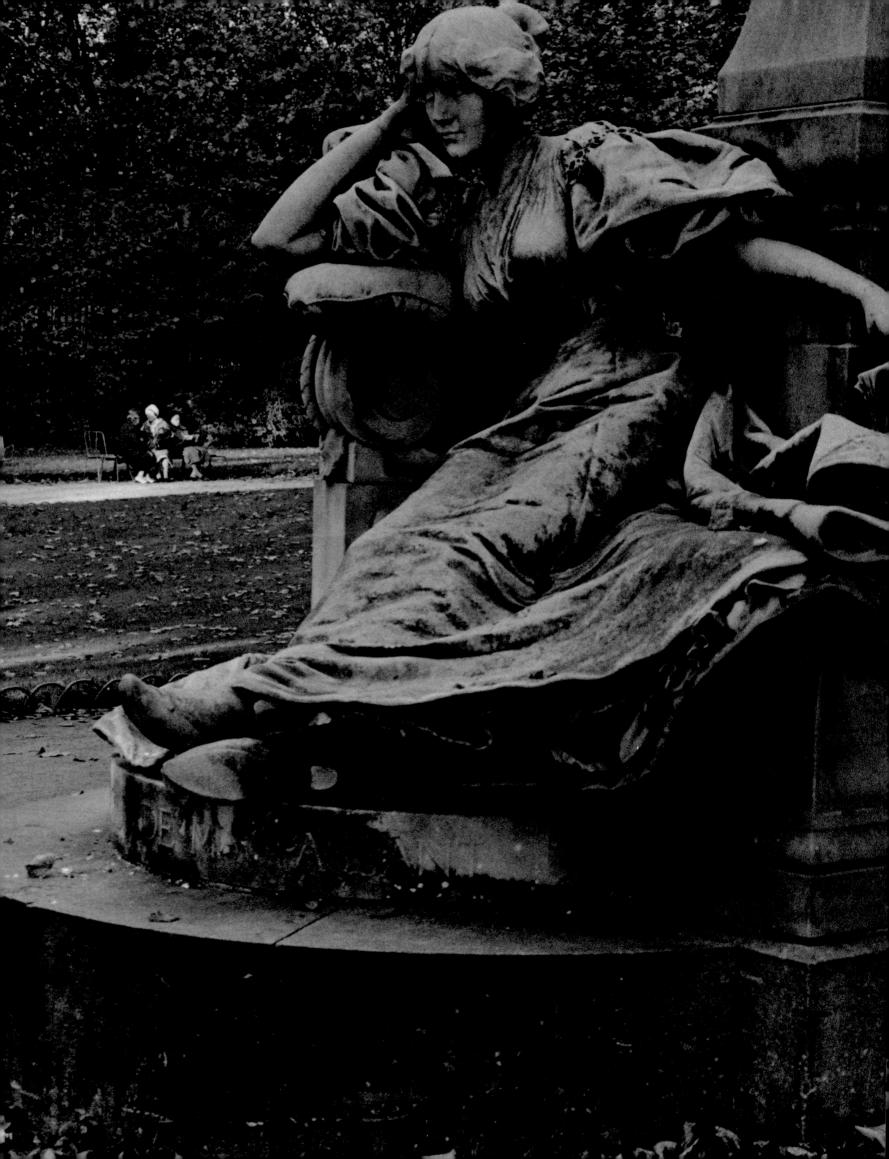

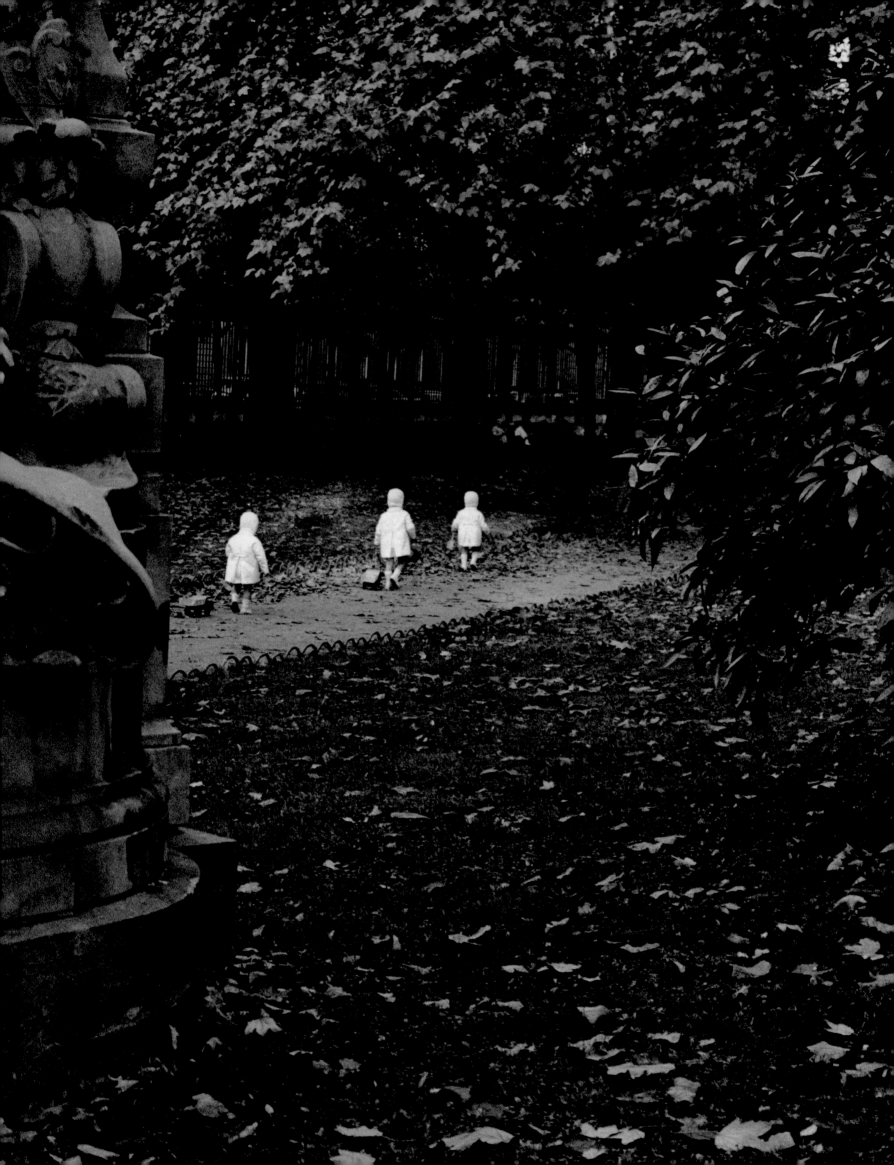

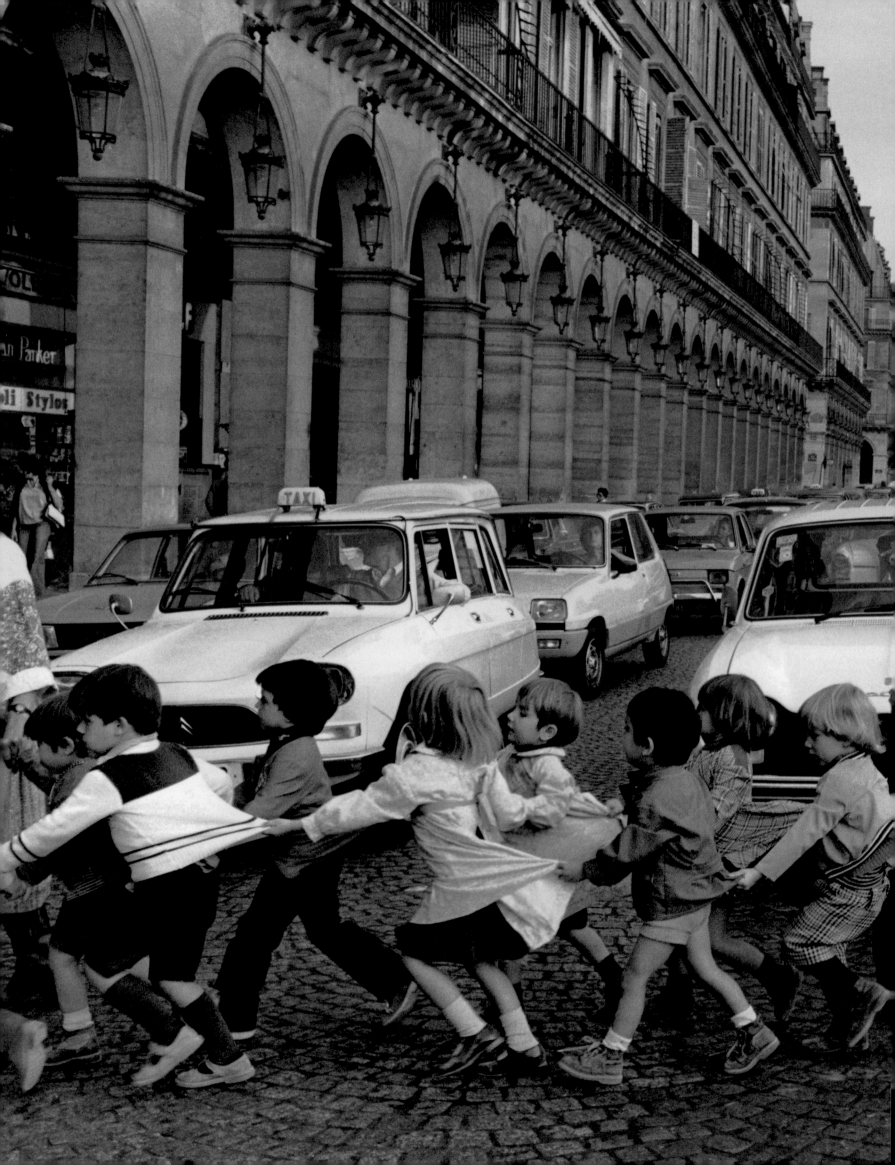

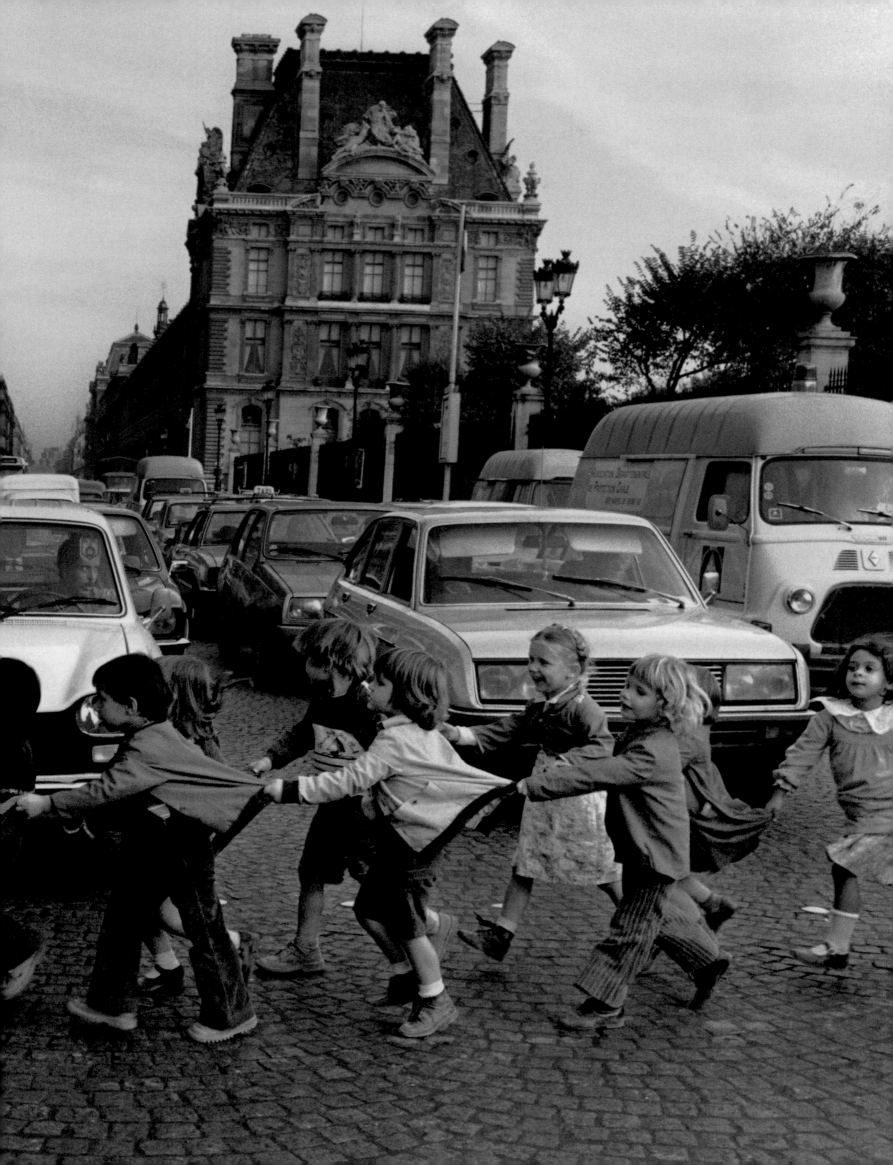

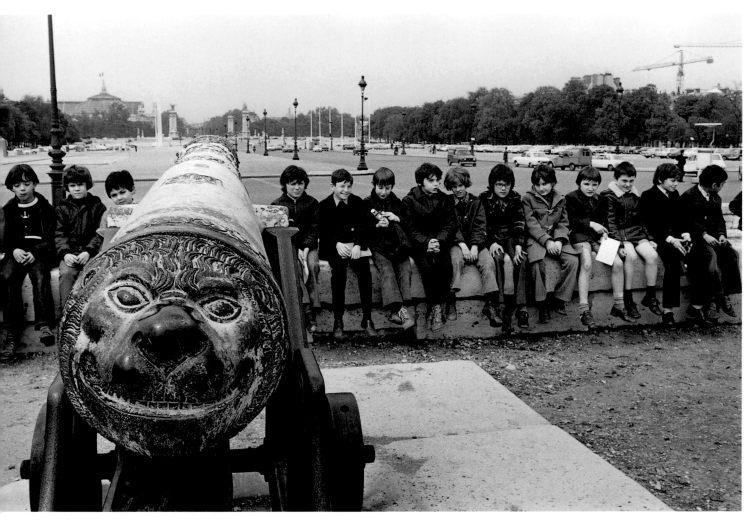

The Cannon of Isabella the Catholic, 1972

Preceding pages: *Daisy Chain on rue de Rivoli, 1978*

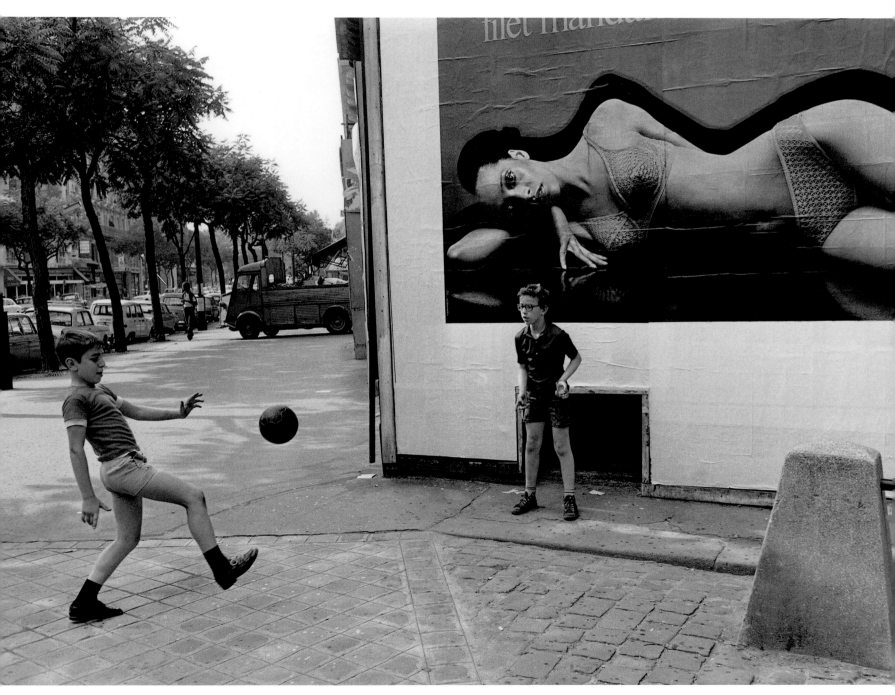

Boulevard Voltaire, July 1971

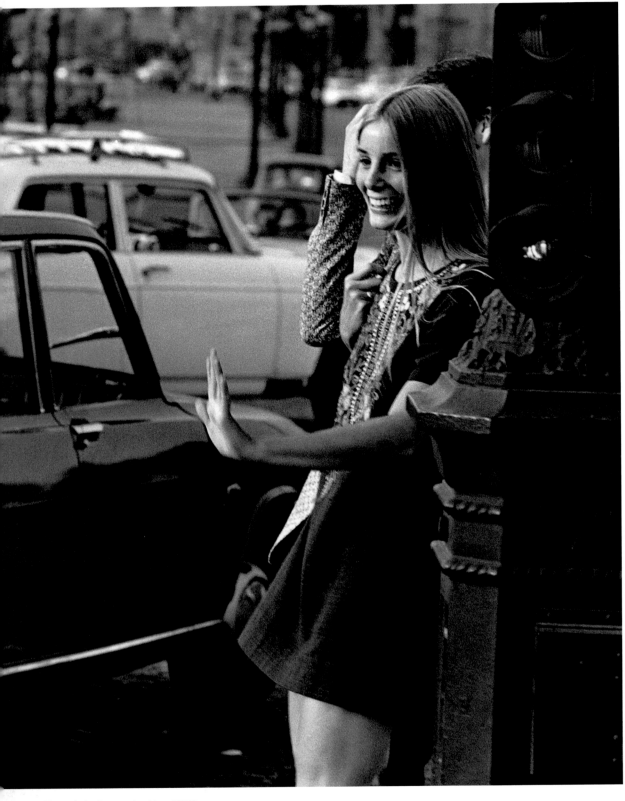

Place de la Concorde, May 1970

FACING PAGE: Place du Carrousel, 1971

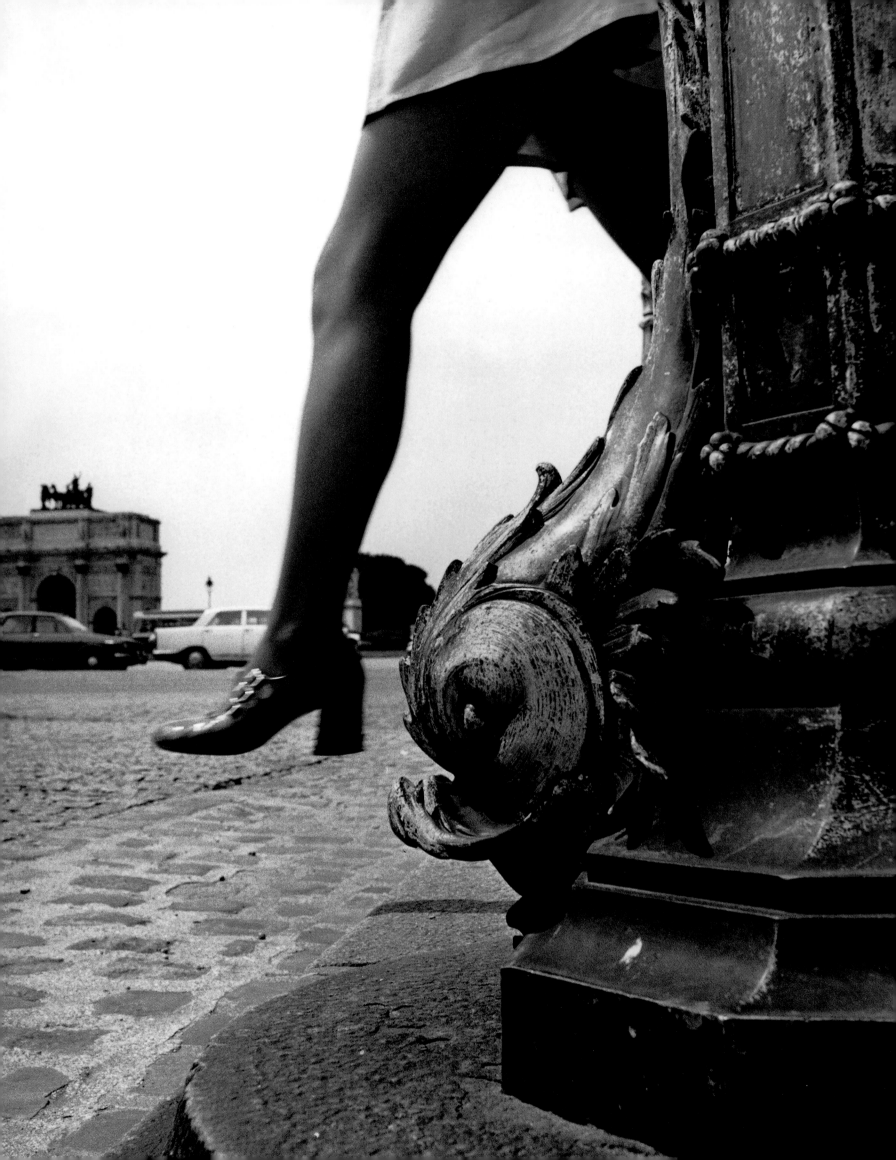

" Actresses are no longer what they used to be.

I remember ones who only agreed to travel if carried in triumph, though I was too young to know the great Sarah [Bernhardt] in her days of glory.

Like everyone else, I read stories of special trains that required an extra carriage just for hat boxes.

Just imagine the reception a photographer would have received if he'd asked a star to pose in front of a truss supplier's window.

The scoundrel would have been thrown into the street by servants.

I managed to avoid this fate when my fair proposal was accepted, just like that, by Sabine Azéma.

The sex symbols of yore, made to be ogled from a distance, have been replaced by a new generation of actresses familiar with photographic equipment that multiplies their image many times over—machines with insect eyes that are hostile to bombast.

Learning to lie artfully in this new language obliges actresses to open their eyes and ears, so it's only natural they develop a certain complicity with professionals who cultivate a sense of observation.

I, too, had a lot to learn from a person endowed with such mysterious power, so I studied her face in quest of reactions produced by the spectacle of the street.

Her face seemed very beautiful, handsomely sculpted, a fine reflector of light—in short, irresistibly photogenic. That's all it took to deflect me from a career devoted to social realism. And that's how I became a portrait photographer. "

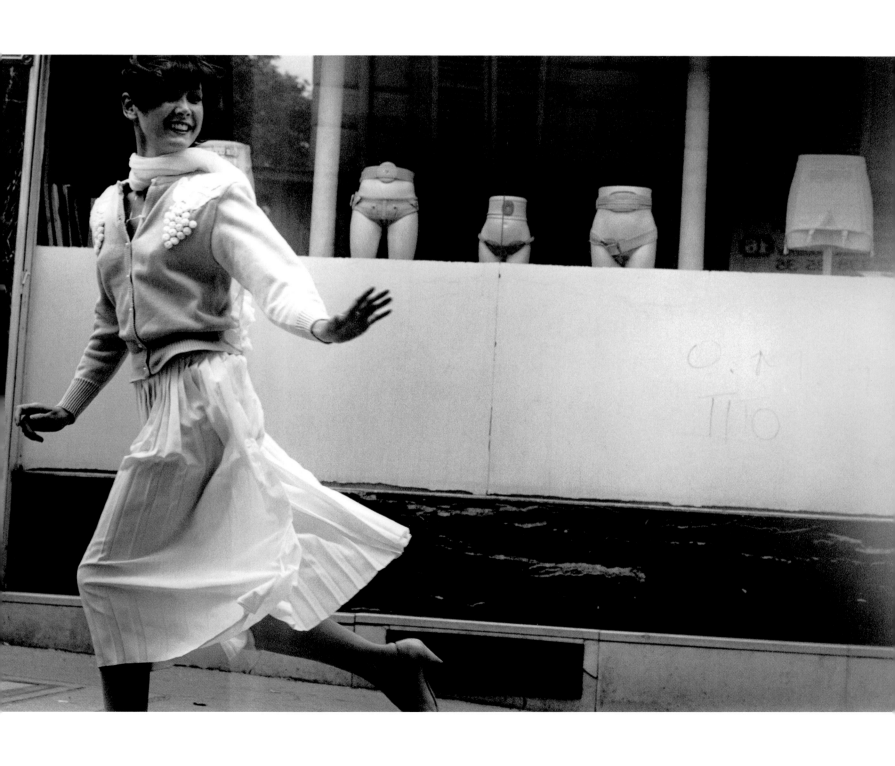

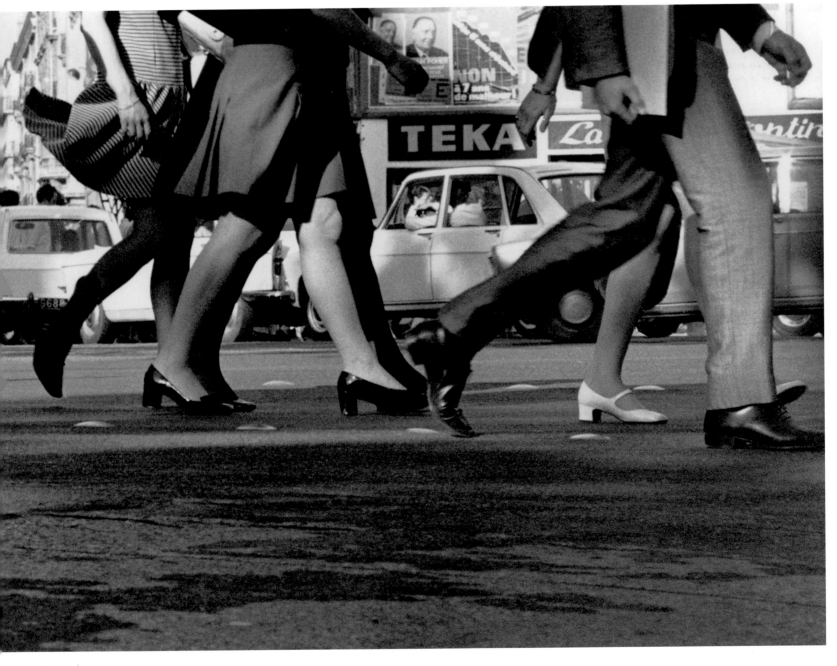

Passing feet

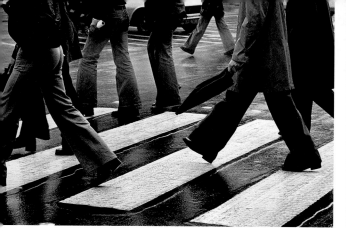

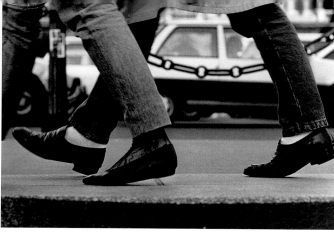

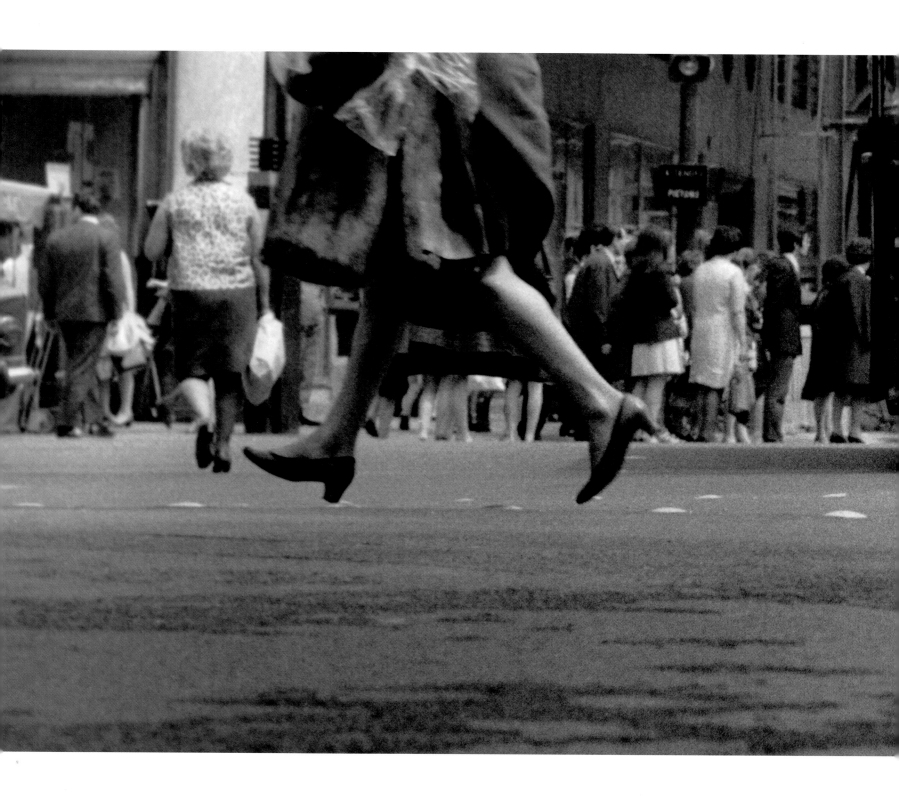

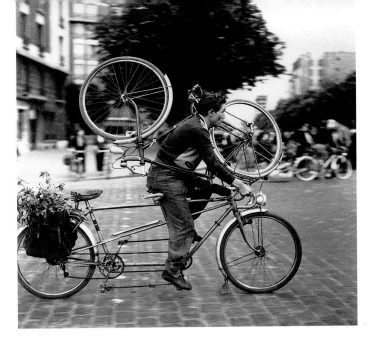

Sunday evening at the Porte d'Orléans, 1953

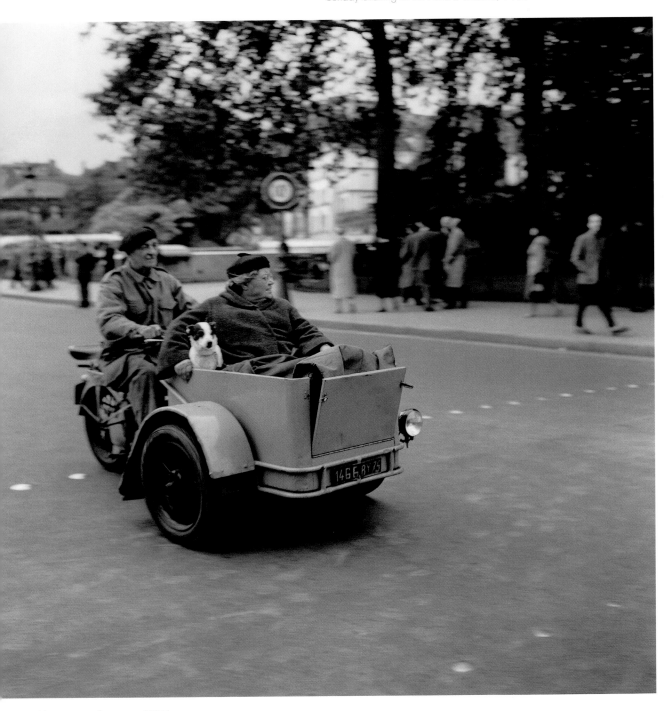

Along quayside streets, 1957

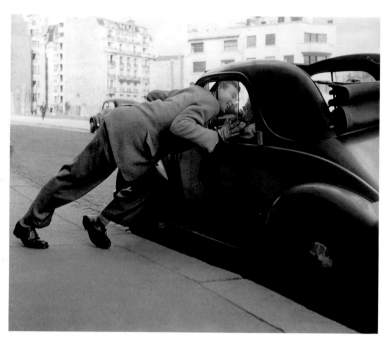

Civilities in a Simca 5, 1945

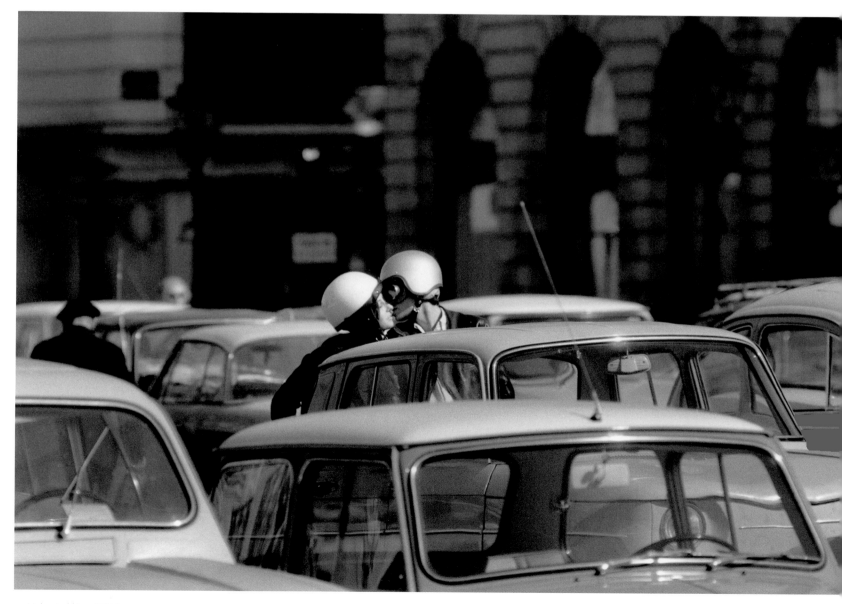

Helmeted kiss, 1966

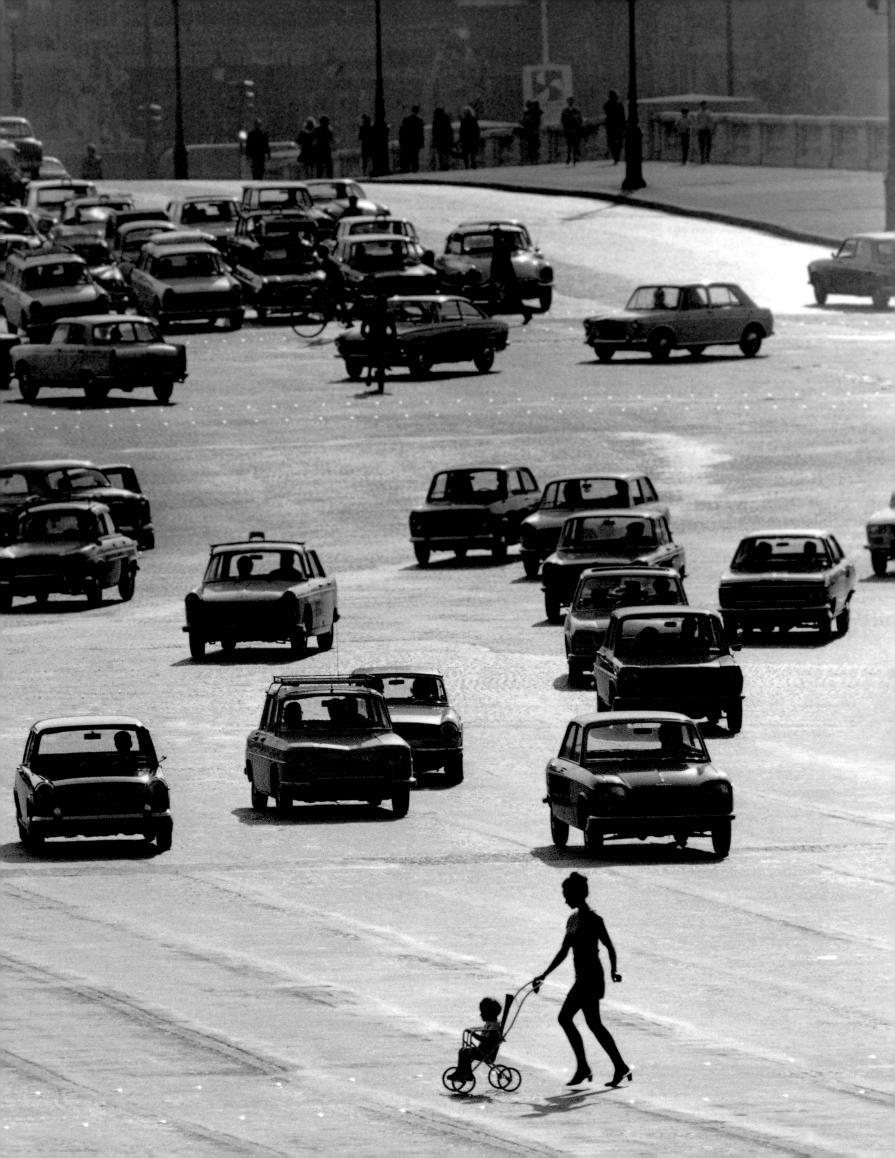

The Mob, 1969

"" Some places in Paris are cursed. The pedestrian crossing on place de la Concorde is located right where the guillotine was erected during the Terror two hundred years ago.

Nowadays, a few extremely agile pedestrians manage to escape the howling mob of cars. To enjoy this sadistic spectacle, there's no better spot than the terrace of the Naval Ministry, where the brass sometimes authorize access for a period not exceeding thirty minutes.

An unbribable sailor makes sure the allotted period is not exceeded. ""

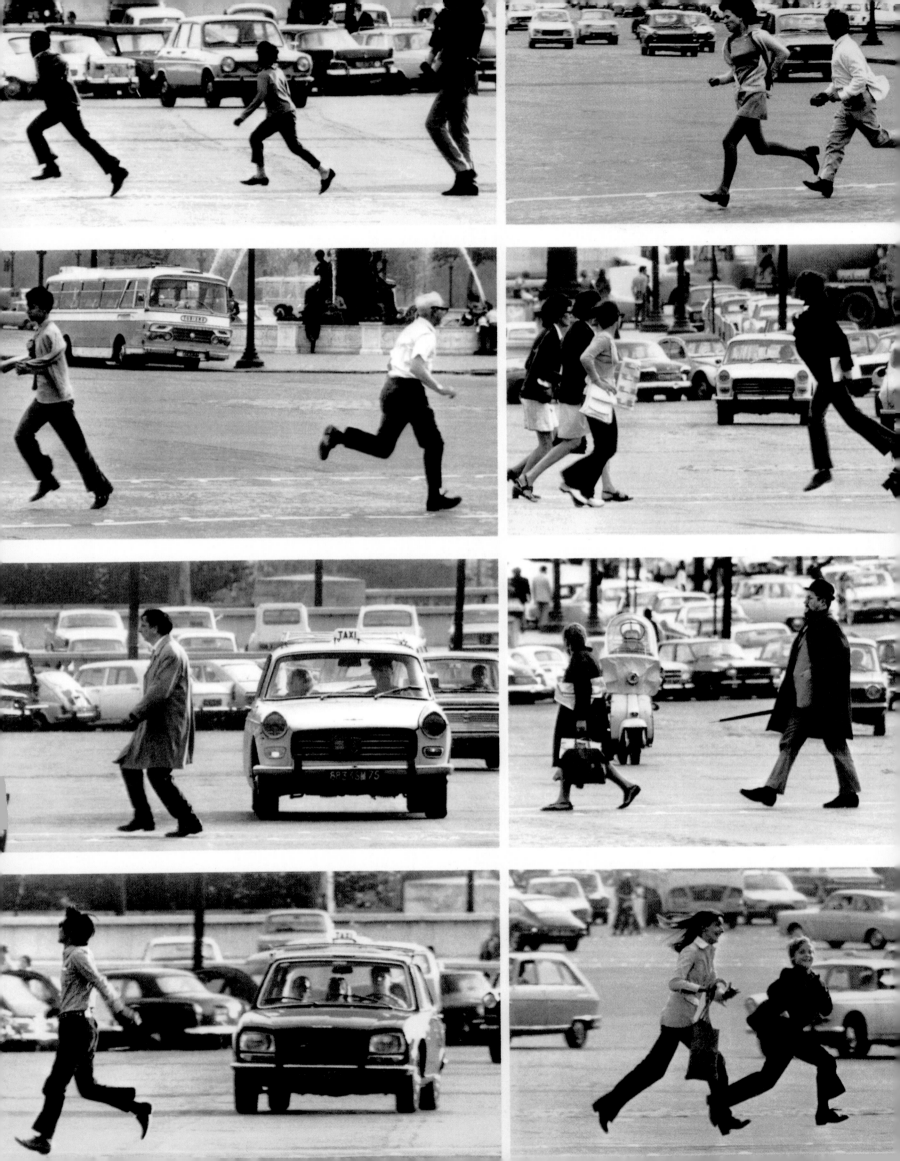

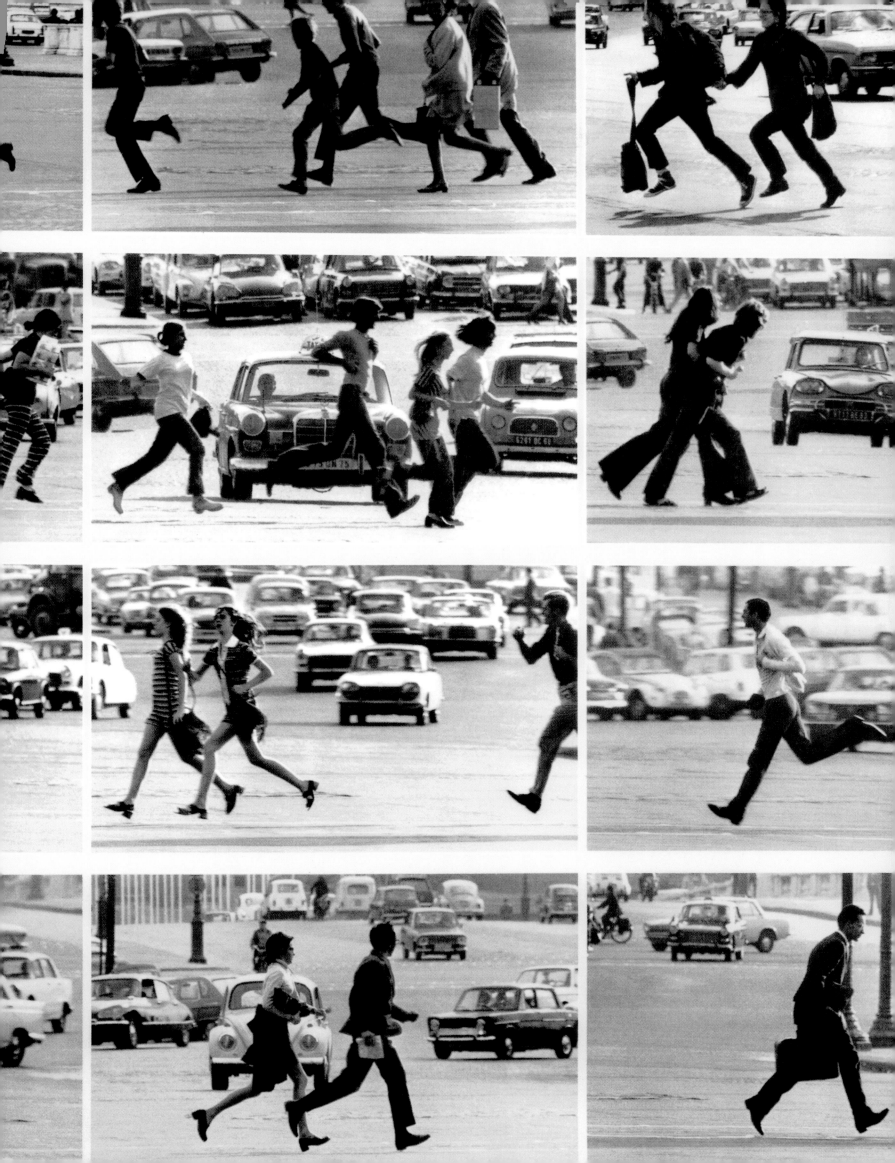

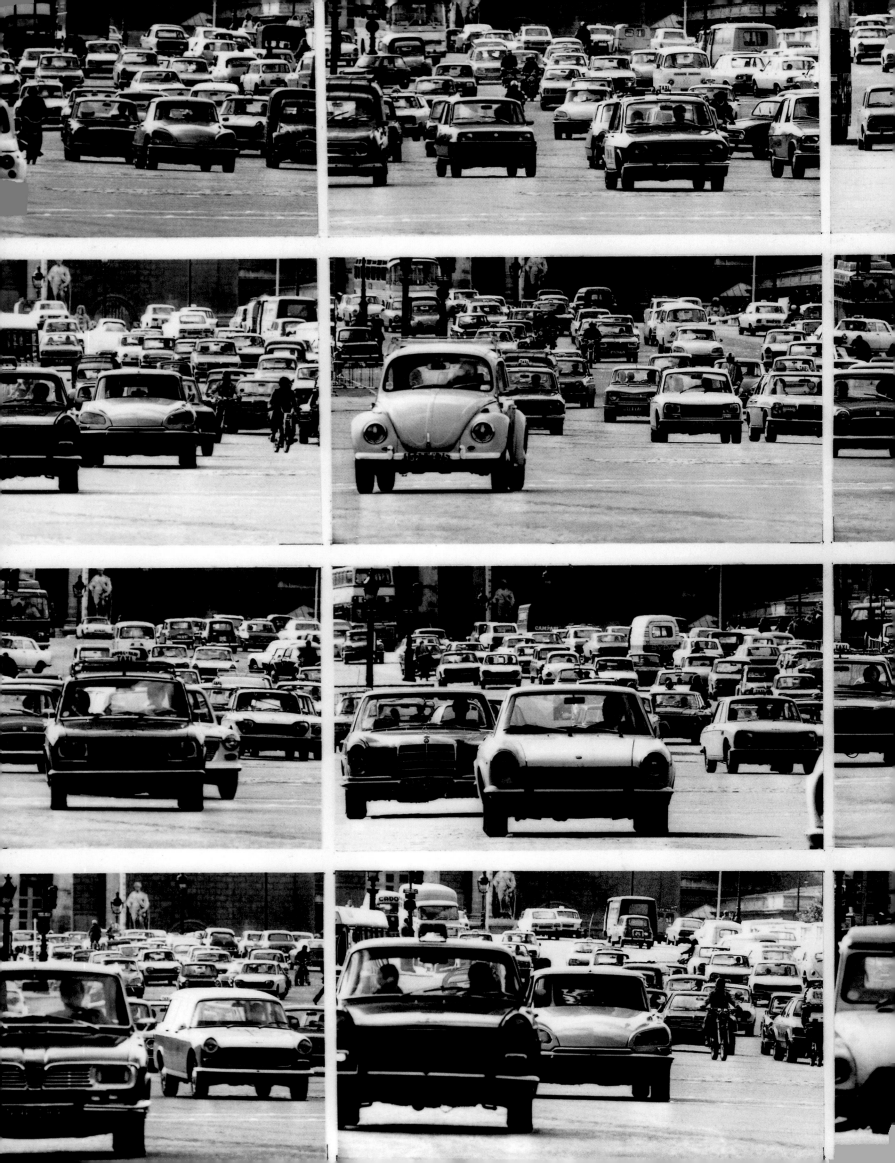

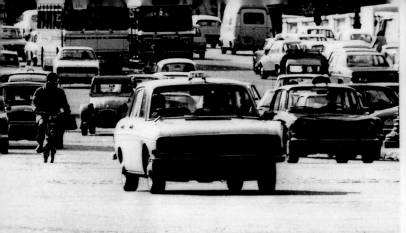
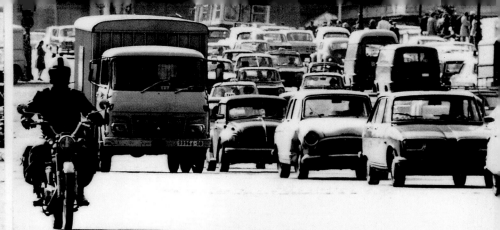
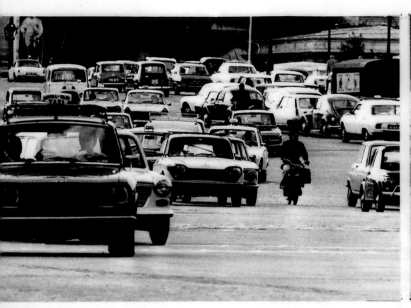
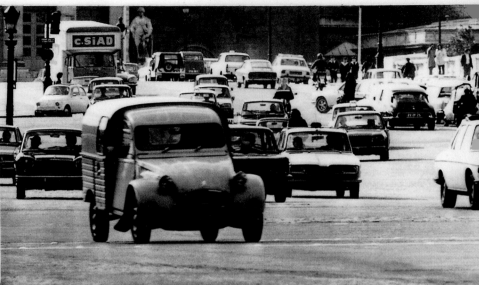
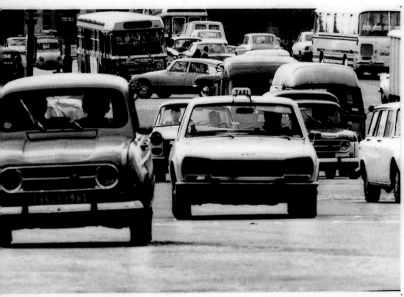
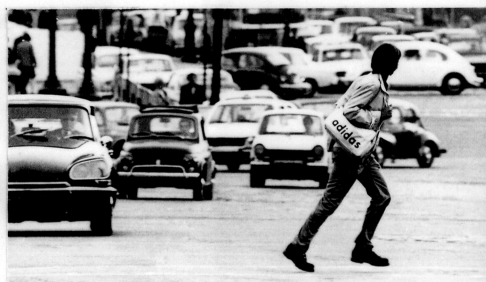
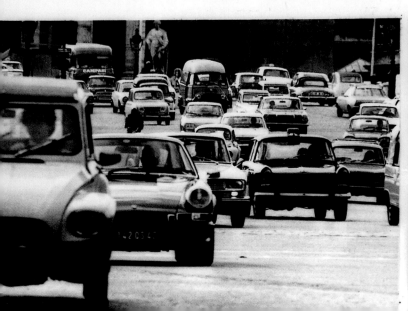
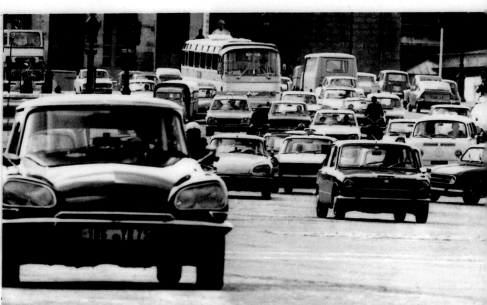

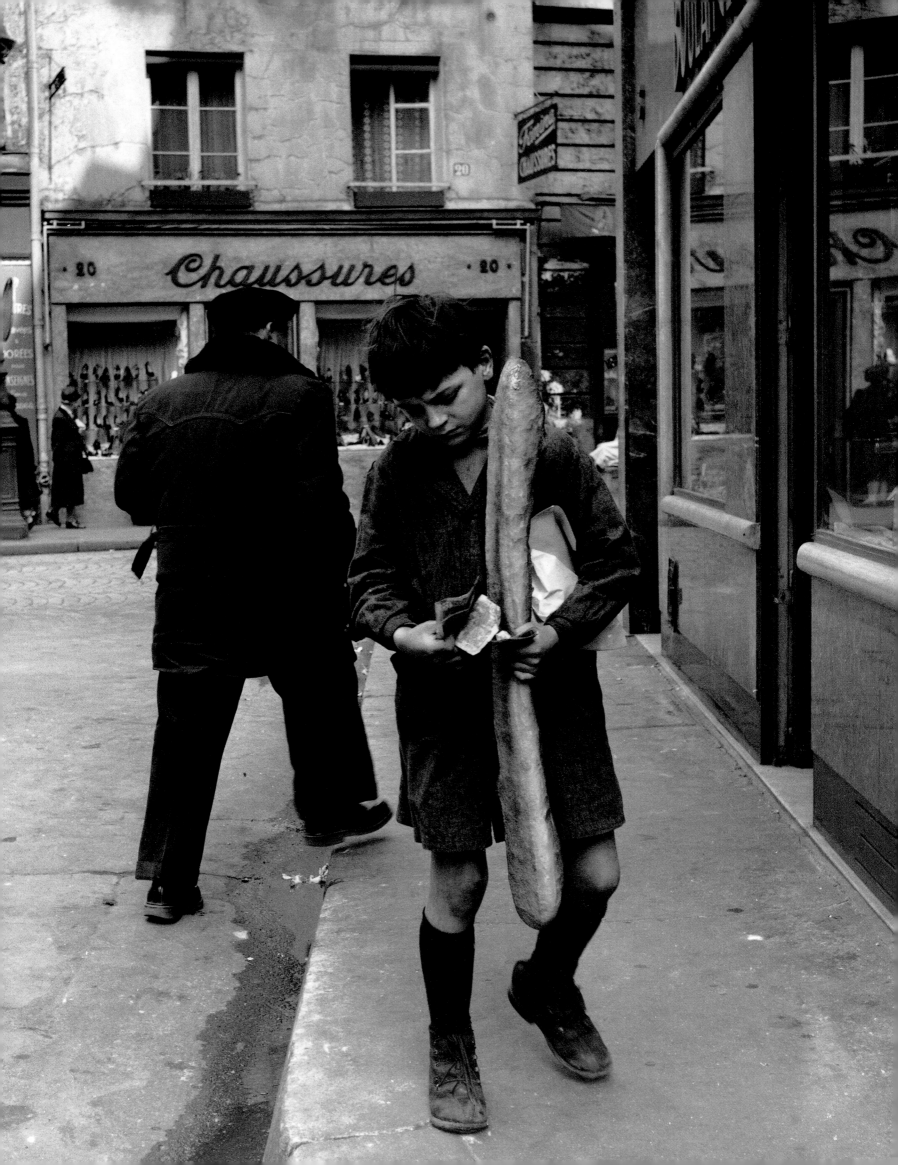

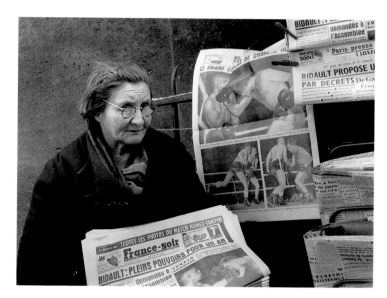

At Passy metro station, 1953

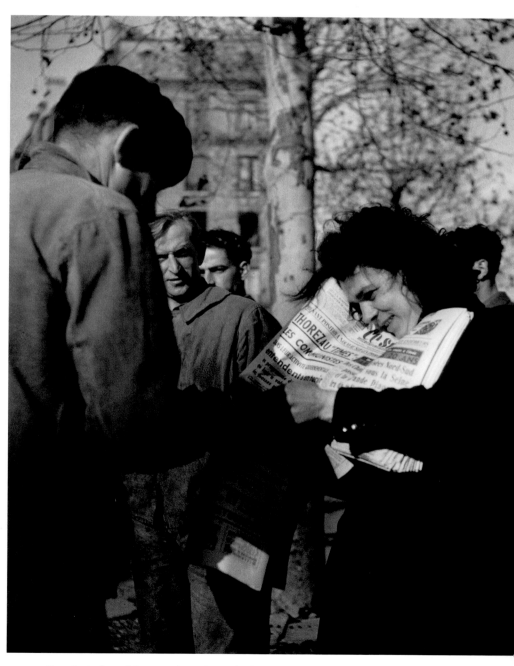

Outside the Renault factory, place Nationale, 1945

FACING PAGE: *Change from Errands*, 1953

PRECEDING PAGES: Place de la Concorde, 1973

LEAPING THE GUTTER, LES HALLES 1953

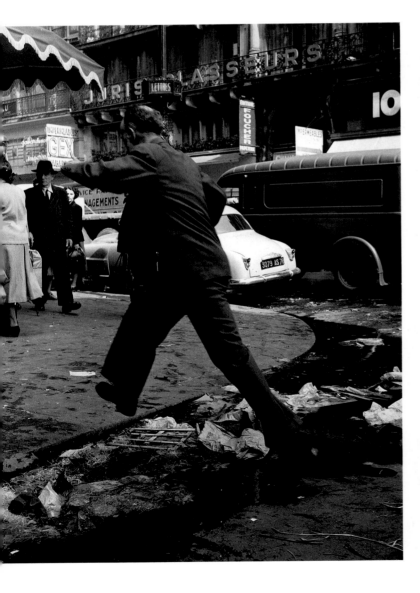
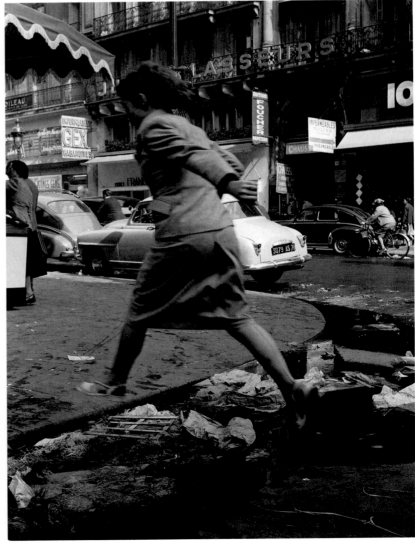

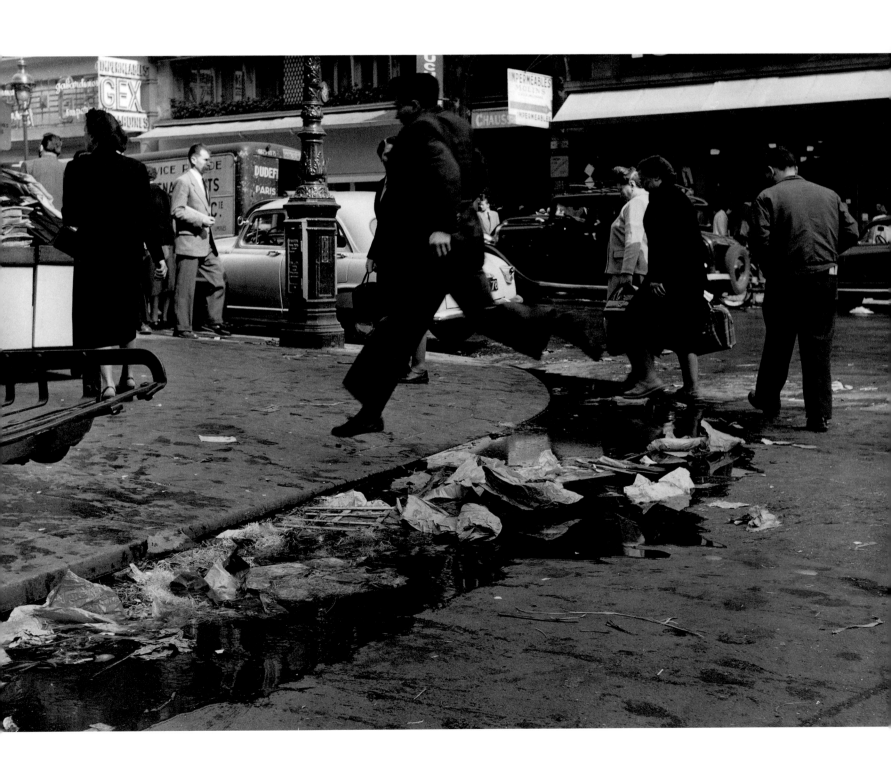

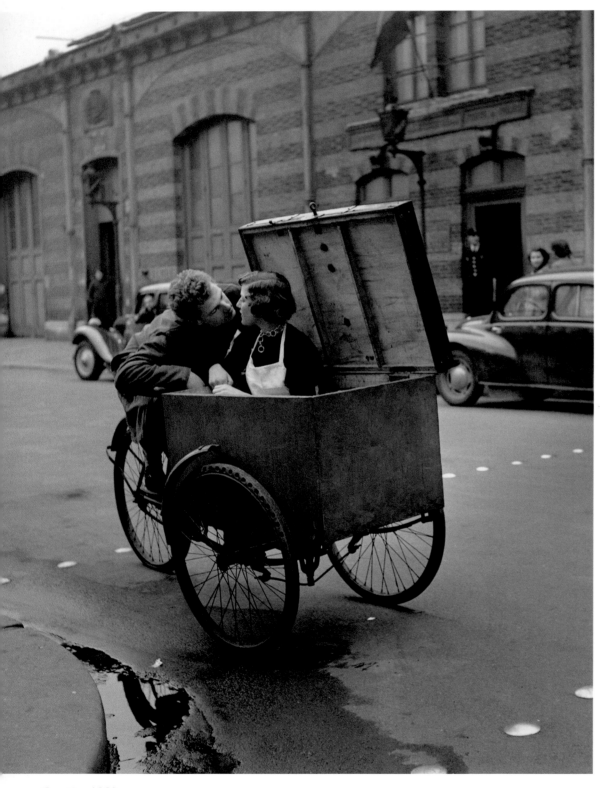

Cosy Kiss, 1950

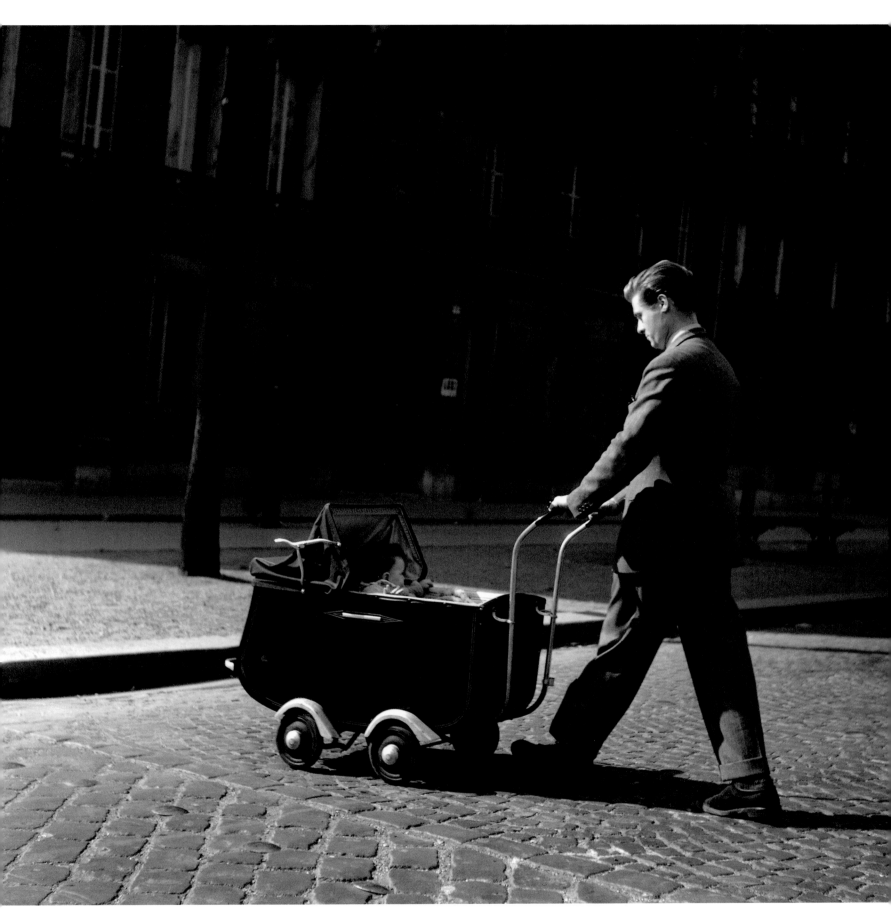

Father, circa 1945

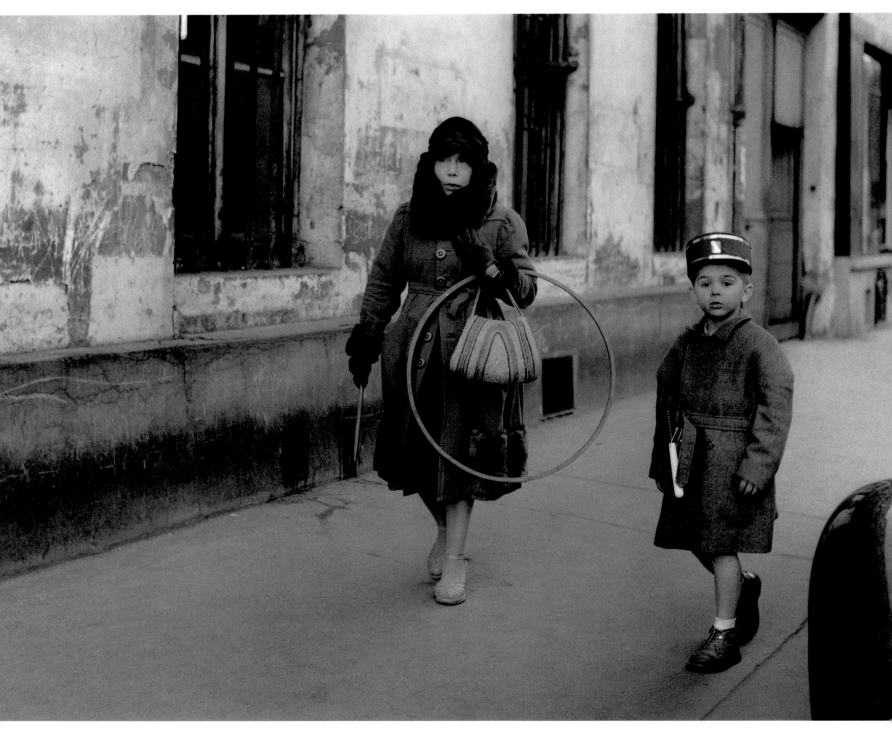

No School Today, 1957

FACING PAGE: *Street Lamp on rue Vilin, 1969*

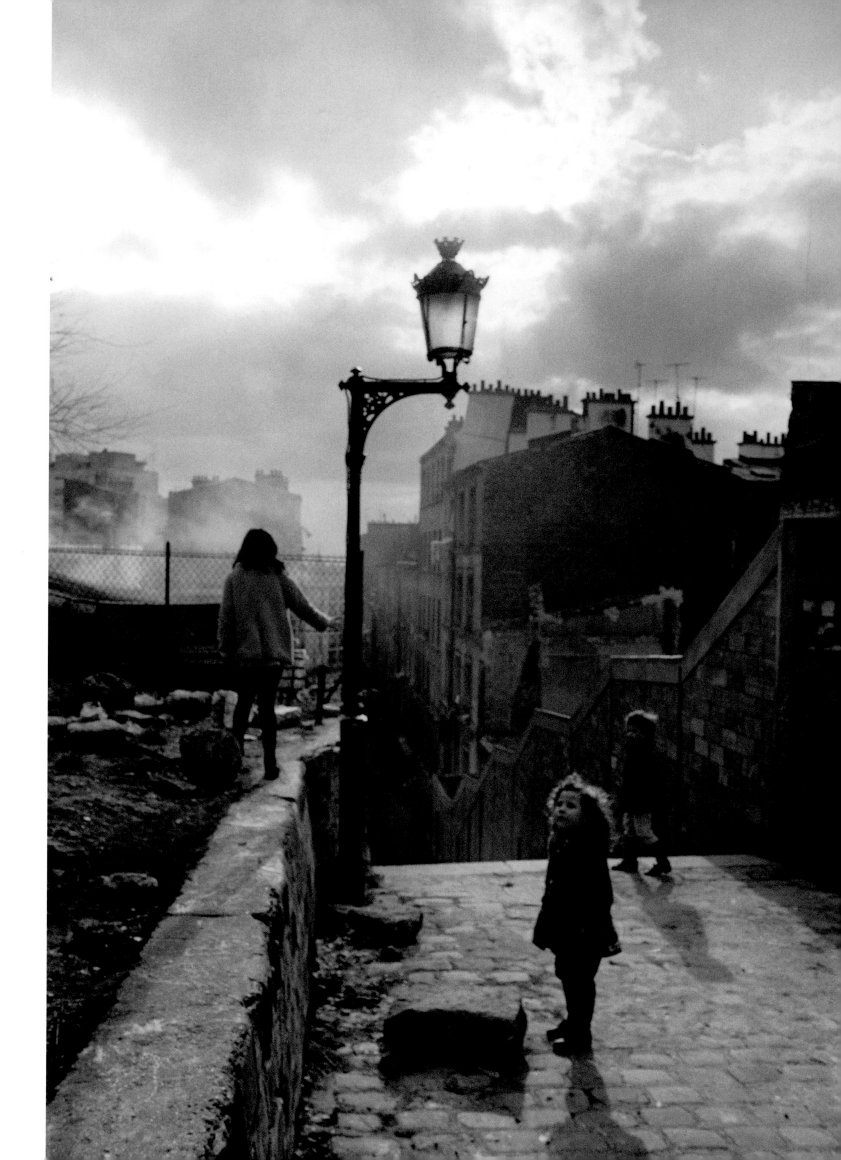

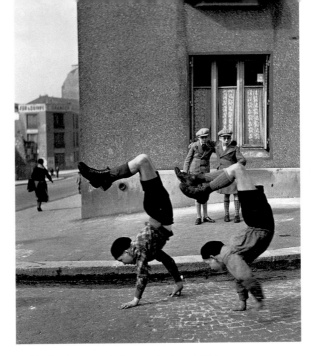

The Brothers, rue du Docteur-Lecène, 1934

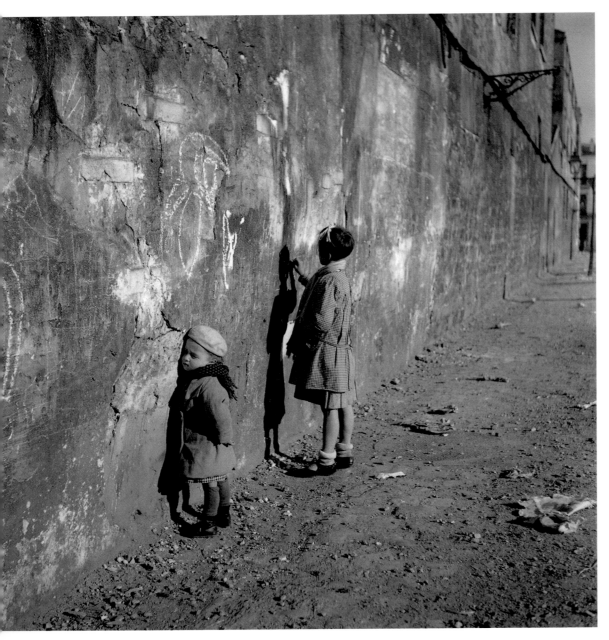

My First Teacher, 1935

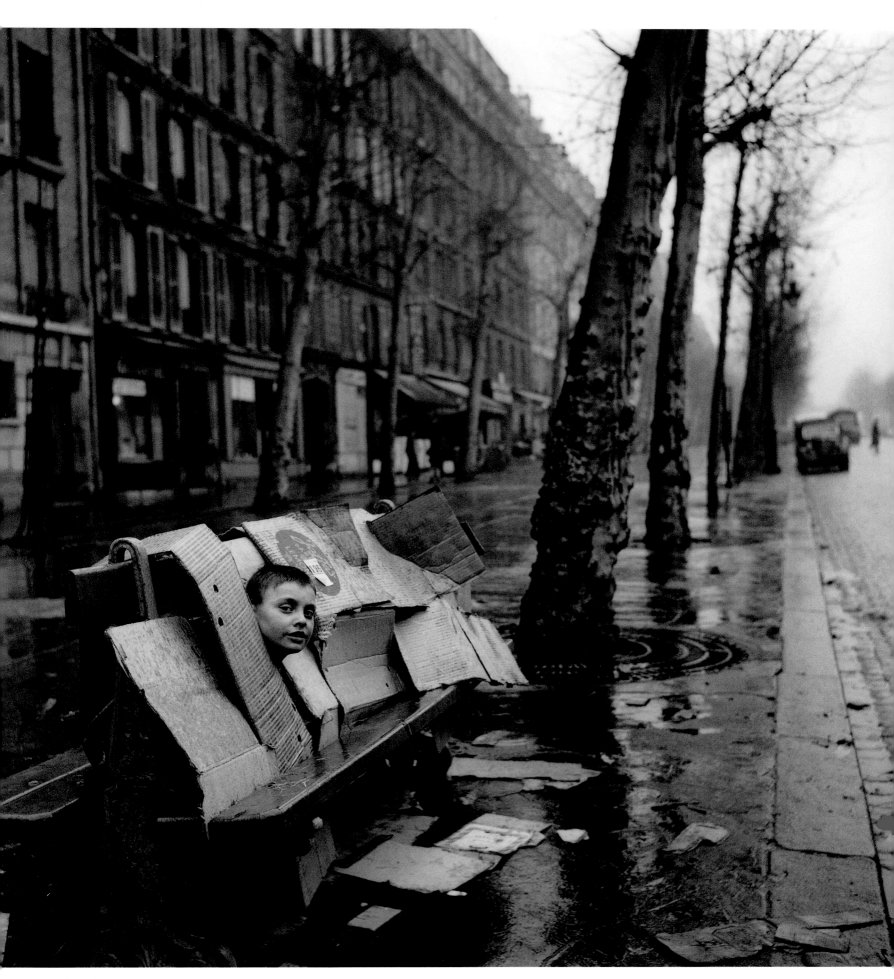

House of Cardboard, 1957

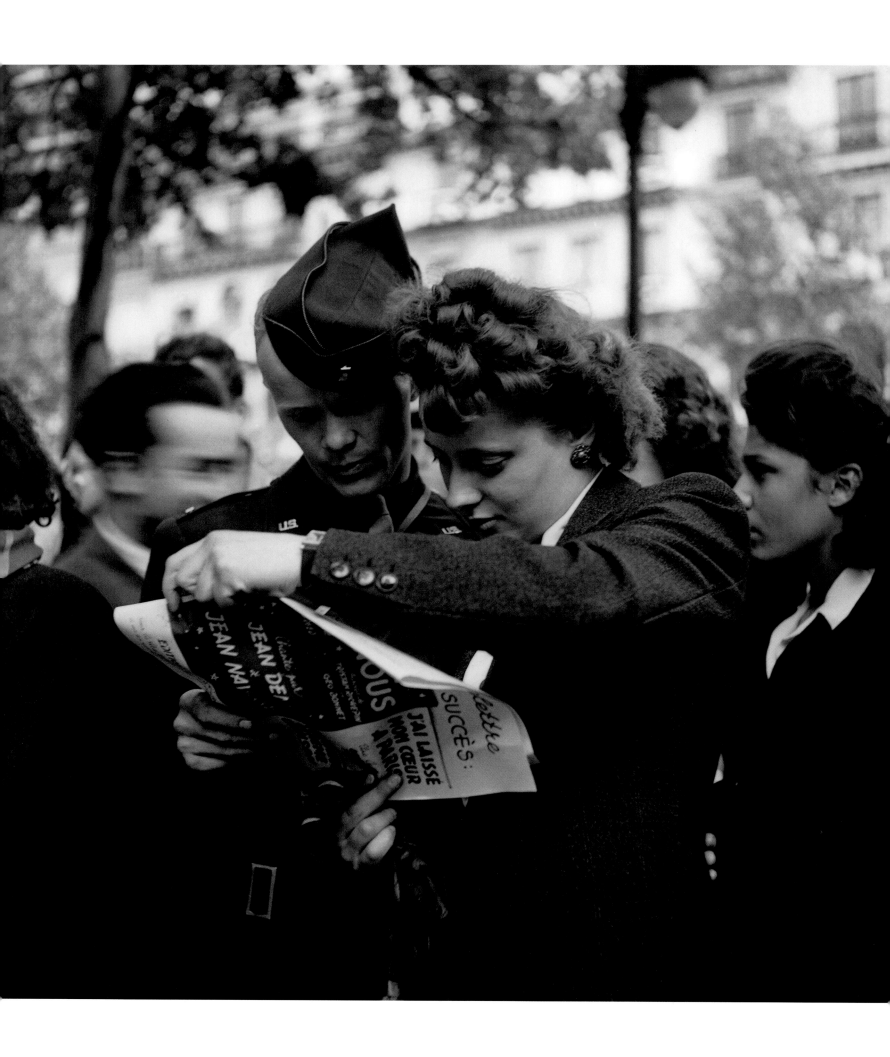

Lyric sheets, 1944

" People not only spoke to one another, they sang together. Street corners would sprout a small band—accordion, violin, drummer, and vocalist—whose leader would sell 'lyric sheets' to the public, so that people could then join in the refrain. Even in the metro someone would sing, and sometimes a dozen people in the carriage would hum along. "

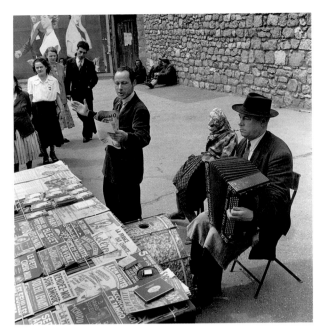

Lyric sheets, 1951

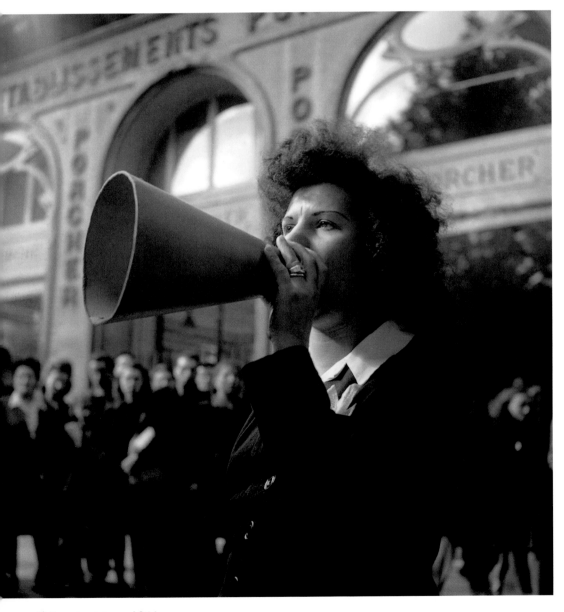

Lili Lian, street singer, 1944

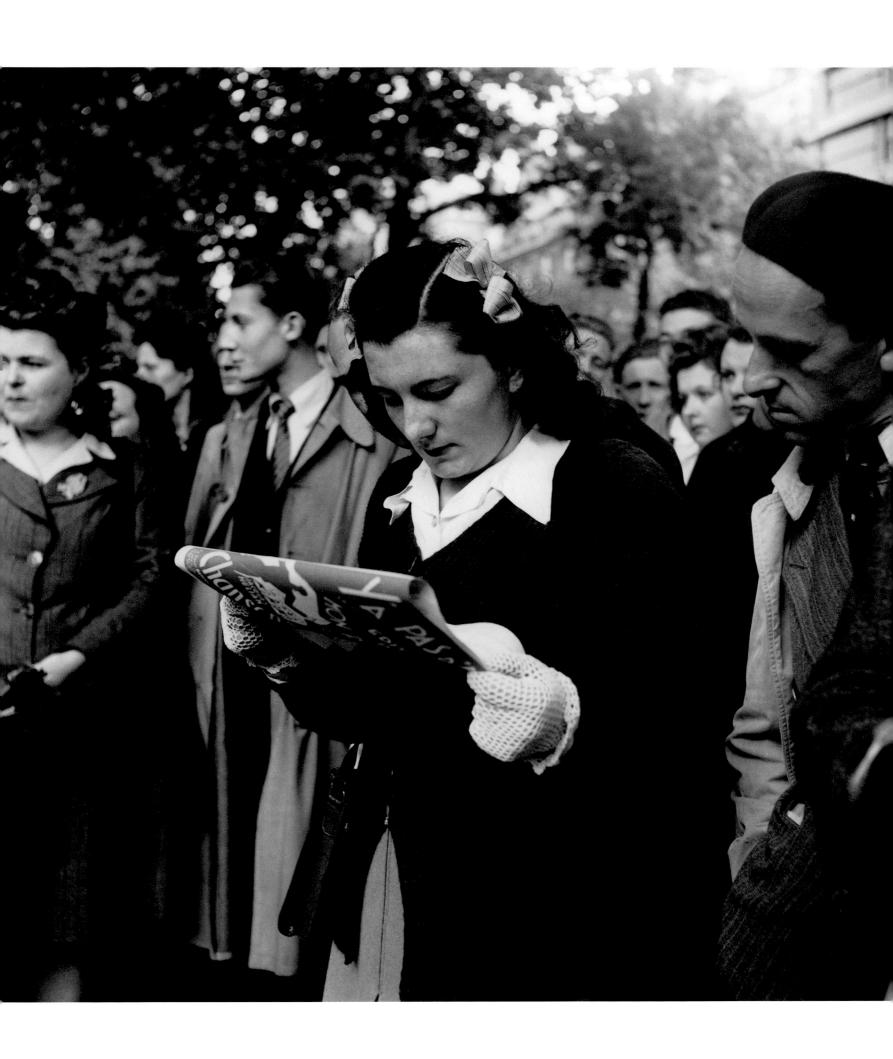

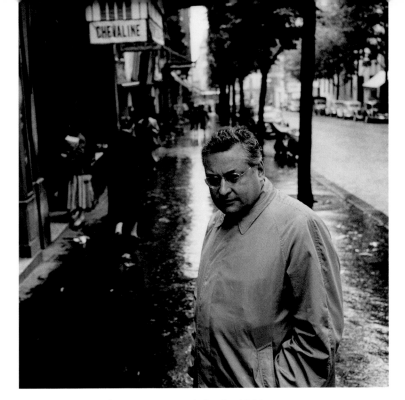

Raymond Queneau on rue de Reuilly, 1956

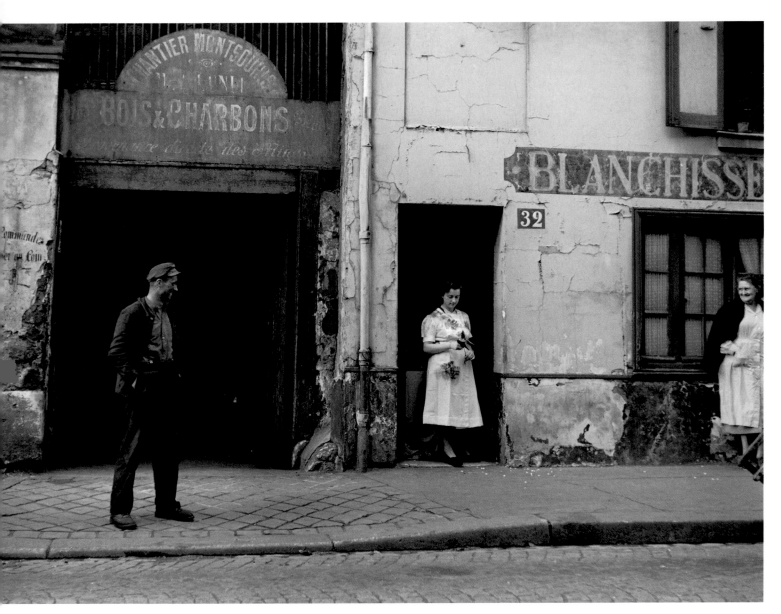

14th arrondissement, 1952

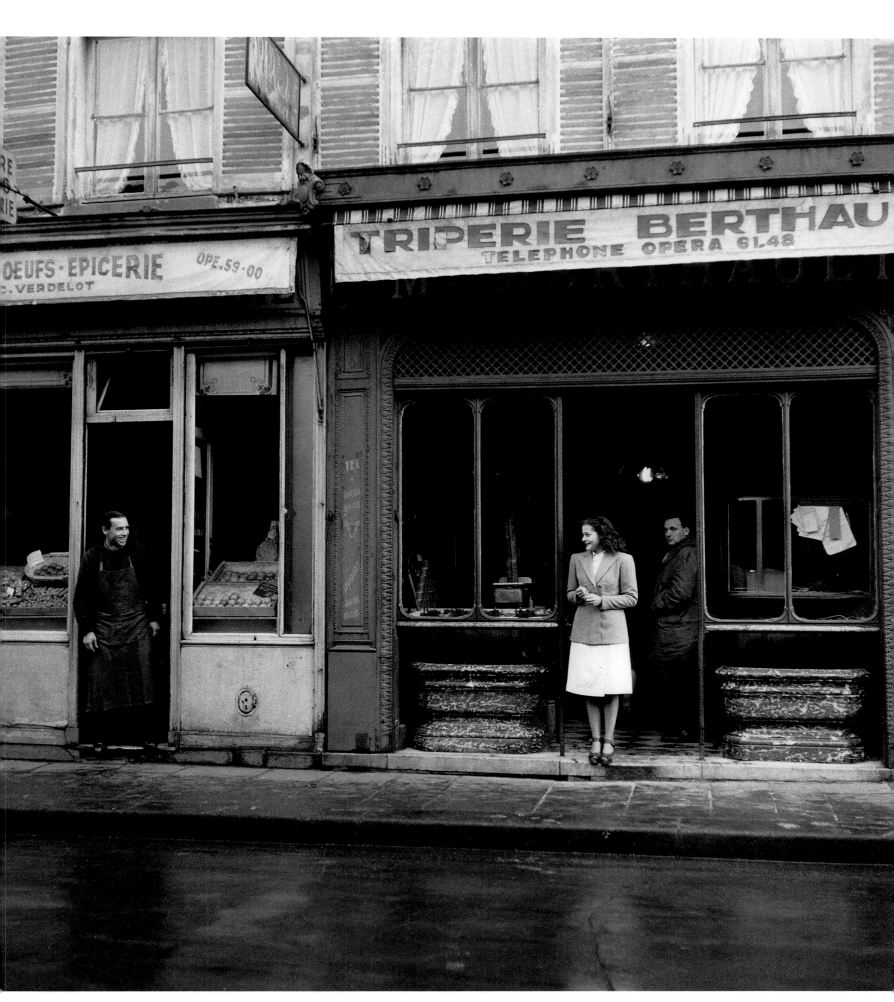

Marché Saint-Honoré, 1945

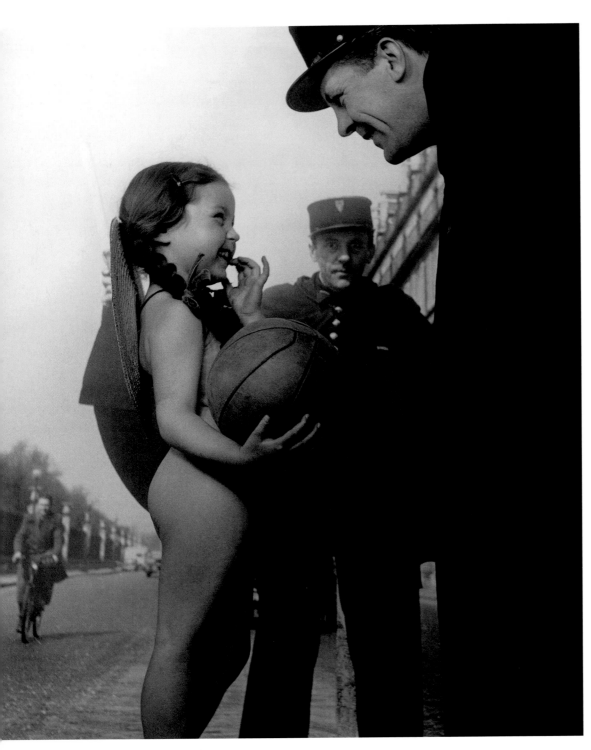

Little Girl and Policeman, rue de Rivoli, 1945

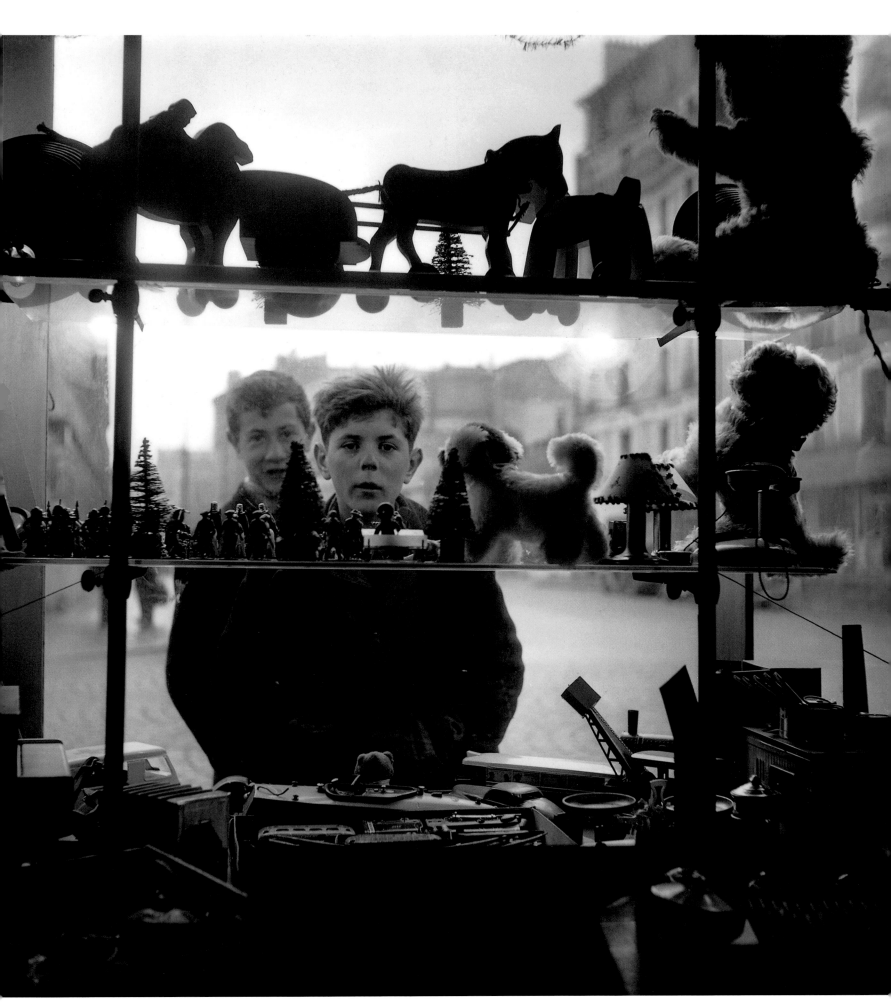

Shop window, 1947

ROMI GALLERY, 1948

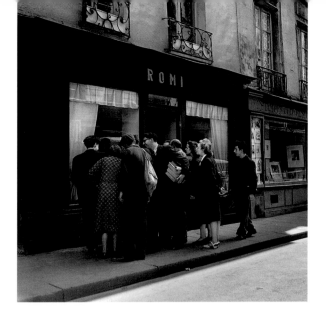

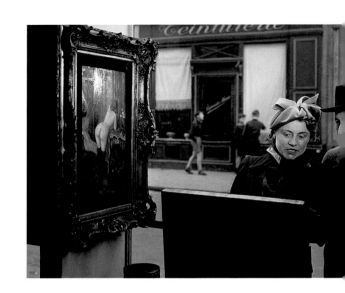

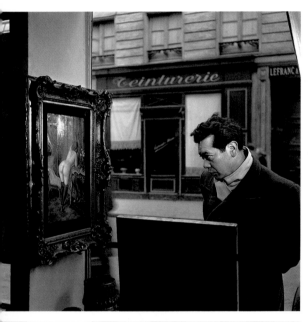

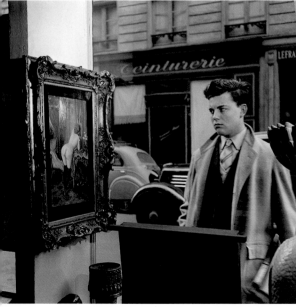

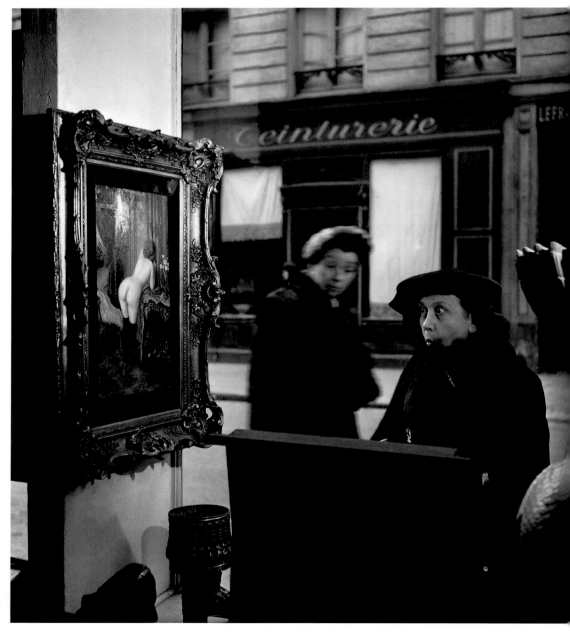

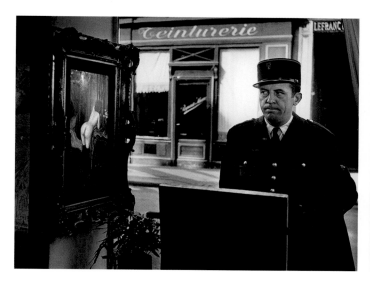

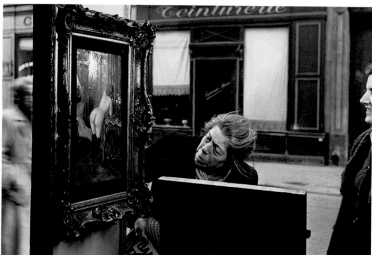

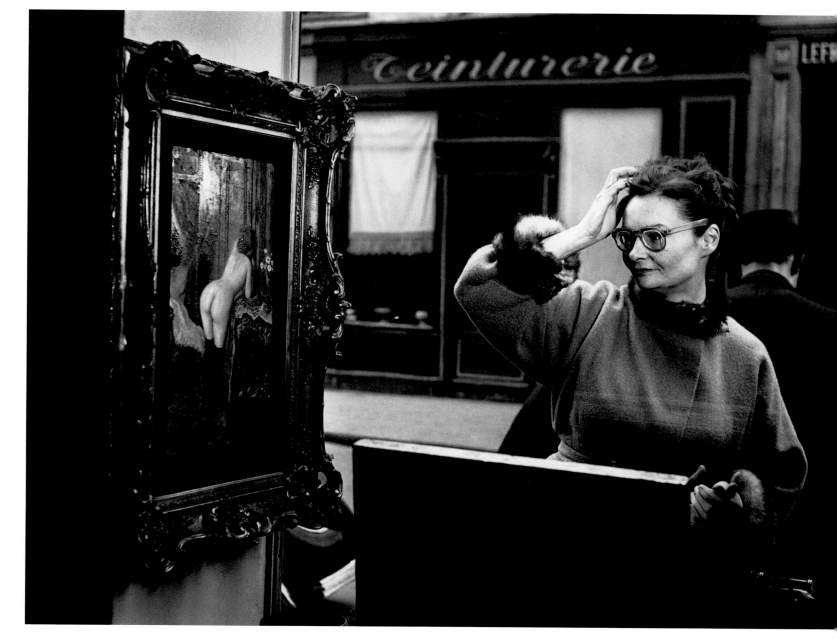

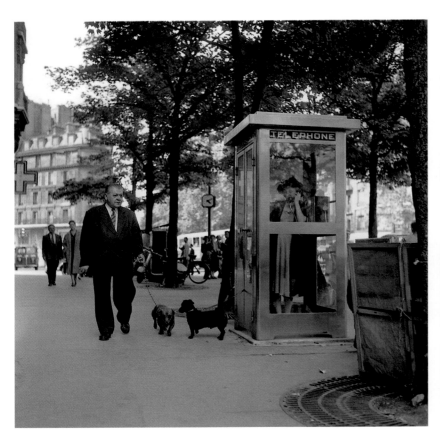

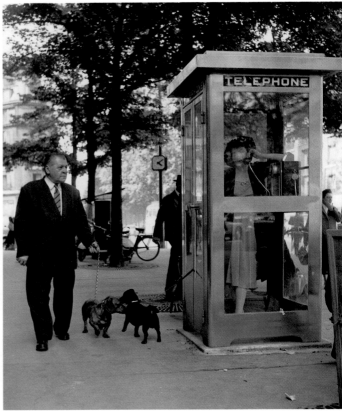

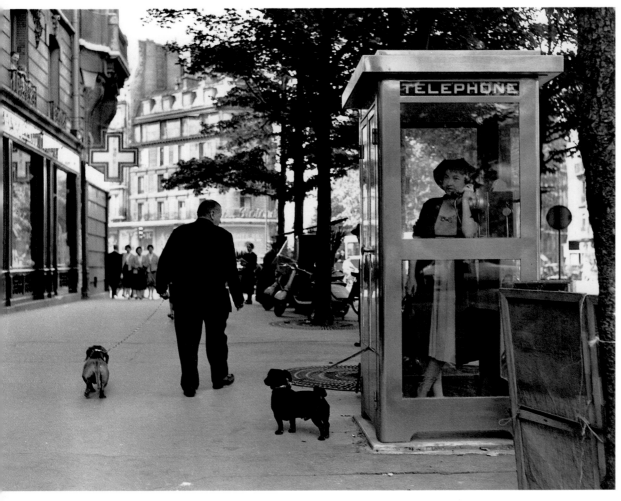

Telephone booth, boulevard Raspail 1958

FACING PAGE: Rue des Artistes, 1988

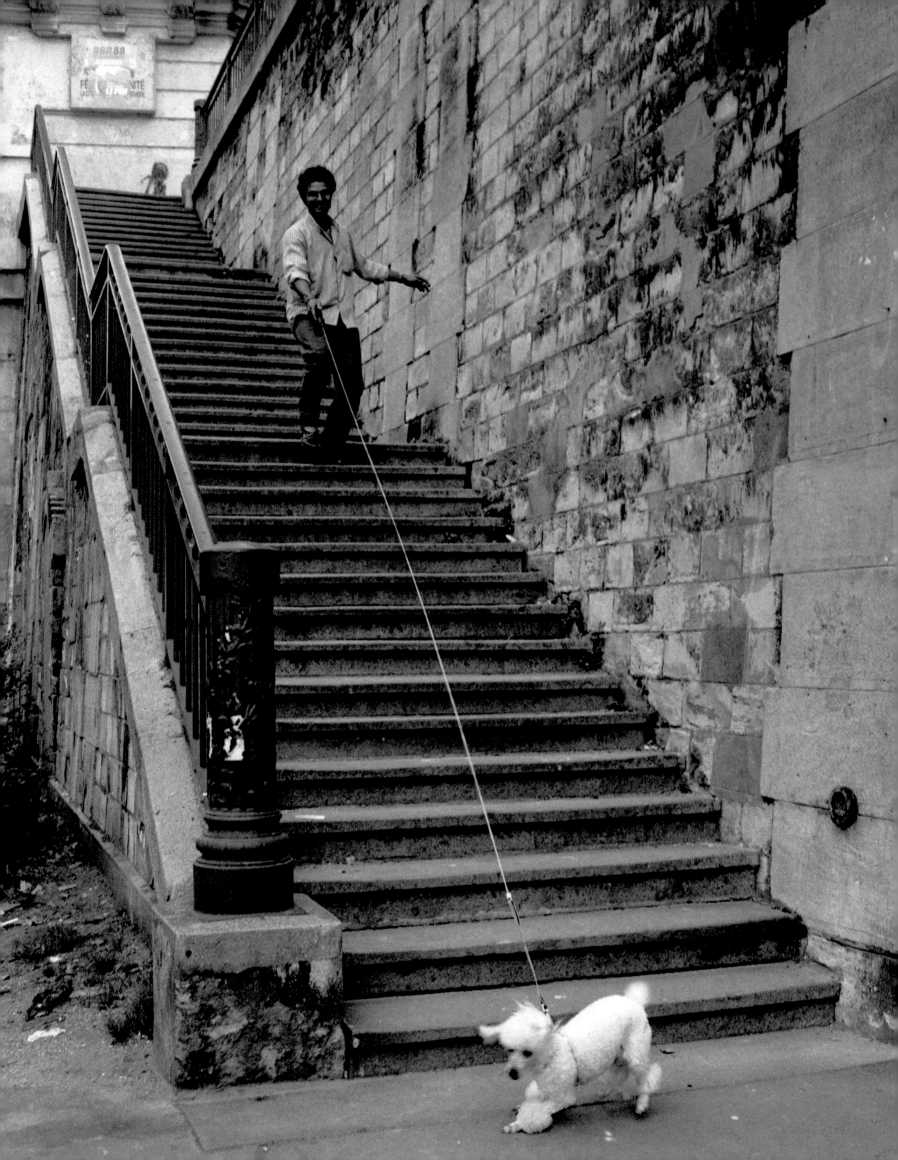

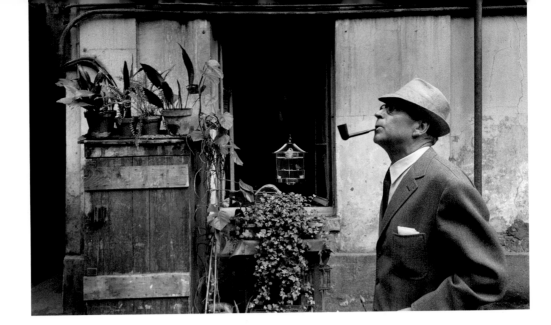

Georges Simenon, 1962

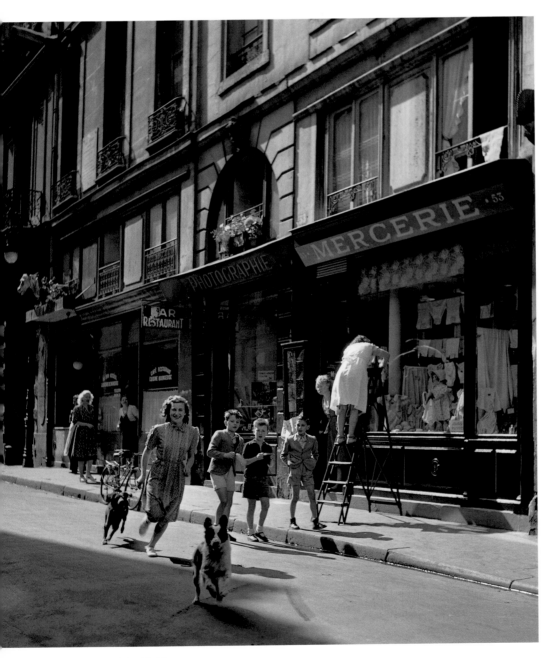

Rue Saint-Louis-en-l'Île, 1949

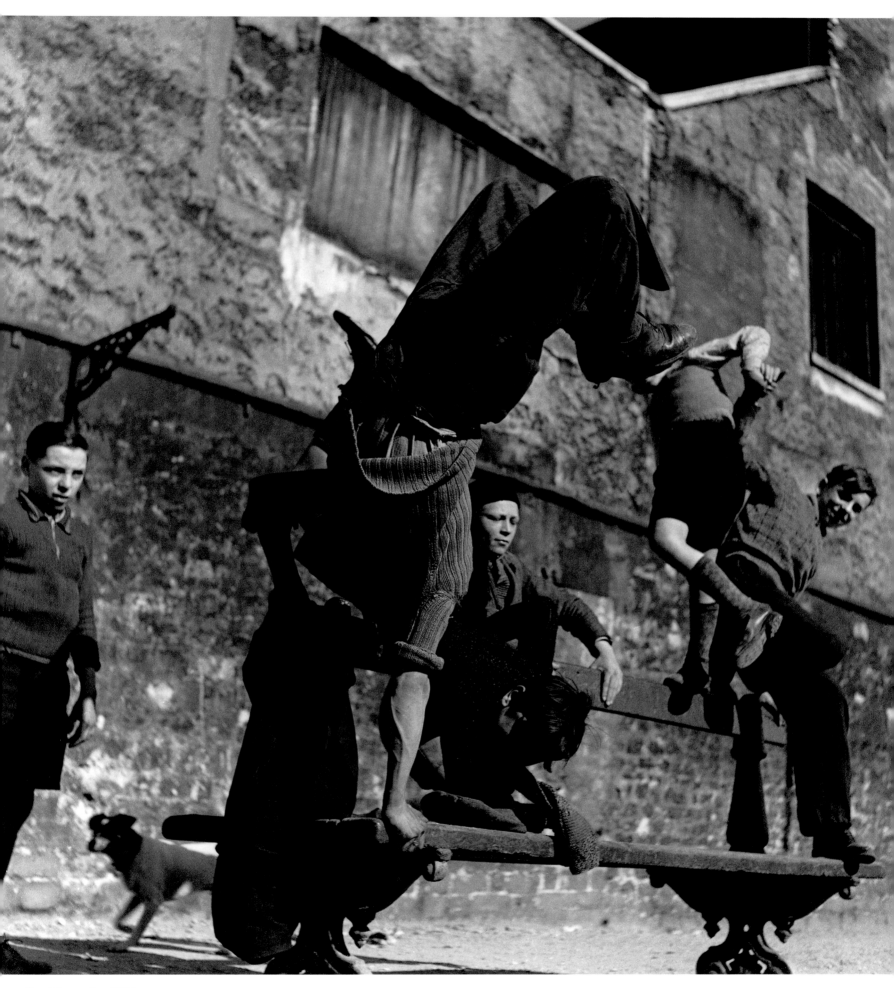

Street Gymnastics, 1934

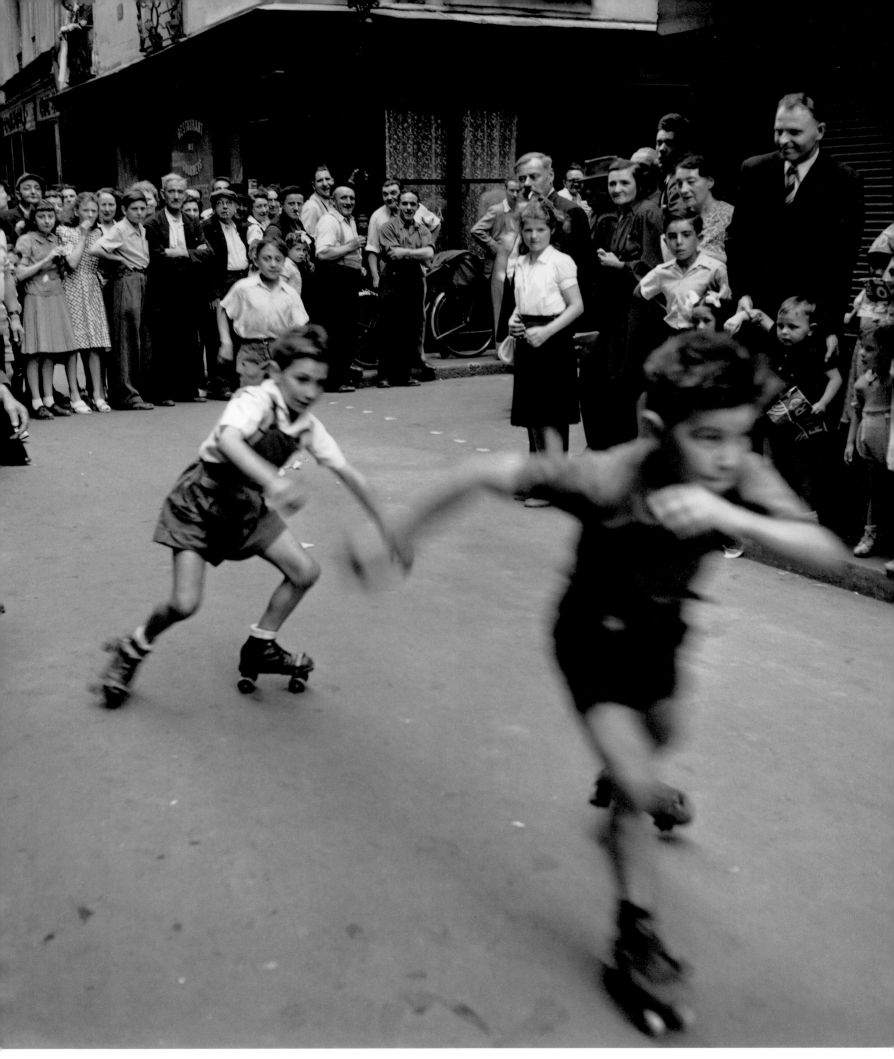

Kids on Skates, 1949

Le Baiser de l'Hôtel de Ville [The Kiss], 1950

"This young couple was not interested in the fact that the old Hôtel
de Ville, behind them, had burned down in 1871 and was rebuilt by
Ballu and Deperthes in 1874."

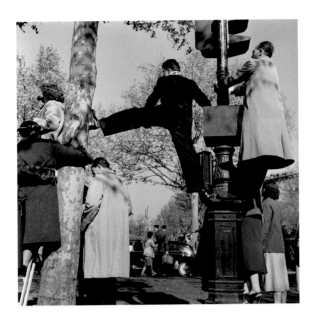

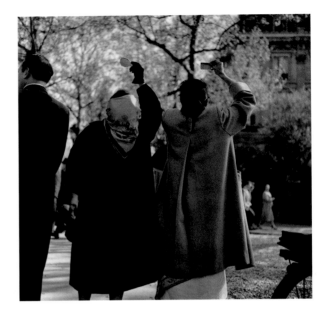

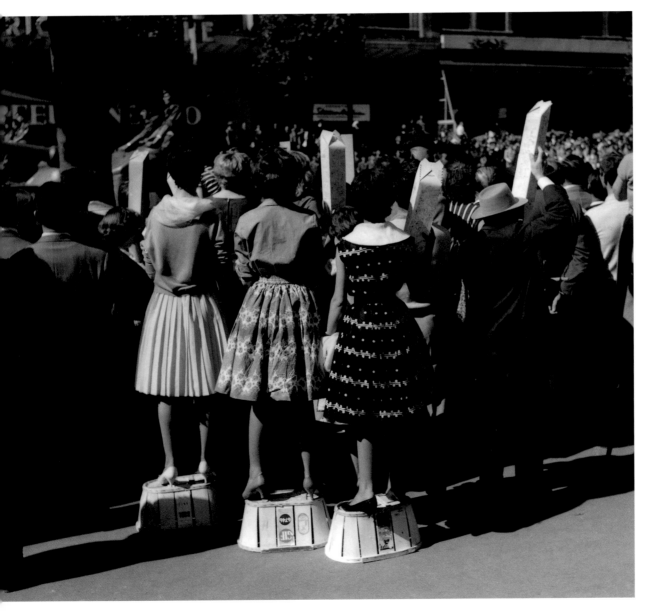

Elizabeth II comes to Paris, April 1957

FACING PAGE: *The Centaur*, town hall of the 6th arrondissement, 1971

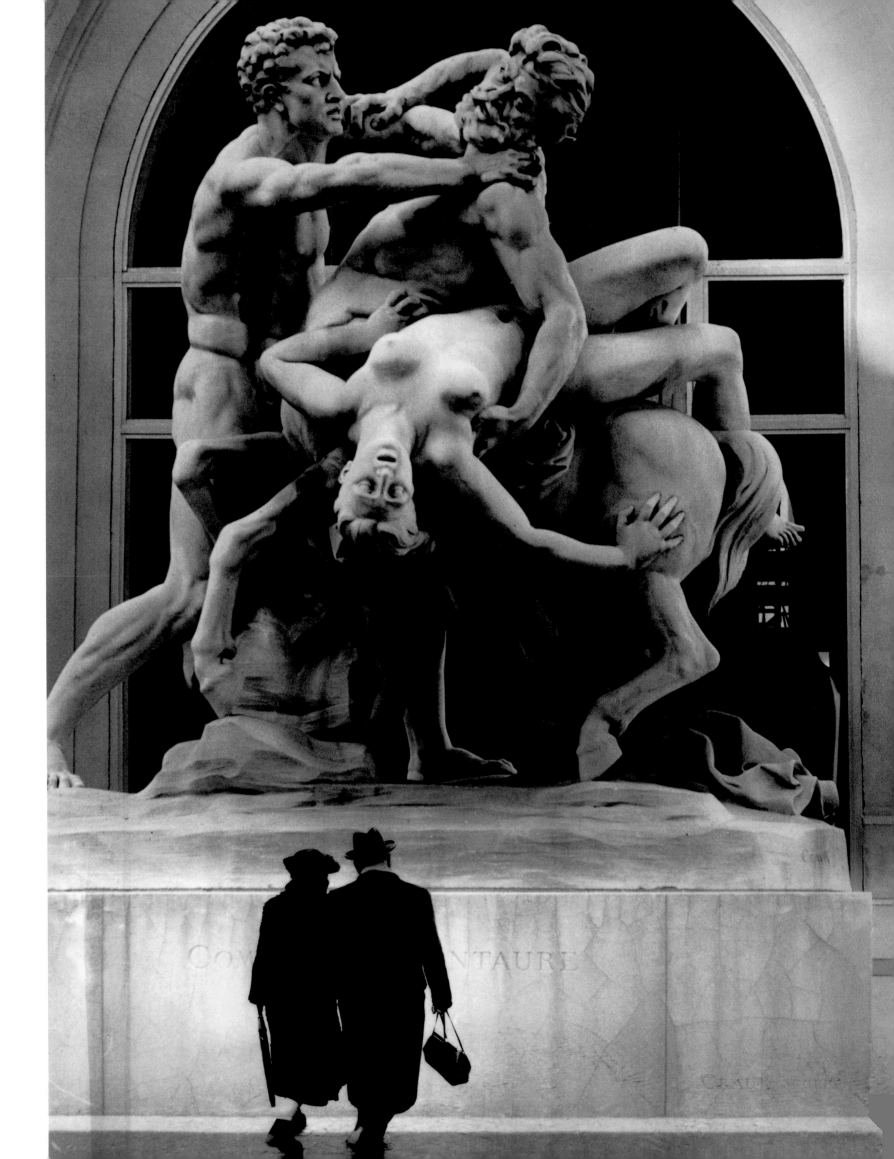

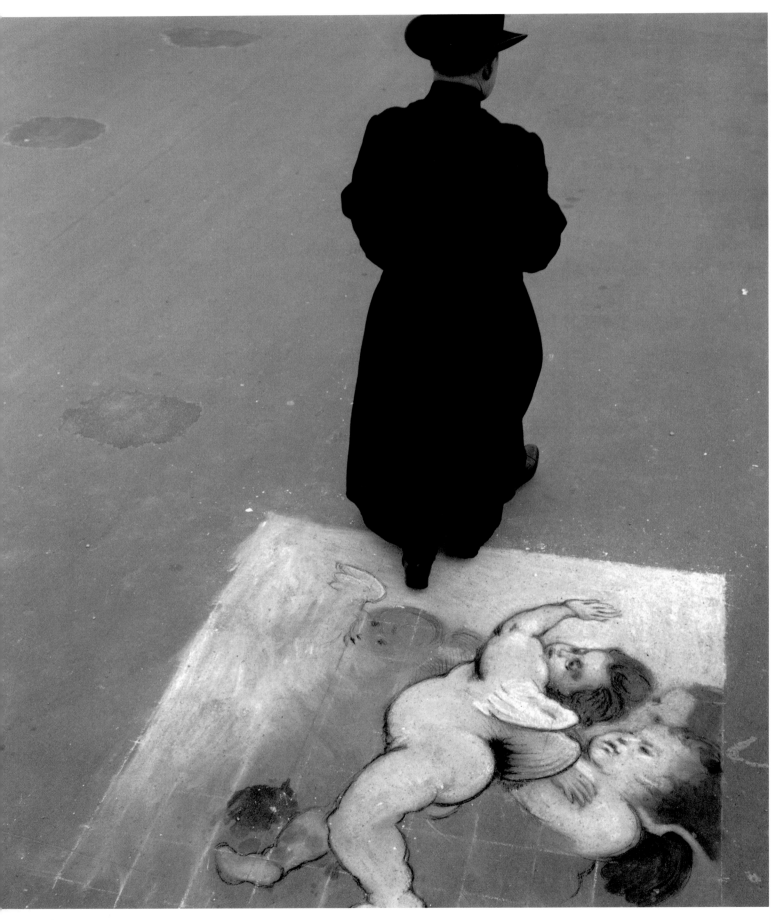

Pitiful Pastel, 1968

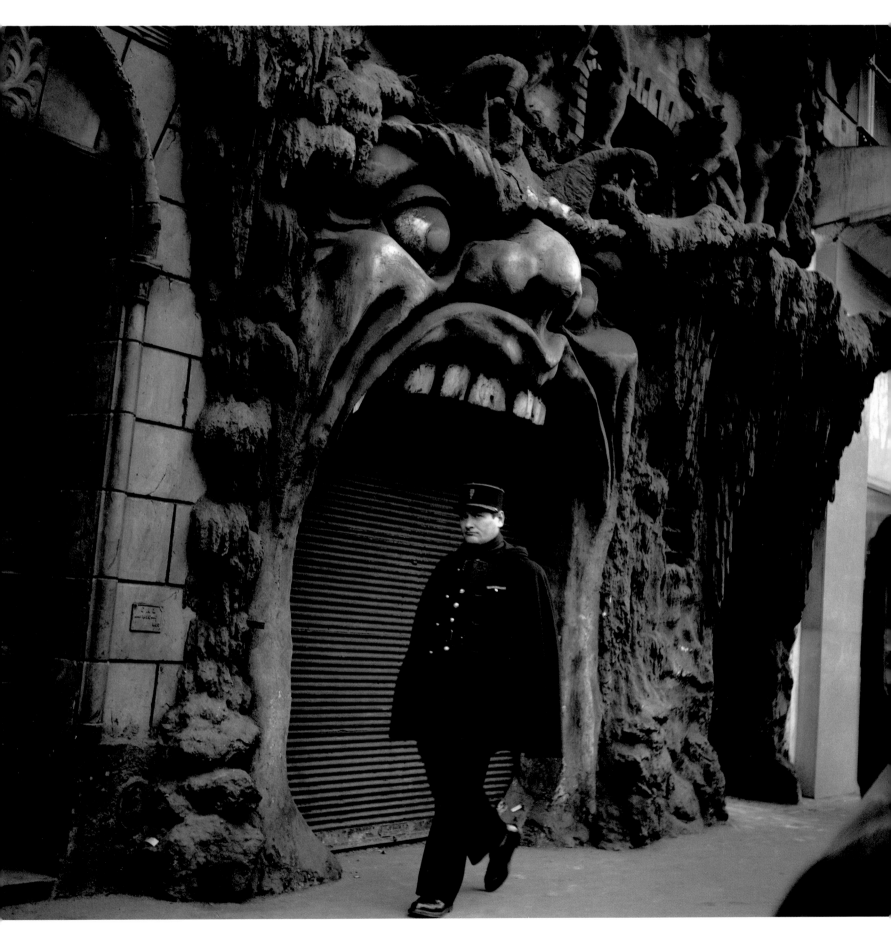

The Inferno, 1952

WINDY RUE ROYALE, 1949

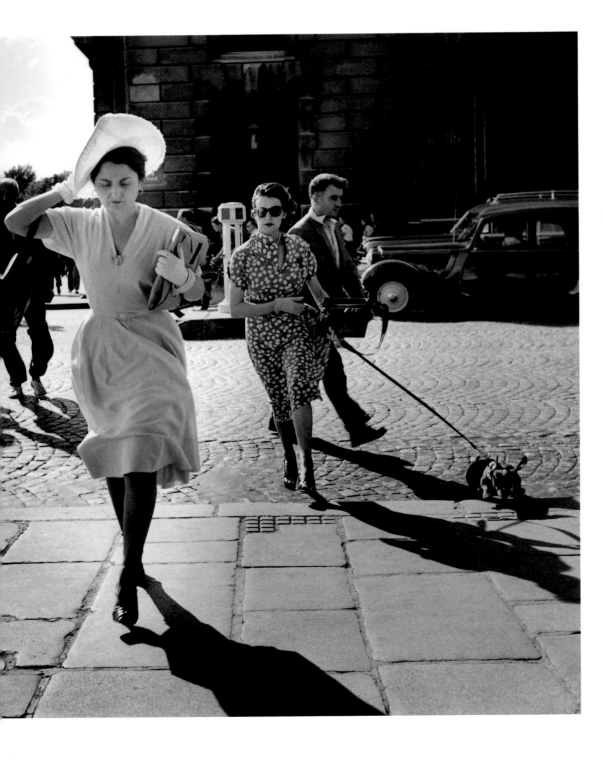

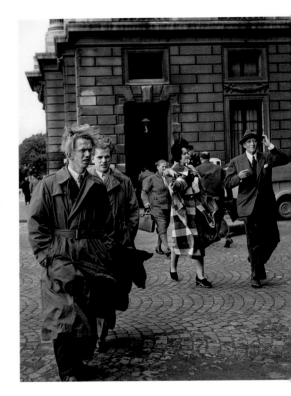

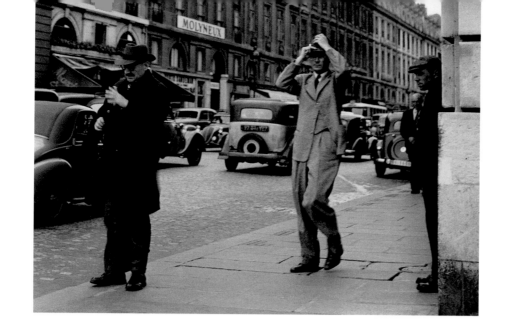

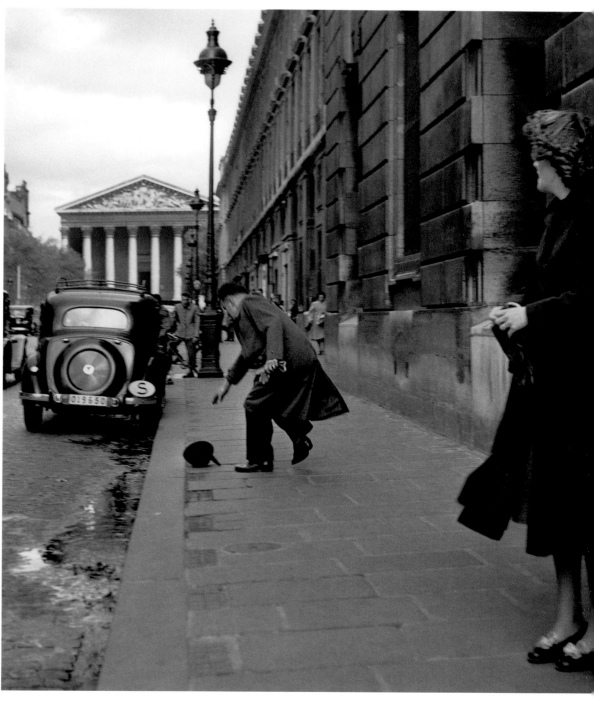

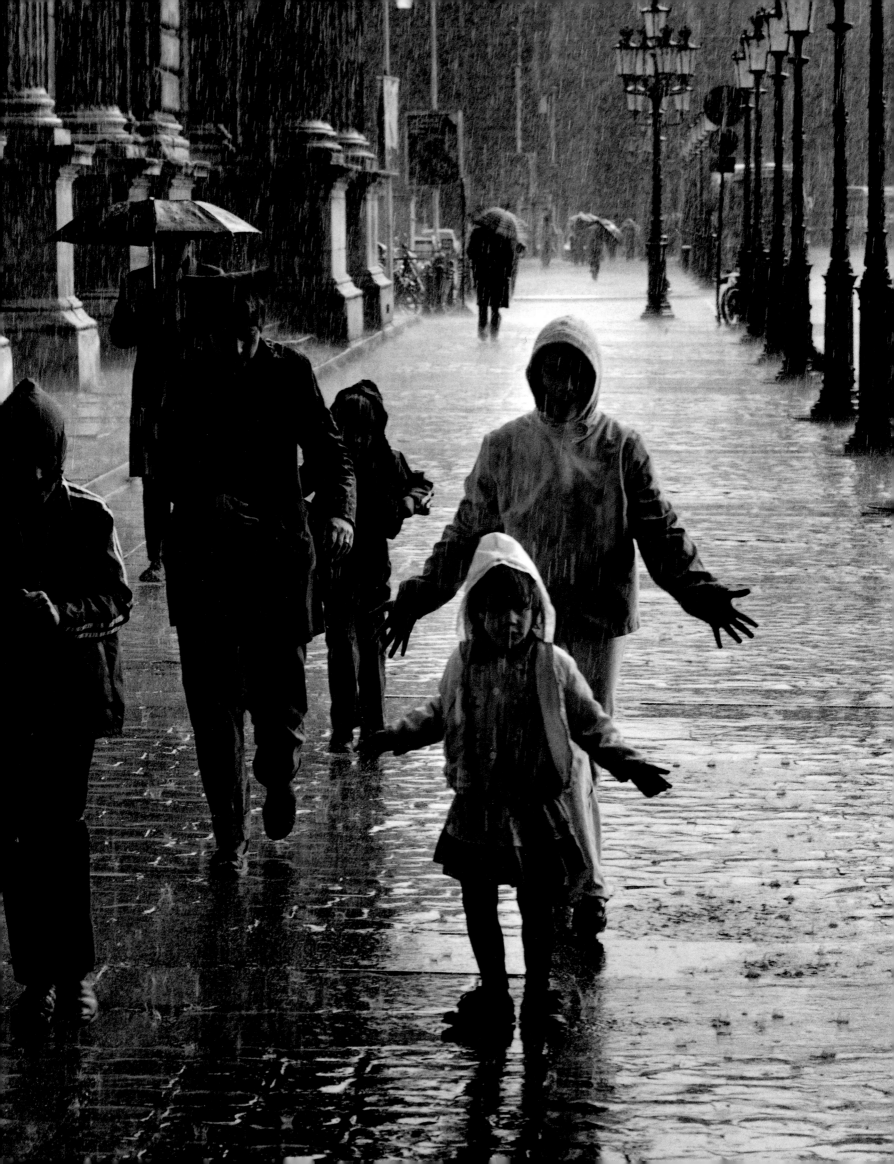

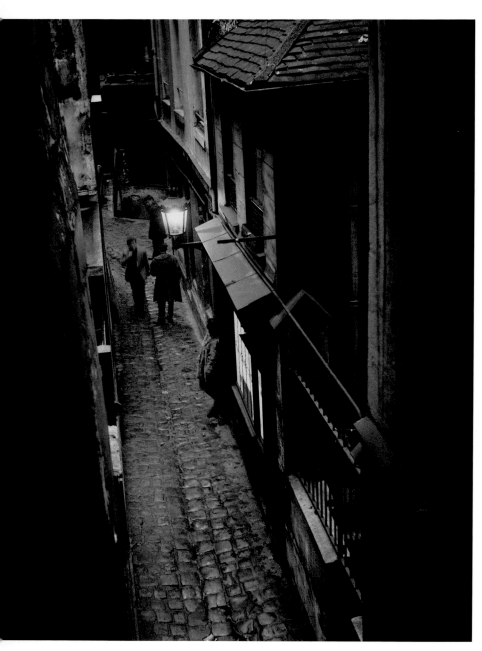

Passage de la Trinité, 2nd arrondissement, 1953

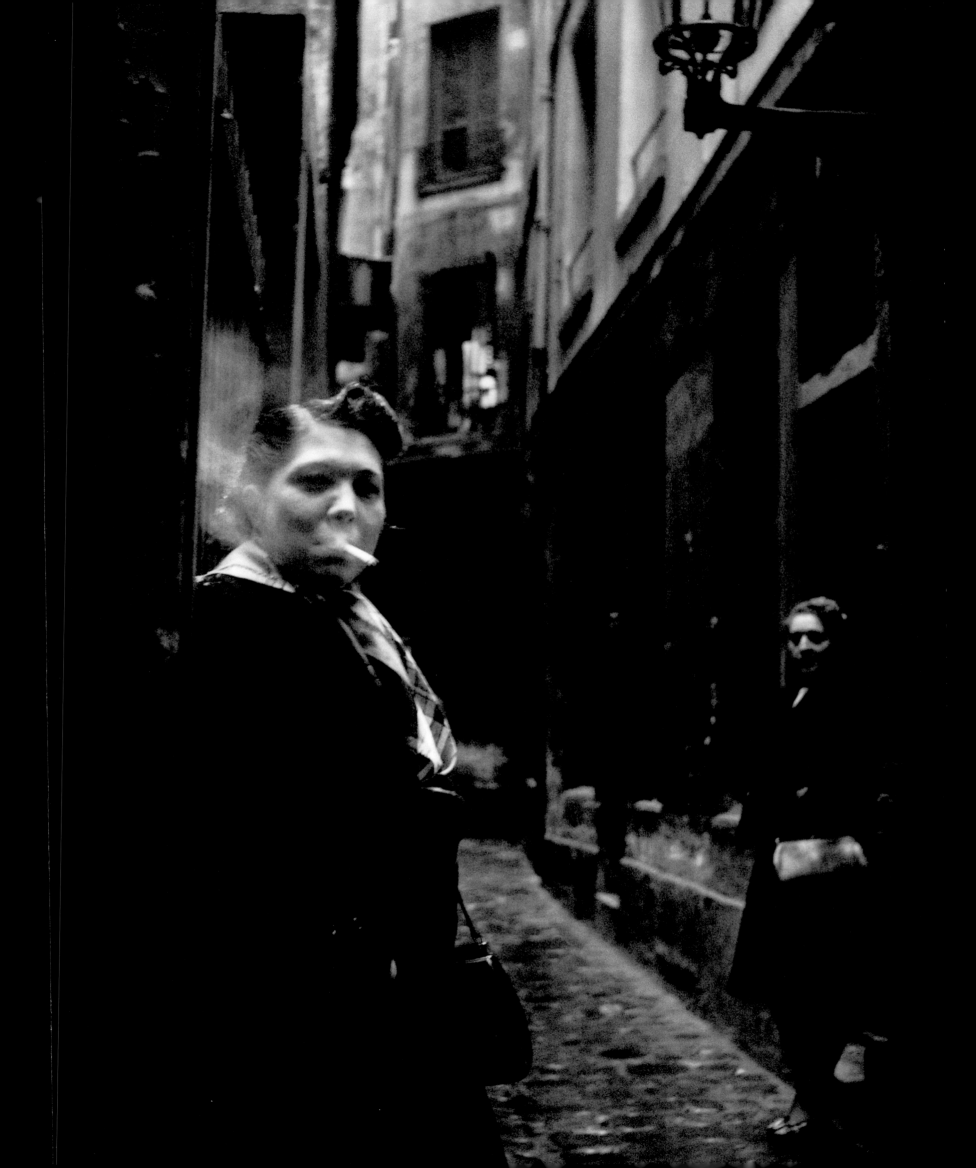

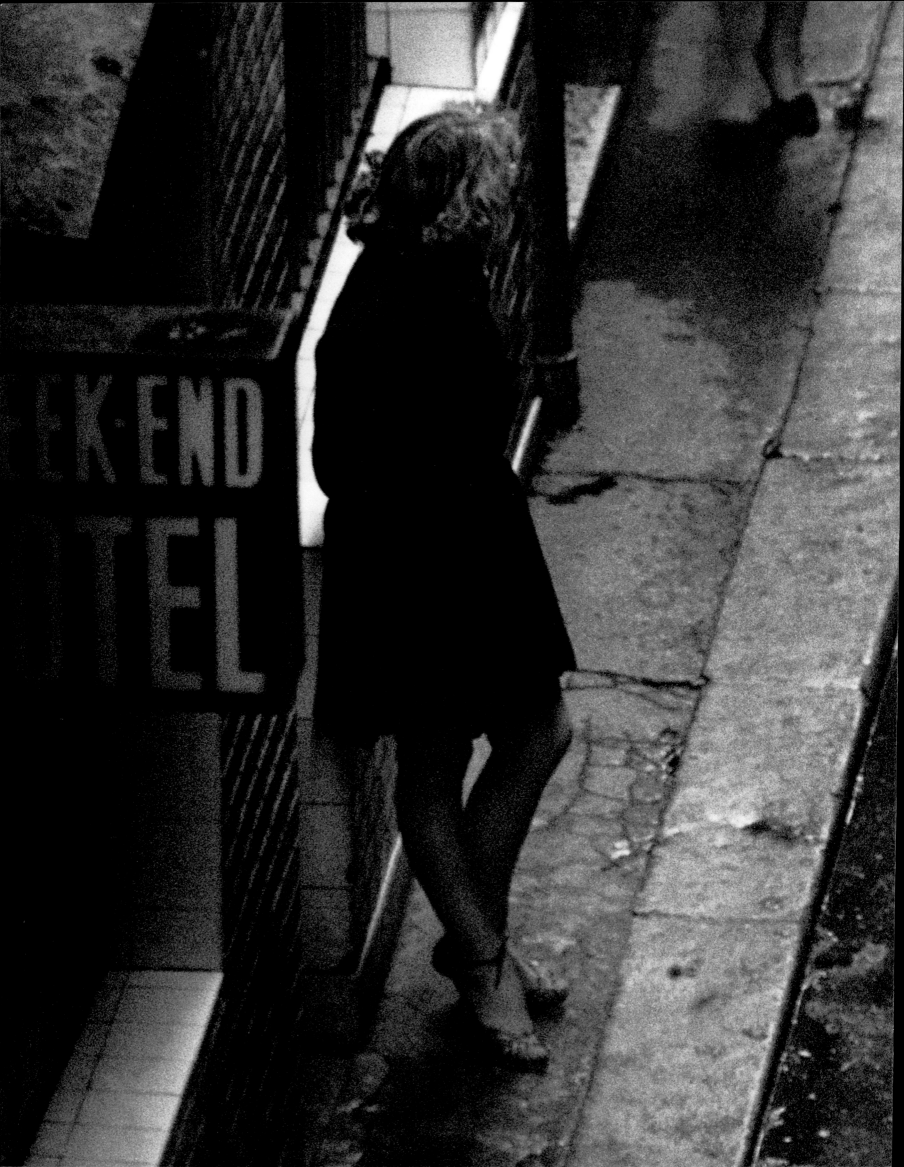

Rue de la Grande-Truanderie, 1st arrondissement 1953

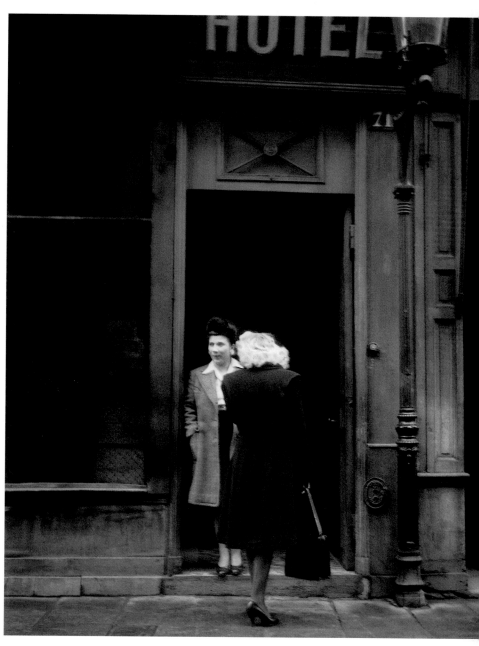

Les Halles, 1946

Facing page: Rue Guérin-Boisseau, 2nd arrondissement

The One-Two-Two Club, 122 rue de Provence, 9th arrondissement

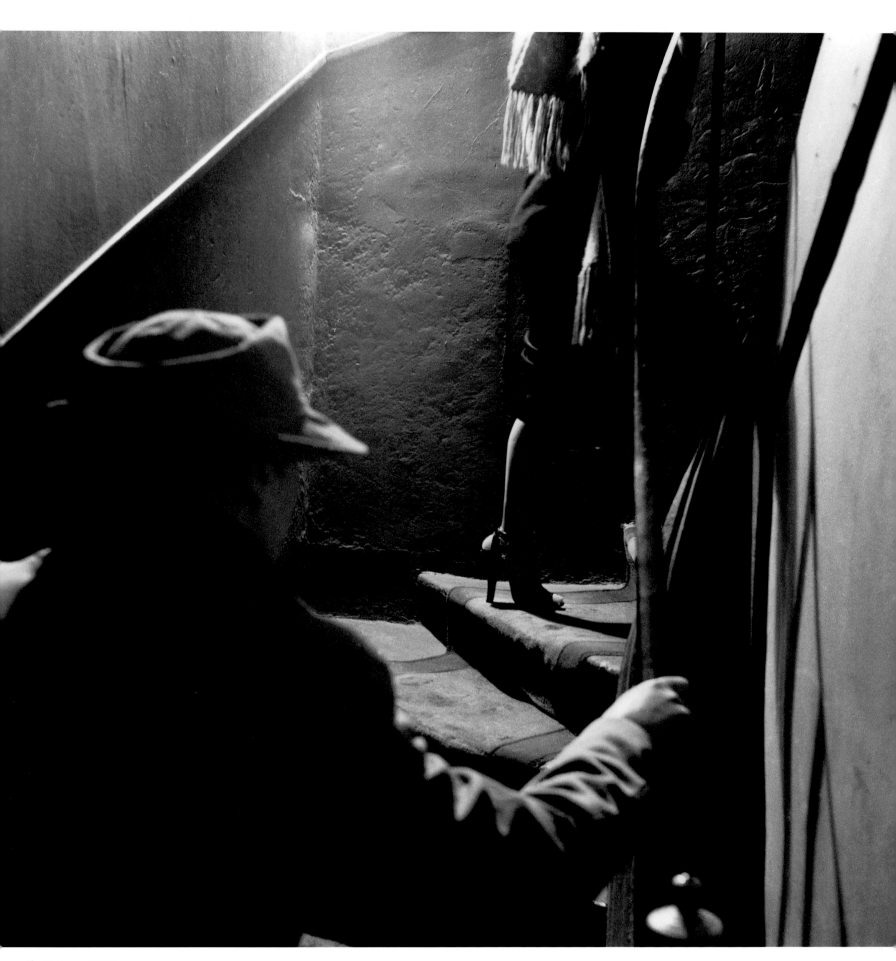

The Stairway, 1952

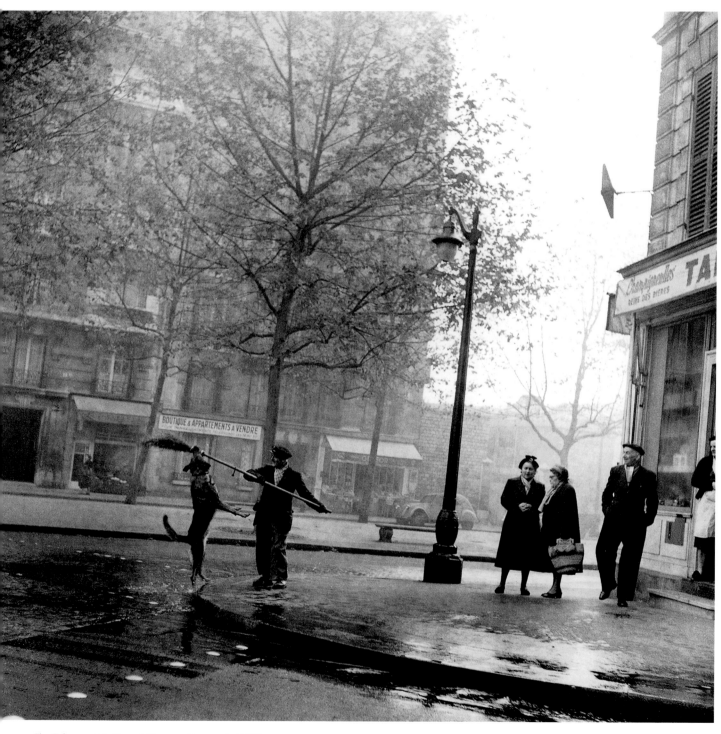

The Tobacconist's Dog; 14th arrondissement; 1953

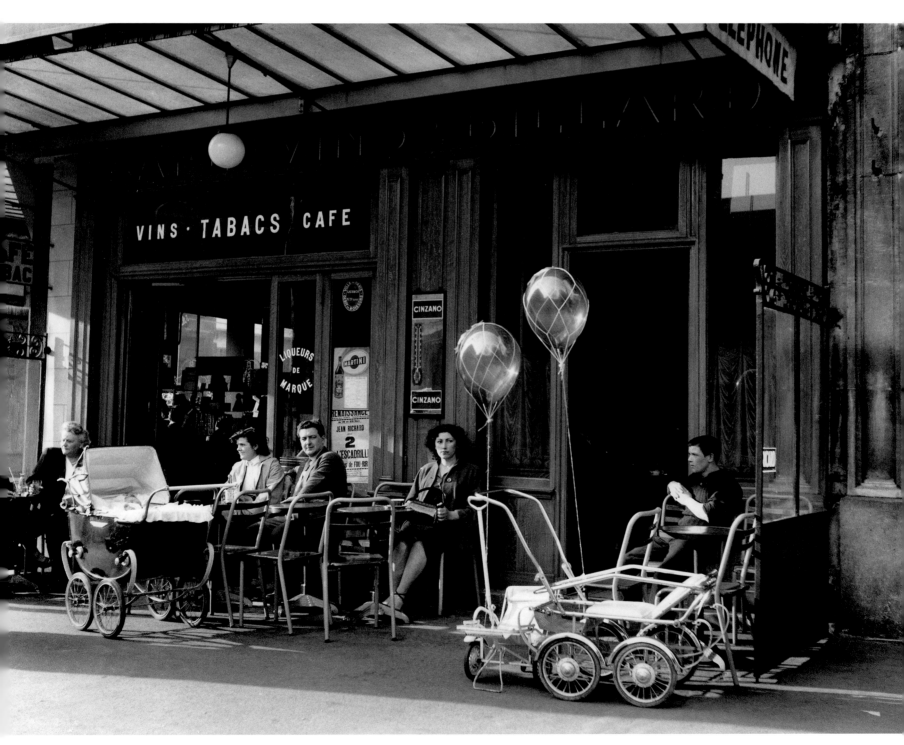

Wine, Tobacco, Balloons, 1953

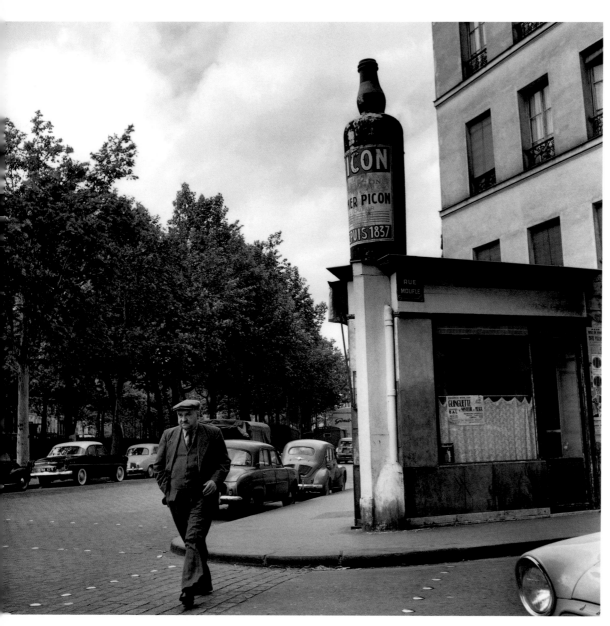

Rue Moufle, 11th arrondissement, 1961

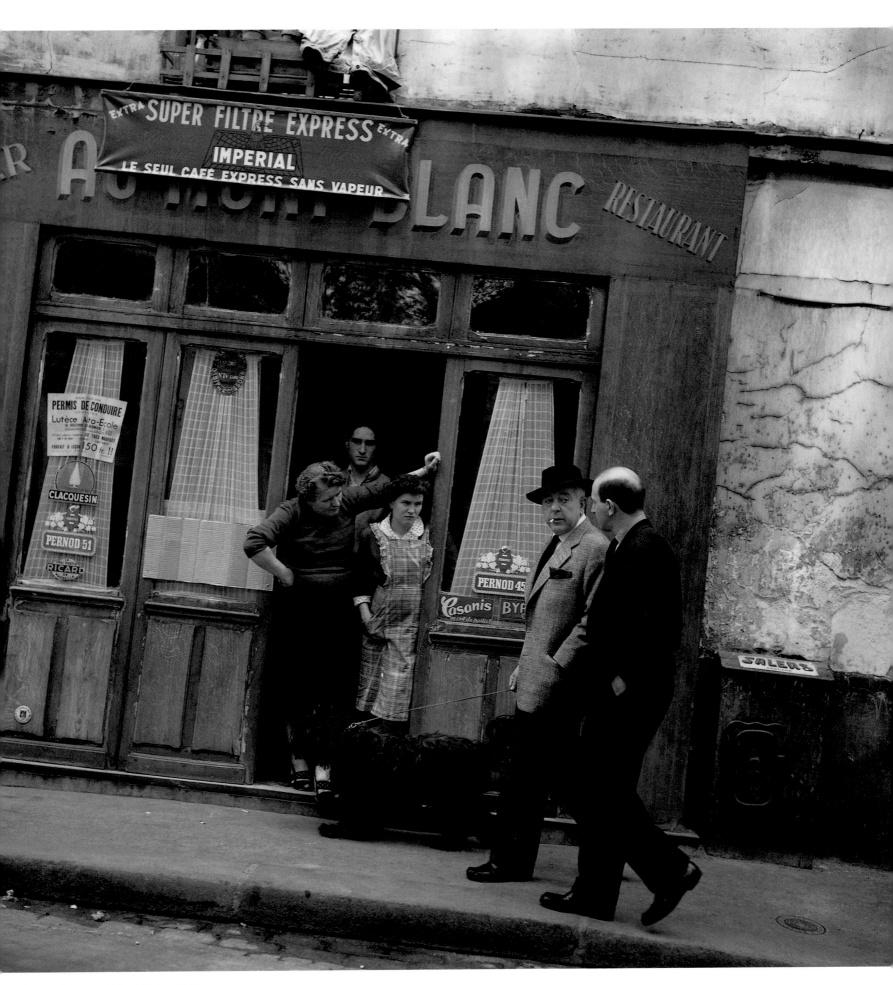

Jacques Prévert and Henri Crolla, 1955

Saint-Germain-des-Prés, 1947

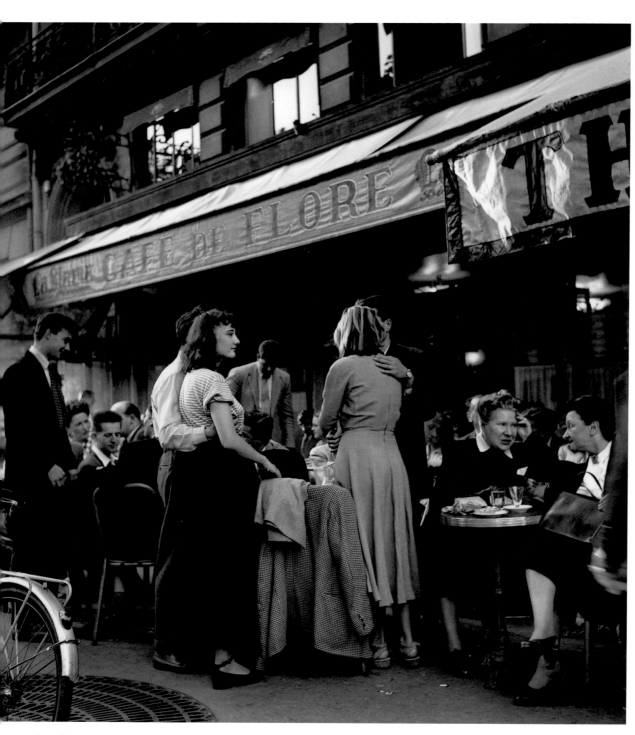

Saint-Germain-des-Prés, 1947

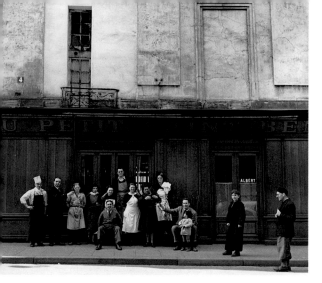

Le Petit Saint-Benoît, 1948

> ❝ The staff of Le Petit Saint-Benoît—good, plain food and all the bread you can eat. ❞

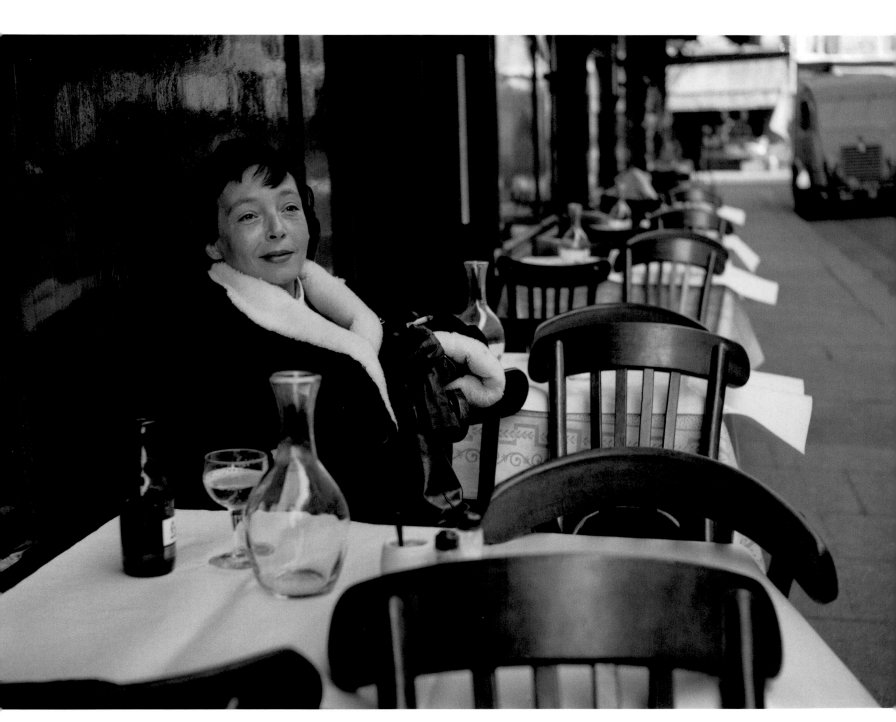

Marguerite Duras outside Le Petit Saint-Benoît, 1955

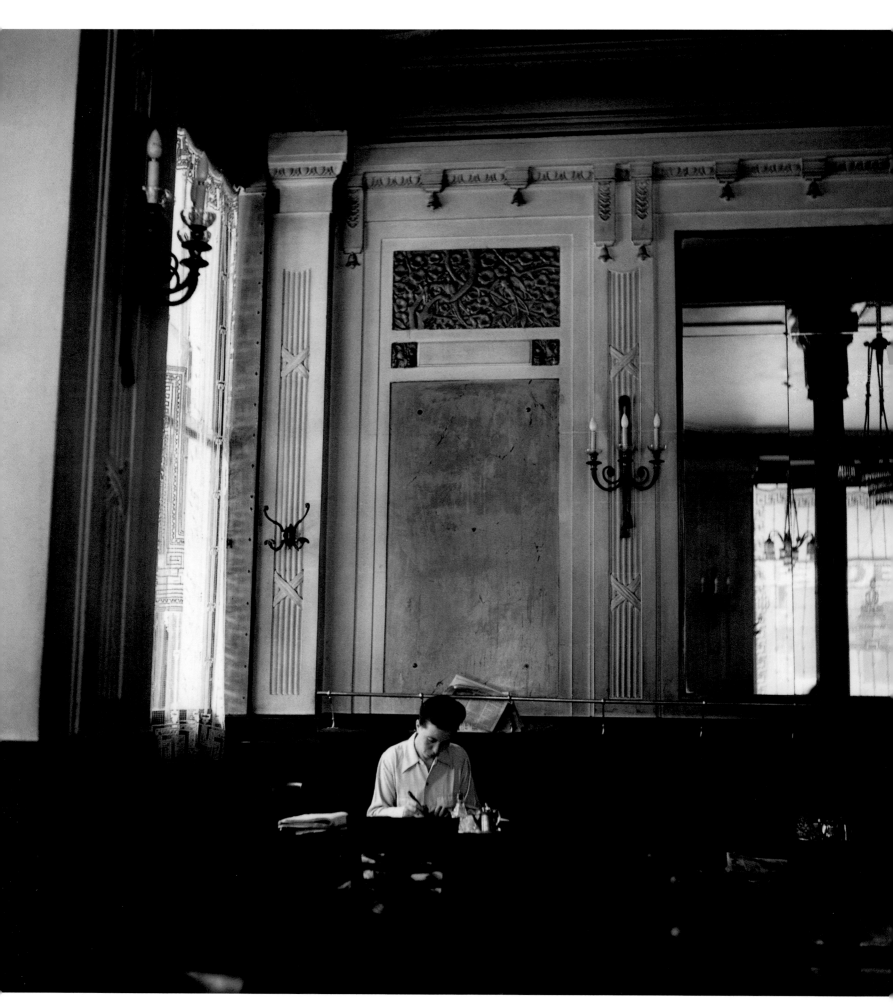

Simone de Beauvoir at Les Deux Magots, 1944

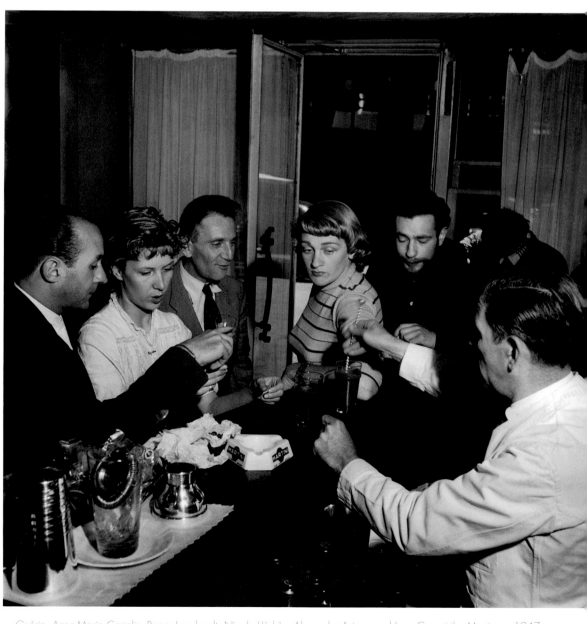

Guérin, Anne-Marie Cazalis, Roger Leenhardt, Nicole Védrès, Alexandre Astruc, and Jean Cau at the Montana, 1947

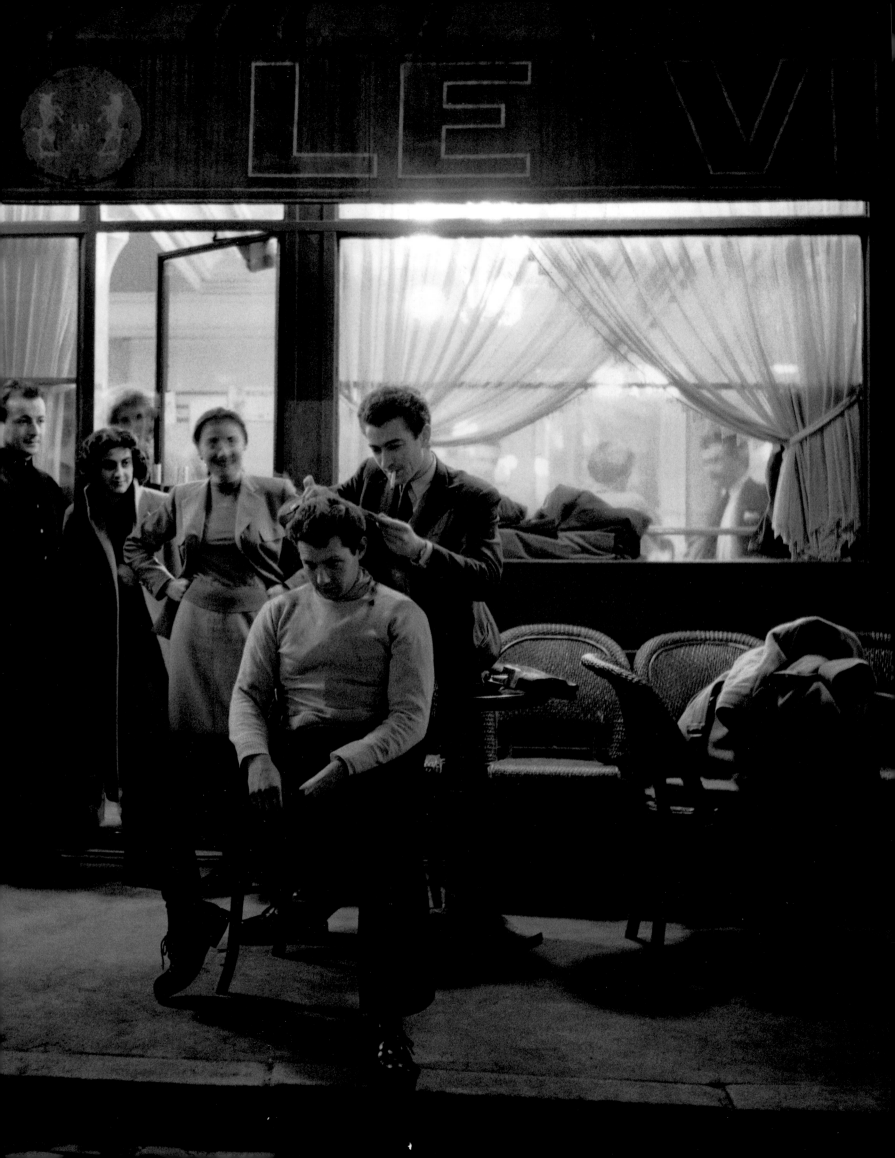

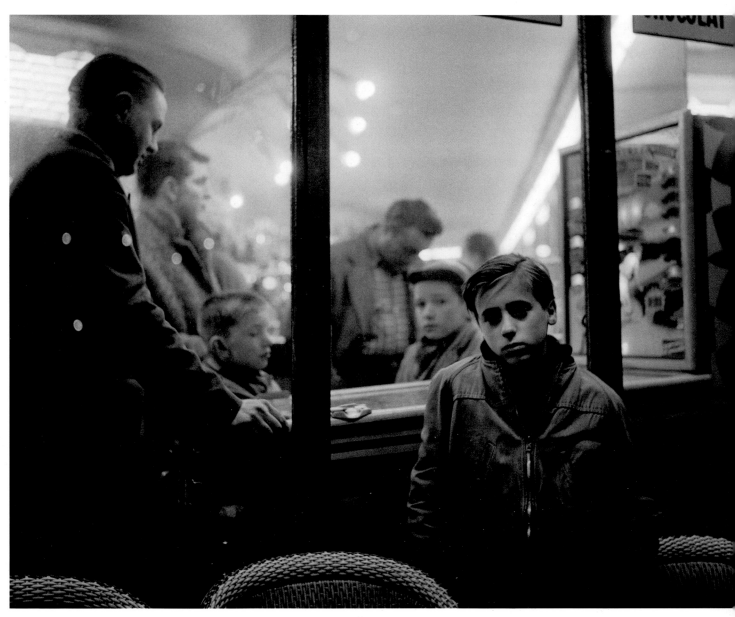

Pinball in a café, 1957

FACING PAGE: The sidewalk in front of Le Villars, November 26, 1951

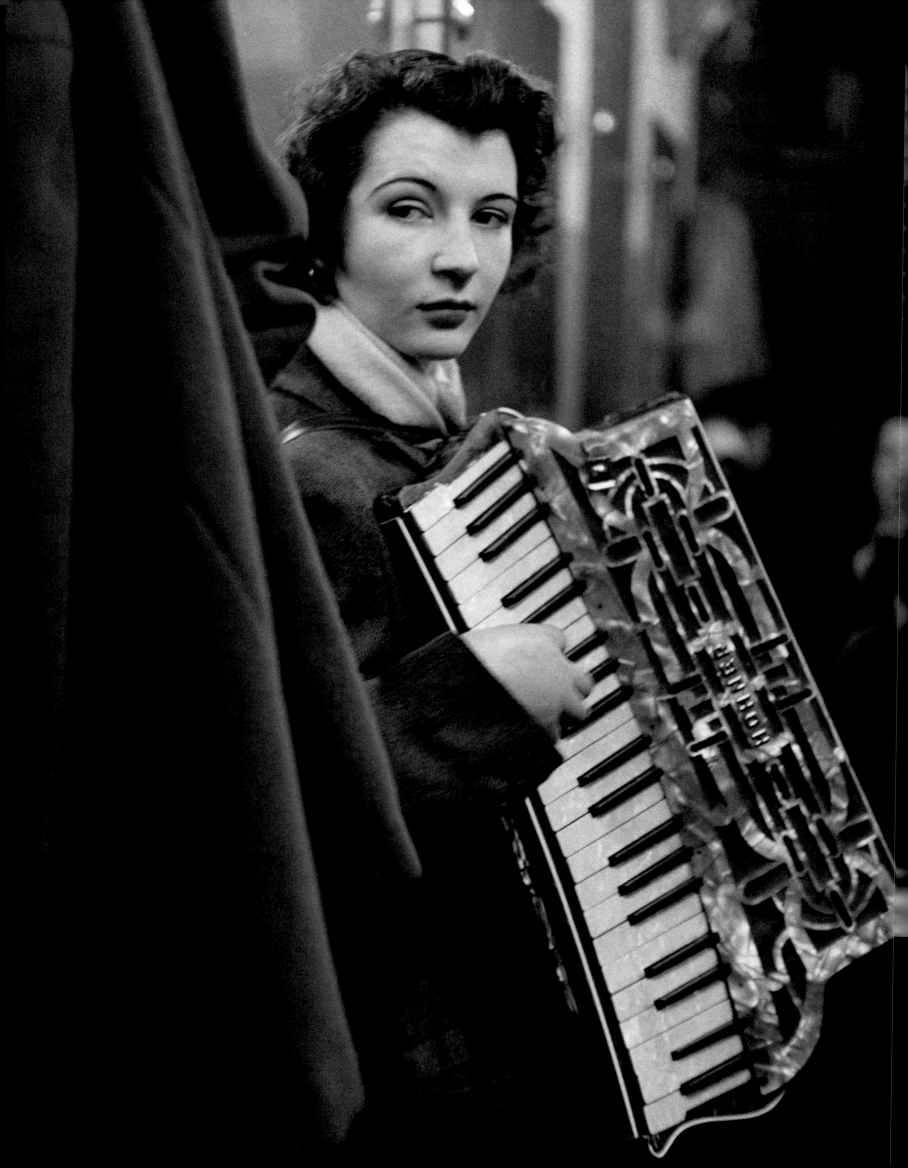

Pierrette d'Orient strolls along, 1953

" One peaceful Sunday morning there appeared two women and an accordion. 'How 'bout a song?' The stocky one, Madame Lulu, was not unlike '30s crooner Berthe Sylva. She had a serviceable voice.

The other one, the accordionist, was a pretty little lady indeed. She delivered her song—always the same slow lament, *Tu ne peux pas t'figurer comme je t'aime* (You can't imagine how much I love you)—with complete detachment, with a little contempt even. Her magnetism worked so well we followed the pair around Paris for days on end, from Les Halles to the Chalon quarter via Canal Saint-Martin and La Villette.

I never understood why they continued to gather pennies in a world where change no longer makes your pockets bulge. "

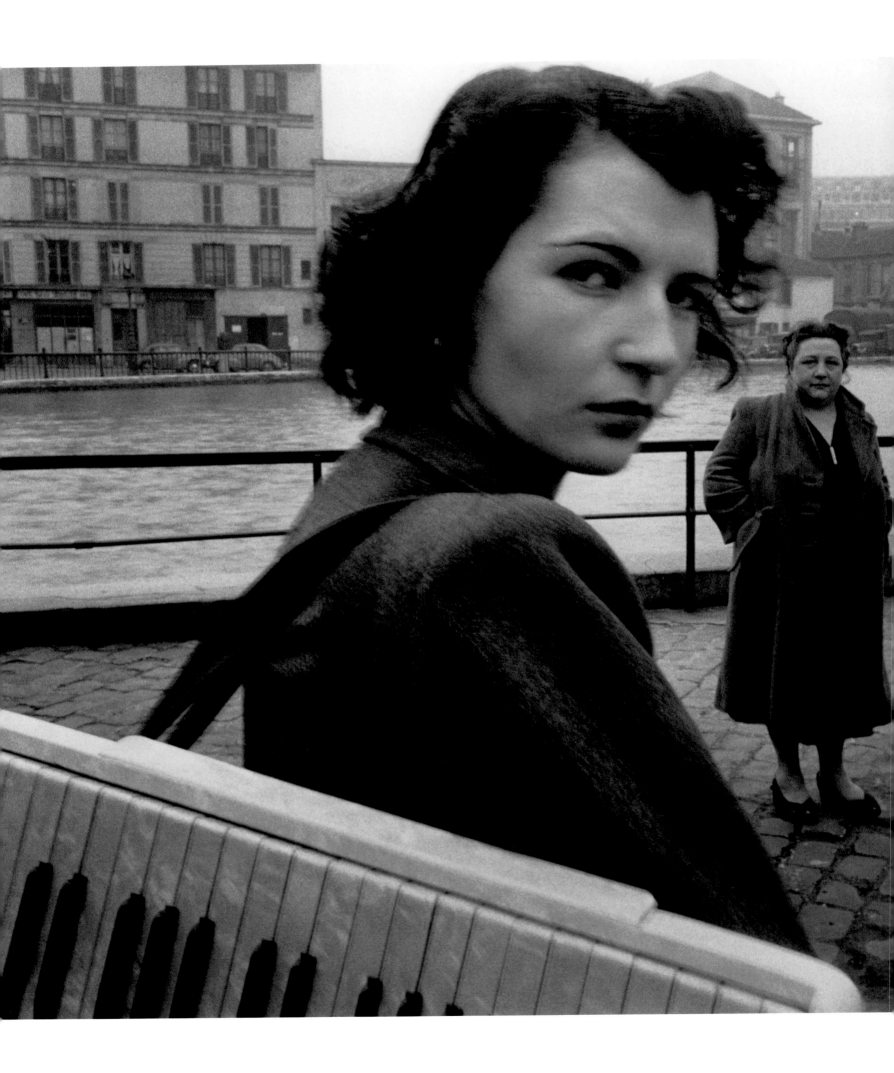

" From rue Mouffetard to rue de Flandre, from the wholesale butchers at La Villette to the lads on rue de Lyon, with zigzags along canal Saint-Martin via the cheap eateries on rue Tiquetonne, I couldn't say how many days the aimless stroll lasted, nor in how many bistros we drank.

Me and my buddy Giraud both fell under the accordion's spell. That really can happen sometimes. How else can you explain the patience of all those customers, for people normally hate to have their picture taken when they're eating (unlike drinkers, who pose willingly, often with a touch of bravado). It was the melody that supplied the anesthesia that made the photographer bearable.

Both musicians had their own style. Madame Lulu was robust, belting out her stuff in the purest street tradition. With the accordionist, the tone was different. Standing before folks molded by hard labor, who held their fingers clenched even when at rest, she luxuriated in a sense of idleness. Her cat-like nonchalance carried the slightest hint of cruelty. Back in the Middle Ages, the spell that woman cast would have sparked a bonfire. "

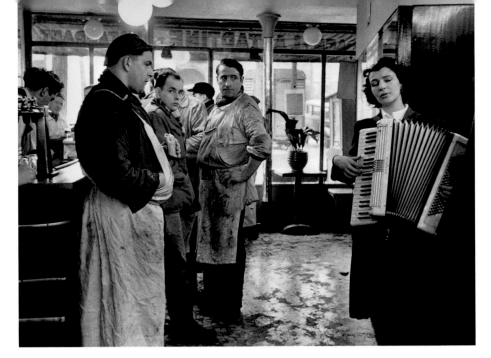

Music-loving Butchers

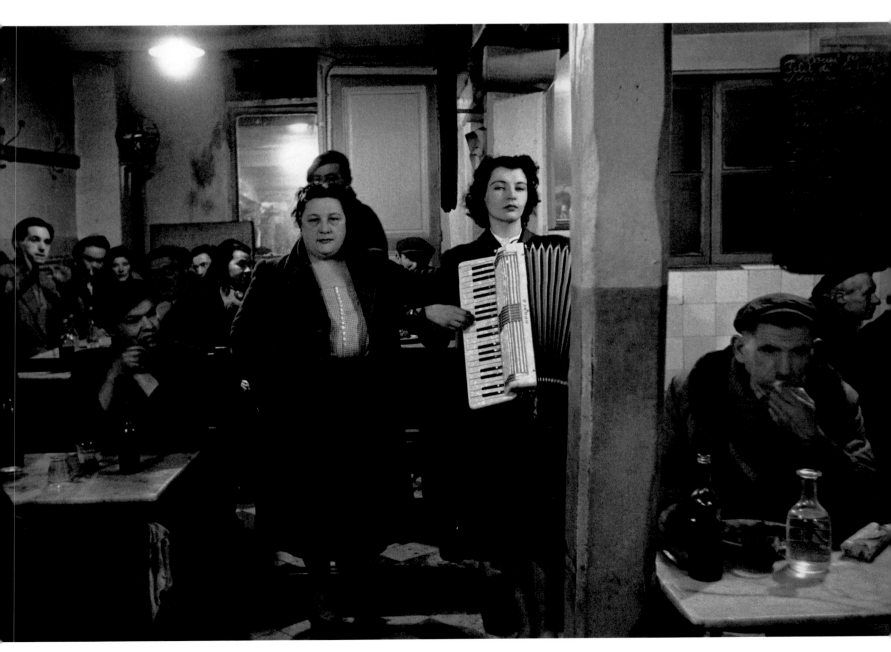

An Eatery on rue Tiquetonne

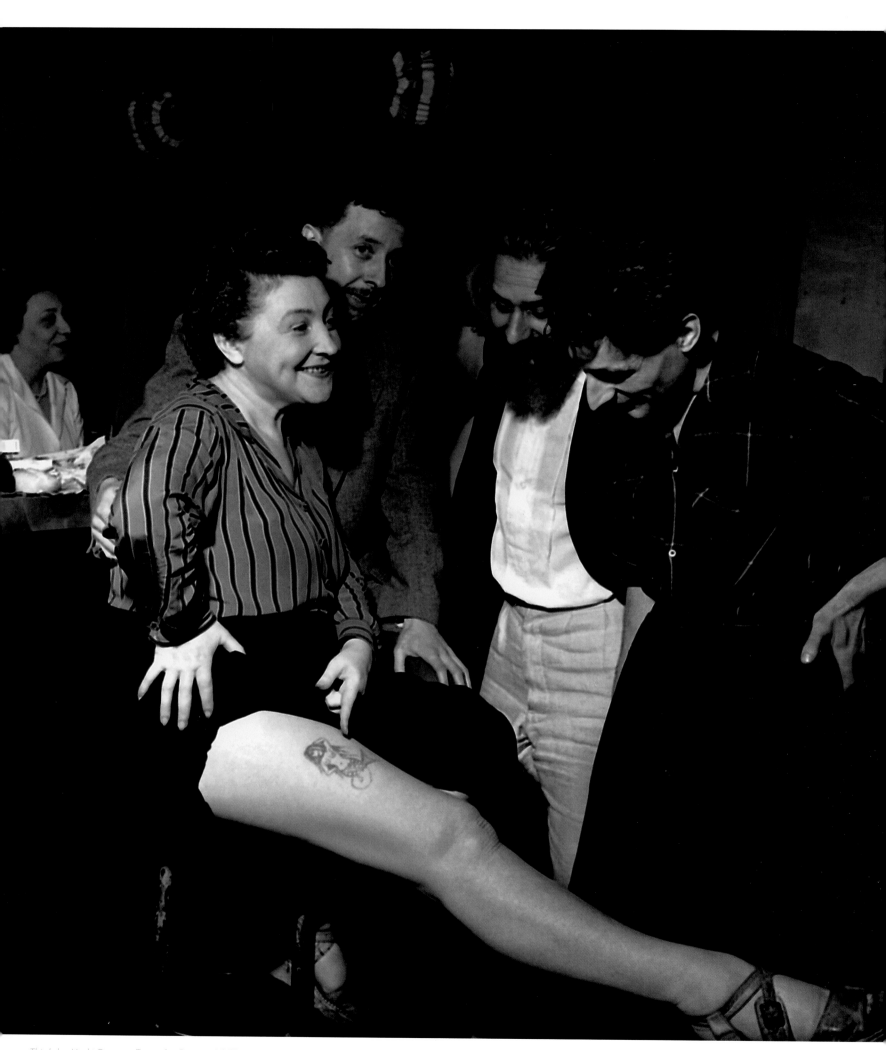

Thigh by Youki Desnos, Tattoo by Foujita, 1950

"Owner Olivier Boucharain confessed to us his weariness with everyday routine. 'Boy, there are days when I feel like throwing out the whole bunch of hungry, ugly customers!'

Momentarily depressed. As Mérindol and Giraud were fond of Boucharain, they suggested an out: 'Olivier, Saint-Germain-des-Prés is packed with clubs and joints. There are nights when it's so crowded that people wait on the sidewalk outside. But on rue Mouffetard, there's nothing. So why not turn this place into a cabaret with a typically Mouffetardian show? Guaranteed to be a hit.'

'You're on,' said Boucharain."

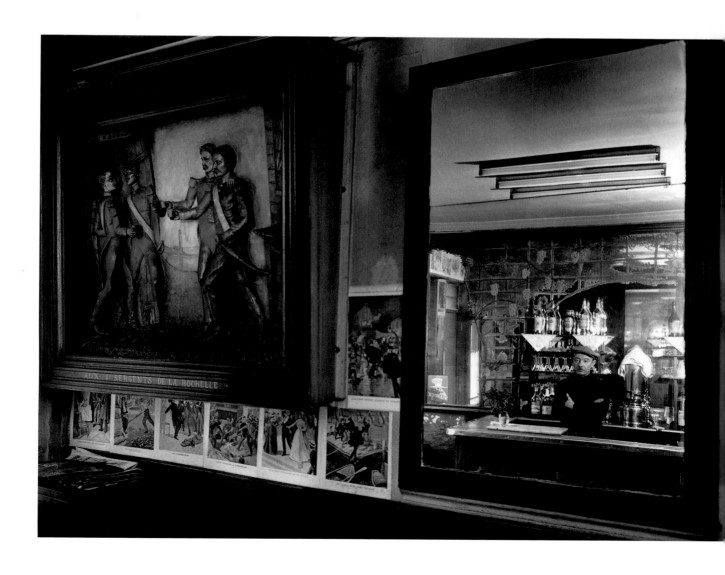

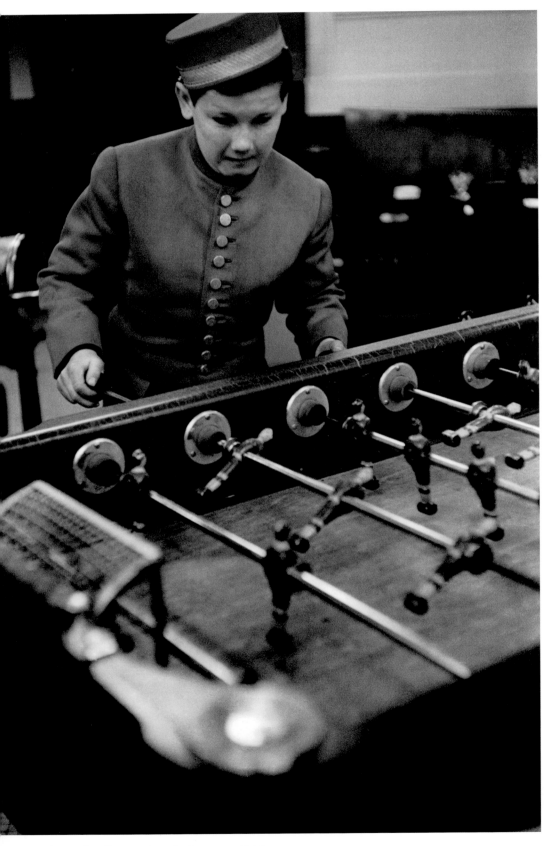

Schiaparelli Bellhop, rue Danielle-Casanova, 1952

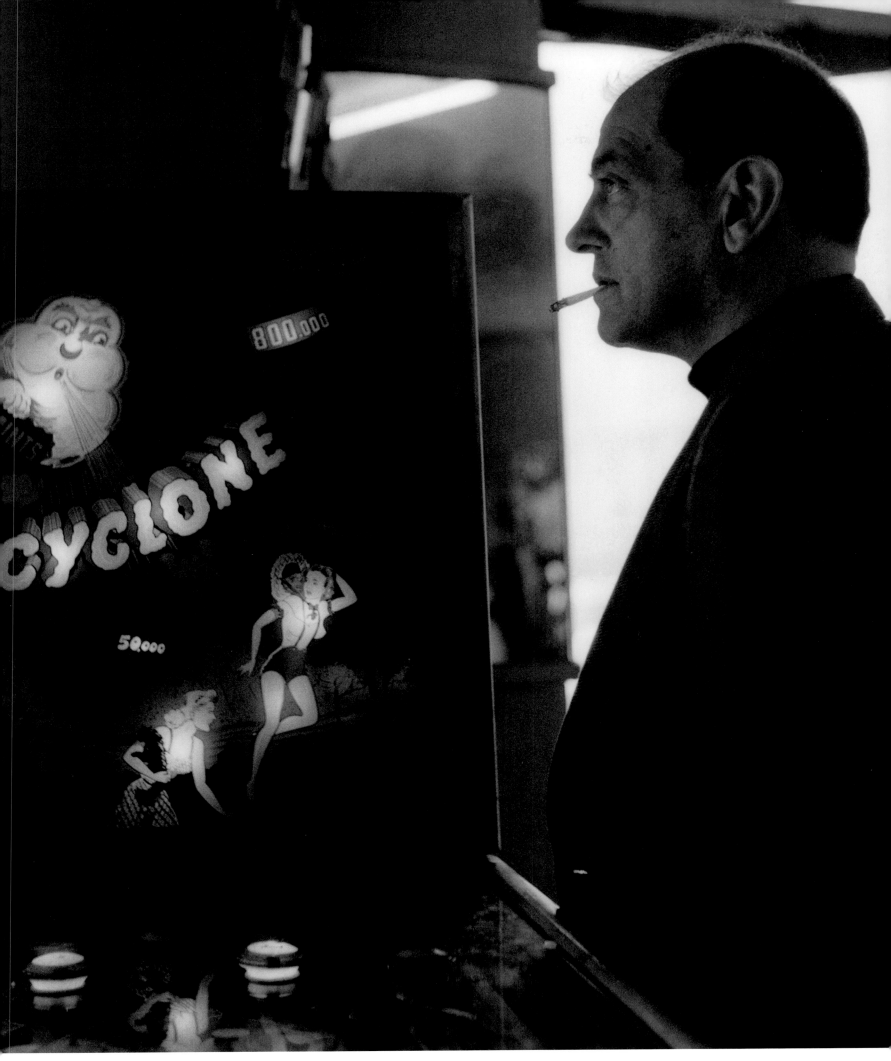

Luis Buñuel, 1955

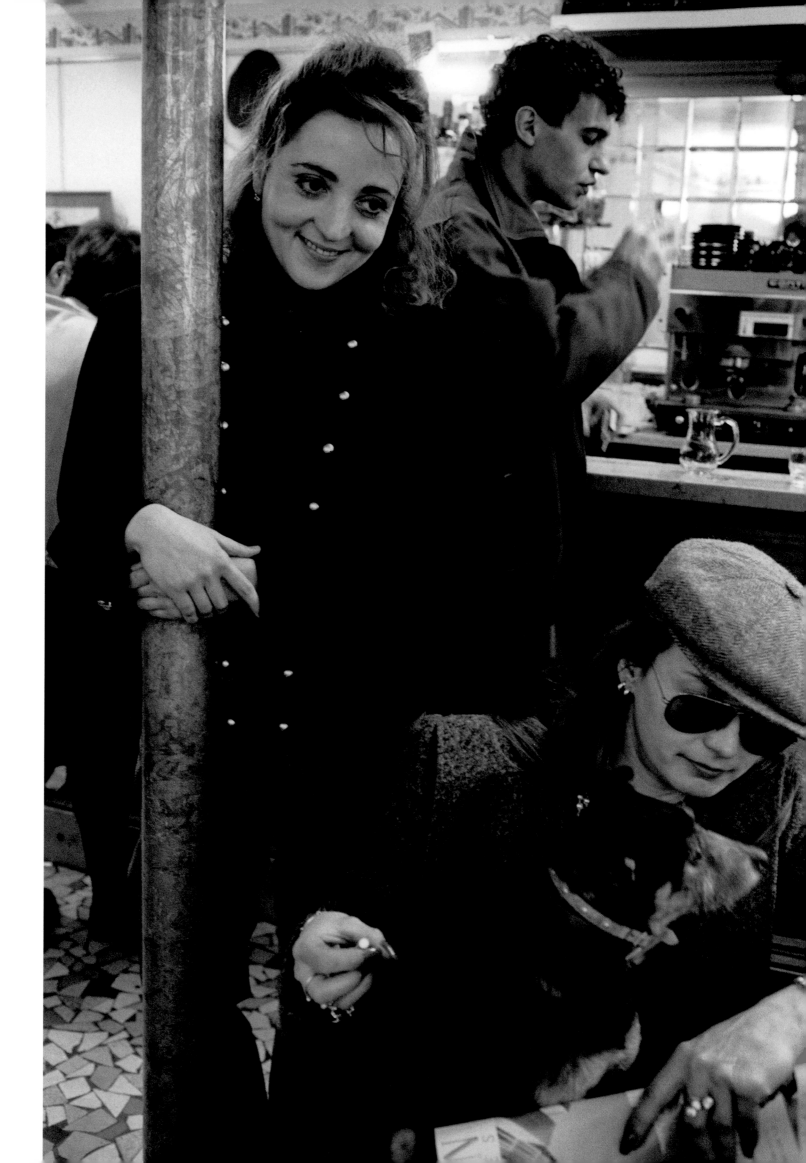

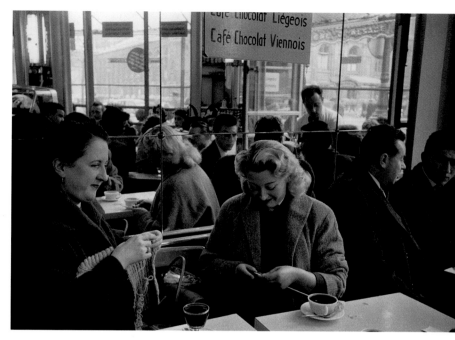

Café, rue de Rivoli, 1957

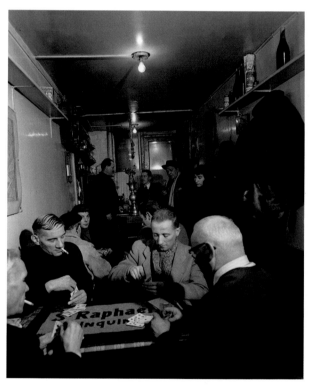

At Tourrette's, 1958

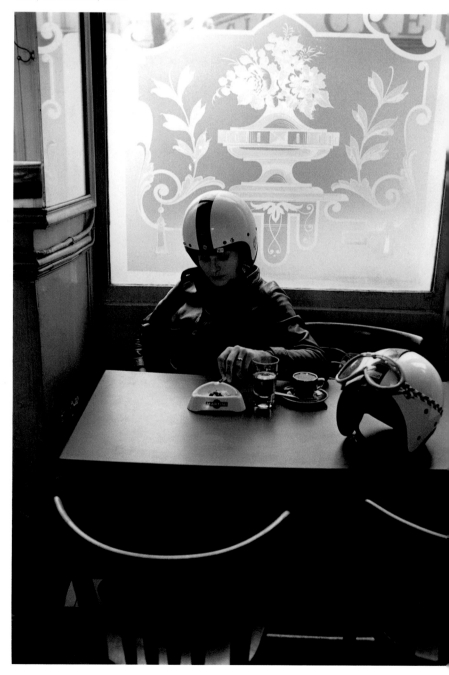

Bistro Flowers, 1971

Facing page: Dominique Blanc in Le Vin des Rues, rue Boulard, January 1989

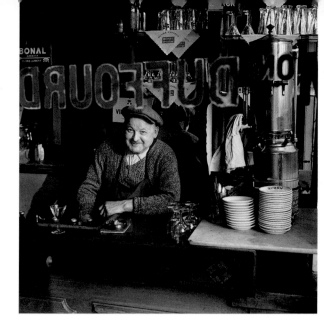

At Duffourd's, 1952

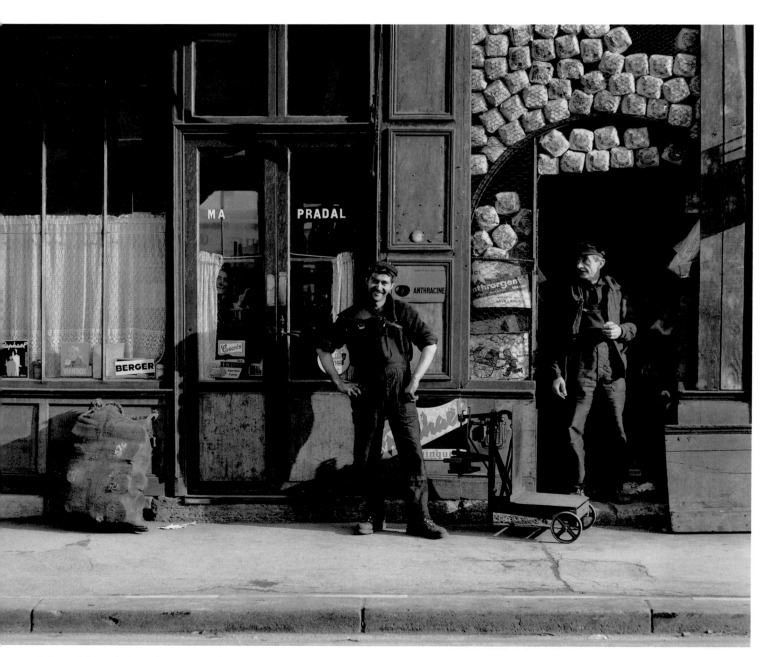

Café Pradal, rue de la Tombe-Issoire, 14th arrondissement, 1964

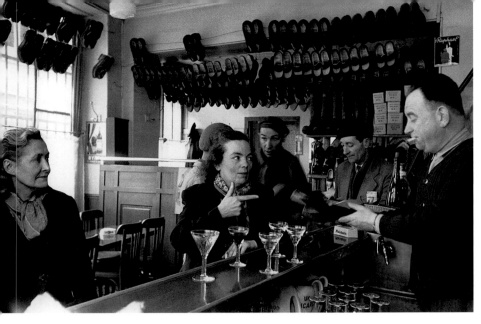

At La Ville d'Aurillac, rue de Lappe, 11th arrondissement, 1953

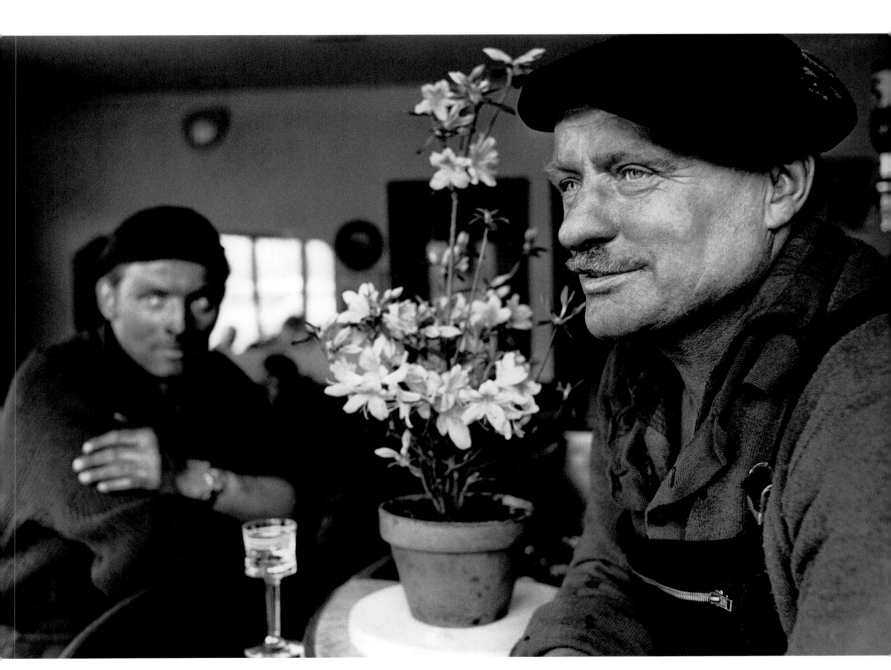

Workers from Auvergne in a café on rue Coulmiers, 1971

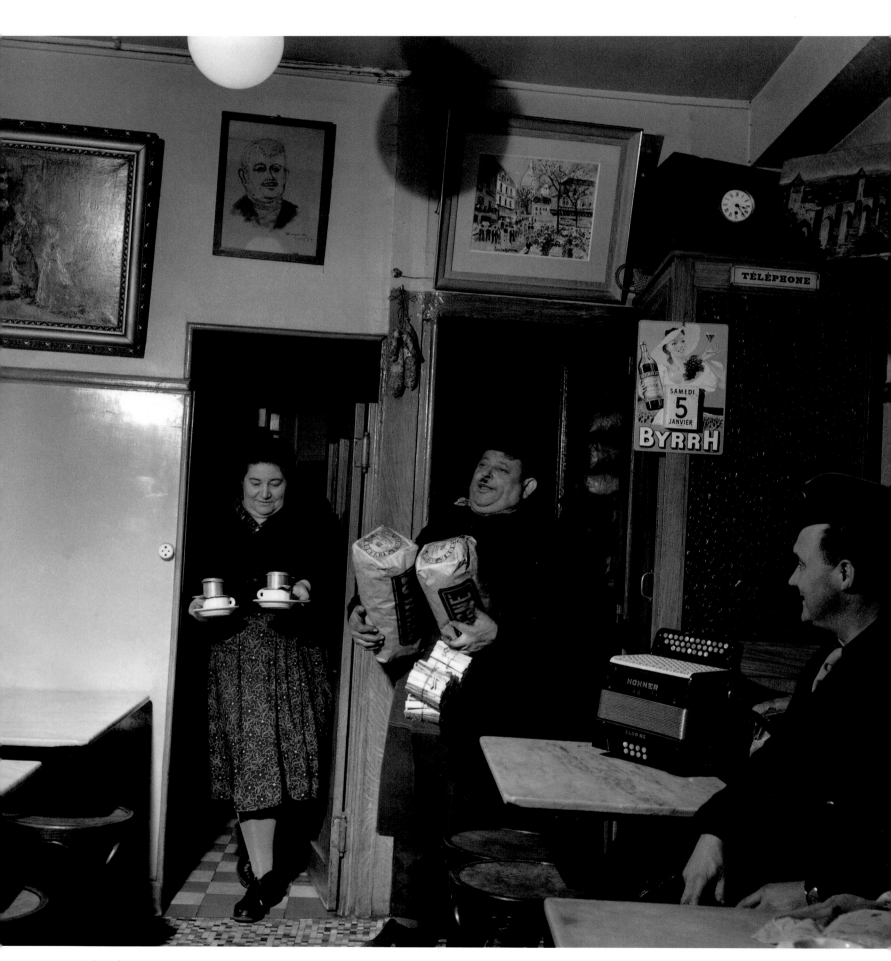

Monsieur and Madame Constant, rue de Seine, 1951

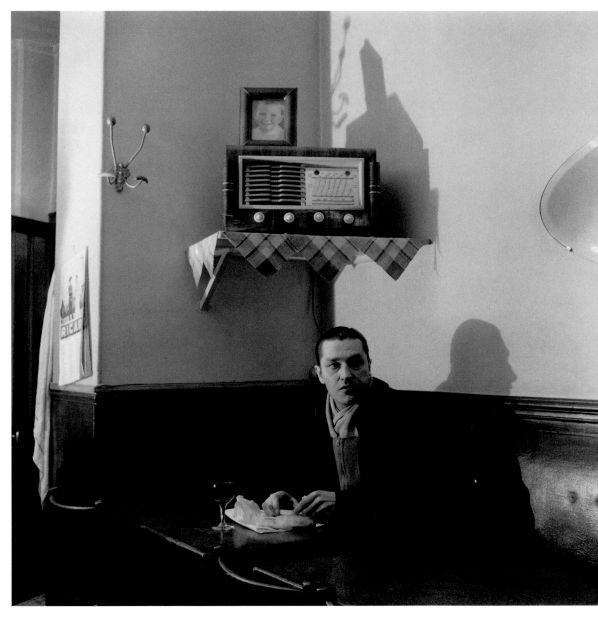

Sandwich and radio, 1957

Madame Rita, rue de la Montagne-Sainte-Geneviève, 1954

“ Single women in a café generally pretend to be waiting for some-one—it looks more respectable. But Rita, ensconced in a little bistro in the Latin Quarter, didn't bother. She'd take some snuff, have a drink, light up a cigarette. Always taking her time. No longer young, she was no longer in a hurry.

I knew she came from Corsica, which is probably why she made me think of Napoleon's mother. The more I drank, the stronger the resemblance. With her God-given authority, her black-rimmed eyes, her very long fingernails, and her trooper's cigarette lighter, Madame Bonaparte was among us once more. She would willingly strike up a song, if you insisted a bit—one of those hard-times tunes: *Du gris que l'on prend dans ses doigts* (Shag tobacco you hug with your fingers)—something you'd never hear under the Luxembourg's chandeliers . . . then the vision would slowly fade. ”

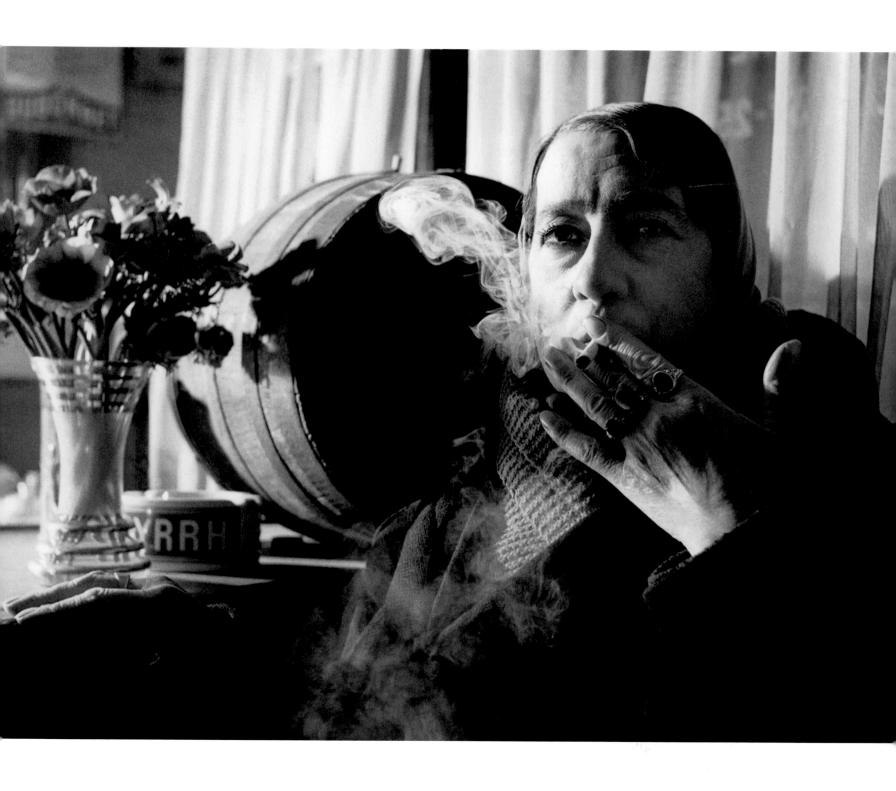

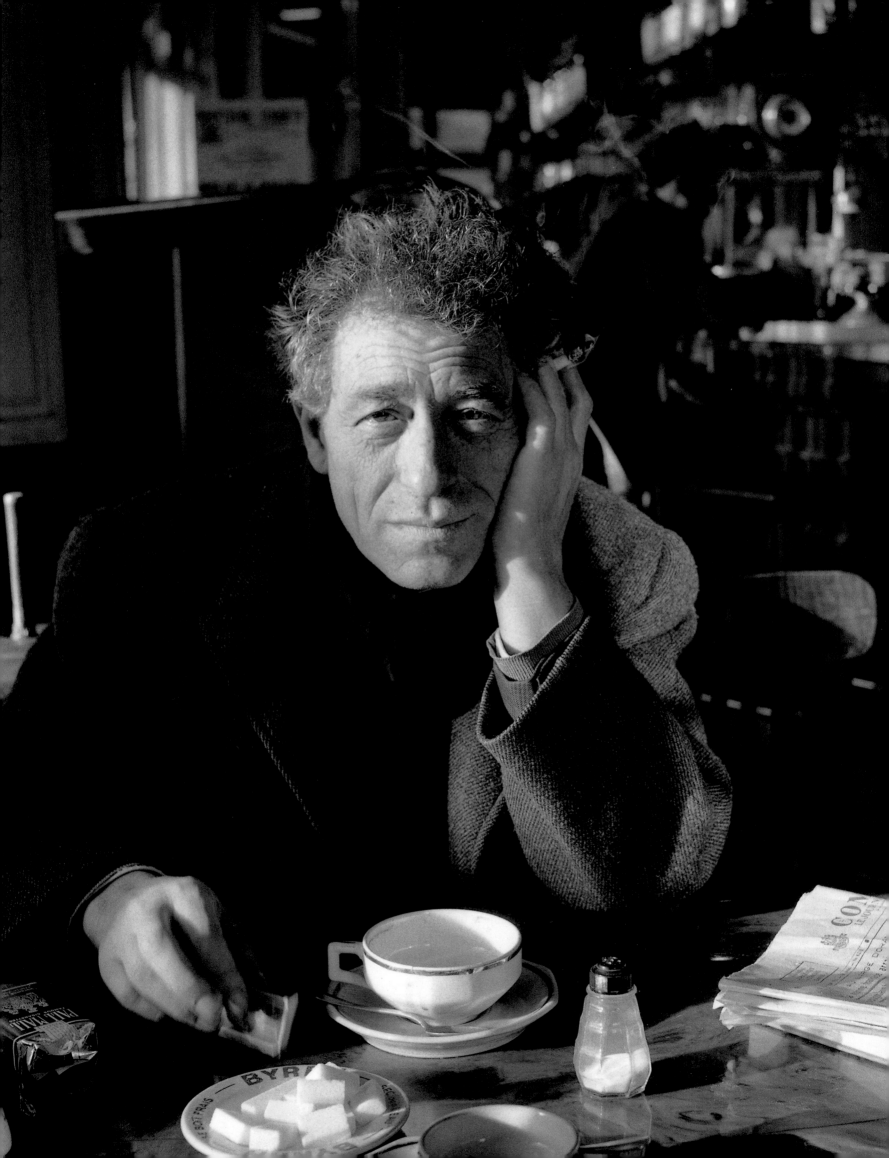

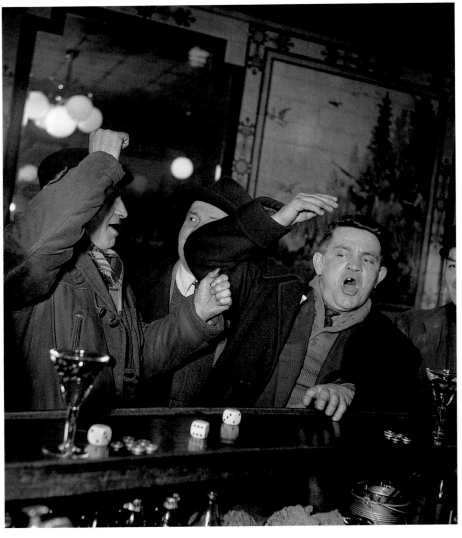

A Game of 421, 1950

The Veteran, Café de l'Ourcq, 1953

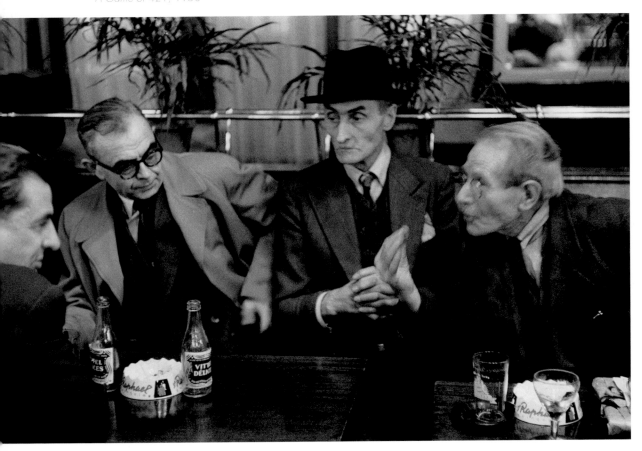

Gathering of "Balloonists" at Le Ballon, place de la Madeleine, 1954

<small>Preceding pages: *Alberto Giacometti, rue d'Alésia, 1958*</small>

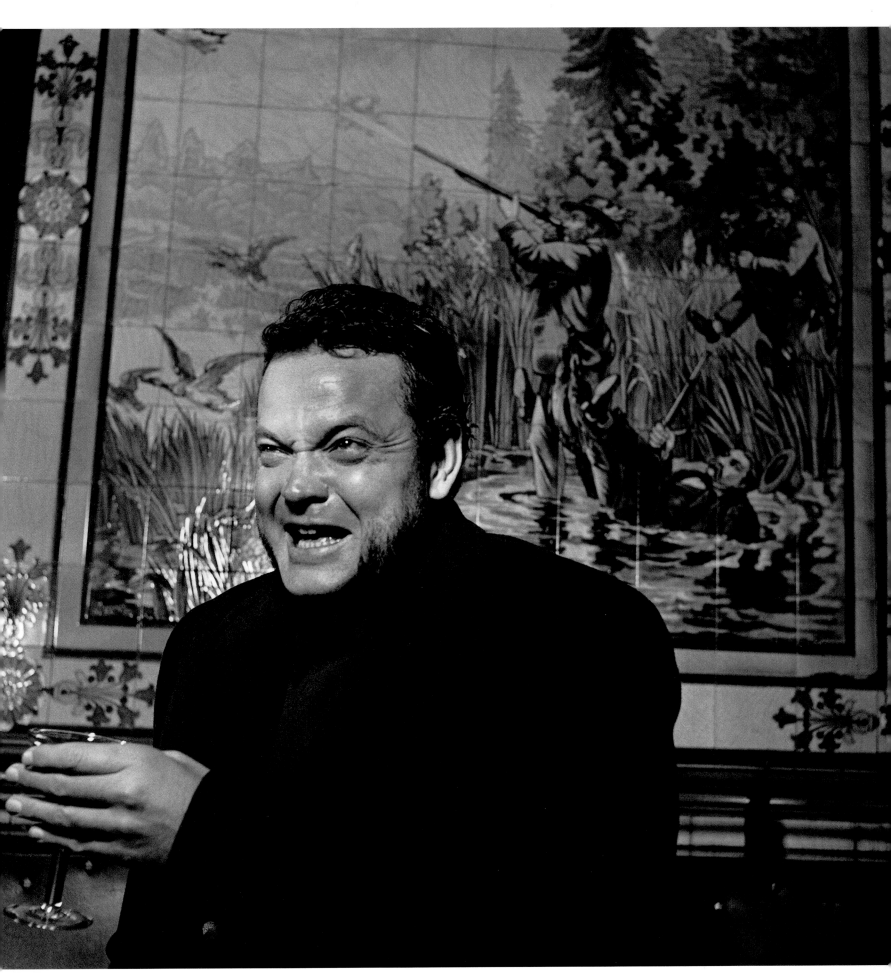

Orson Welles, 1950

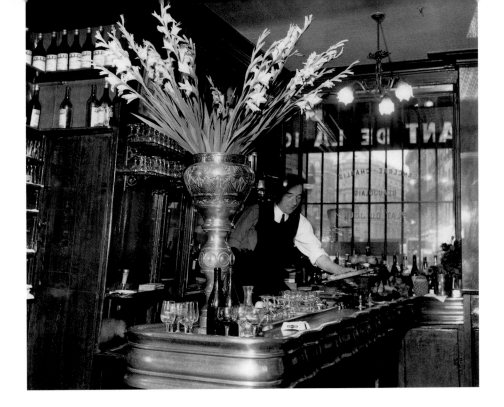

Le bouquet du comptoir

"Being a regular at watering holes has allowed me to uncover a basic law about the way they operate: the speed of service increases with the brightness of the lighting.

The large brasseries, glittering with lights, are the preserve of an ever-changing clientele of tourists.

The staff who work in such places execute feats that defy the laws of gravity—keeping a clutch on several glasses and bottles balanced on a steeply inclined tray calls for great professional skill.

Perhaps their juggling act is designed to astonish, to establish a sign language with customers who often speak some alien tongue.

This is the realm of the feverish and the fidgety, a place where no one wants to linger.

Personally, I prefer less glitzy bistros where, at the same time each day, and in more subdued lighting, you find the same regulars swapping comments in a relaxed, friendly way.

Everything has its place: the inevitable bouquet of gladioli and the poster on the wall forbidding the sale of alcohol to minors and condemning public drunkenness (even though the text, eroded by cigarette smoke, is completely illegible). It all creates a reassuring atmosphere where the owner, shepherding his peaceful flock, avoids all unnecessary effort by discreetly producing the desired drink with a friendly nod.

This is where, elbow on bar, you feel like a great philosopher in his ivory tower, studying the agitation of modern life in the streets outside.

Nowhere else can you find a better vantage point for taking stock of things as the twentieth century draws to a close."

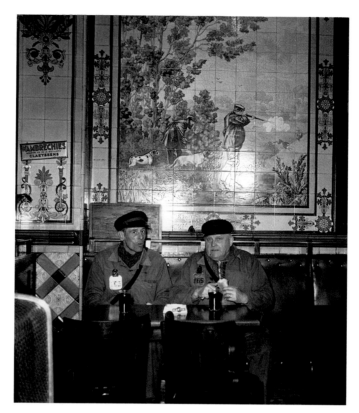

Café Les Chasseurs, rue du Faubourg Saint-Denis, 1955

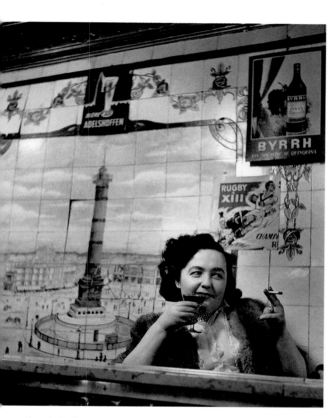

Rue de la Roquette, 1953

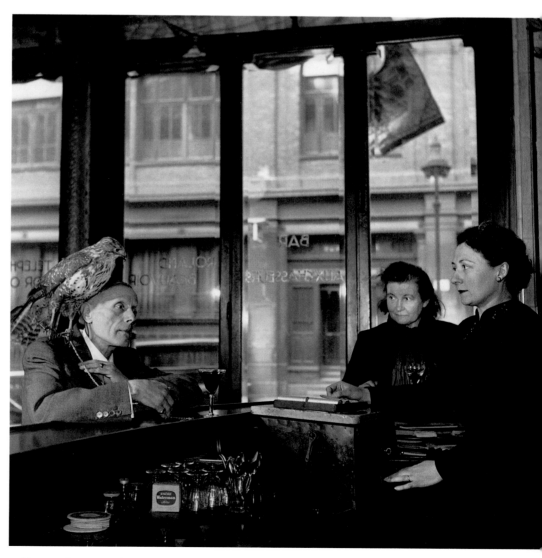

Monsieur Beauvoir, 1950

" Héloïse and Abélard in bronze, Sacha Guitry in shaggy wool, Claude Bernard in terra-cotta—and market porters in flesh and blood.

The whole gang is here under Baccarat chandeliers: Baron Haussmann, Joan of Arc, a lighthouse keeper, a wild beast with all its trappings, two Chinese vases as big as foot tubs, a bear with club, Mozart as a child, and so on.

It's hard to tell whether this is a museum or palace; in fact, it's Alcide Levert's bistro on rue Saint-Merri, where none of these fine figures have ever been shouldered aside by a porter from Les Halles market. "

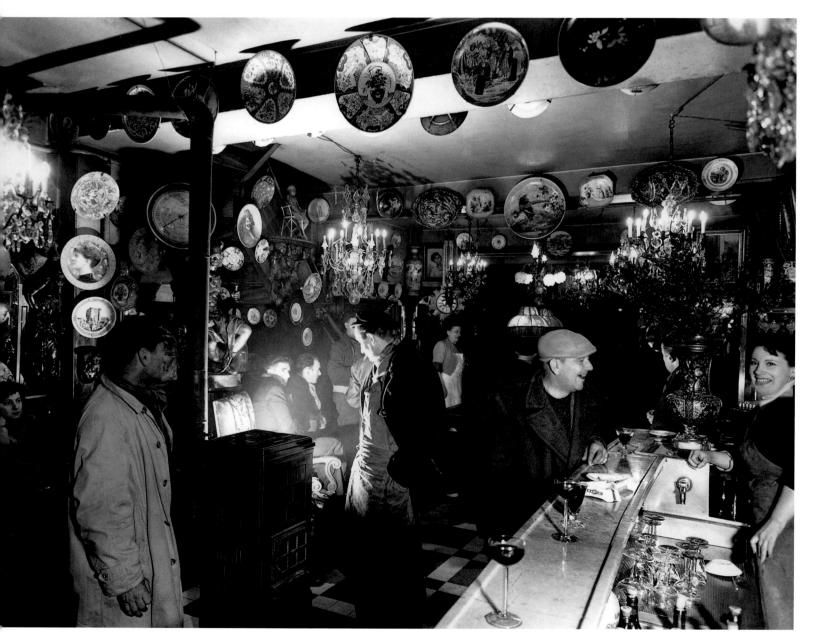

Café Curieux, 1953

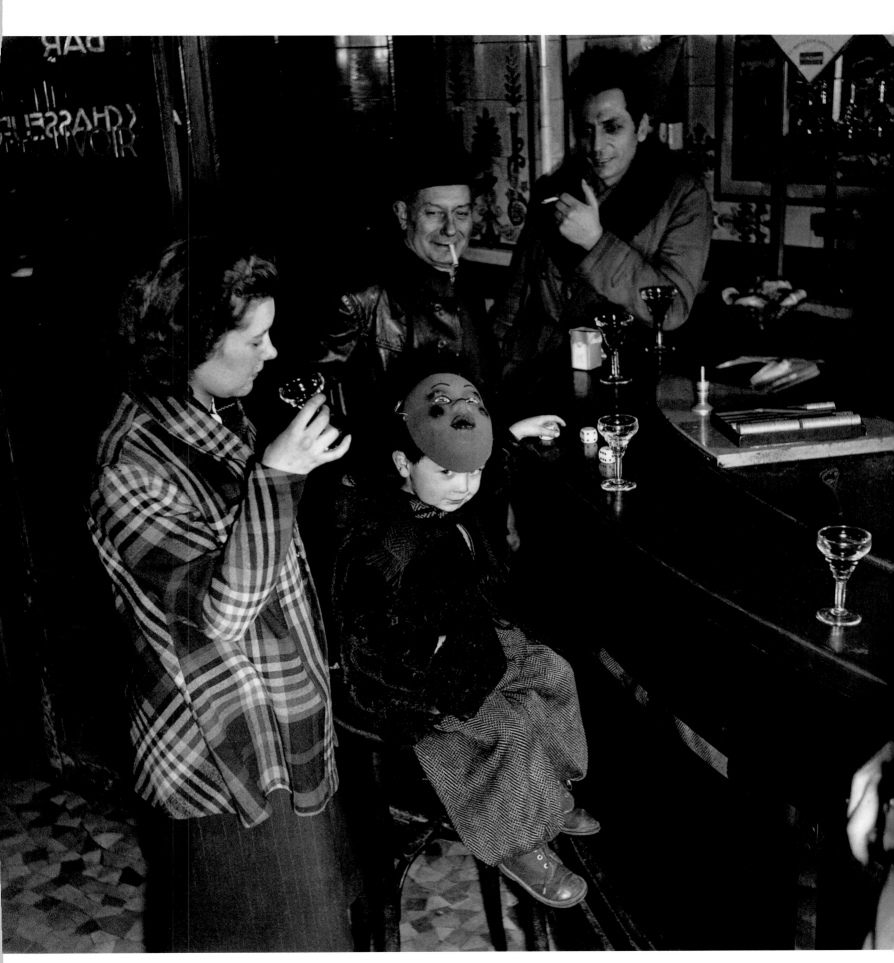

Café Les Chasseurs, 1950

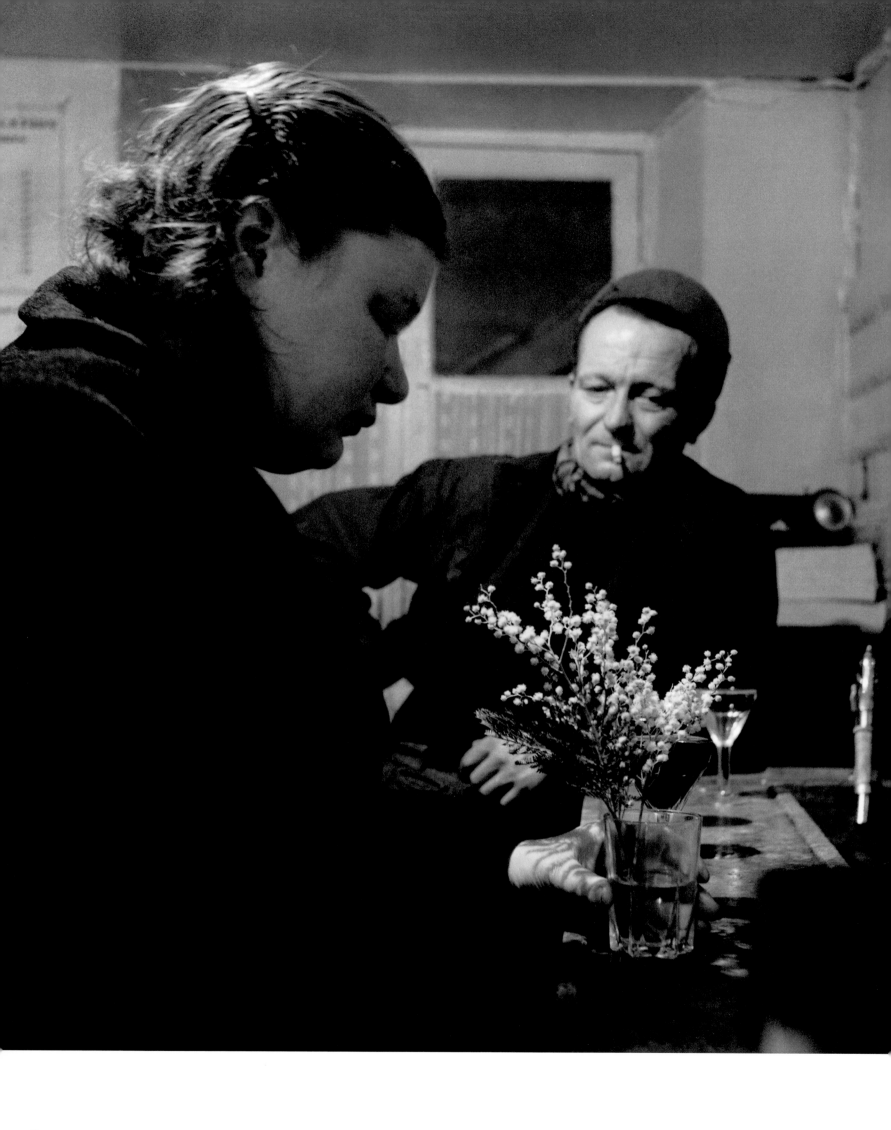

" It wasn't the type of joint to feature potted plants or sprays of glad-
ioli, this bistro on rue Maître Albert.

Its clientele of bric-a-brac dealers and ragmen was happy enough
with bare, strictly functional surroundings.

Just how the sprig of mimosa landed there, on the counter, and
who brought it in, remains a mystery. But it lent its shy fragrance
to an atmosphere smelling of cigarette smoke and sour bar cloths.

Which is all it took to turn big Maddy back into a little girl. "

BAR GAMES, RUE LACÉPÈDE, 1954

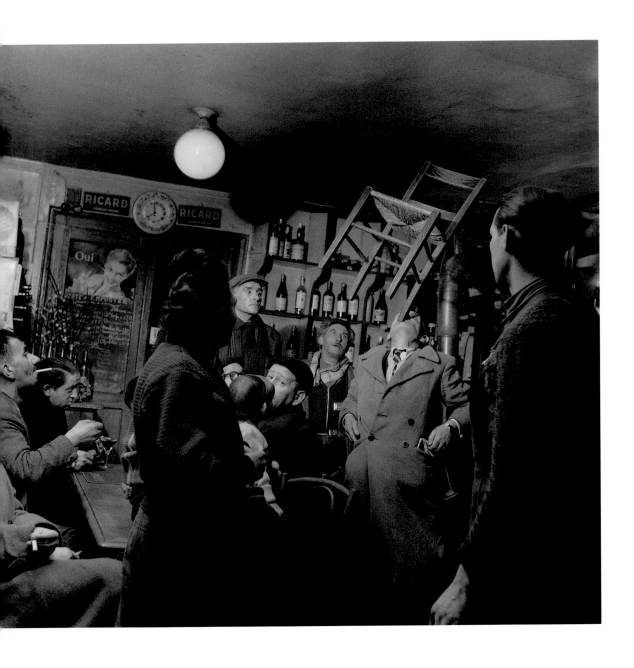

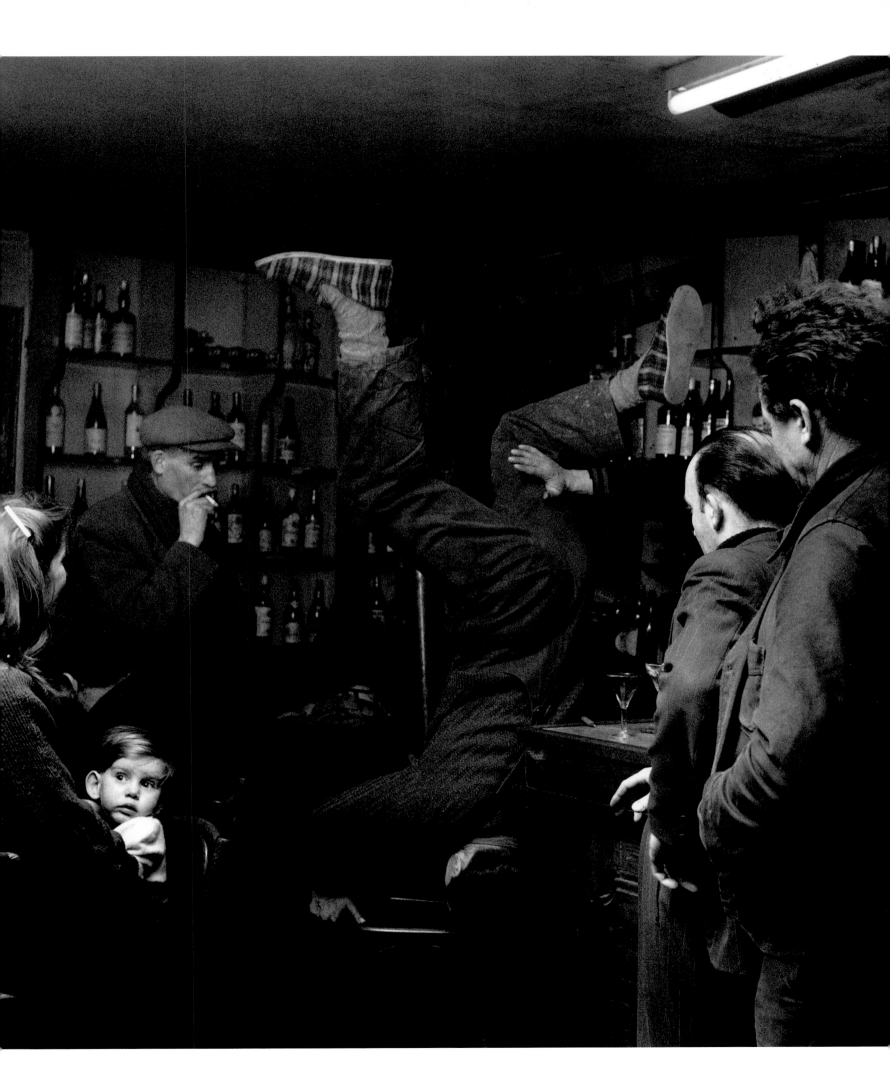

Coco, 1952

" It was Robert Giraud who introduced us in a panhandlers' bistro on rue Xavier Privas. Coco didn't have much to say, though. Solicited by the red wine in front of him, he obligingly returned the favor.

The big attraction was to imitate a drum beat on the seat of a stool, pounding out a legionnaire's chant, *Voilà du boudin!* Suddenly Coco would snap to attention, as if back in the foreign legion. Everyone present would laugh, which didn't really bother him. He seemed to enjoy the mockery. "

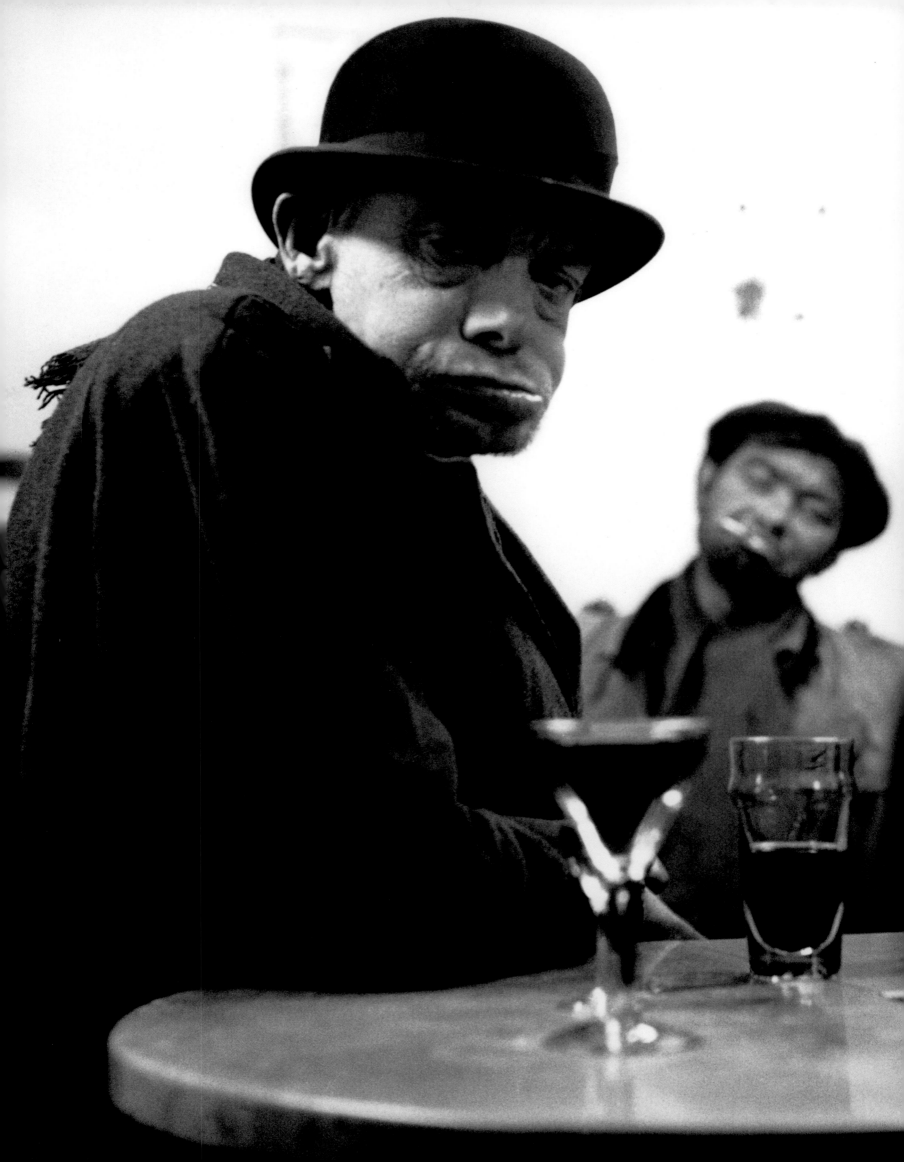

[PARIS

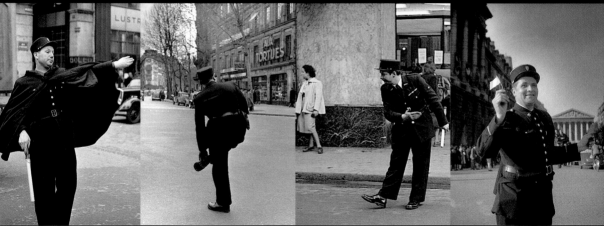

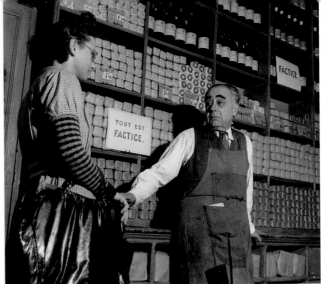

Bakery, Belleville neighborhood

"Everything is fake"

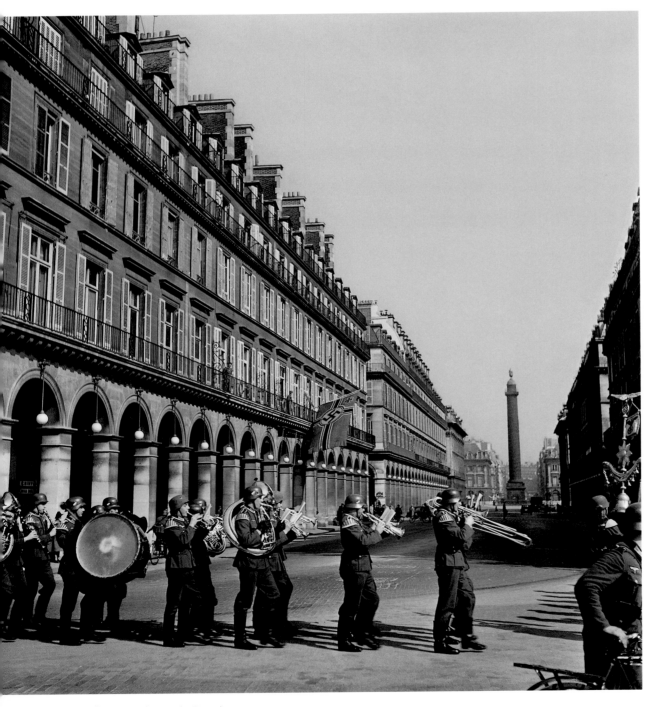

Germany military parade; rue de Castiglione

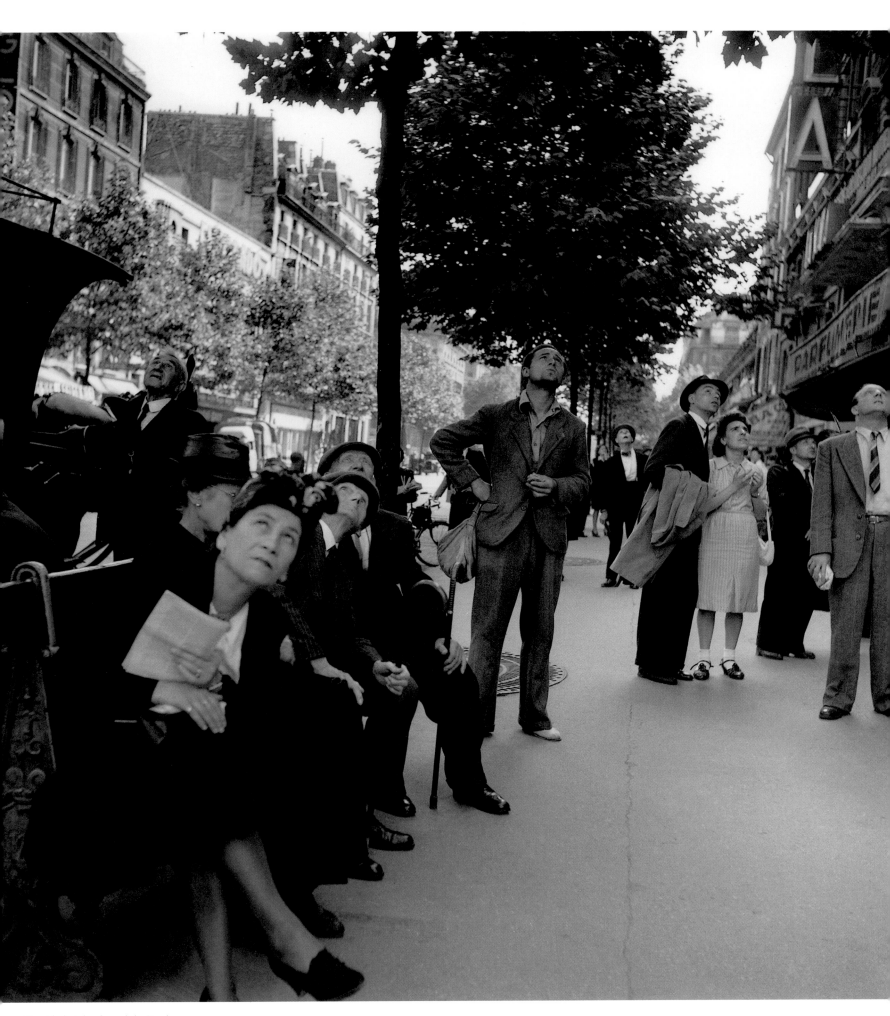

Air-raid alert, boulevard de Strasbourg

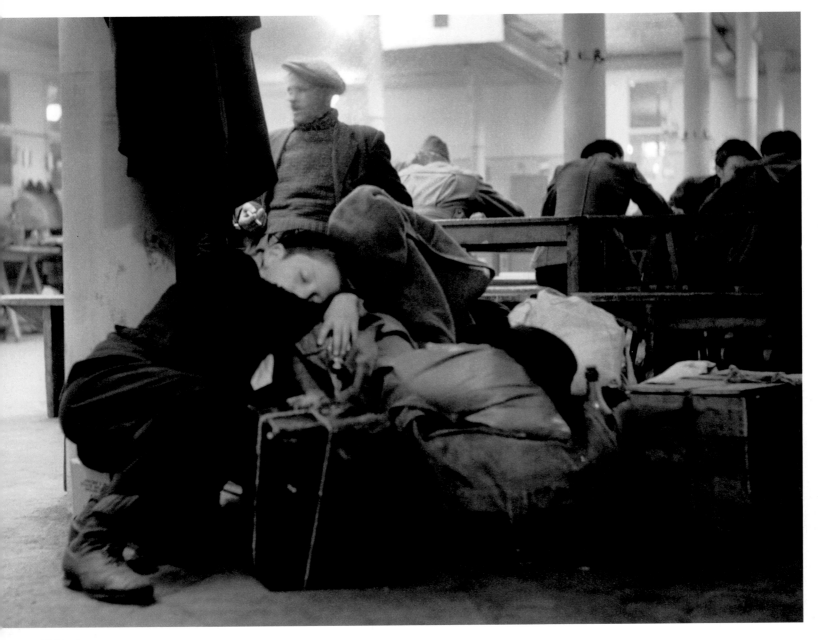

Child asleep on a suitcase

Facing page: Alert, shelter in the metro

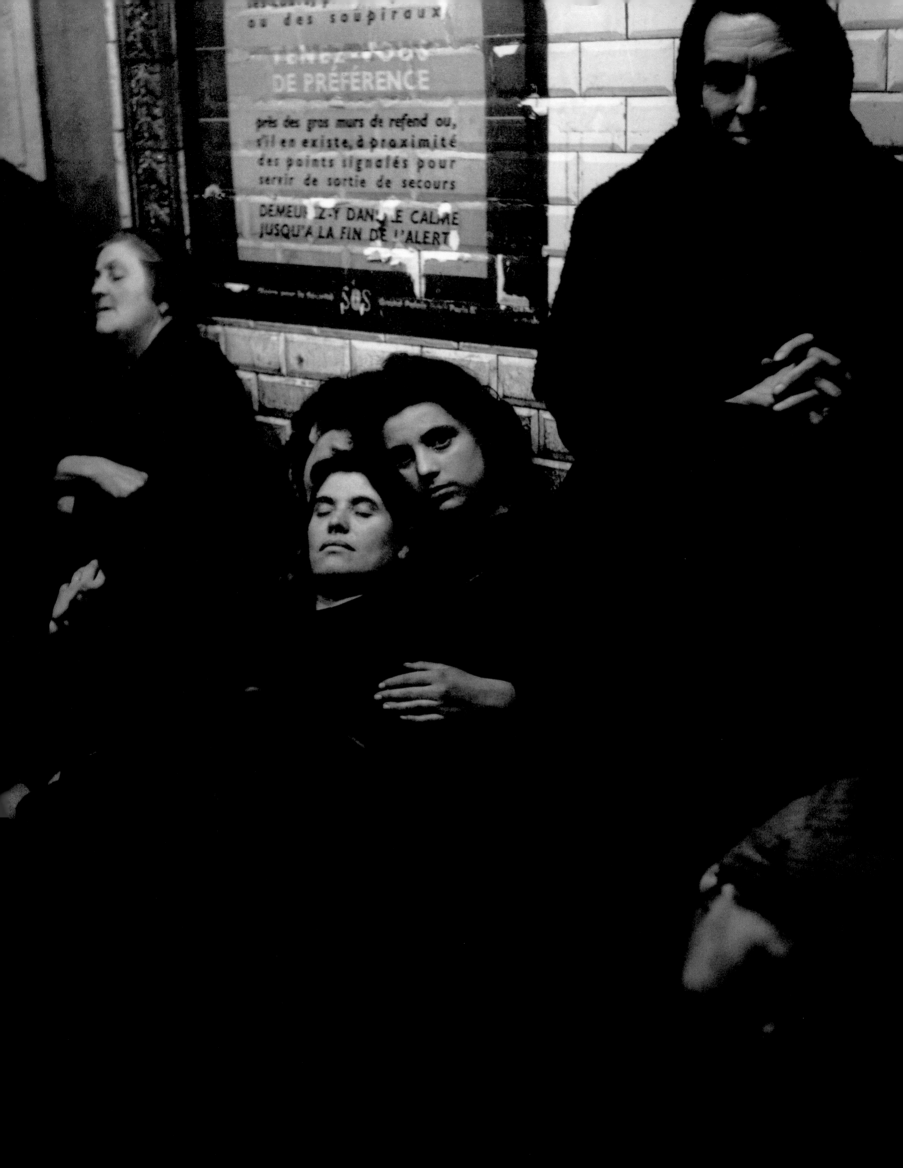

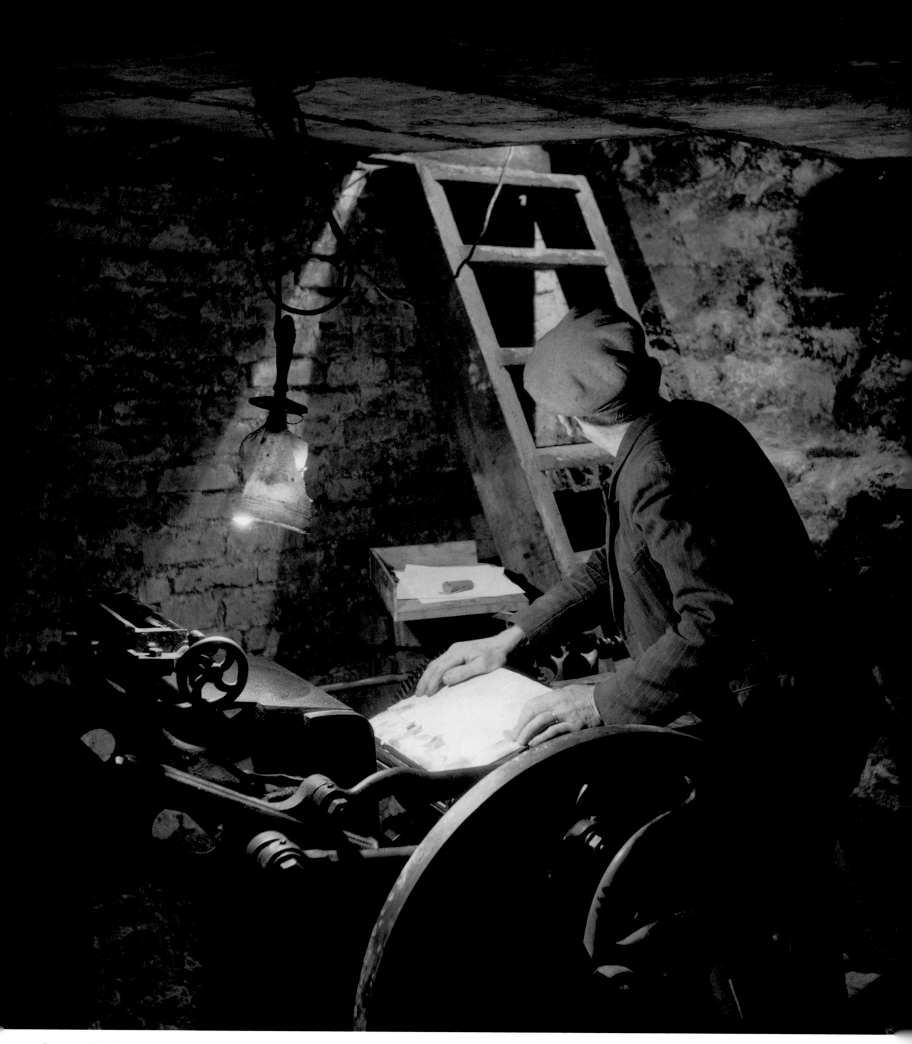

Comte and his Phoenix

> " Harambat printed pamphlets and brochures for the national liberation movement. "

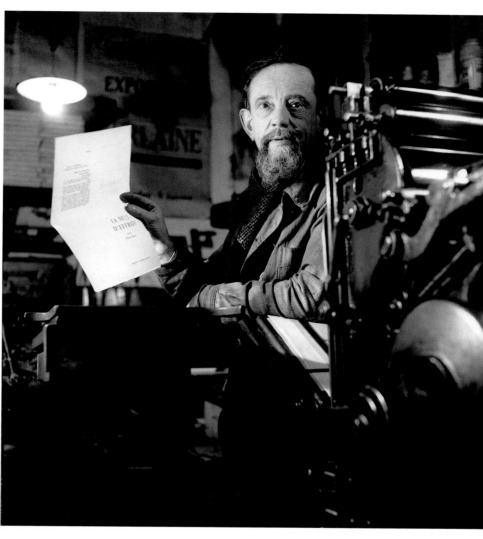

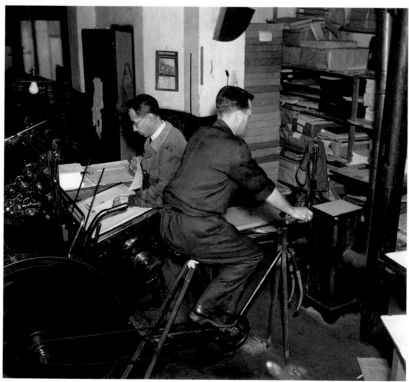

Printing during a power cut

Philippeau, and Olga and Enrico Pontremoli

" For me, Monsieur Philippe was like the usherette's flashlight, guiding me to my seat during the horror film of the German Occupation. At first I was a little frightened of him. Naturally, I'd already 'put together' some identity papers for friends in trouble, and he brought that up—he seemed fully informed. He asked me to work with him in a less amateurish way.

I pretended I didn't know what he was talking about. But then I had to make a choice. I decided to trust my native instincts, and what convinced me was his gaze. It wasn't a cop's gaze. I gave in—and good thing, too.

When the Liberation came, like everyone else who dropped their cover names, Monsieur Philippe suddenly became Enrico Pontremoli. Here he is seen with Olga, his wife, and Philippeau printing some lithographic stickers to plaster over the Germans' 'Red poster.' "

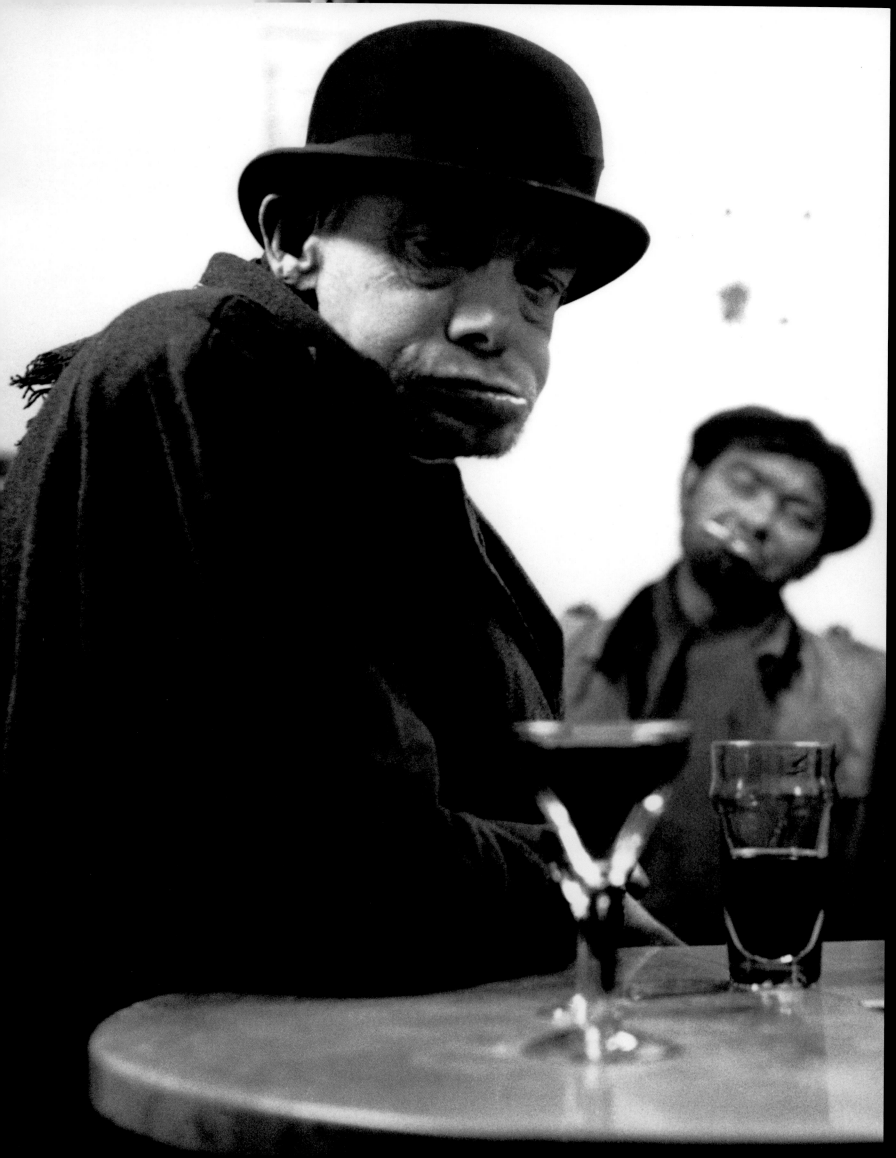

[PARIS

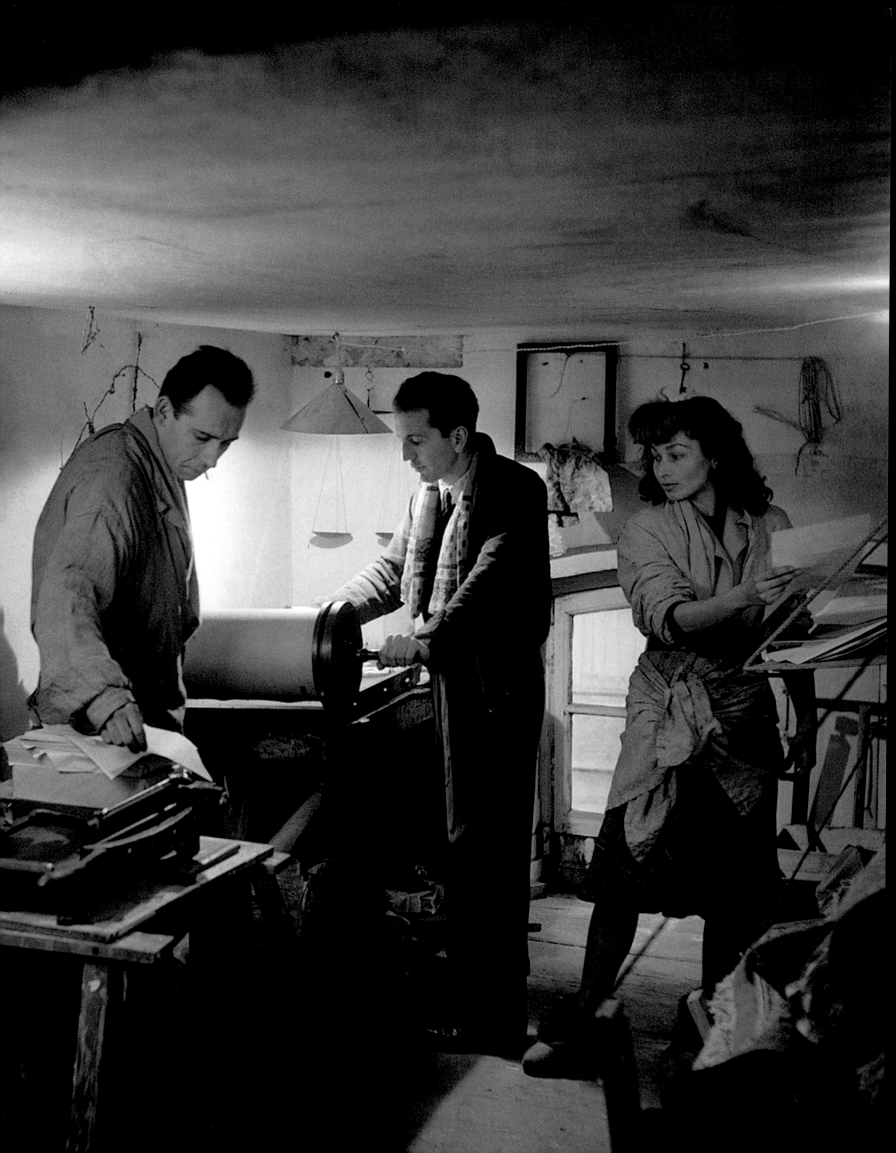

> 66 Claude Oudeville was a printer who typeset Vercors's war-time novel, *Le Silence de la mer*, by hand. Three hundred and fifty copies were printed. 99

Le Silence de la mer, the first book published by Éditions de Minuit, February 1942

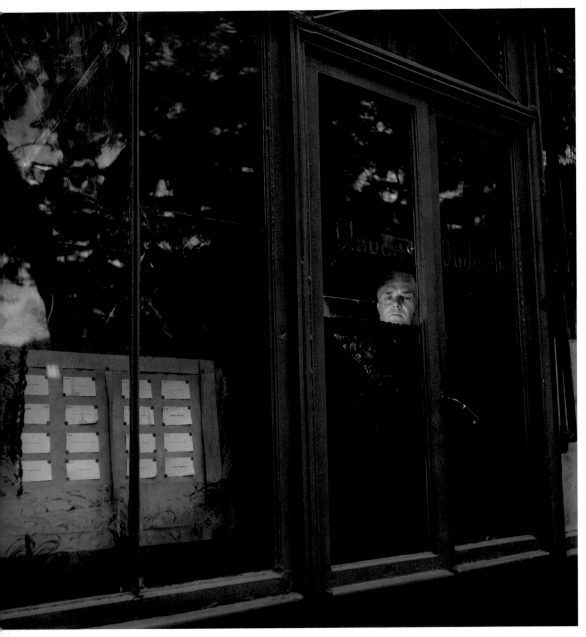

Claude Oudeville, printer of *Le Silence de la mer*, 1942

> 66 Vercors was the pseudonym of Jean Bruller, an engraver. Contacted by Pierre de Lescure at the start of the Occupation, he wrote *Le Silence de la mer* for the review *La pensée libre*, founded by Jacques Decour and Georges Politzer. Their arrest delayed publication. 99

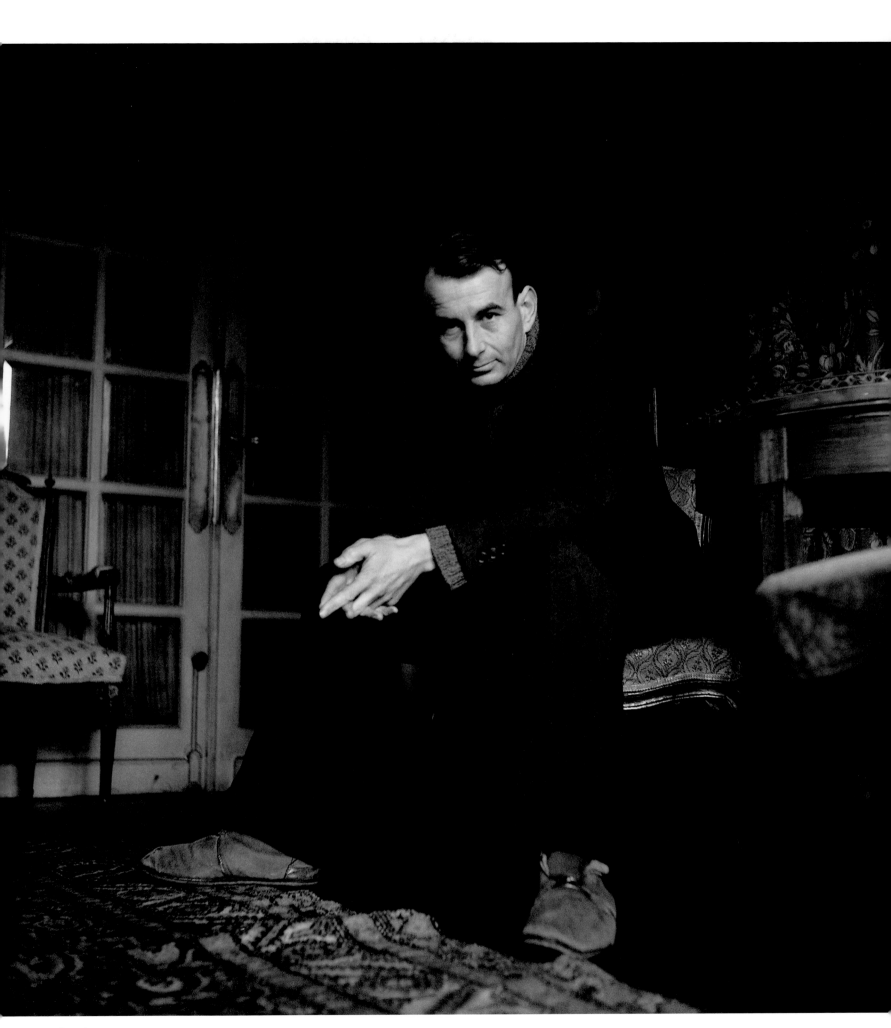

Jean Bruller, aka Vercors

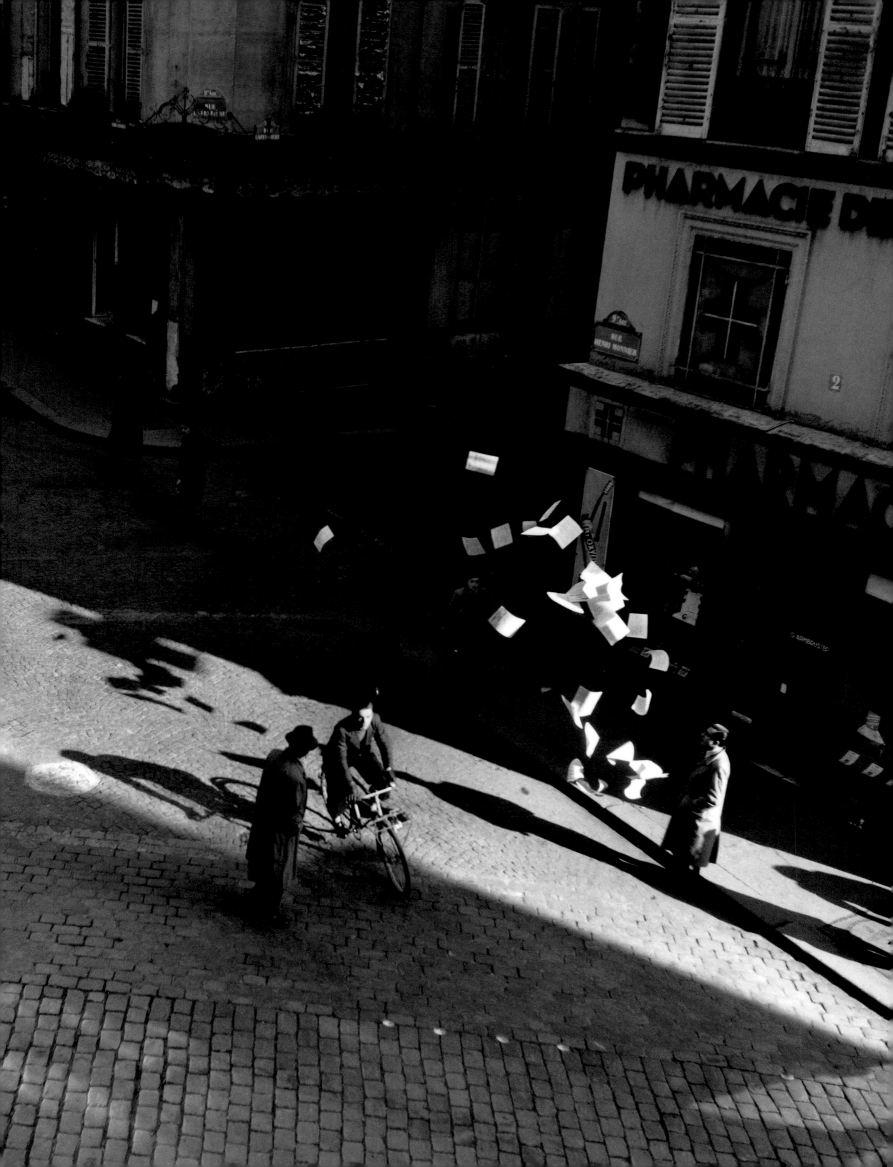

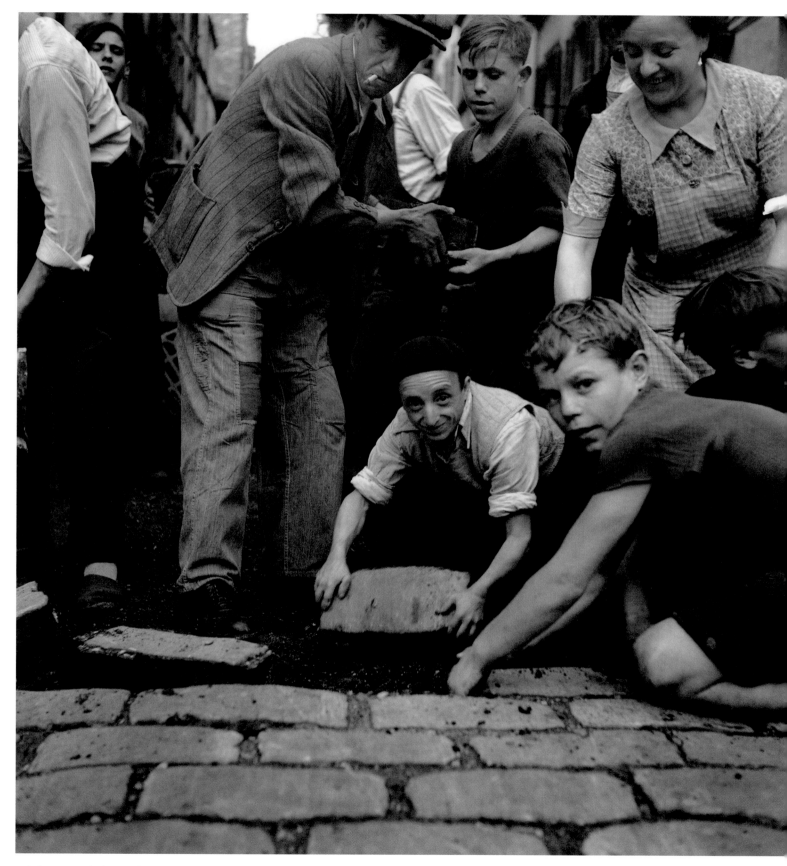
Little man on the barricades

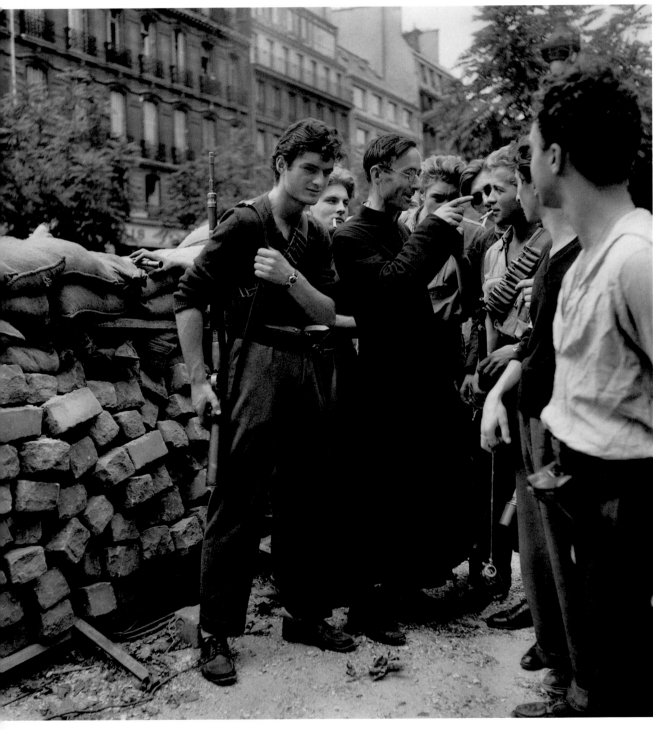

Abbé Camille Folliet on a Barricade, August 1944

Facing page: *FFI fighters at Rest*

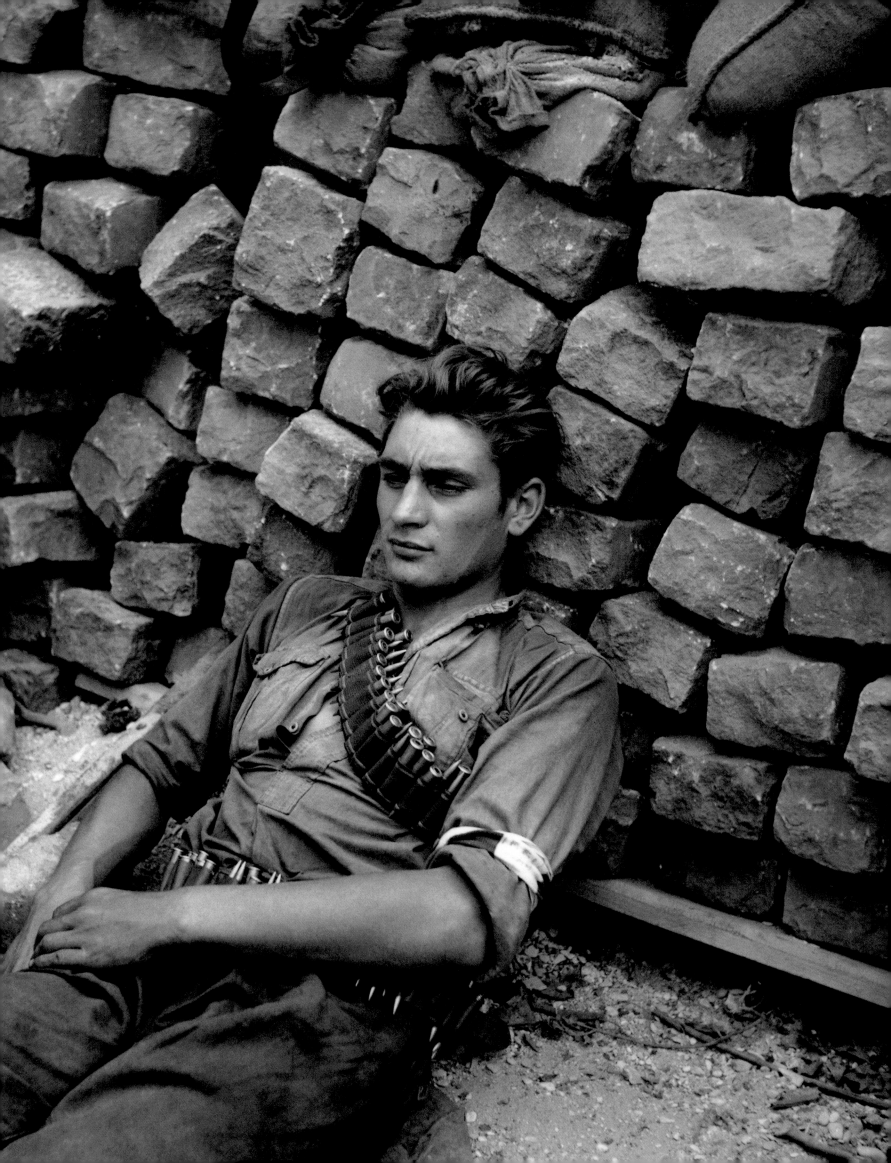

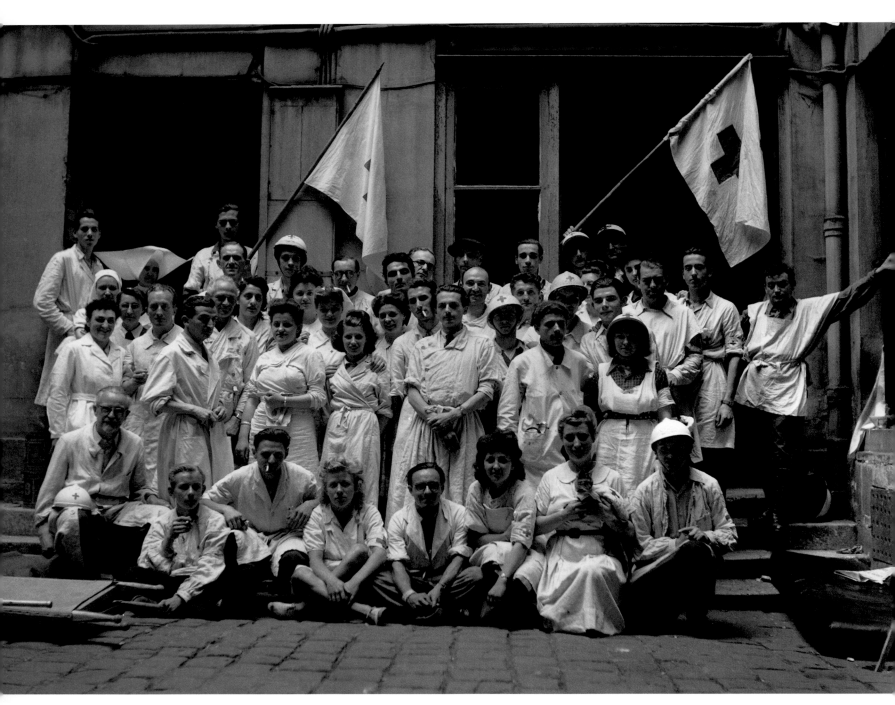

Group of medics, May 8, 1945

" The news came by telephone to the makeshift press headquarters in an apartment on rue de Richelieu. 'The FFI has just derailed a German train on the circular belt line. Send a photographer to the Ménilmontant headquarters.'

While riding over on my bike, I imagined the scene: a string of dislocated carriages, the smoking locomotive on its side. I pedaled harder, even uphill.

The meeting place was a bistro—henceforth district headquarters—over by rue Sainte-Marthe, I think. I remember all the bustle very clearly. We climbed rue des Couronnes and coasted into the Ménilmontant train station. But we could kiss our train wreck goodbye: the derailment had taken place a good one hundred yards inside the tunnel leading to Buttes-Chaumont. Total blackout. On reaching the train, you could feel with your hands that the wheels had slipped off the rails, that's all.

Return to daylight and bicycles on rue des Couronnes, heading to the Belleville metro station where we found some wandering FFI fighters, enough to make up a wedding-party-sized photo. I didn't think much of this picture at the time, but now I rather like it, though I'd be hard put to say why. "

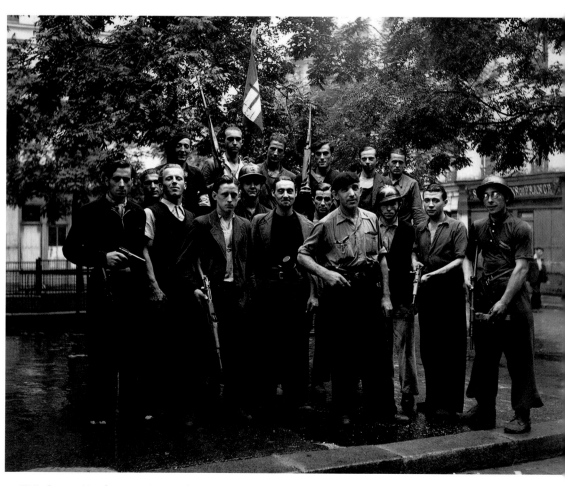

FFI Fighters in Ménilmontant, August 1944

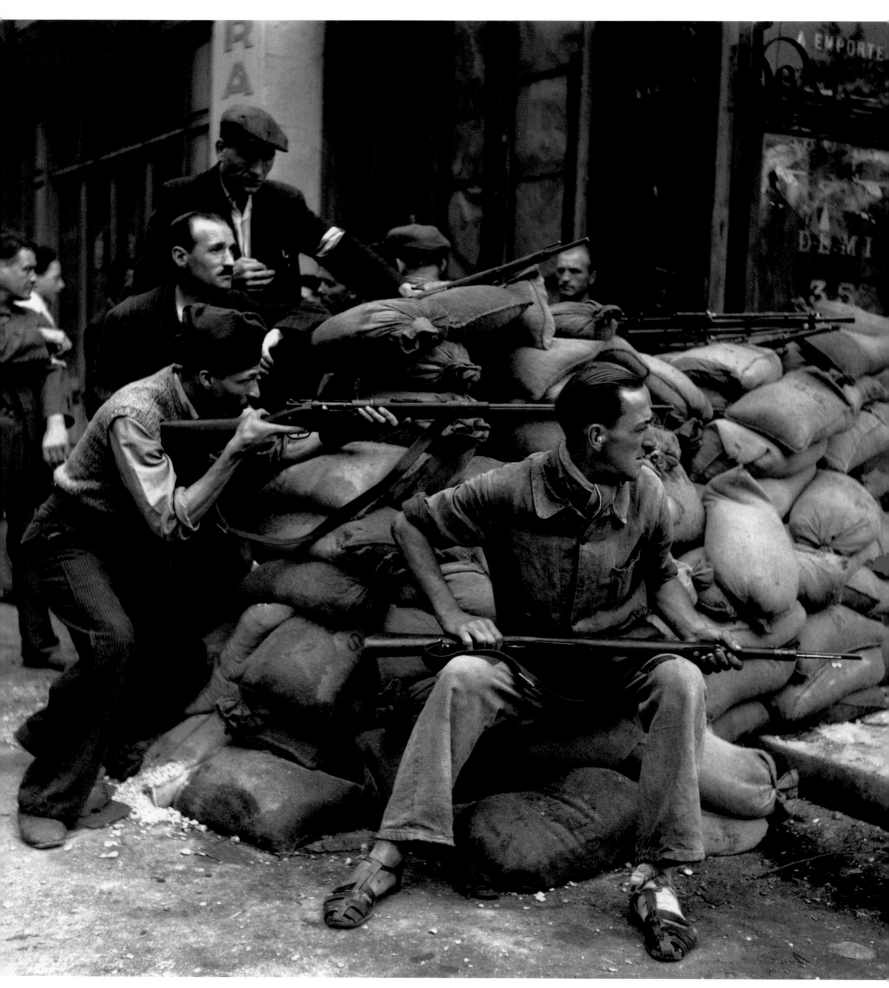

Barricade on rue de la Huchette, August 1944

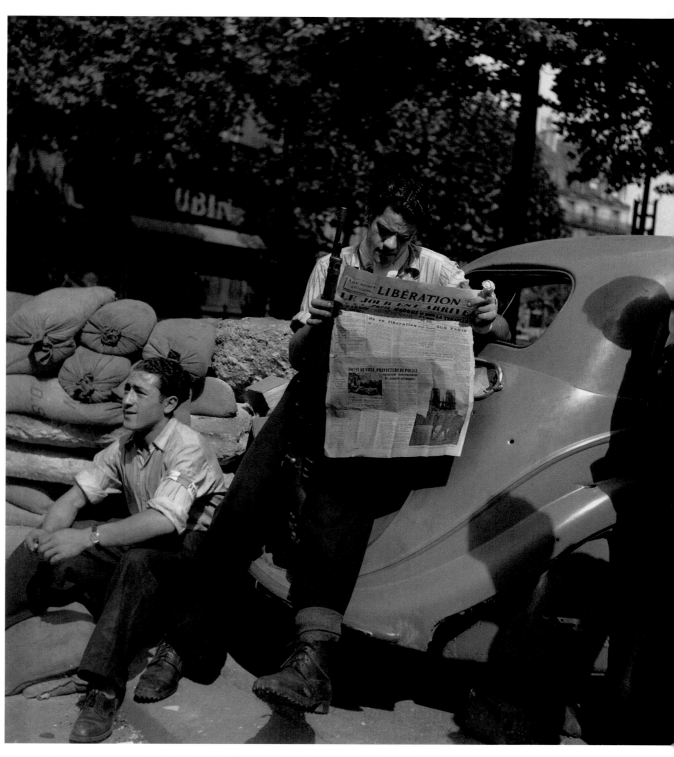

Barricade at the intersection of boulevards Saint-Germain and Saint-Michel, August 1944

" On August 26, 1944, General de Gaulle, president of the provisional government of the French Republic, walked down the Champs-Élysées flanked by members of the National Resistance Committee. Behind de Gaulle is General Leclerc. "

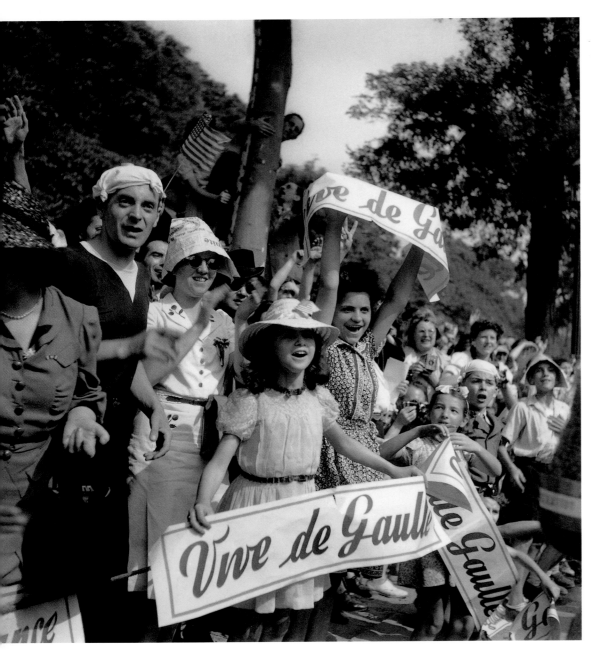

Vive de Gaulle

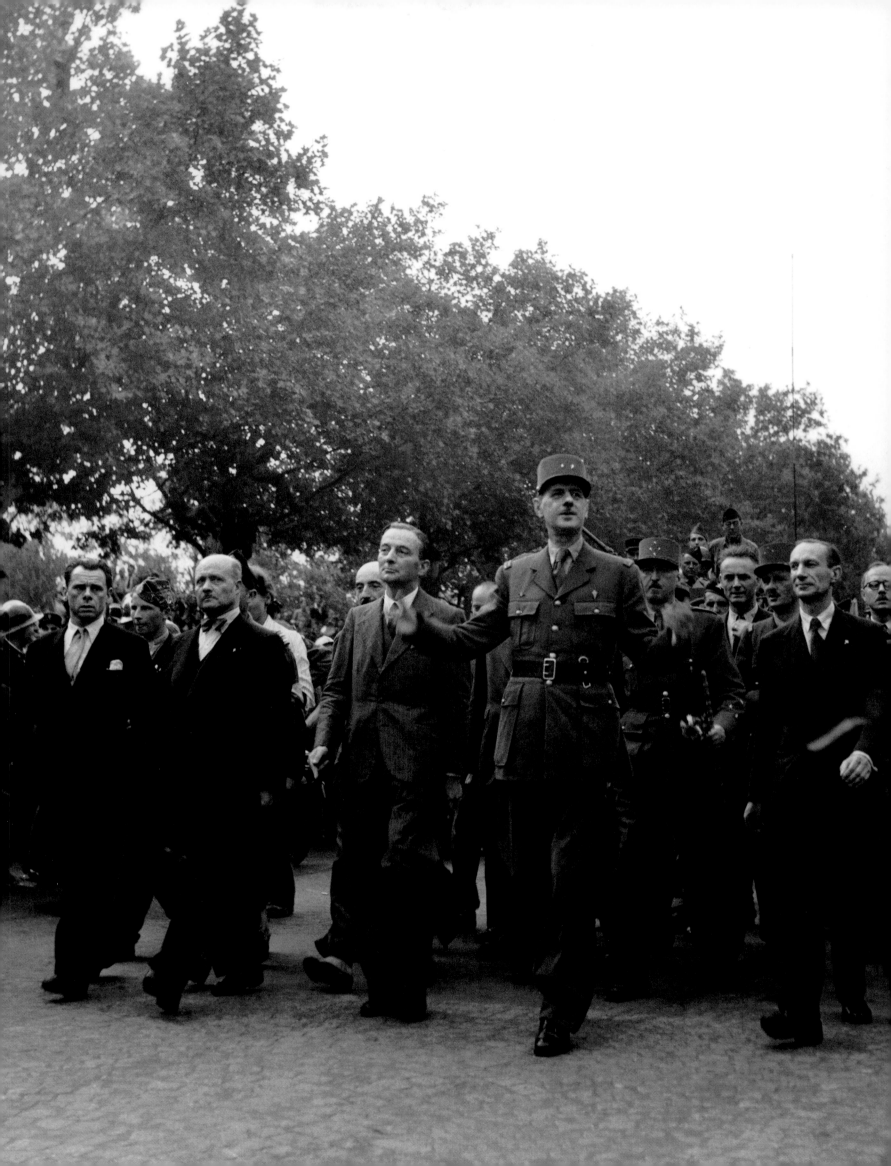

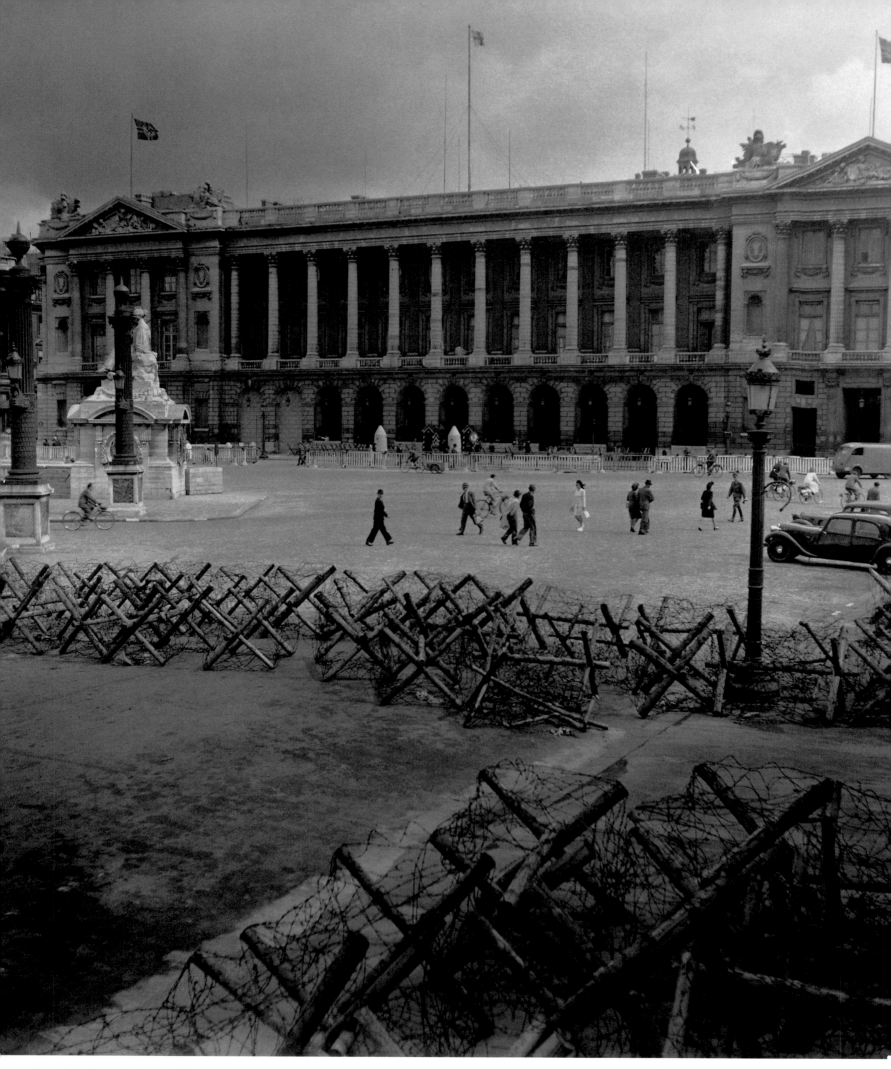

Place de la Concorde, August 1944

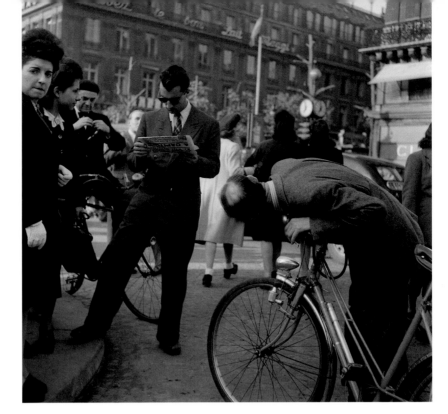

SURRENDER! *Recto verso*

A collector of German road signs, August 1944

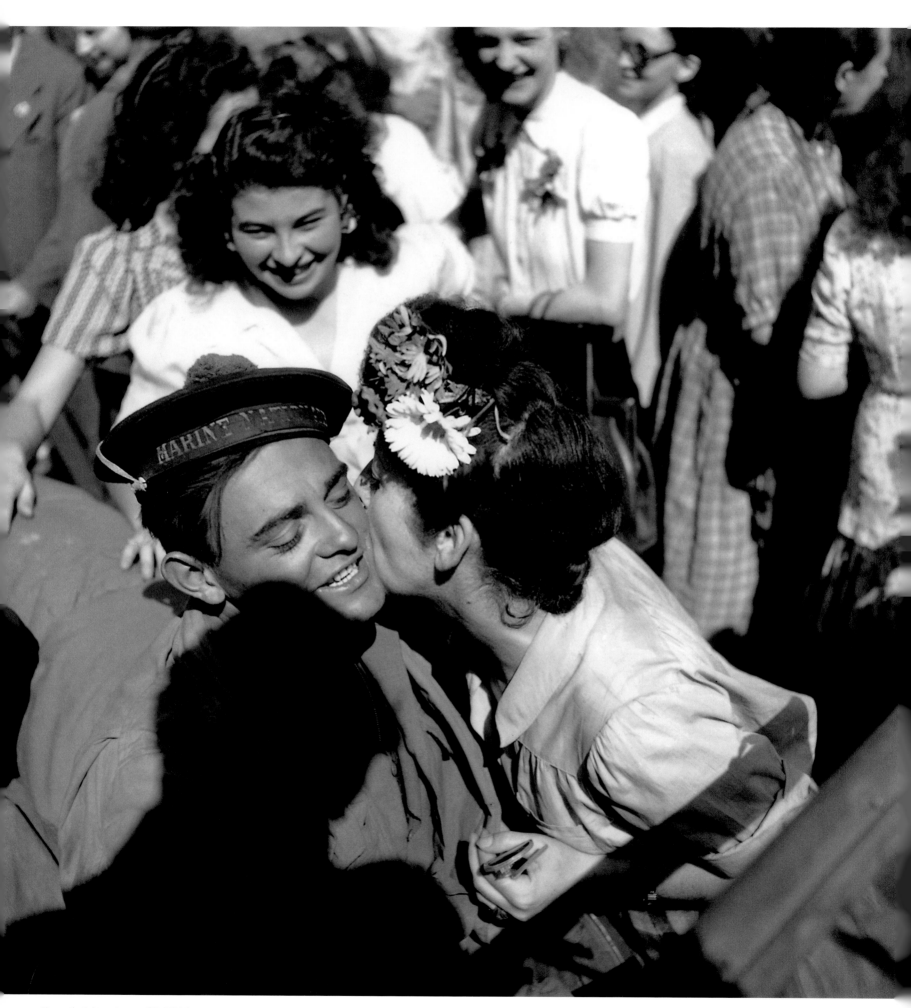

The sailor's kiss, August 26, 1944

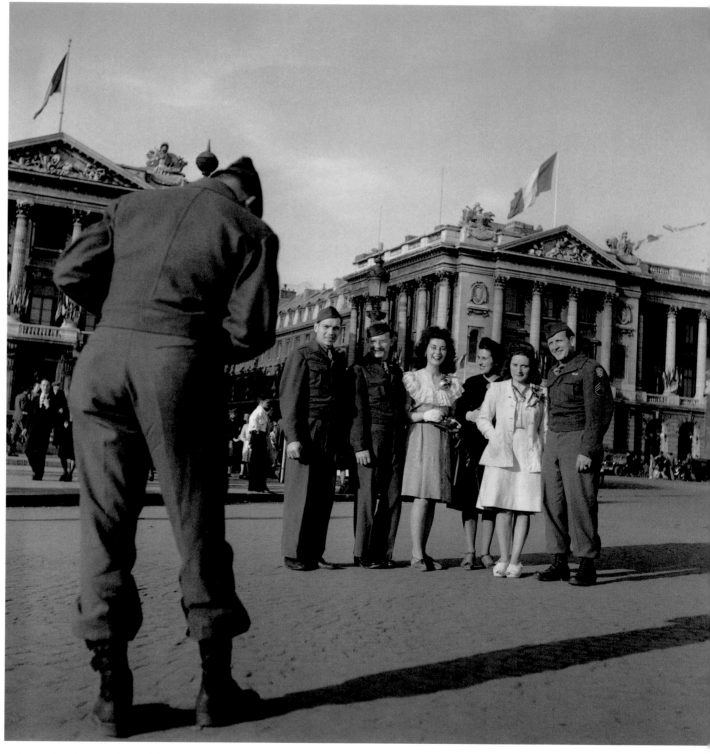

A snapshot of victory, August 1944

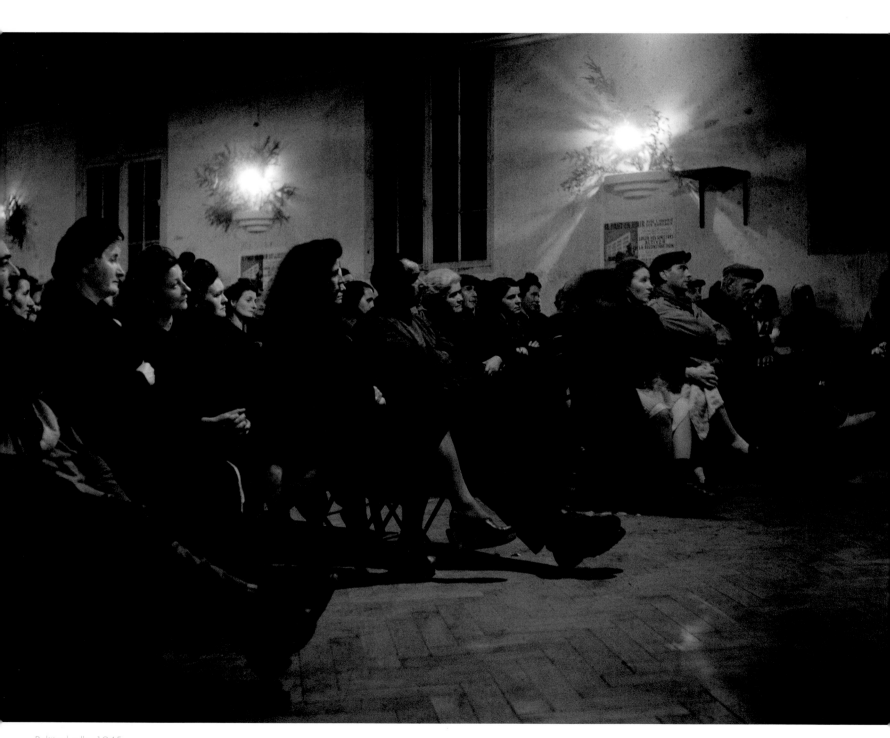

Political rally, 1945

Mathilde Péri and public schools, 1945

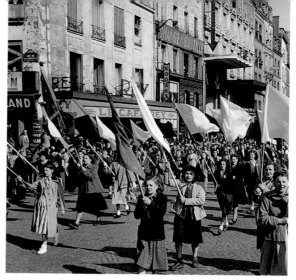

Demonstration in 1949

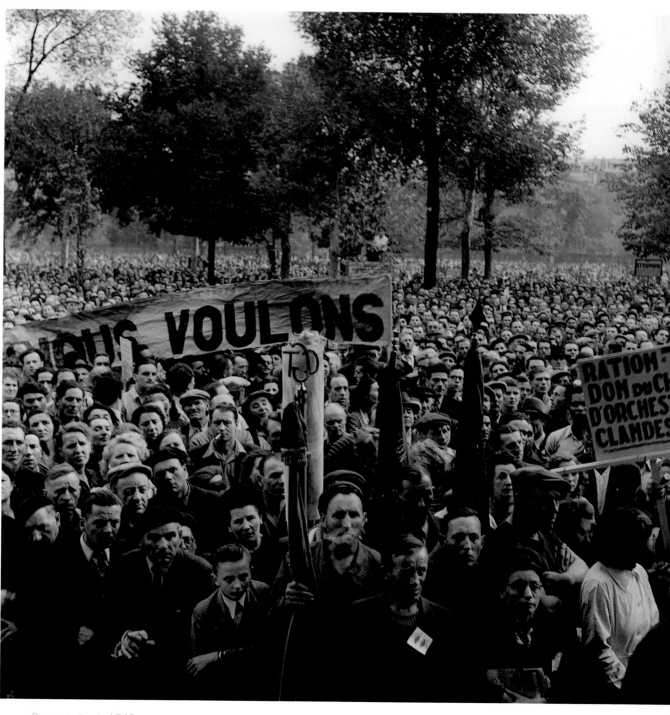

Demonstration in 1945

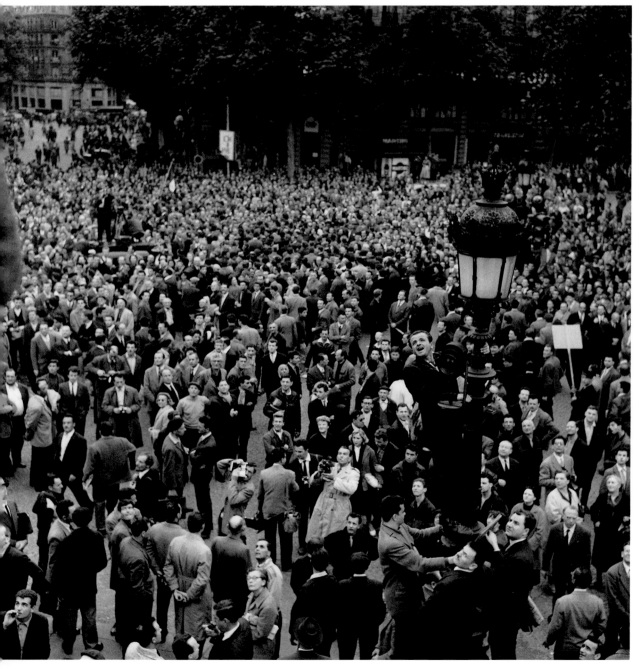

Rally, 1958

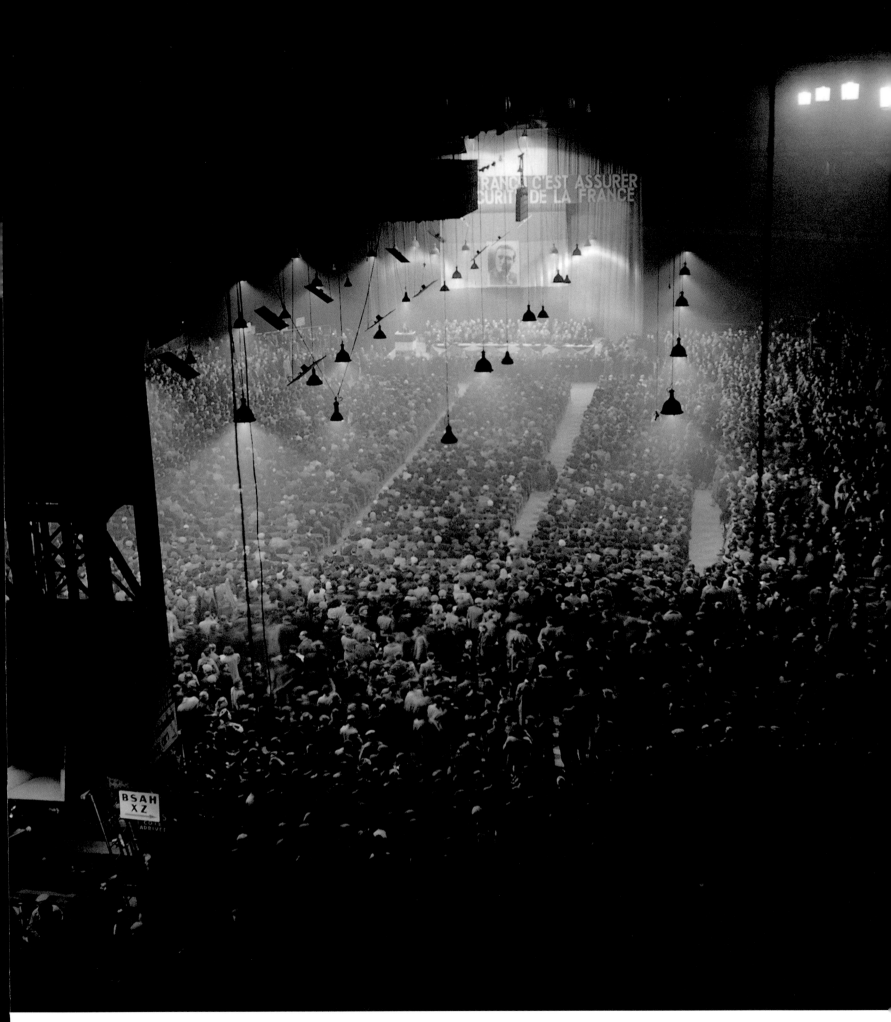

Rally at the Vélodrome d'Hiver, 1945

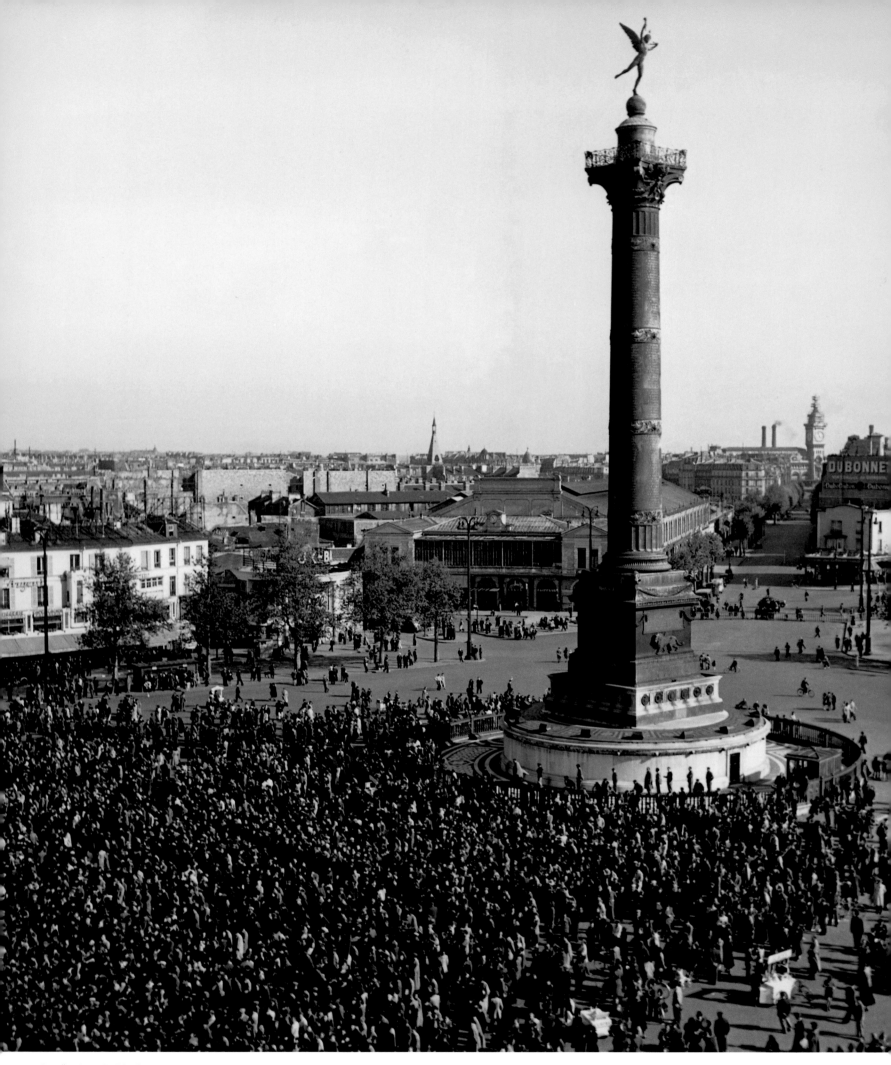

Bastille, May 1, 1949

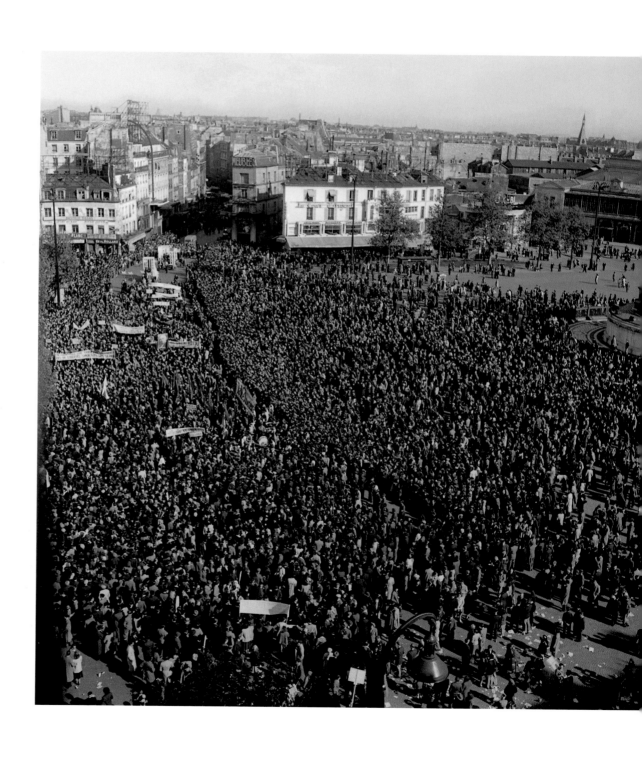

Demonstration in 1949

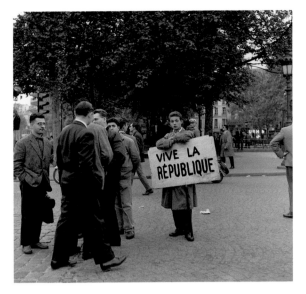

Demonstration in 1958

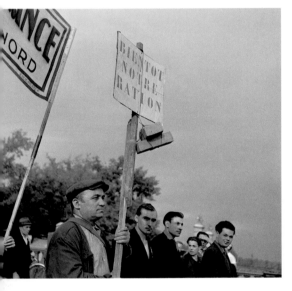

Demonstration in 1945

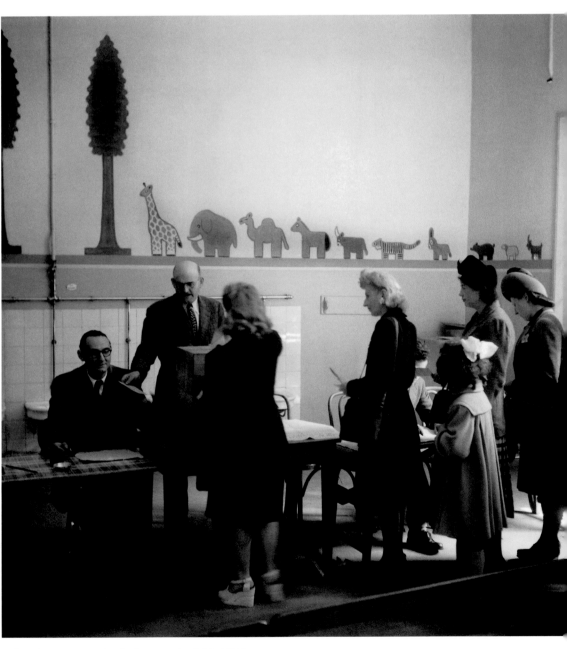

French women vote for the first time, April 29, 1945

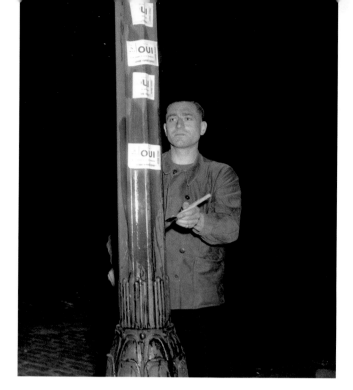

Activist in 1945

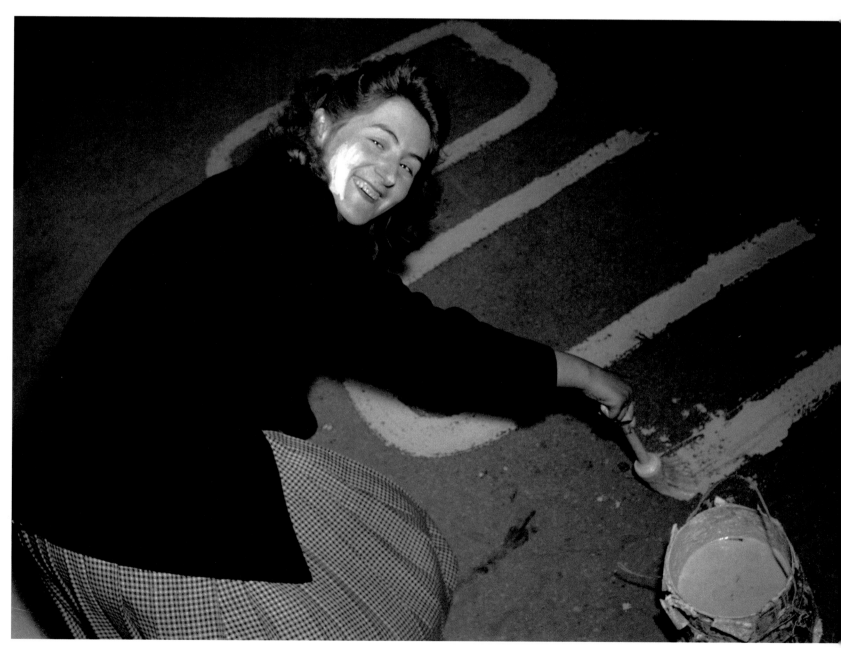

Activist in 1945

PARIS

FOR PARISIANS

LES HALLES, EVERYDAY PARISIANS, A HOME FOR TENANTS, A FEW TENANTS MORE, PARIS-BY-THE-SEINE

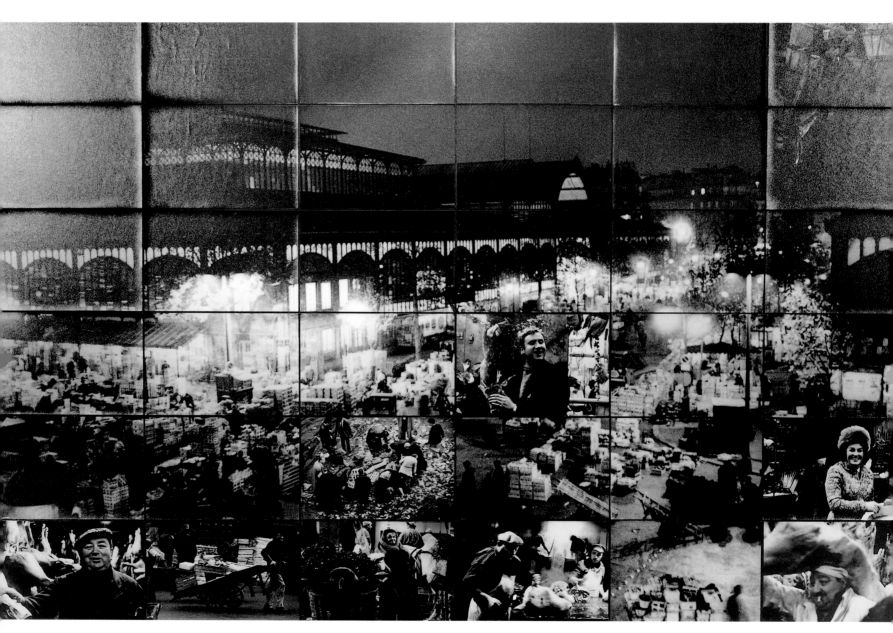

Photomontage of Les Halles, 1968

FOLLOWING PAGES: Metallic structure, Baltard pavilion, 1969

“ Technicians studied the problem of the old market hall, Les Halles, clogging the center of Paris. Shrewd men—politicians, town planners, financiers.

By 'studied,' I mean they looked down from their great height on all the bustling folk.

I had a lot of friends there. In that village-like quarter I was a harmless photographer, considered mildly obsessed. I didn't understand these technocrats' ideas, with their 'geometric' goals labeled profitability, specialization, division of labor, and efficiency. All of this was in diametric opposition to everything I came to Les Halles at night to seek, everything I was trying to picture.

Saint-Eustache, the 'village church,' was itself a mixture of styles and odors. Incense-smelling Gothic on the inside, celery-smelling Renaissance on the outside. And all around, humanity massed in the glow of fairground lights, rich and poor alike, truck drivers and market porters, butchers and Dior customers, grocers and drunkards. Everyone addressed each other in the familiar *tu* form, and above all there hovered great gaiety and good will, values that electronic computers cannot calculate.

Now a brutal chill has frozen the entire quarter.

Paris is losing its 'belly' and much of its spirit.

I couldn't give a damn about night clubbers in search of a breath of fresh air after their debauched pleasures, but I worry about the drifters, men on the skids in a sleeping city when telephones are silent; if one of them drifted into Les Halles, with a little luck he'd find something to keep him going. With a little more luck, he'd be adopted. This is no legend, but a true story that has been quietly repeated a hundred times.

Paris needed a functional market: so now we have the cubical sheds out in Rungis.

The day is not far off when television will announce a pressing need for two highways running through town, north–south and east–west. The latter shouldn't be too difficult, they'll just cover the Seine with a freeway. As to the north–south route, they could always try covering the canal Saint-Martin, ripping through the botanical gardens and continuing southwards with a viaduct over-flying the Gobelins quarter.

Cars would finally be right at home, in a city reeking of boredom.

At which point sociologists will begin to talk of the evils of huge complexes and the distress of human relationships in a mechanical society.

But to get back to Les Halles: a market had occupied the site for nine hundred years. Long enough for people to get used to it. Closing it down risked causing disgruntlement among the good people of Paris.

So the public authorities raised the specter of rats. One newspaper mentioned the presence of 100,000 rats. Two days later the press was talking about 300,000—Baltard's cast-iron structures were suddenly like ships on a sea of rats.

On the morning they it shut down, you could see street cleaners all dressed in white, buckets of rat poison in each hand, roaming the neighborhood followed by a pack of photographers.

Well-informed Parisians can now sleep in peace. They had a close call. Last I heard, they're planning to install a leisure center down at Rungis. A functional one, no doubt. "

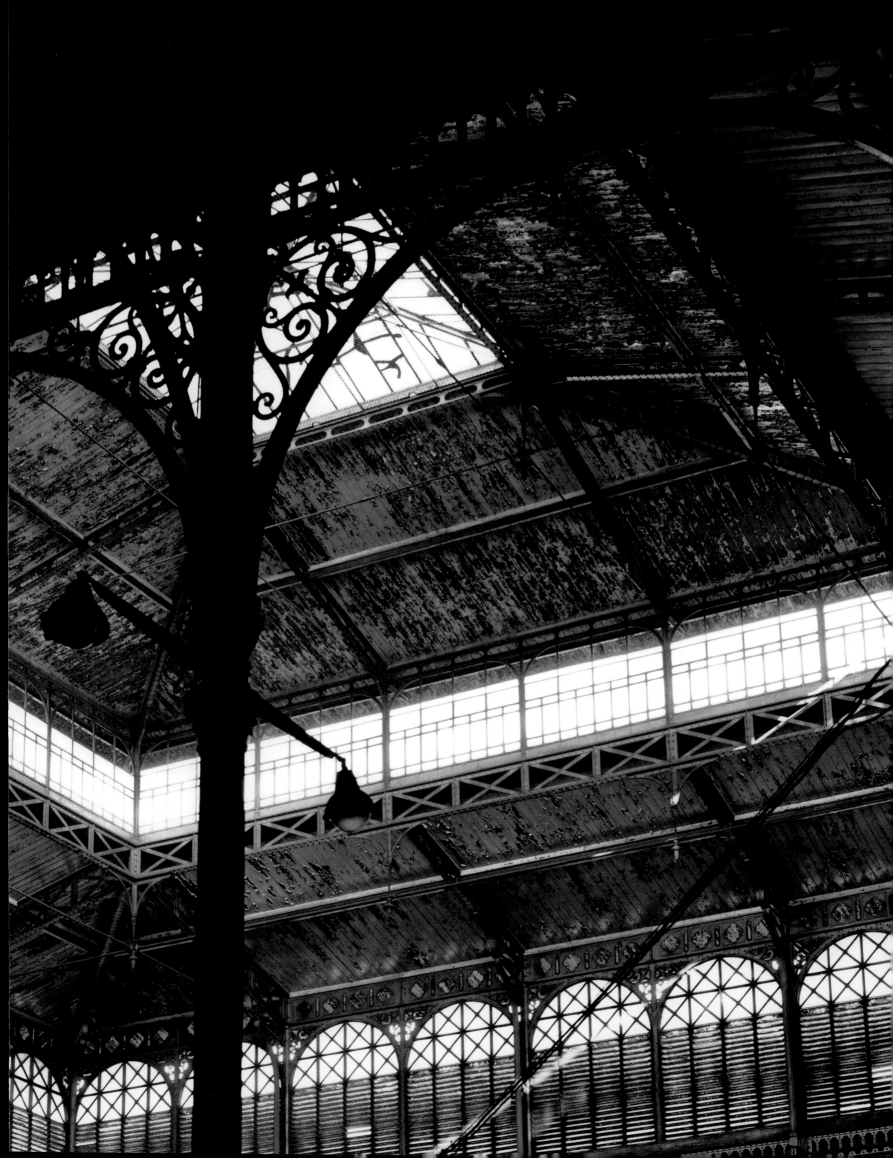

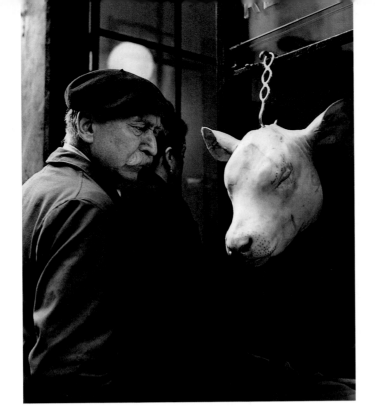

The Innocent, 1949

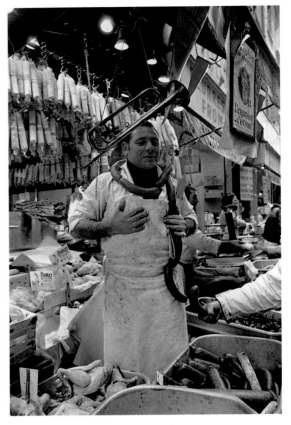

Roger, rue Montorgueil, 1969

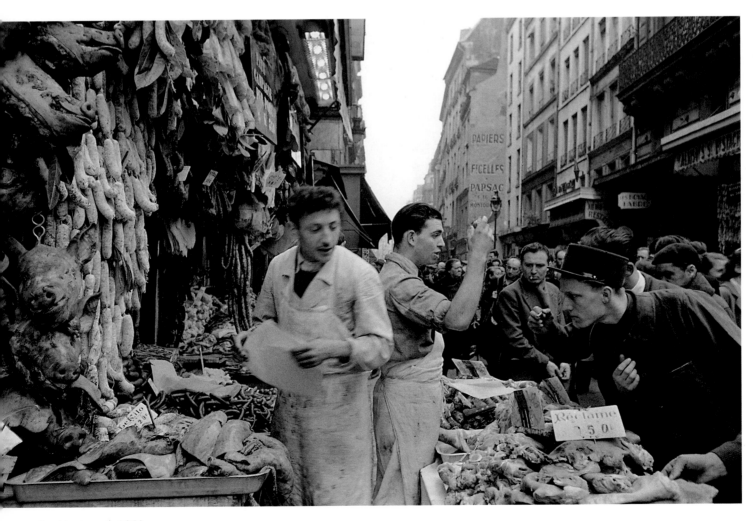

Rue Montorgueil, 1953

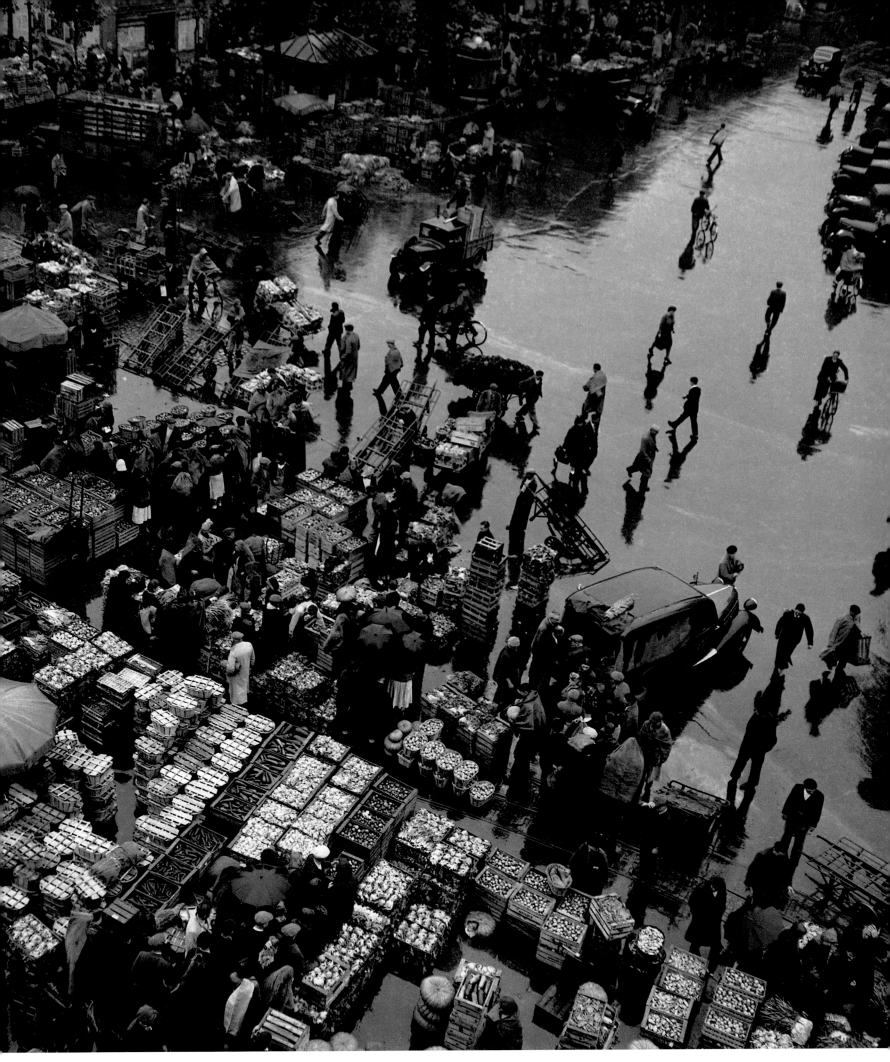

Rain, 1945

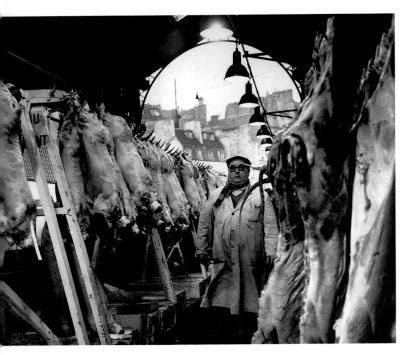

Market porter with glasses, 1967

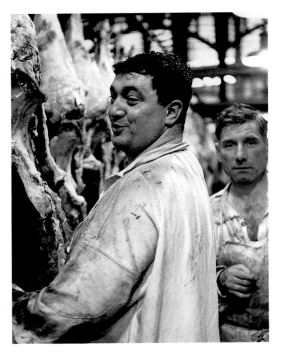

Smiling porter, 1955

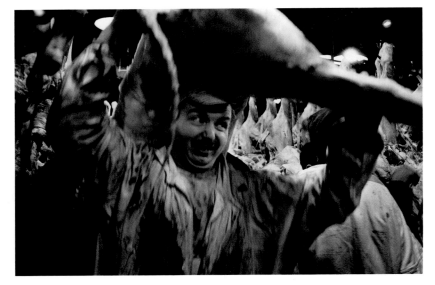

Pavillon de la viande—Deplanche, 1967

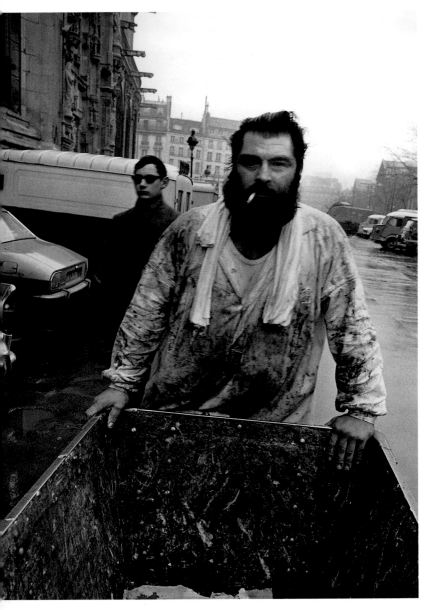

Bearded Butcher, 1969

FACING PAGE: *Meat market—Deplanche, 1967*

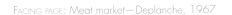

" With a whole side of beef on their backs the butchers hustle along, then return slowly back to the truck, breathing hard, arms so thick with muscle they stick out from the body. "

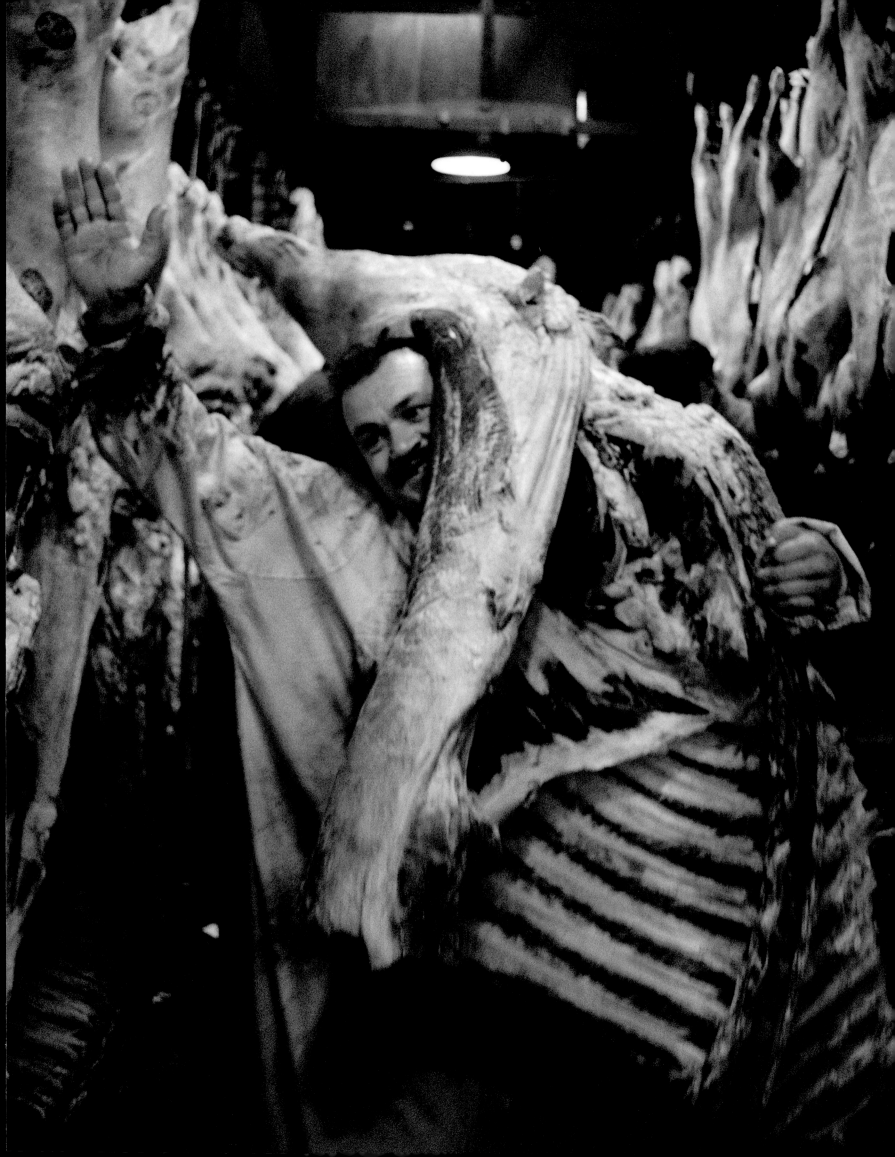

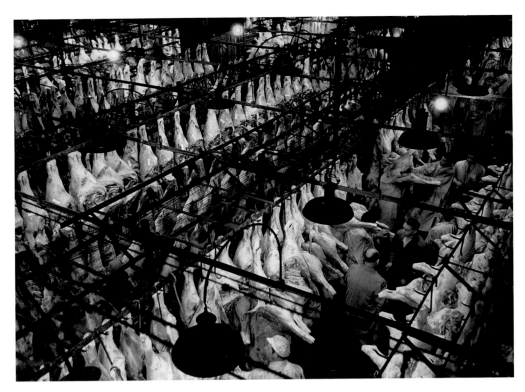

Meat market, 1955

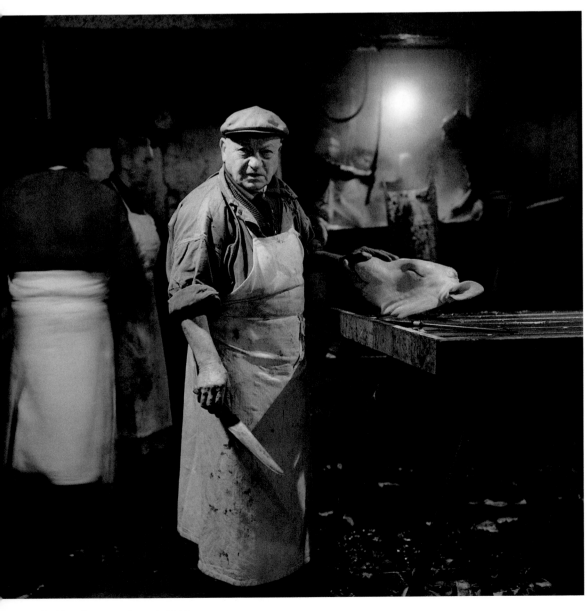

Scalding Room, rue Sauval, 1968

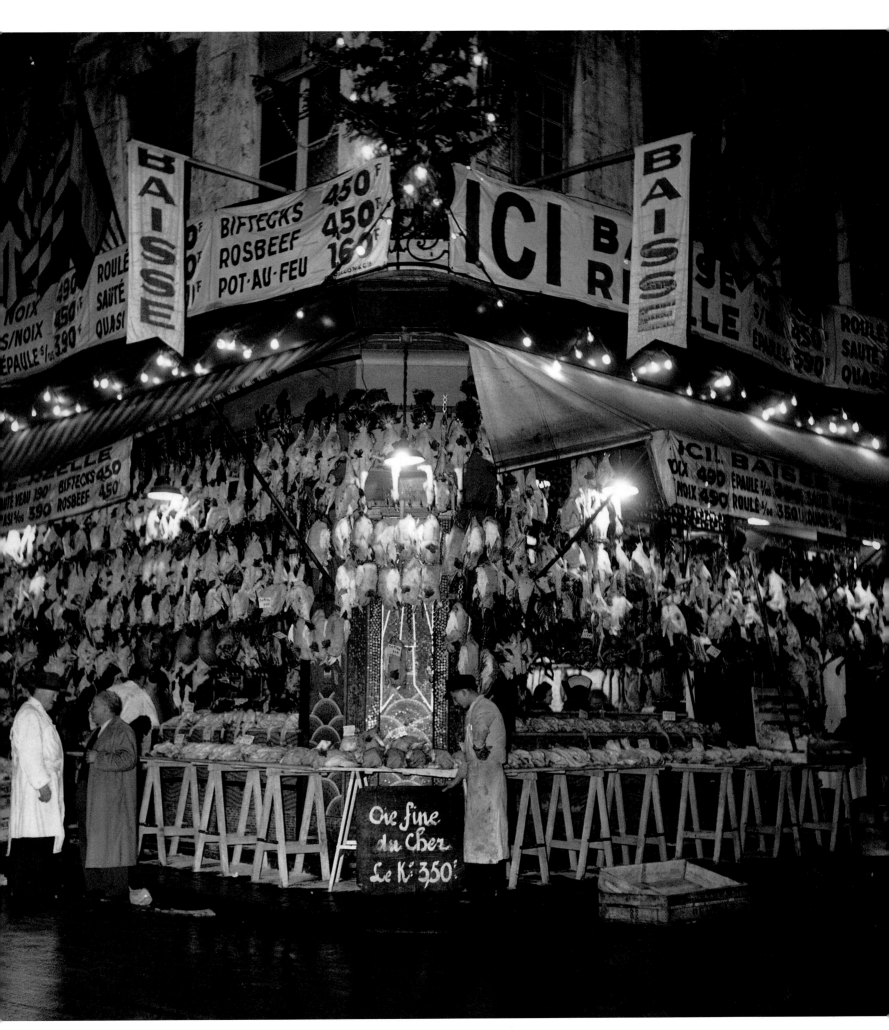

Christmas Birds, 1954

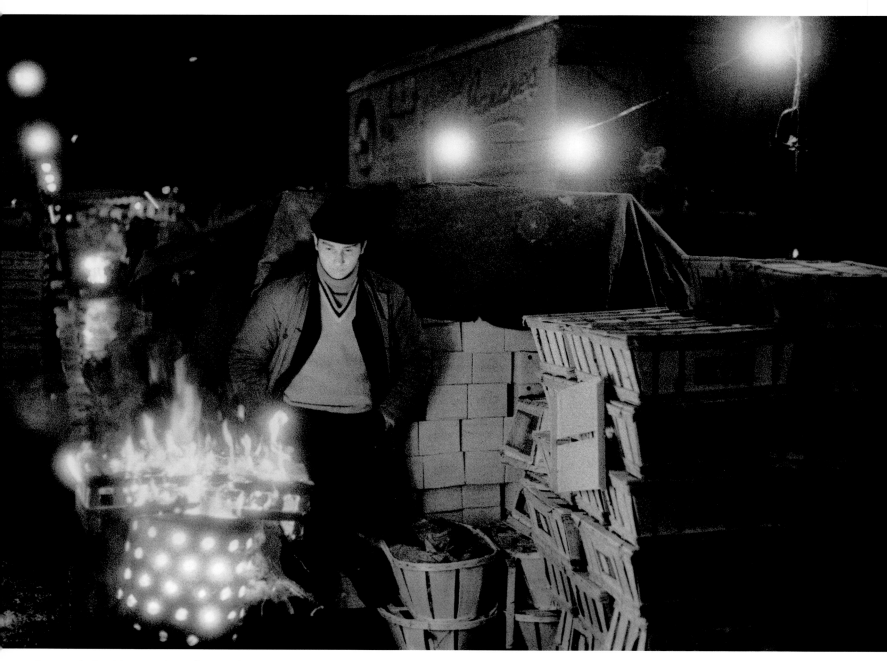

Brazier—the Last Morning at Les Halles, March 1969

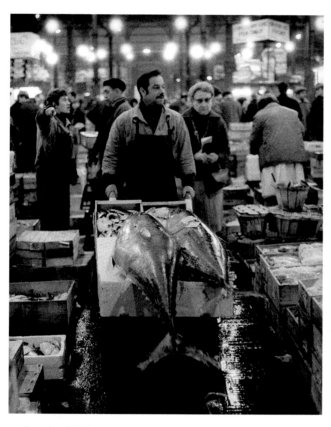

The tide, 1968

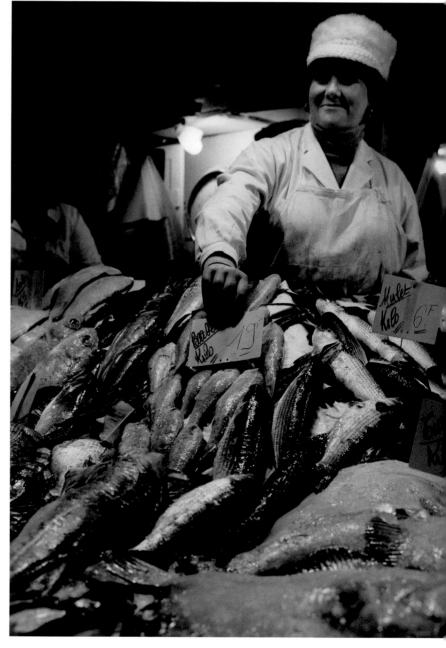

December 1967

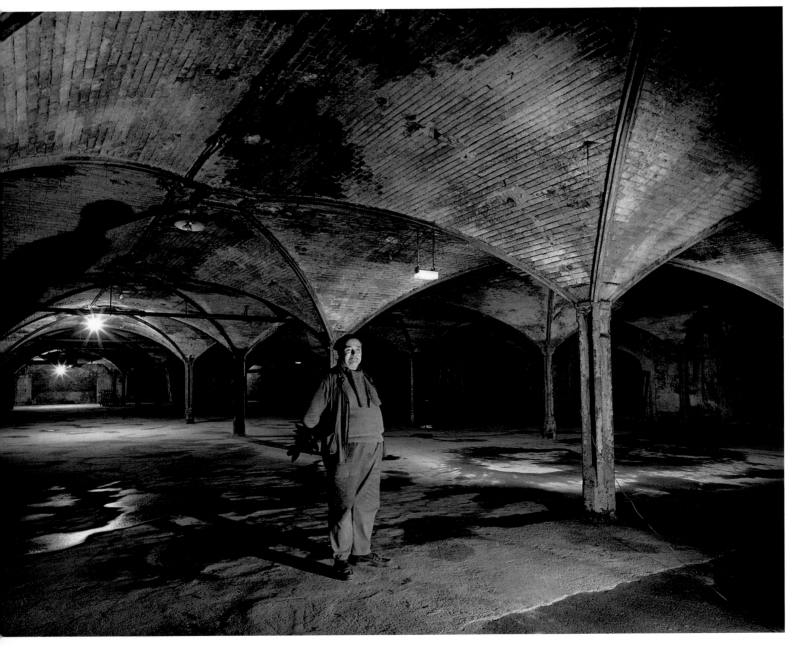

Underground at Les Halles, 1968

FACING PAGE: The market porters of Les Halles, coming out of Mass at Saint-Eustache, November 24, 1968

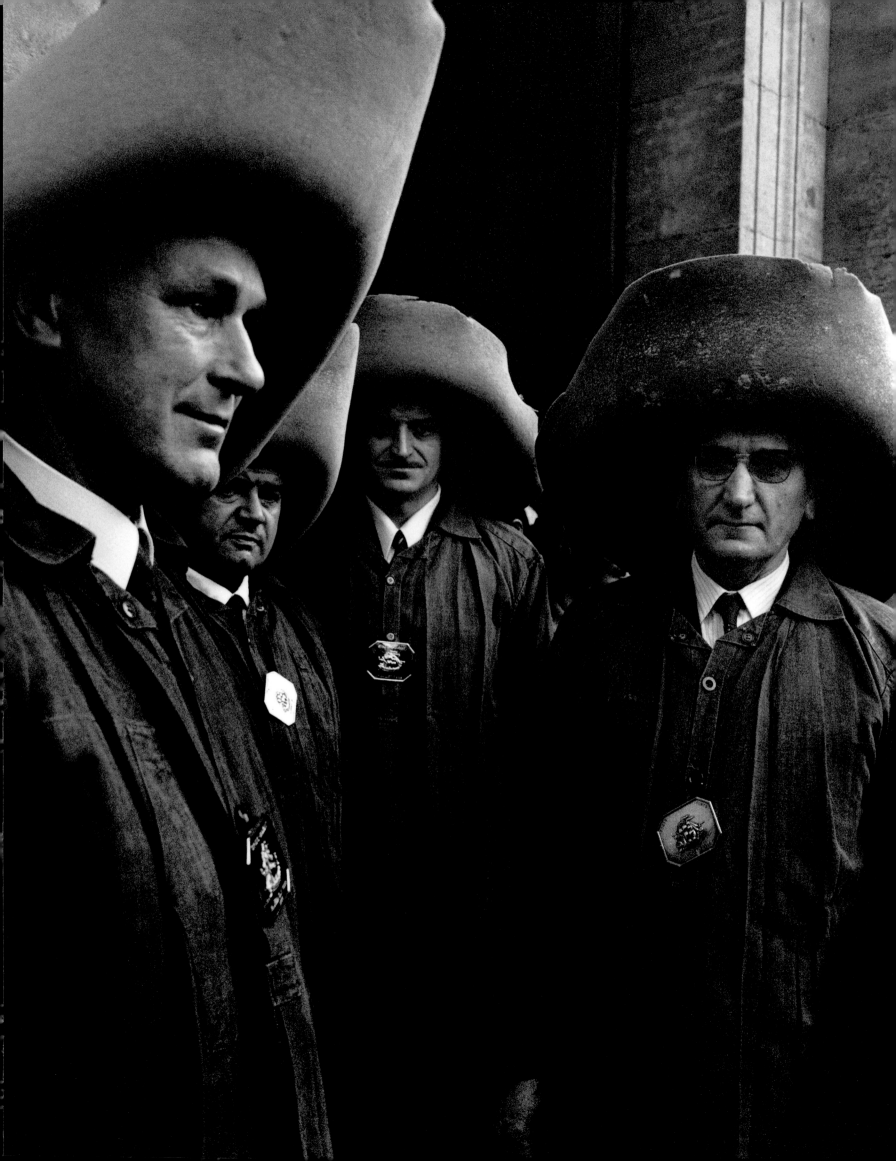

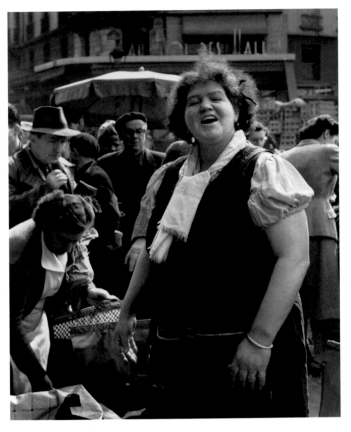

Seller at Les Halles, 1953

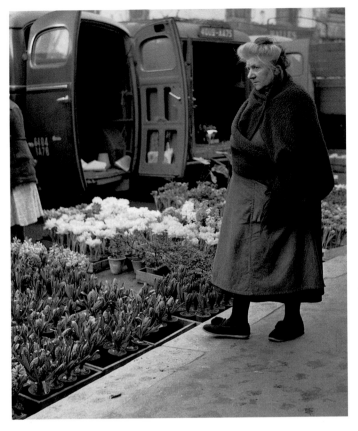

Florist in slippers

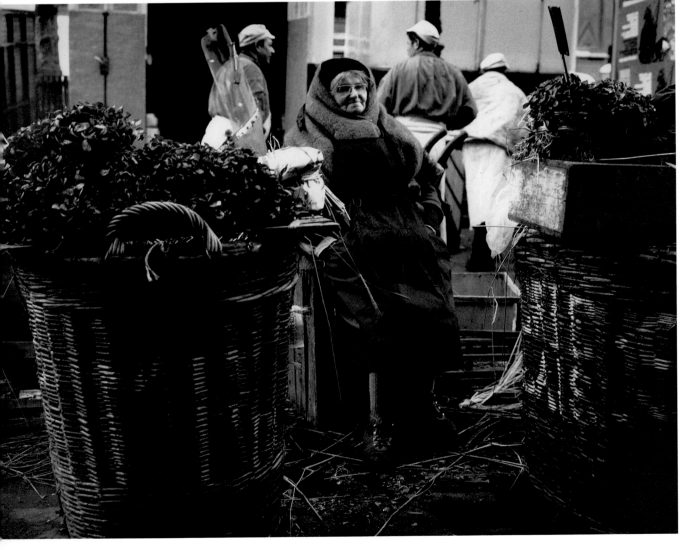

Watercress seller, 1968

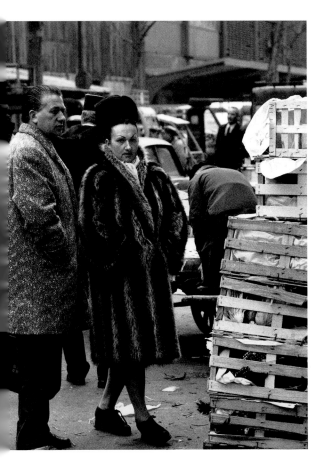

Crates and Fur, 1967

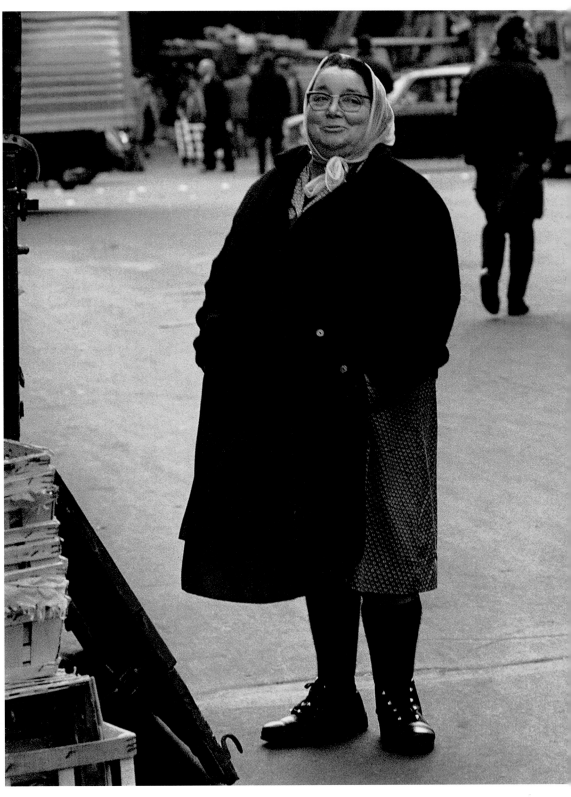

Seller in Pataugas, 1967

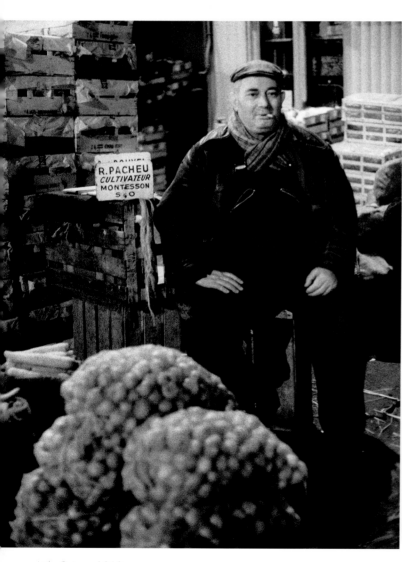

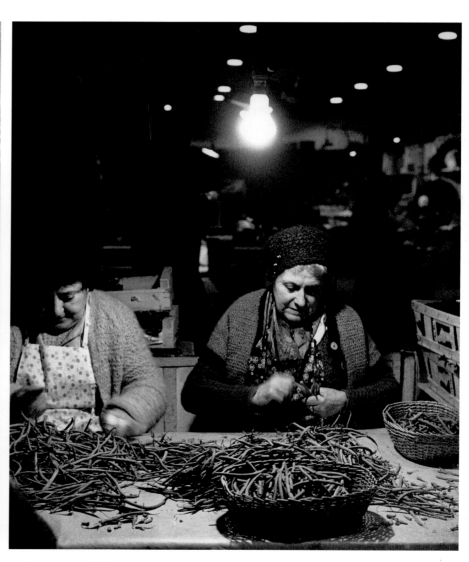

Little Onions, 1968

Green Beans, 1968

Facing page: *A Discreet Little Corner, 1953*

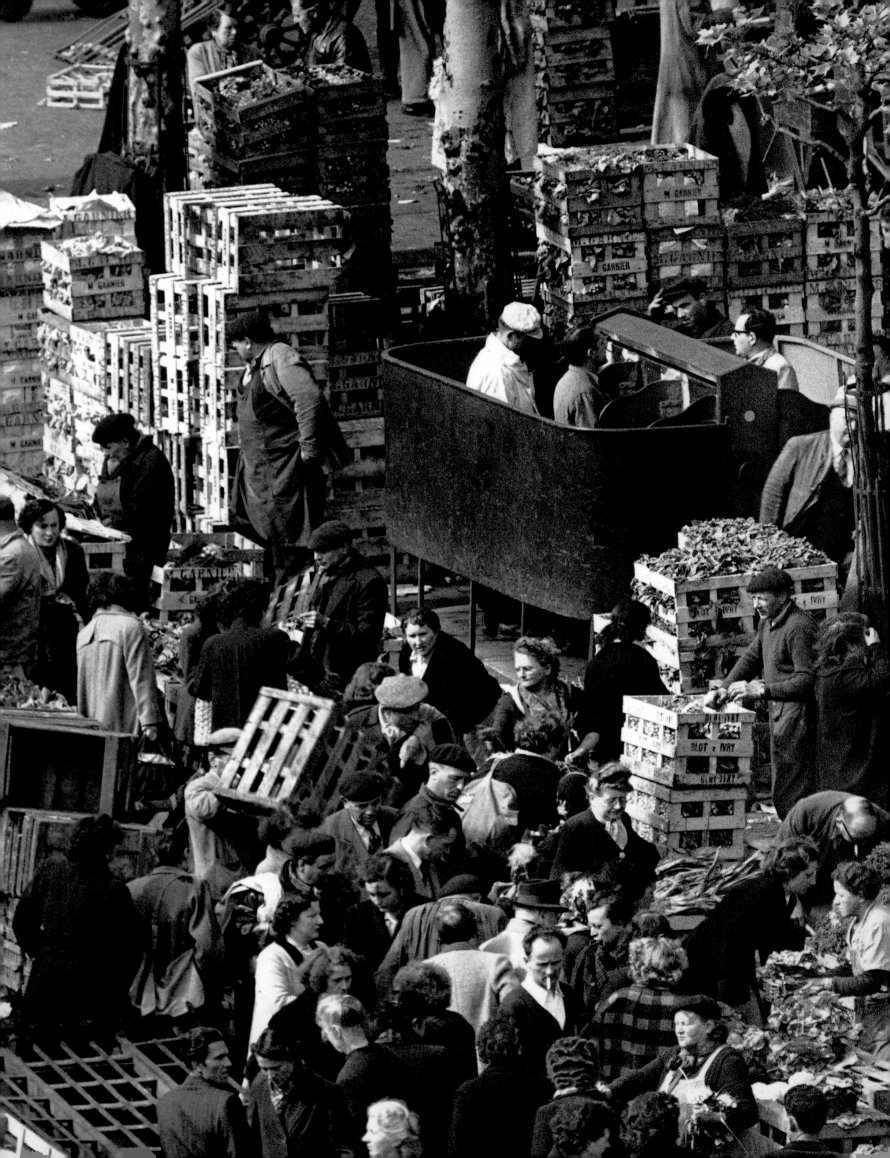

Jean Settour's bar, 1966

"After a footloose morning, I liked to relax at one of those little bars that also sold butter, cheese, and eggs. I could see the Fontaine des Innocents reflected in my glass of Bourgueil. The glass would be accompanied by a slice of cheese carefully matured in wine marc by the owner himself, Jean Settour.

Gone is the bar, gone Jean Settour.

To fuel my melancholy, I also remember that in his wine cellar, dug beneath the former cemetery of Les Innocents, bottles were still propped up by bones left behind when the cemetery was transferred in 1787.

I also recall that Jean paid great heed to the phases of the moon when bottling wine.

The moon—effect guaranteed. Fade to black. End."

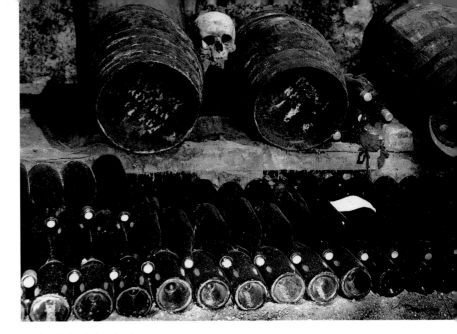

The Cellar Below Les Innocents

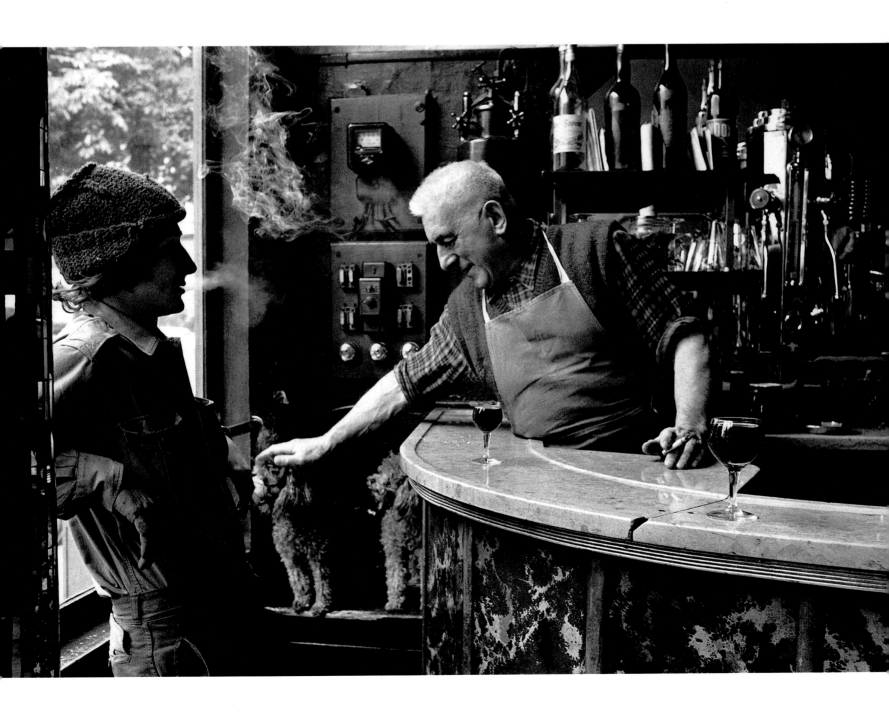

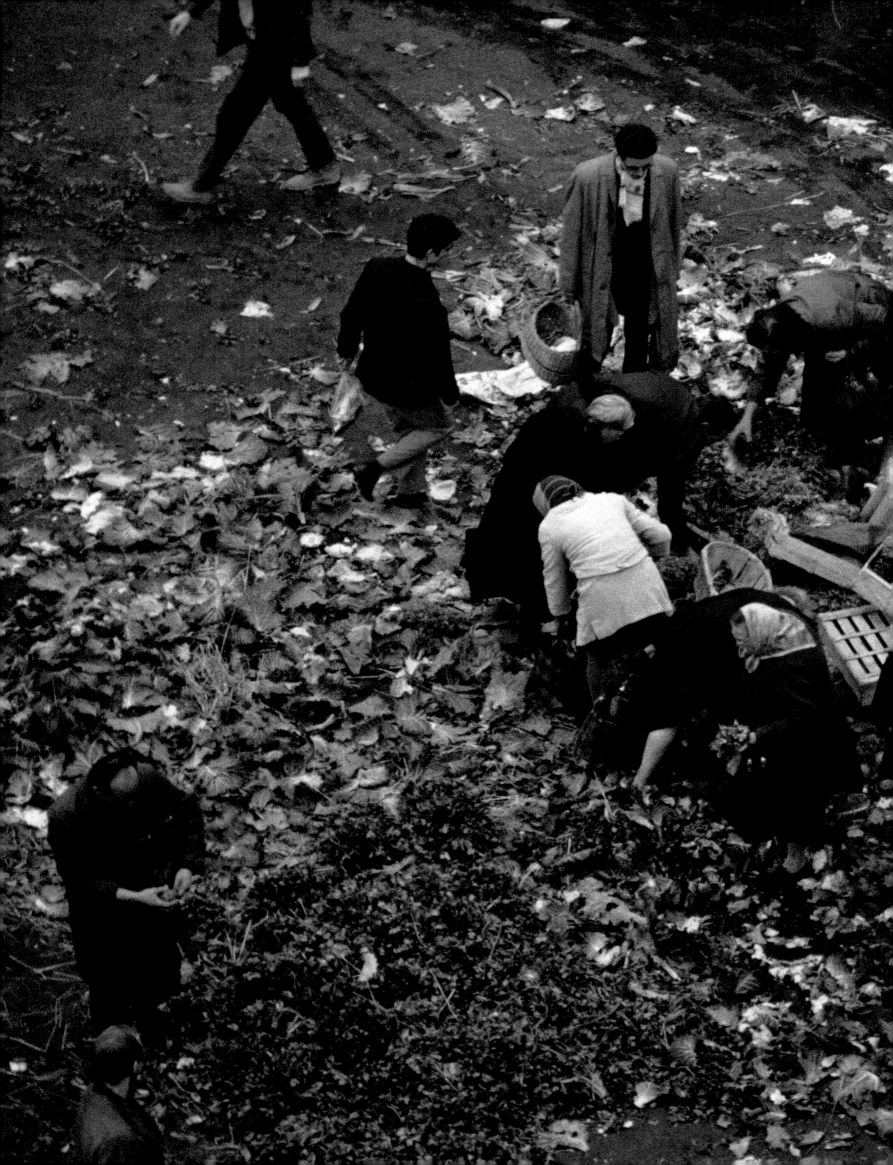

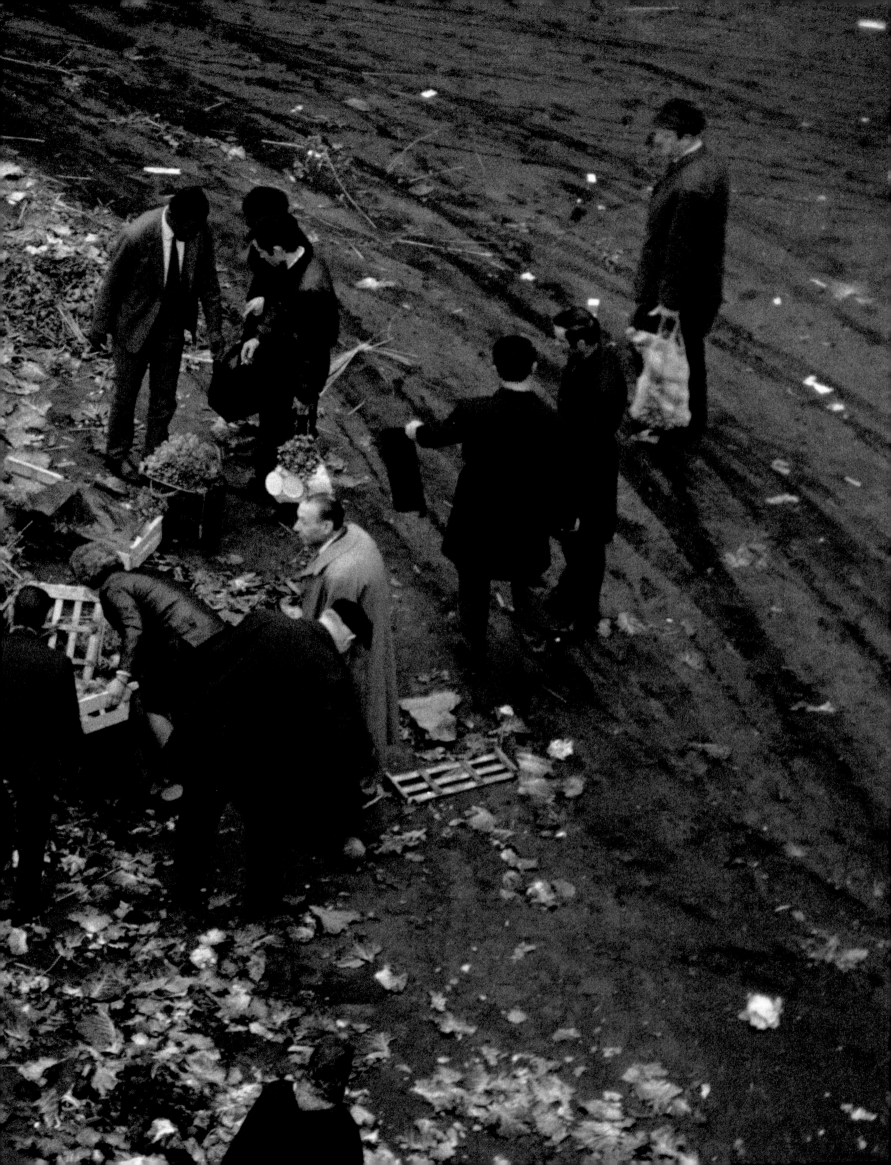

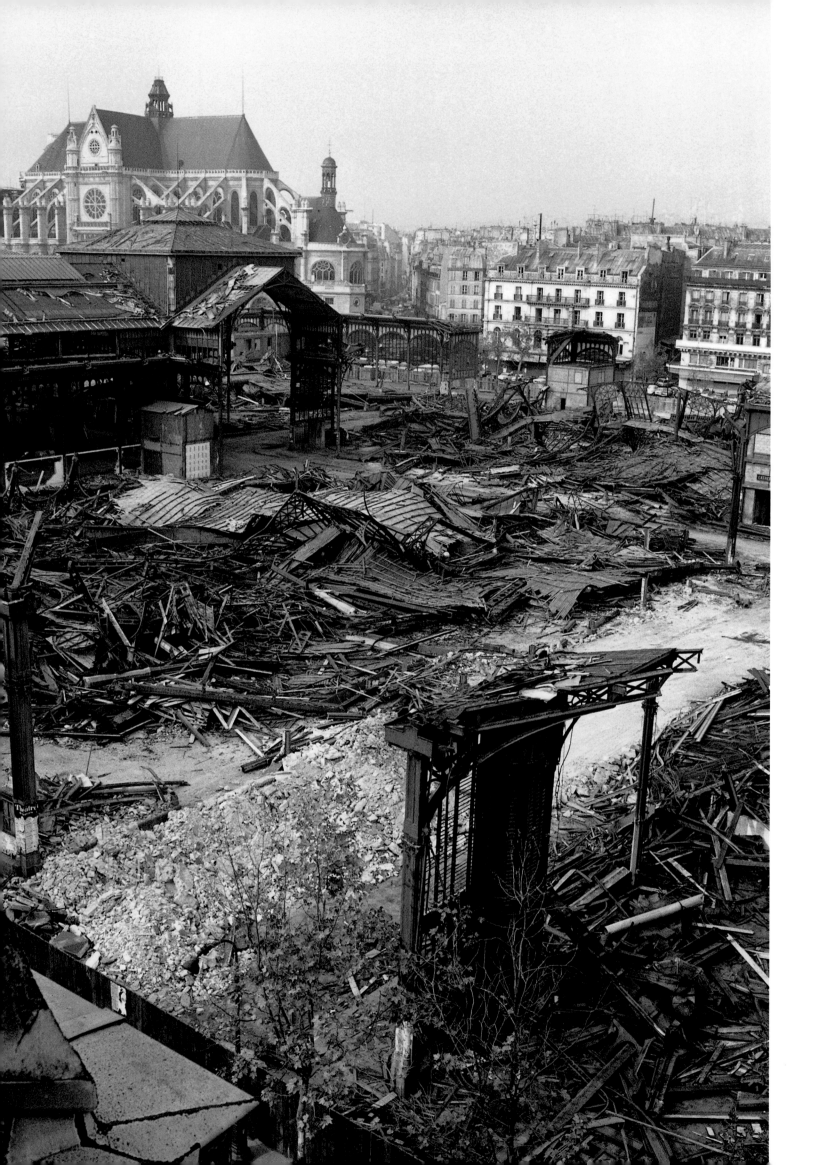

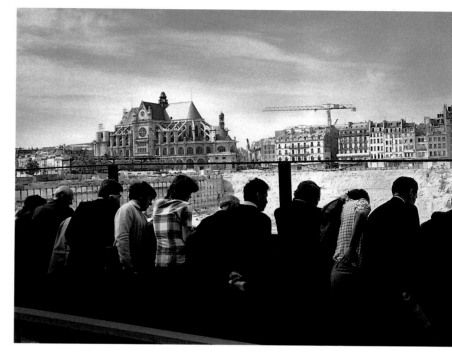

The hole at Les Halles, July 1974

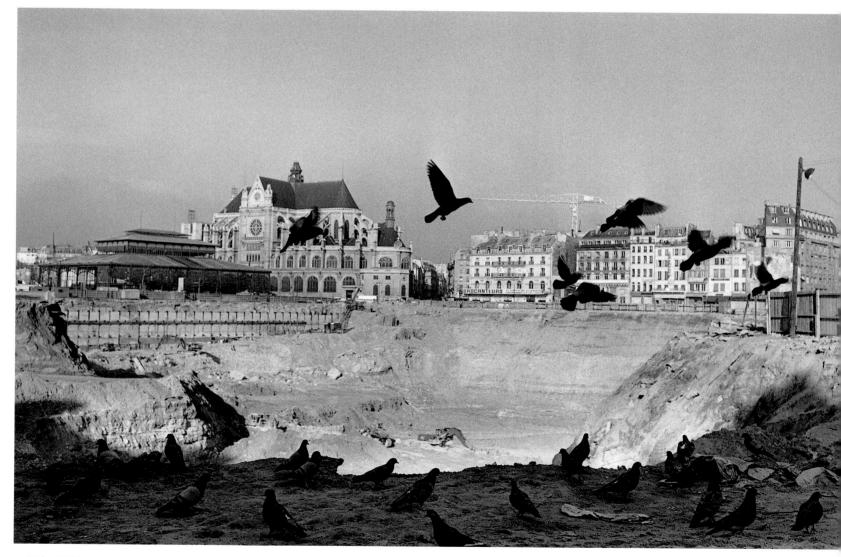

Birds, 1973

FACING PAGE: Demolishing Les Halles, 1971

PRECEDING PAGES: *Scavengers at Les Halles, 1967*

The Spirit of the Bastille at Night, 1973

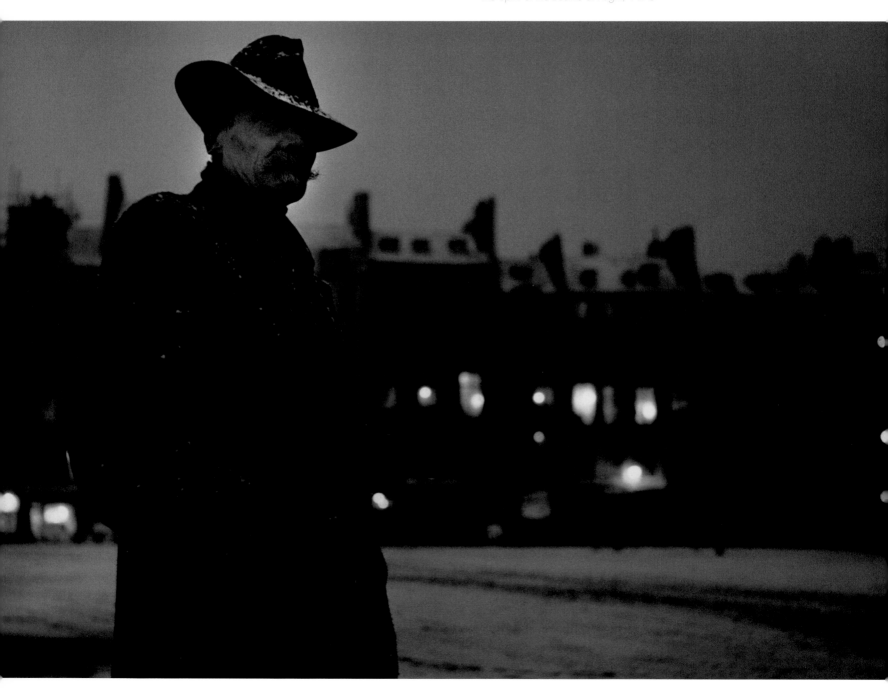

The Archduke, December, 1952

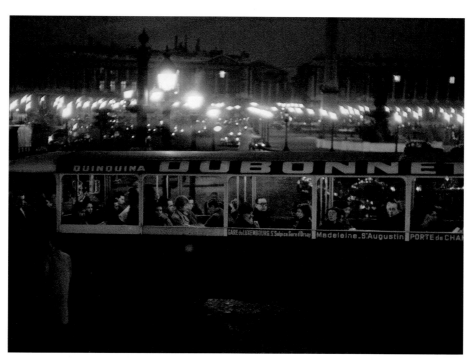

Place de la Concorde, March 1953

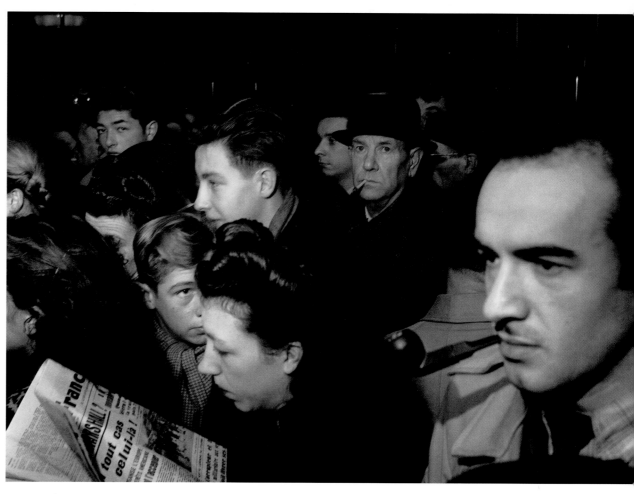

Sceaux line, 1946

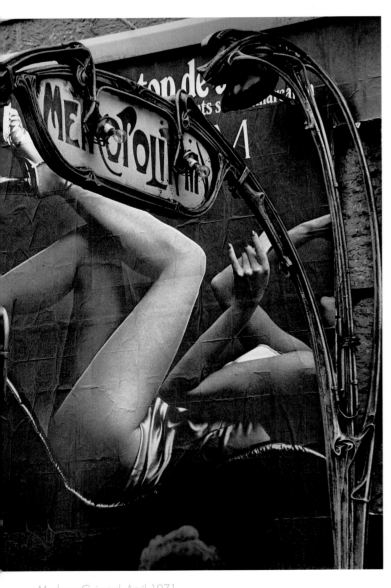

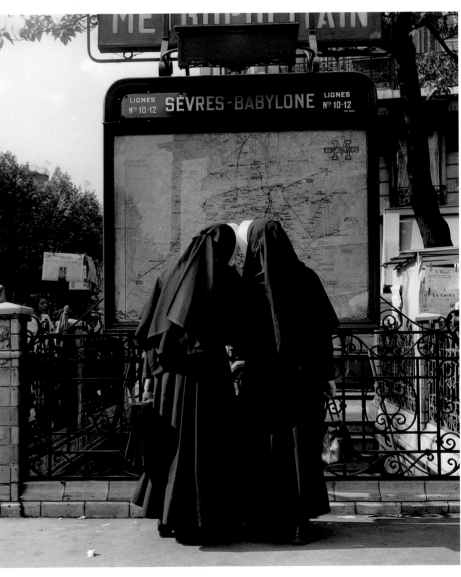

Madame Guimard, April 1971

Sèvres–Babylone, 1953

FACING PAGE: *Lily-of-the-valley in the Metro, 1953*

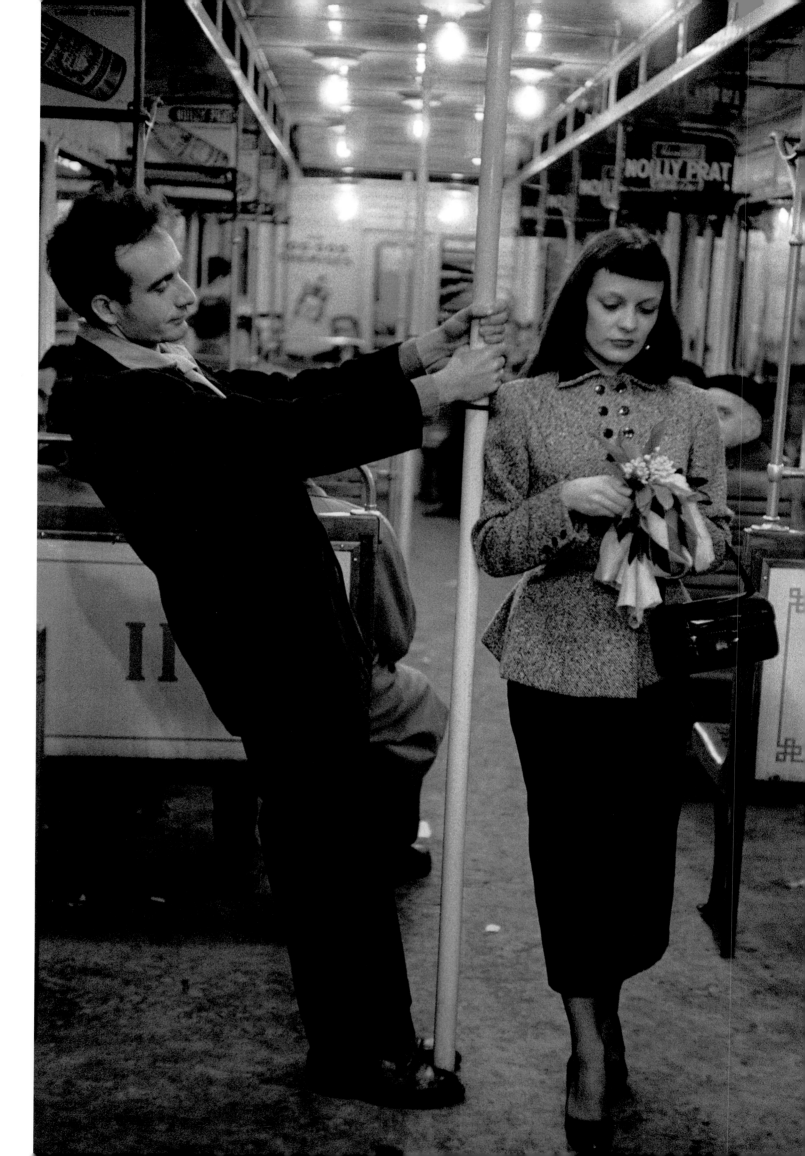

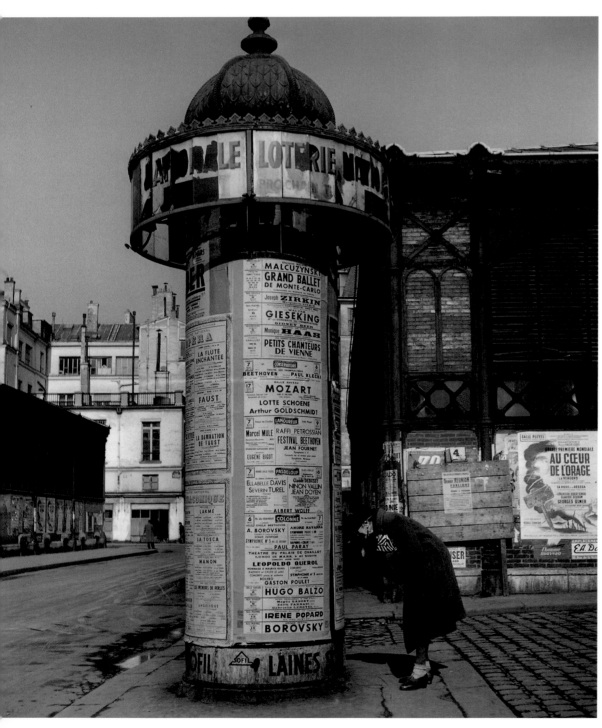

The Morris Column, 1946

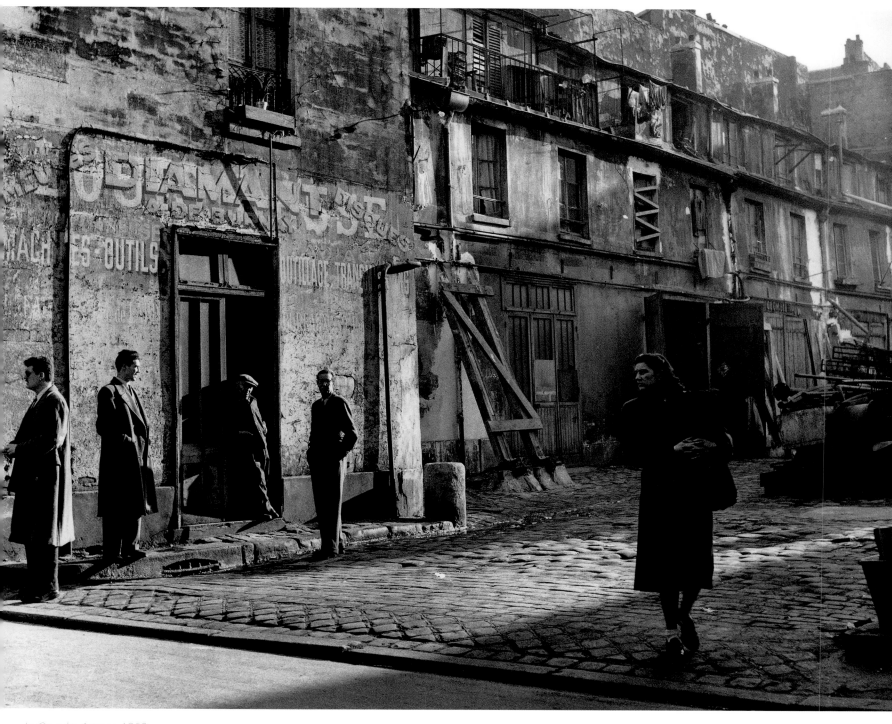

La Cour des Artisans, 1953

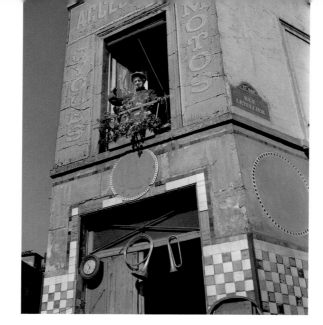

Pensioner, rue Letellier, 1939

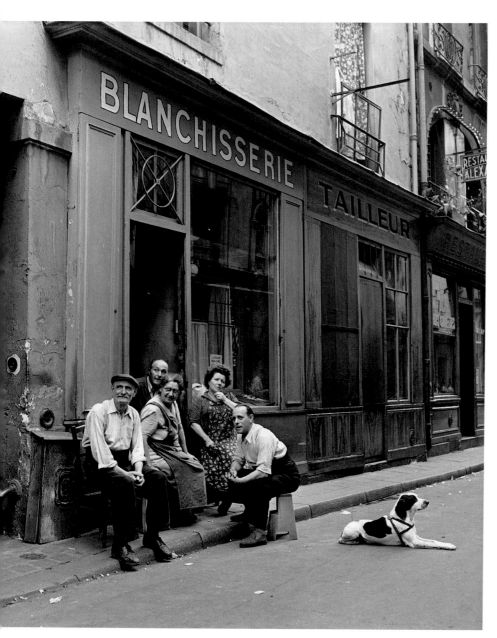

The Launderer's Family, 1949

FACING PAGE: Little girl, rue Saint-Louis-en-l'Île, 1947

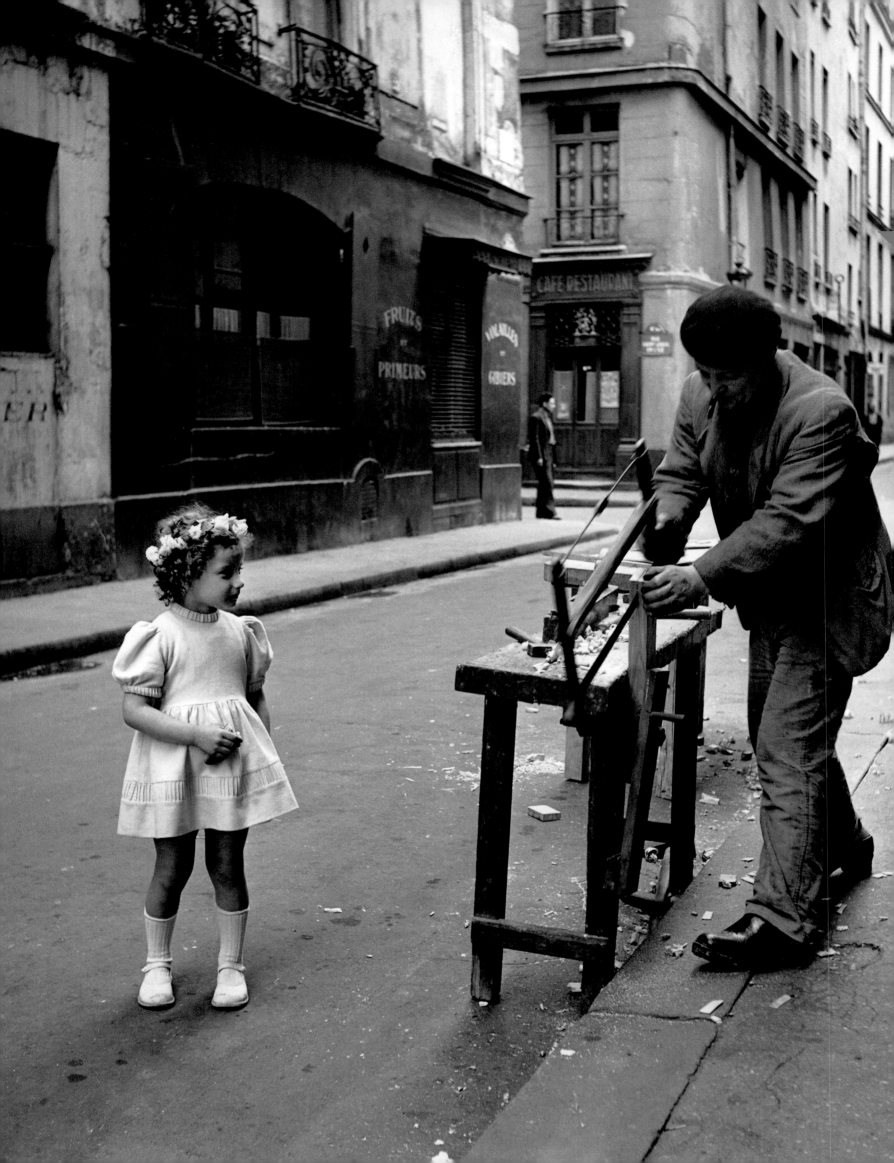

Rue de l'Abbaye, circa 1940

Juliette Gréco in Saint-Germain-des-Prés, 1947

" I'm doing a photo spread on Saint-Germain-des-Prés—the clubs, the crowd, the artists—everything that represents the extreme tip of Western civilization. This 'new Montparnasse' is very important to me, who believes that archives age well. "

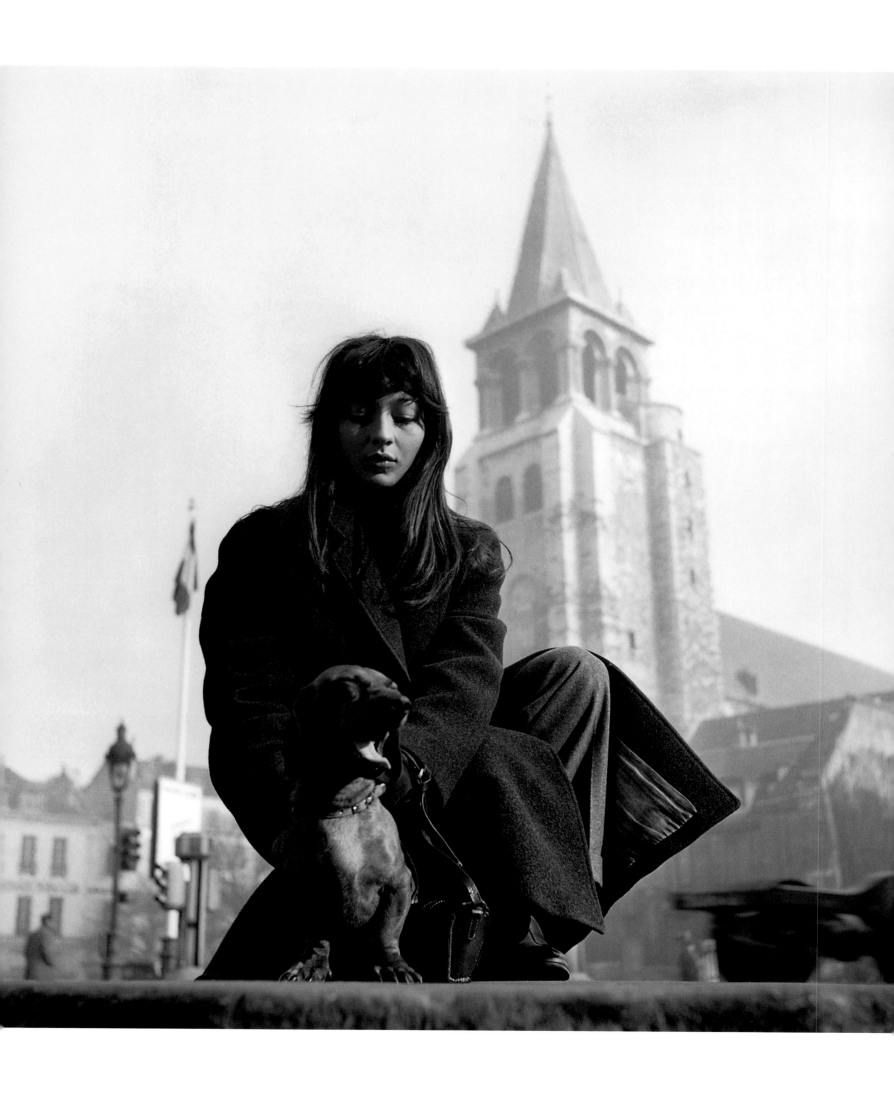

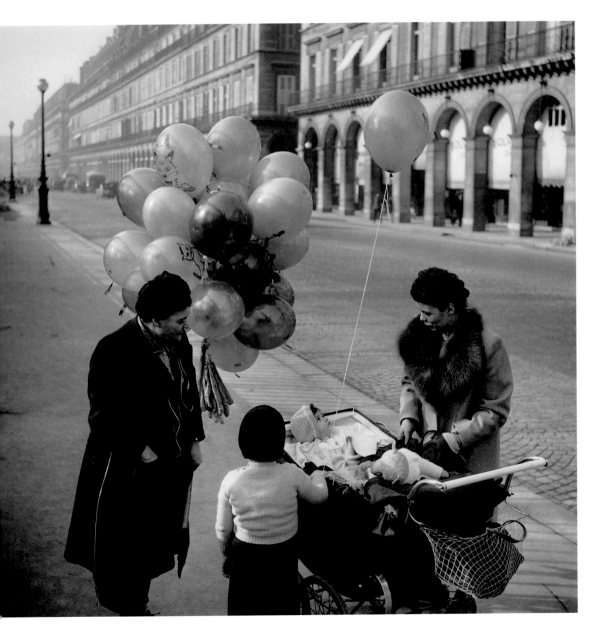

Balloons, rue de Rivoli, 1946

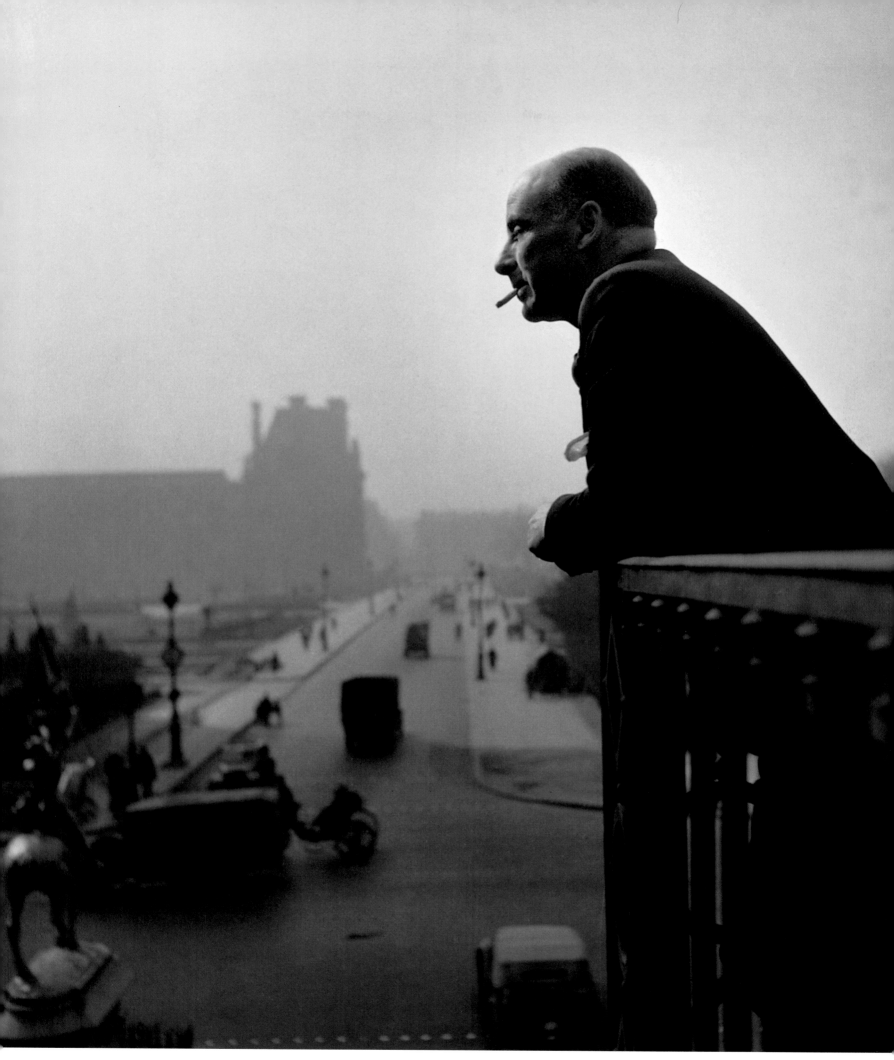

Francis Ponge on the balcony of the *Action* offices, 1945

Triumphant Photograph, 1947

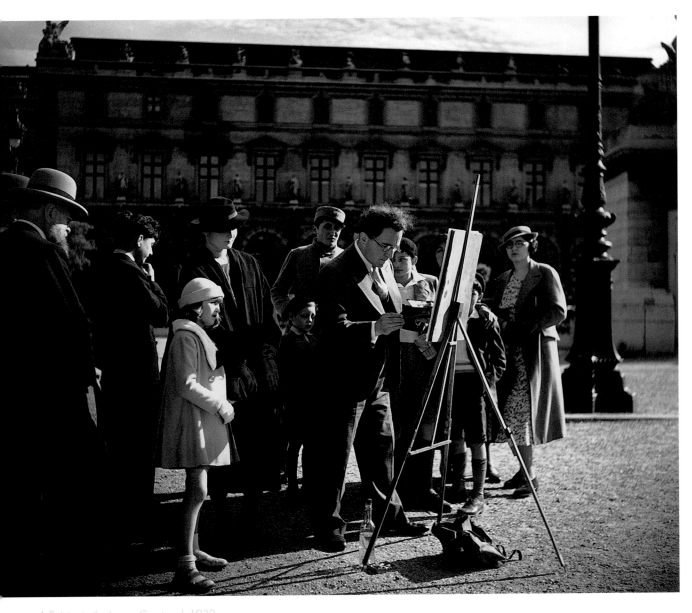

A Painter in the Louvre Courtyard, 1932

Catherine Prè, April 1950

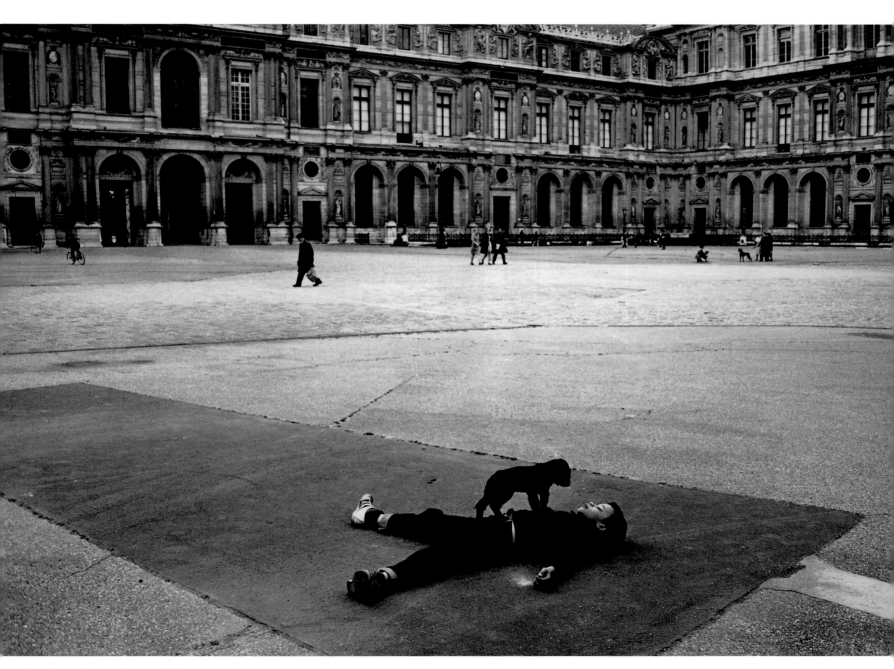

Main Inner Courtyard, Louvre, 1969

IN FRONT OF THE *MONA LISA*, LOUVRE, 1945

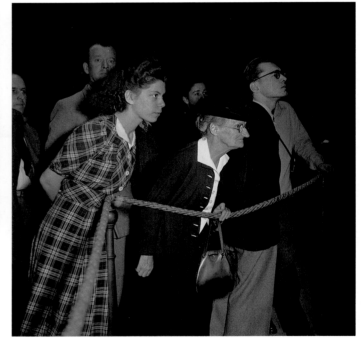

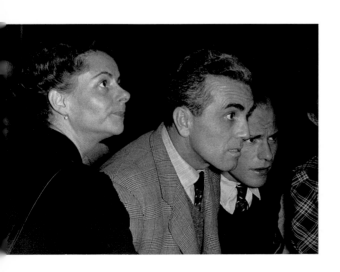

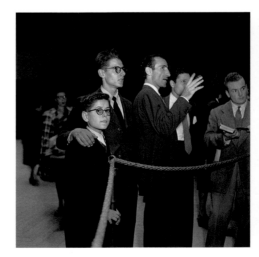

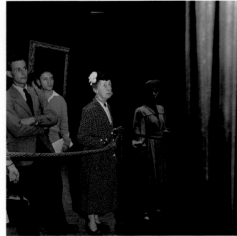

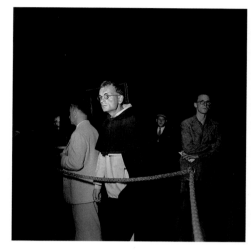

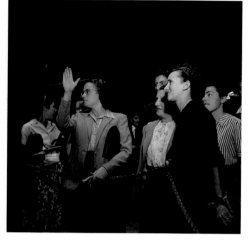

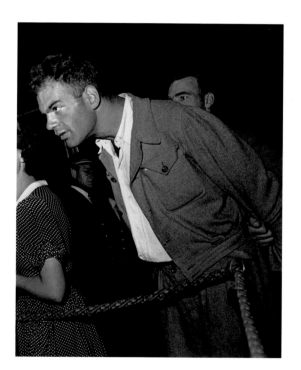

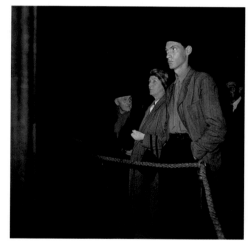

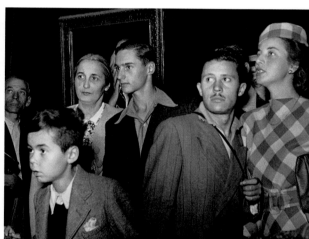

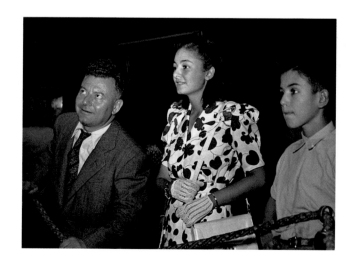

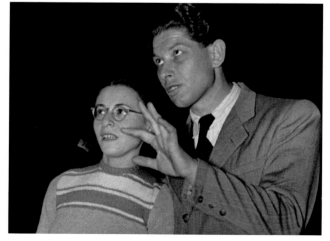

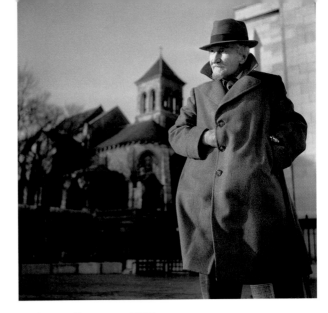

Gustave Charpentier, 1950

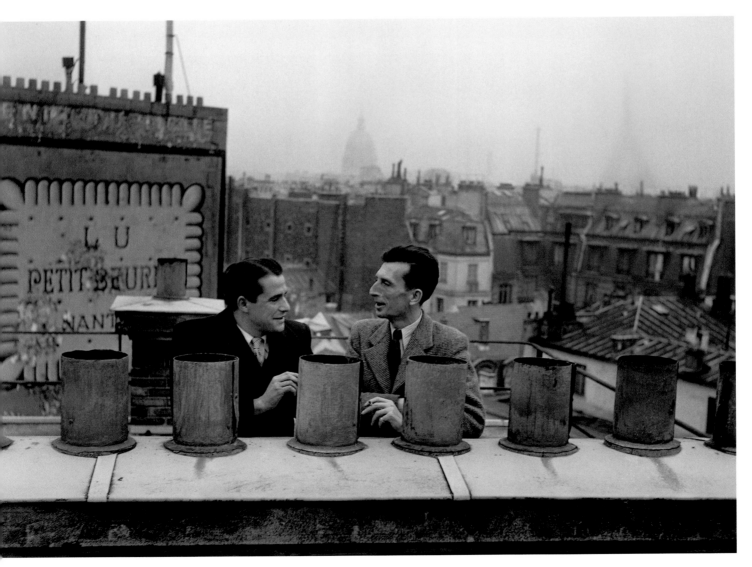

Pierre Courtade and Roger Vaillant, 1945

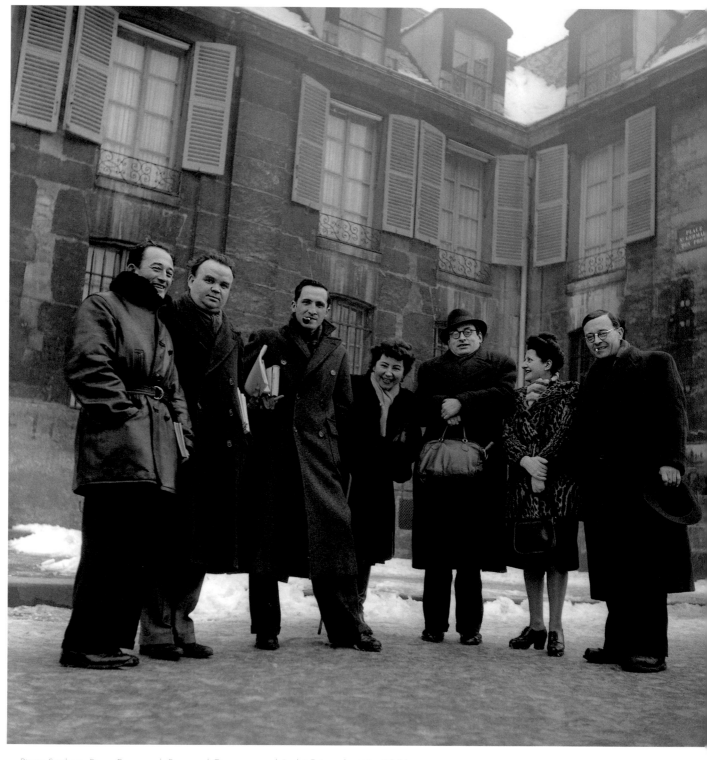

Pierre Seghers, Pierre Emmanuel, Raymond Queneau, and André Frénaud, winter 1944

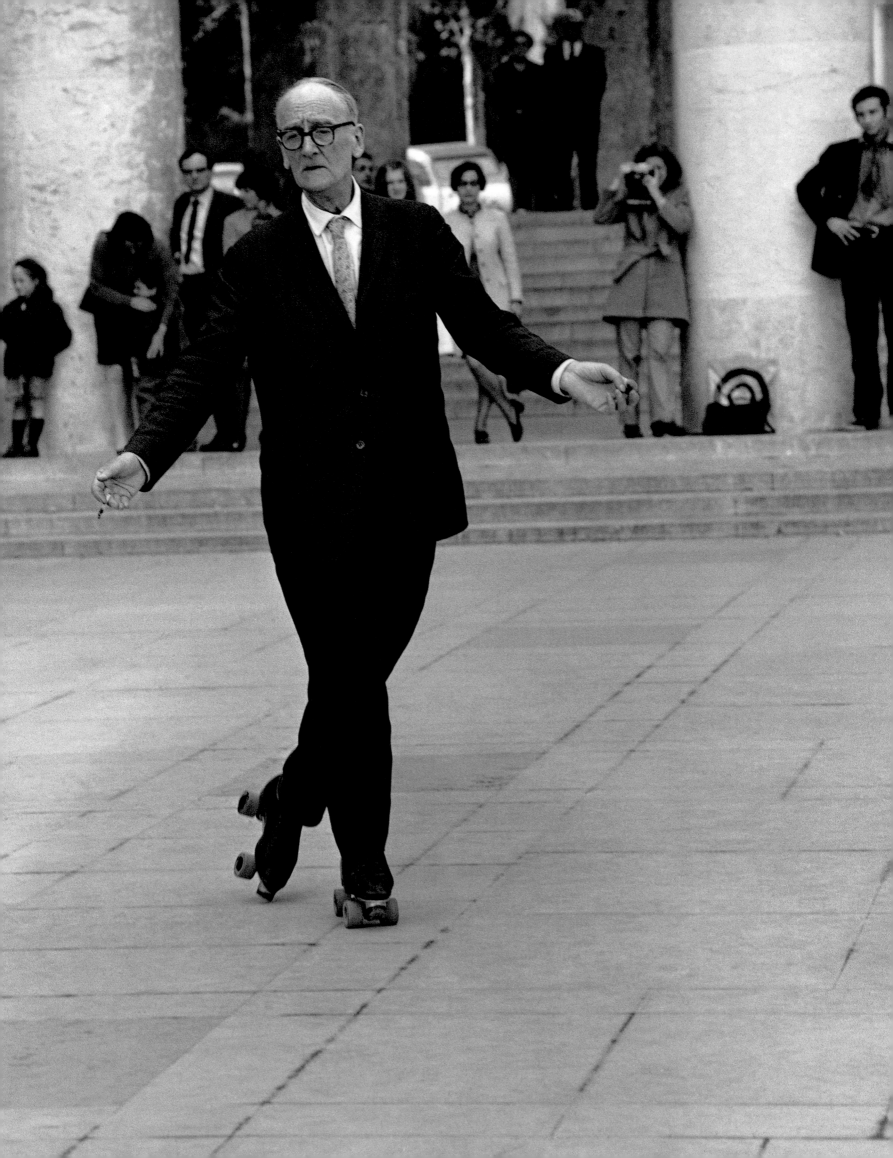

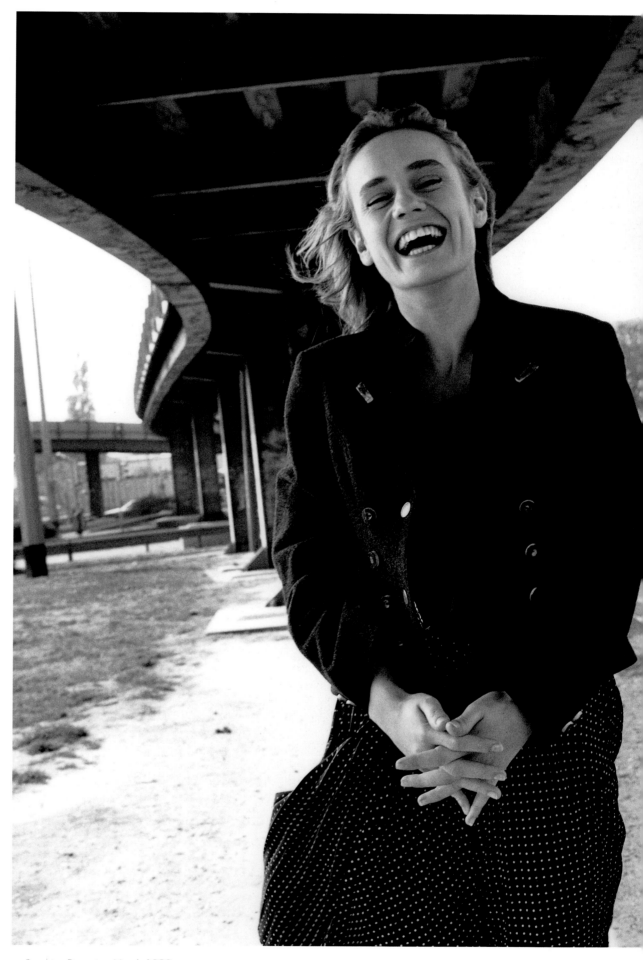

Sandrine Bonnaire, March 1990

FACING PAGE: *Solitary Skater*, Trocadéro, April 1969

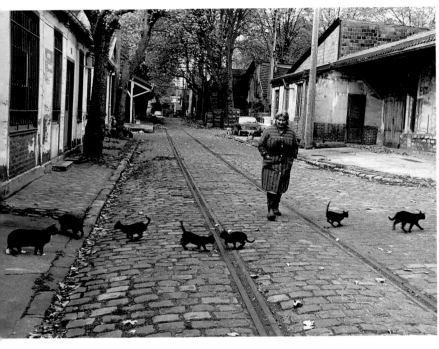

Cats in Bercy, October 1974

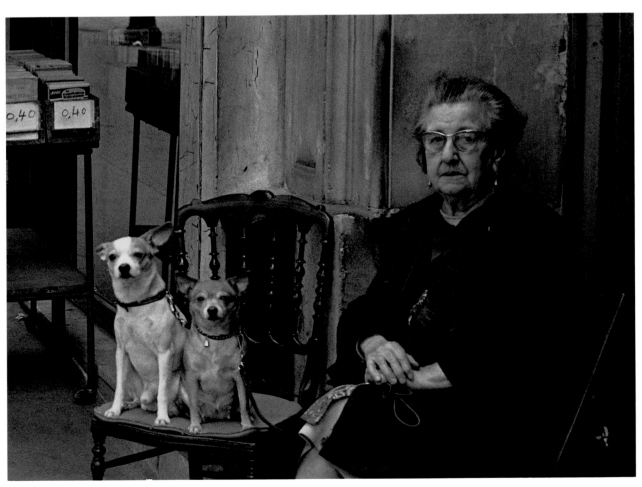

This Seat is Taken, May 1971

Madame Augustin, concierge on rue Vilin, 1953

" The simmering concierge is an endangered species. Nobody today
knows the scent of beef simmering all day long, wafting up three
or more flights of stairs, leaving walls greasy and banisters sticky. "

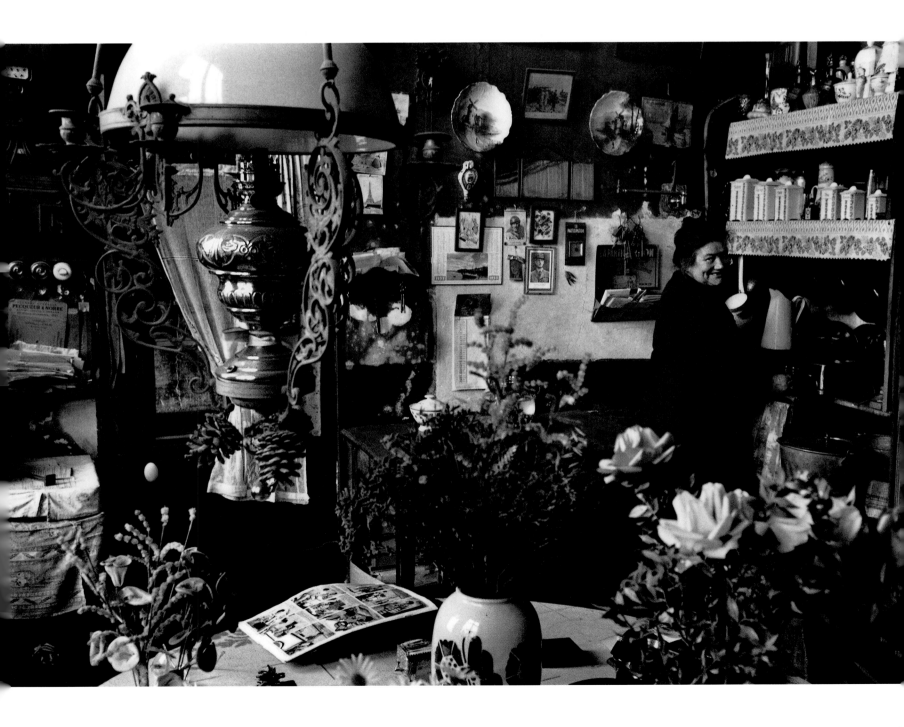

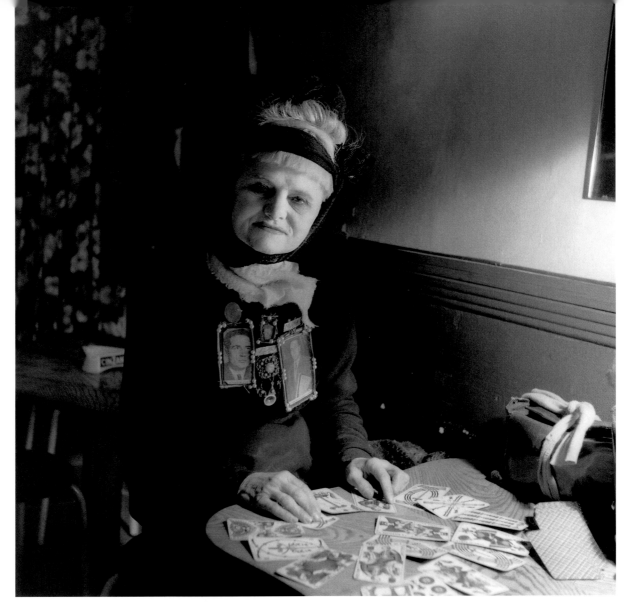

Madame Arthur, Fortune-teller, 1955

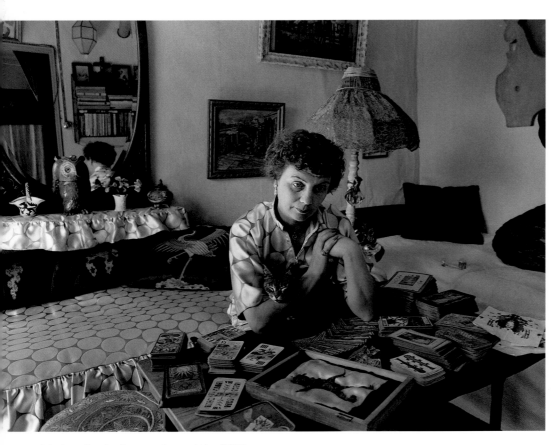

Madame Rayda, Fortune-teller, rue Vilin, 1953

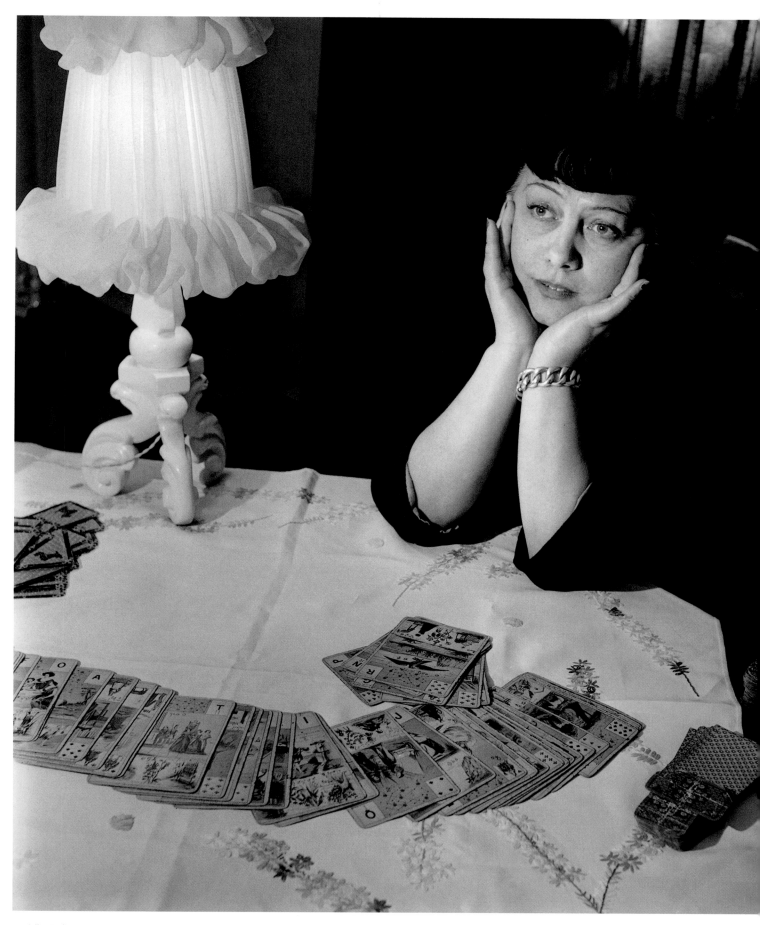

Silky Pink Reverie, 1949

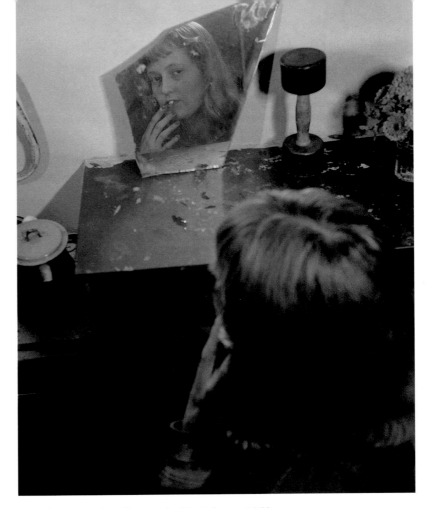

Broken Mirror, Saint-Germain-des-Prés, February 1950

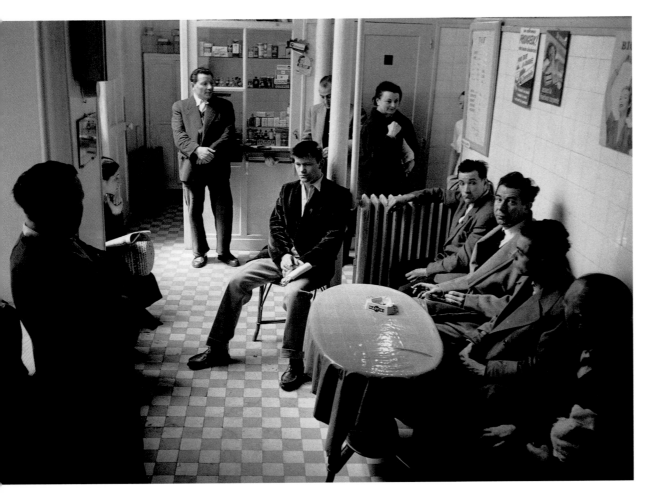

Public Baths, rue de Buci, 1953

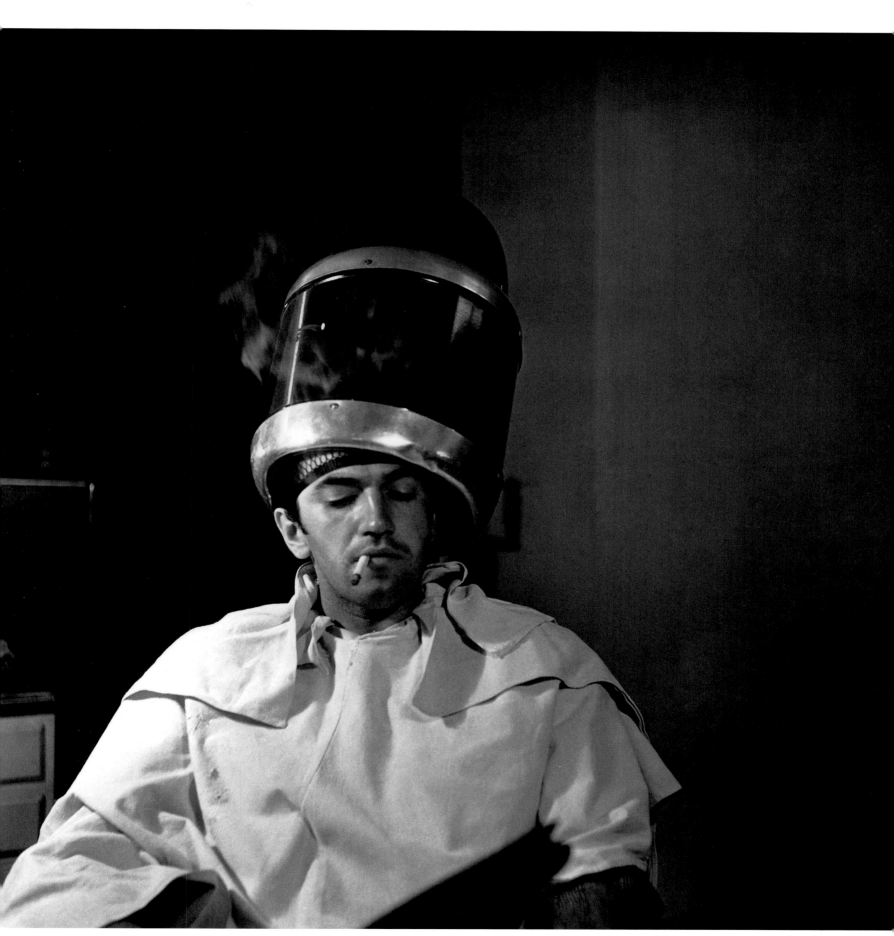

Capped Smoker, 1945

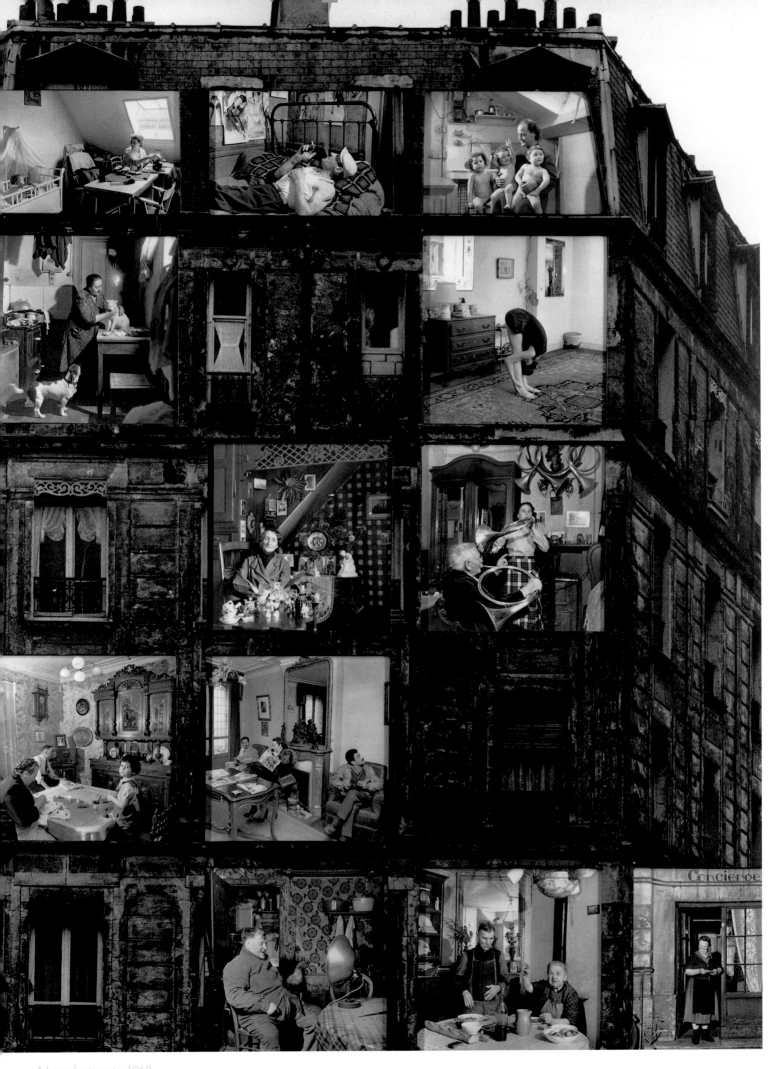

A home for tenants, 1962

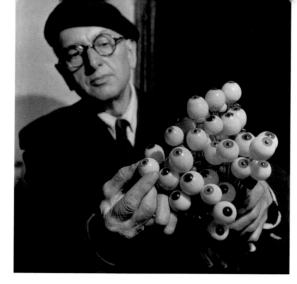

Charles Pêtre, oculist, 1944

Monsieur Dassonville and his duck, rue Le Regrattier,
4th arrondissement, 1950

Formerly a stage-hand at the Comédie Française, Monsieur Dassonville lives
for two things: his pet duck Grisette and the annual ball on Bastille Day.

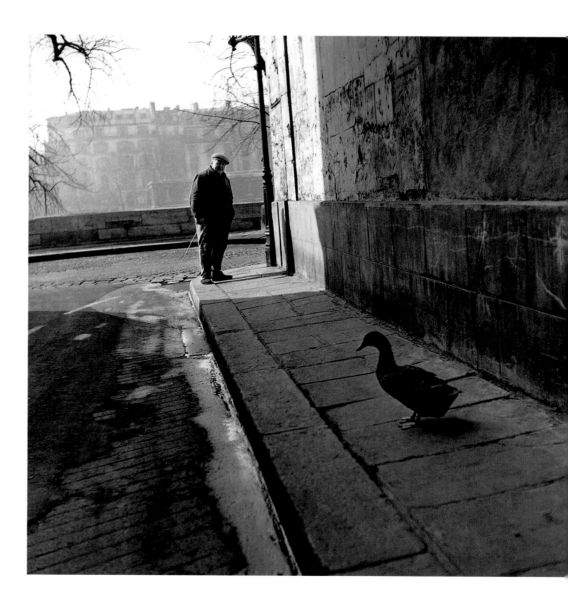

Monsieur Bayez and his monkey, 1970

“ Monsieur Bayez, a craftsman who specializes in Boulle marquetry in his workshop in Faubourg Saint-Antoine, came back from Africa with an irascible, sharp-toothed monkey. ”

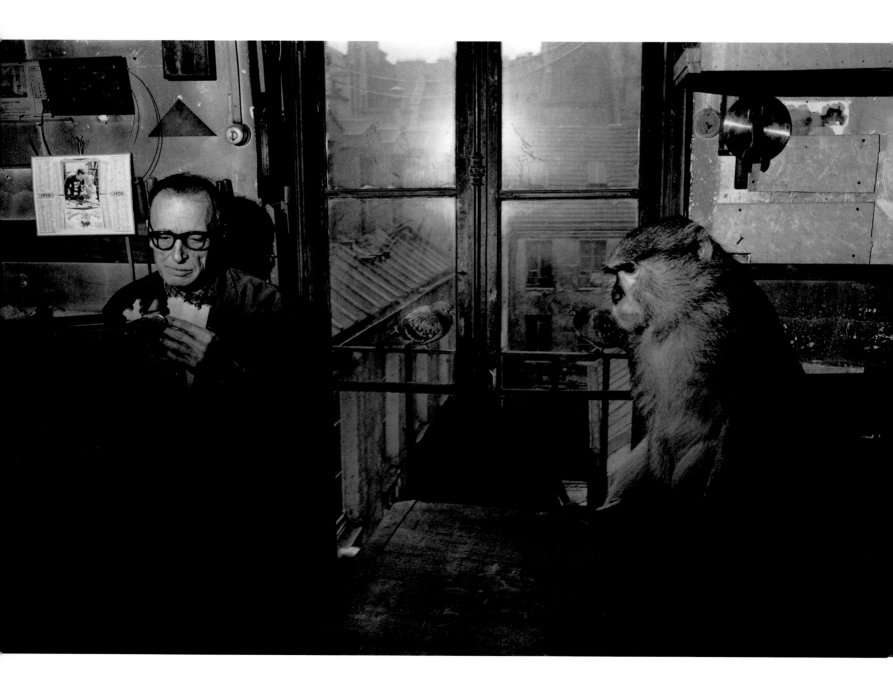

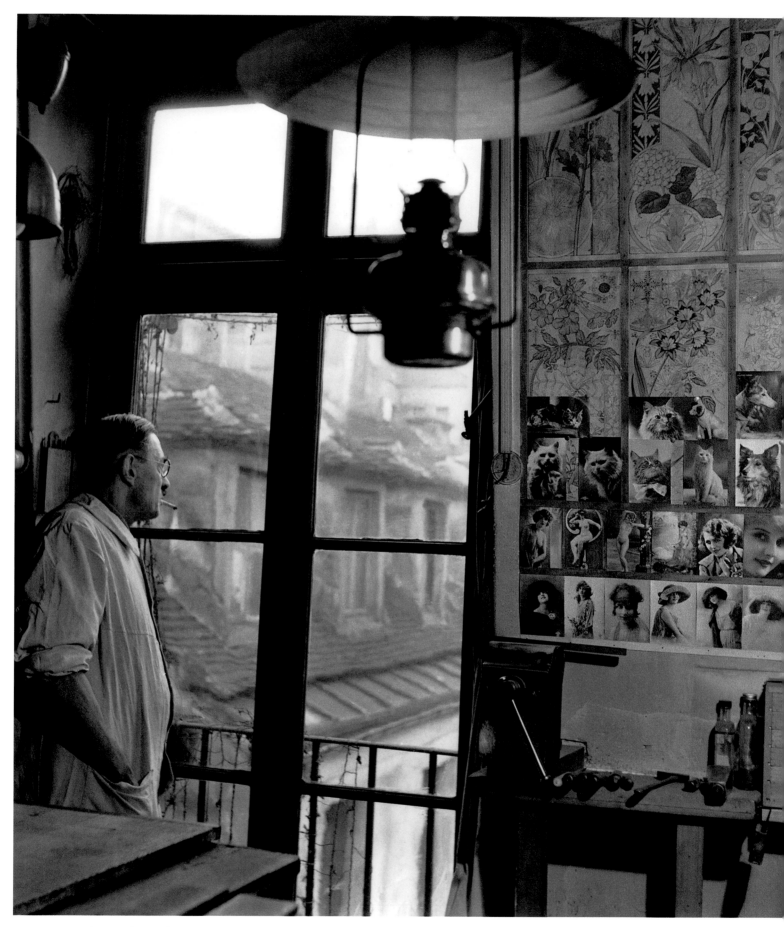

Marquetry craftsman at his window, 1945

Monsieur Rochard, horn teacher, 1949

" Gaston Rochard is both music teacher and concierge on rue Nollet.
He gives horn lessons to individual students in his concierge's apart-
ment, though when he gives group lessons he heads for the cellar
beneath the café across the street. 'You mustn't annoy the tenants,'
says old Rochard. 'I'll retire to the country when I'm elderly, so I
can play in peace,' he adds at the youthful age of seventy-seven. "

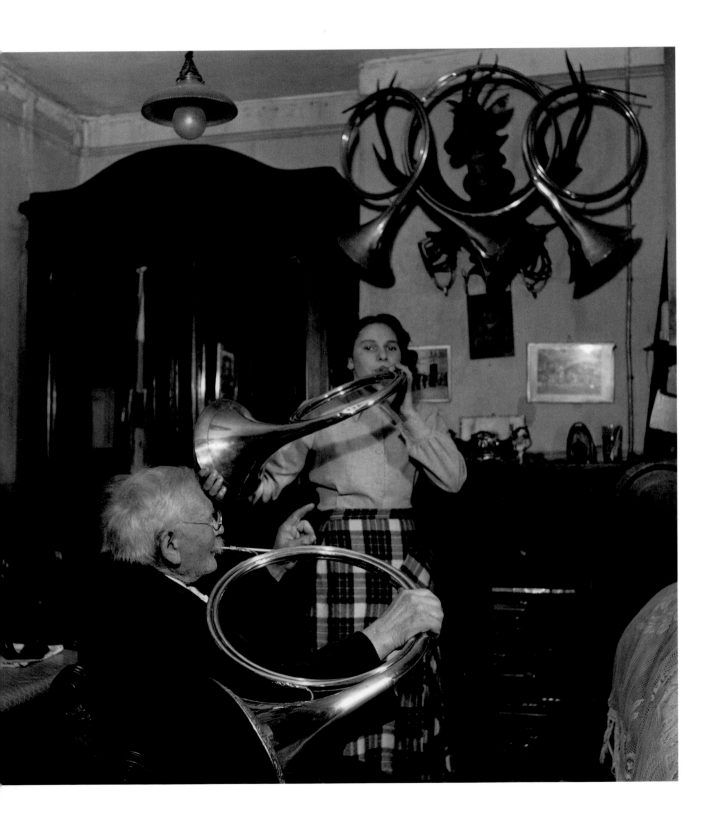

" Monsieur Salkhazanoff has dubbed himself 'Ambassador of the Stars.' He's the founder of the Free Observatory and Center for Citizens of the Universe (in Saint-Denis, just outside Paris).

His first official petition, deposited at the Préfecture de Paris in November 1951, ended in his arrest and imprisonment.

Salkhazanoff devotes all his energy to the defense of world peace. He has drawn up a three-point program:

1) Establishment of a multinational world state with a sole world-wide government to defend the interests of all humans on the planet;

2) Abolition of all borders, while allowing all peoples to retain their specific characteristics;

3) Abolition of all weapons and all armies, henceforth pointless.

Salkhazanoff has sent this program to fifty-seven major heads of state. He is a metal worker, has received a commendation for his work, and is a father of five. He lives like a prophet, rejecting all creature comforts.

When the sky is clear and the weather draws Parisians out of doors, he sets up a telescope in the street, inviting passersby to gaze at the heavenly bodies, thereby putting them in the right mood to strive for universal peace. "

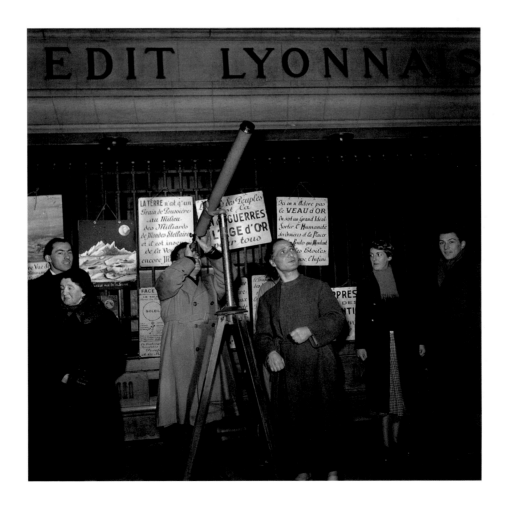

" I met Claude the stevedore in a bistro one Saturday night where he was demonstrating his insensitivity to pain. He would pierce his cheeks and ears with needles.

If he began bleeding too much he'd say, by way of apology, 'Looks like we hit a bone of contention.'
 He lived above Les 4 Sergents de la Rochelle, where this photo was taken. "

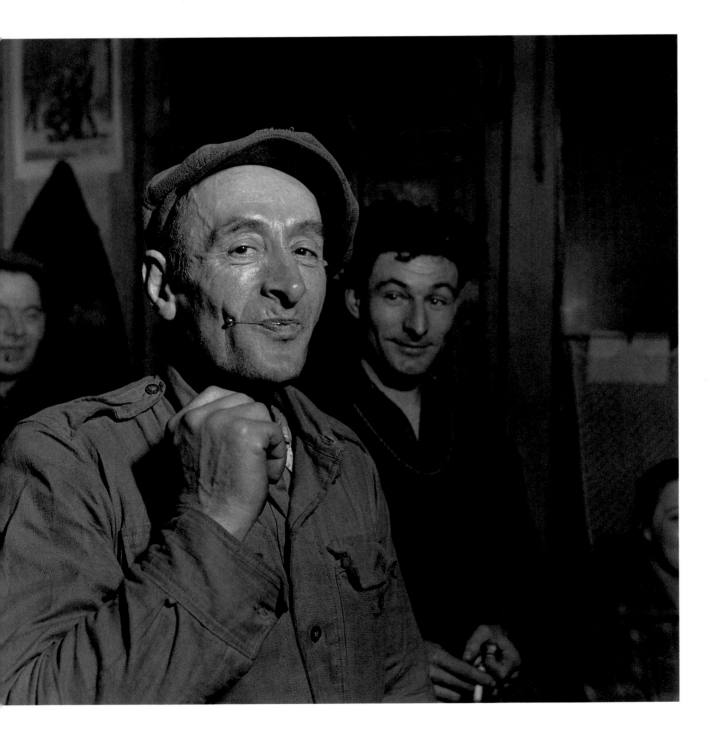

" Claude liked to surround himself with fine things: a scantily clad pin-up two feet high. His wife asked me, 'Are they real photos, or drawings?'

I replied, 'Drawings, Madame Mireille.'

'Well,' she said, 'I'm not like a lot of other people, when a woman is well built I'm the first to admit it. And these ones here are pretty well built, right, Claude?'

Claude chuckled quietly. "

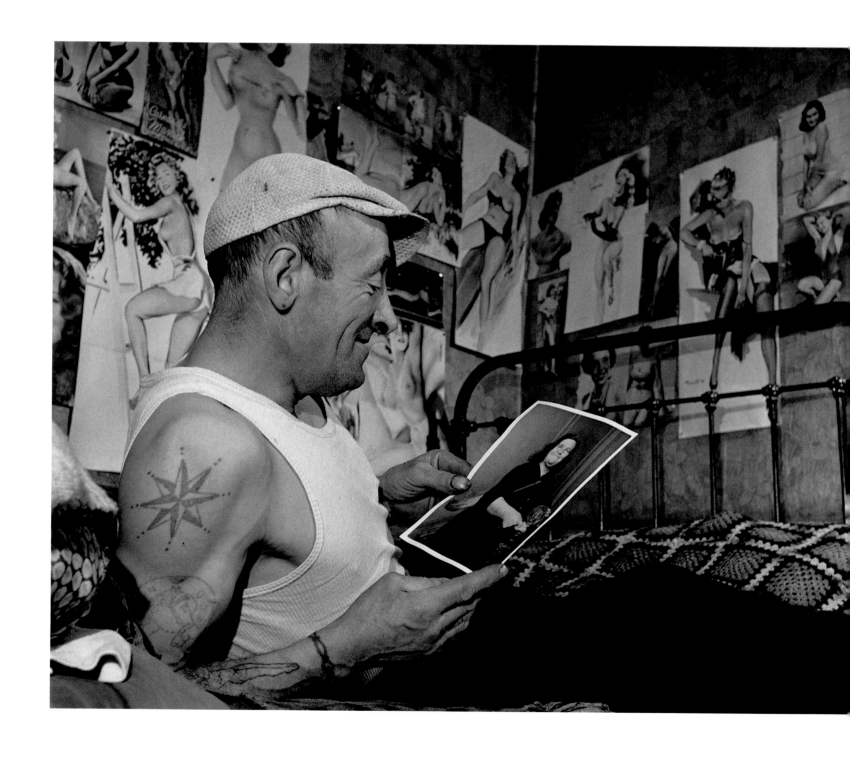

Jean Savary, last of the bohemians

Having withdrawn from society once and for all, Jean Savary lives his life as he pleases. In the afternoons, if he's not sculpting, he reads in a library. Each morning, hammer and chisel in hand, he goes to quai de la Tournelle where river barges dump tons and tons of burrstone. He chooses his piece and swiftly roughs it out on the spot, then carries it home to finish it. On Sundays he displays his work on the sidewalk in front of the Lycée Saint-Louis on boulevard Saint-Michel. That's the only place you can catch him and have a chat.

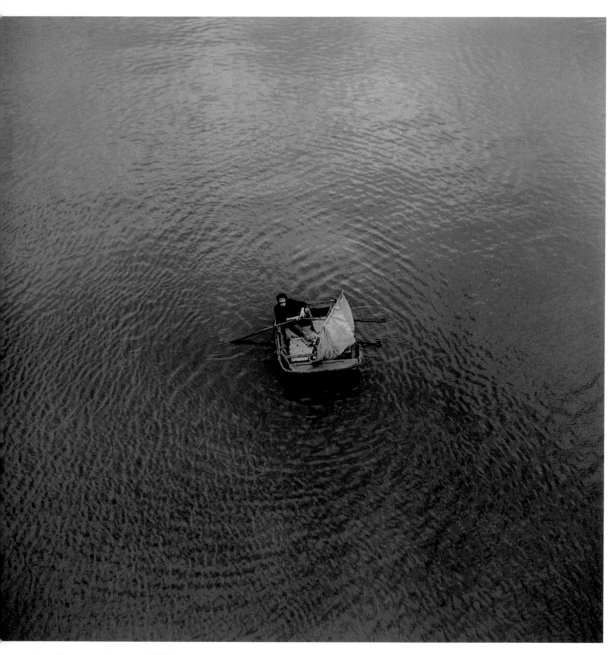

Jean Savary in his boat, 1955

FACING PAGE: Jean Savary, sculptor, 1949

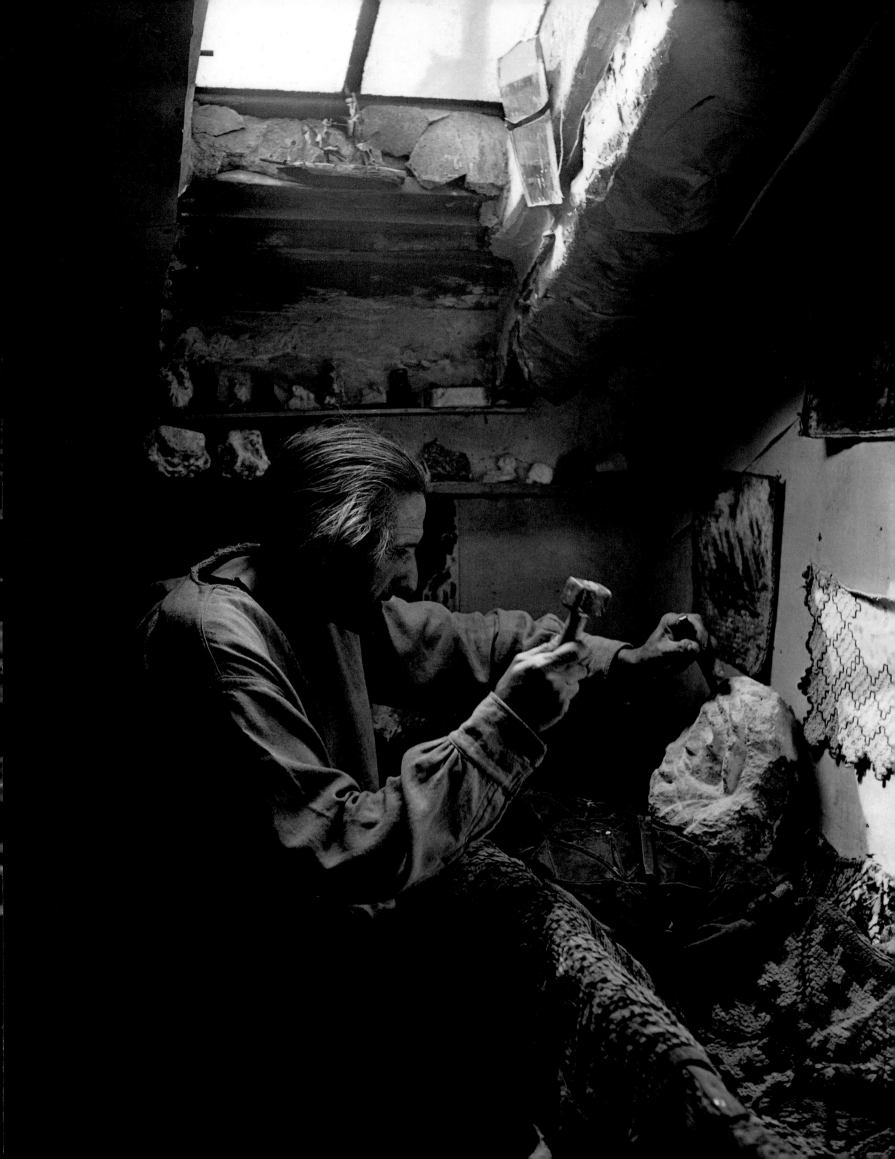

Duval, artist-cum-ragman, 5 rue Visconti, 1948

In the early morning when everyone is still asleep, Maurice Duval is at work. He goes through the garbage cans on rue des Beaux-Arts, not only to find sustenance but also materials for his art. In the afternoon, he paints on the banks of the Seine..Sometimes. an art student stops in front of his work, amazed. When evening draws in, Maurice washes his oilcloth canvas in the river. It will be dry again by the next day and ready for reuse.

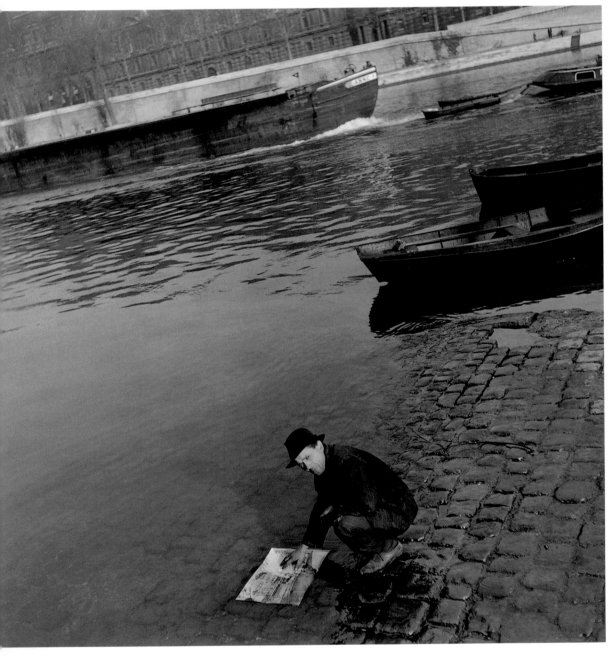

Duval Washes his Oilcloth Canvas, 1948

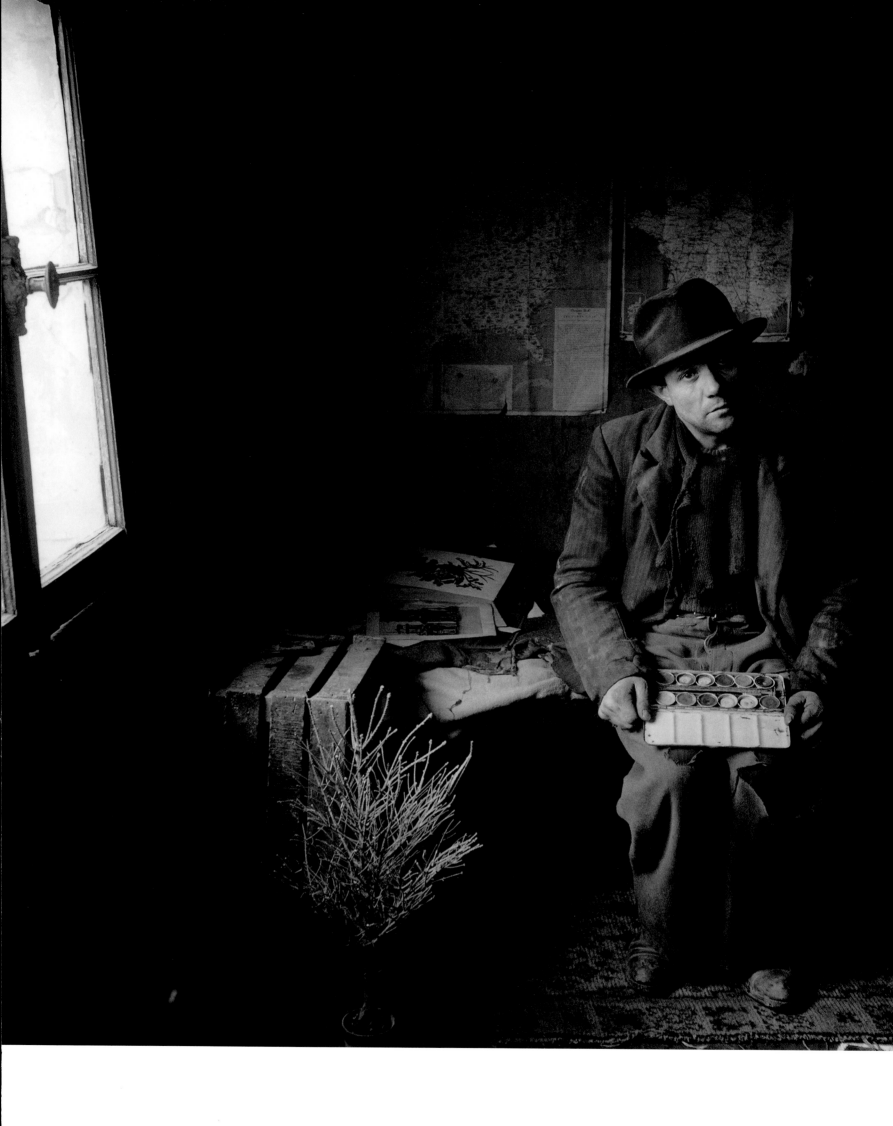

Julien Nollan

❝ In his ground-floor room on rue des Saint-Pères, he is the most courteous man in the world. He once knew Caroline 'La Belle' Otéro and Liane de Pougy. He says, 'I like to surround myself with pretty things, you see, so don't even mention those operating theaters they call modern apartments.' ❞

Doorman at a Montparnasse nightclub, Monsieur Nollan dresses in an admiral's uniform and collects everything that glitters.

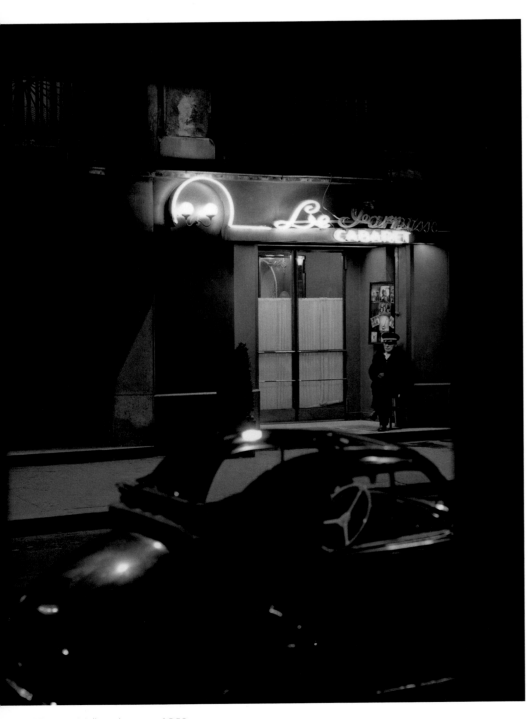

Monsieur Nollan, doorman, 1950

FACING PAGE: *The Admiral Among his Collections, 1950*

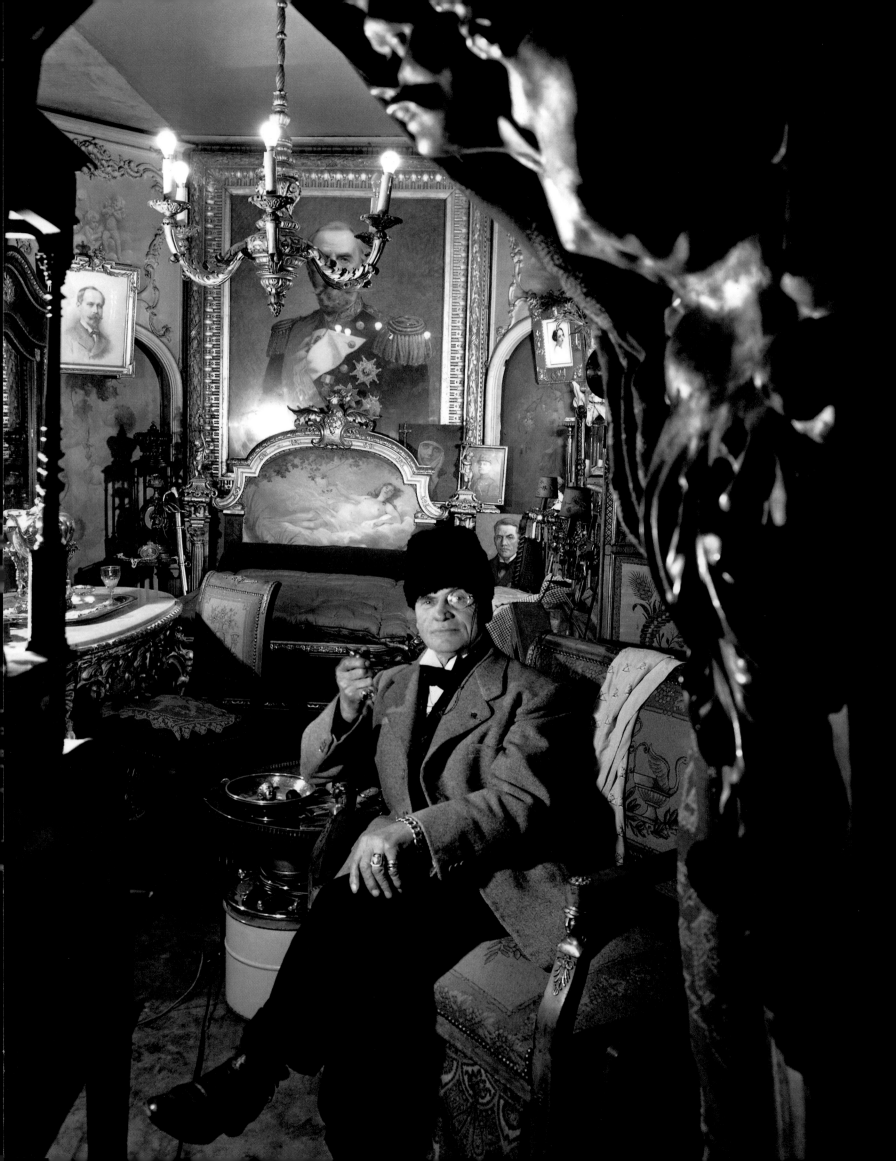

"Henri Héraut is ill at ease in public places, no matter where they be. His gaze flits around, his speech is hurried, he seems ready to flee.

But he's an entirely different man in his studio on rue du Moulin de Beurre in the 14th arrondissement, a stone's throw from the giant buildings of Maine-Montparnasse. Here he's found refuge in the setting he's created for himself. On the wall are dolls—long-suffering dolls, bald dolls, naked dolls, dolls in rags.

In the middle of his studio there's a gap in the flooring, which he calls the Tomb of the Unknown Doll: it's a clutter of faded flowers, flotsam of all kinds, objects that have landed there after sundry digressions, and, in the middle, a doll who embodies all the wretchedness of the world.

Henri Héraut believes in the power of dreams. This magic climate inspires him. His paintings are as delicate as a wisp of smoke, his tonal harmonies very subtle, and his unreal figures have an intense gaze that leaves you feeling vaguely disturbed."

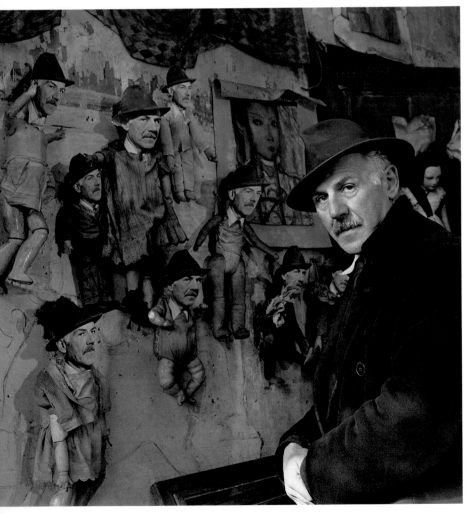

Henri Héraut and his Brothers, 1950

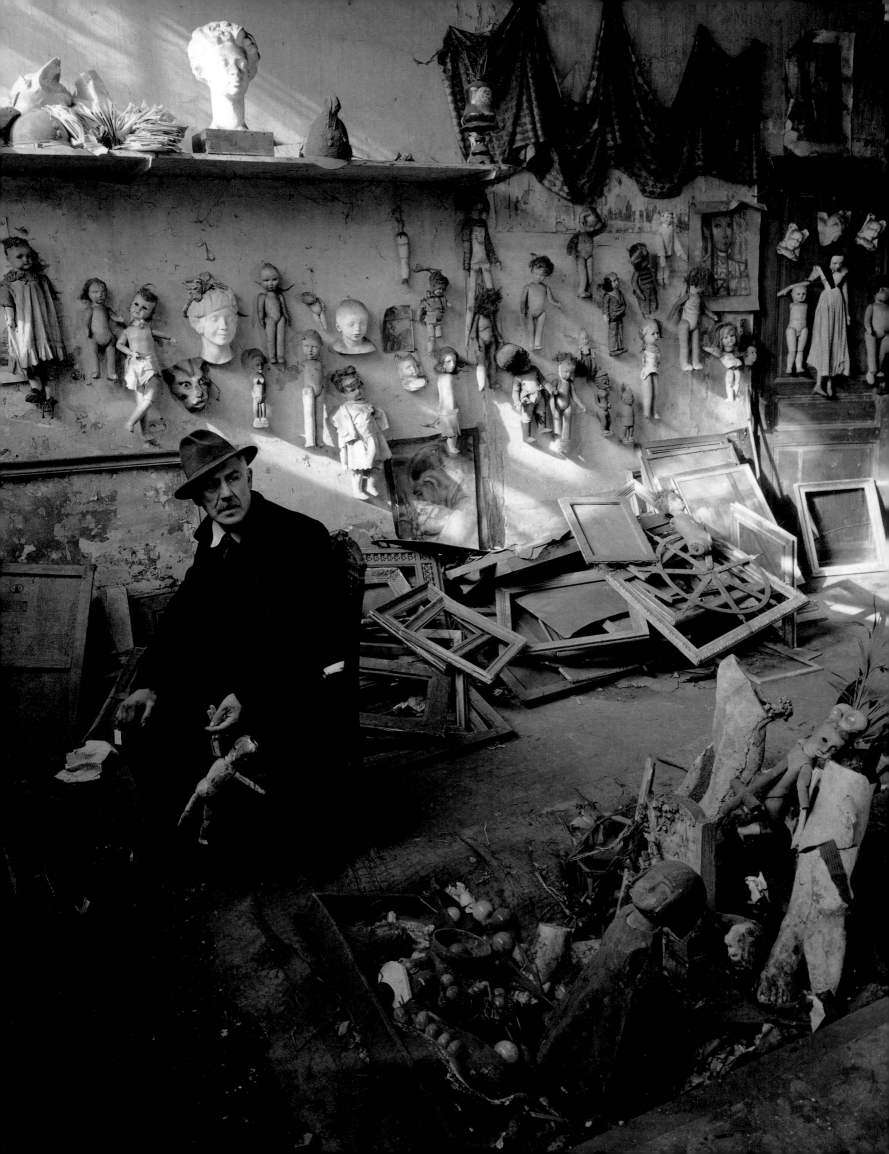

Armand Fèvre, last of the Bonapartists

One day Pierre Mérindol, a fellow journalist, described Armand Fèvre as 'dried up' in print. Esteeming himself insulted, Fèvre challenged Mérindol to a duel. The chosen weapon was the navy cutlass. The encounter took place in the forest of Sénart. After a few skillful thrusts, the Bonapartist managed to wound his opponent on the hand. Blood having been drawn, honor was restored.

Robert Giraud

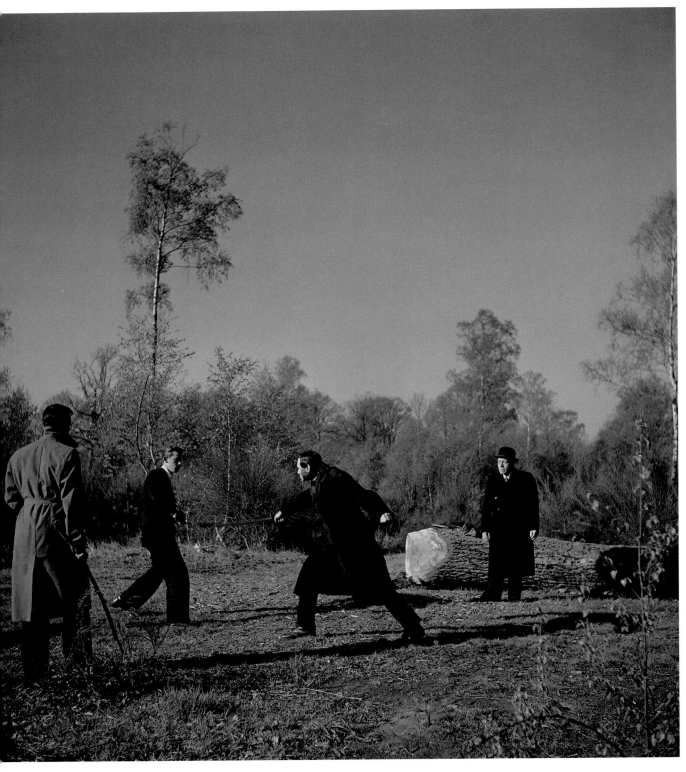

Armand Fèvre fights a duel, 1949

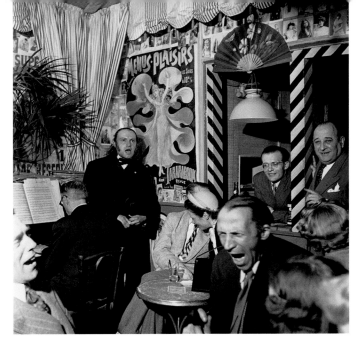

Armand Fèvre sings at Le Saint-Yves, 1949

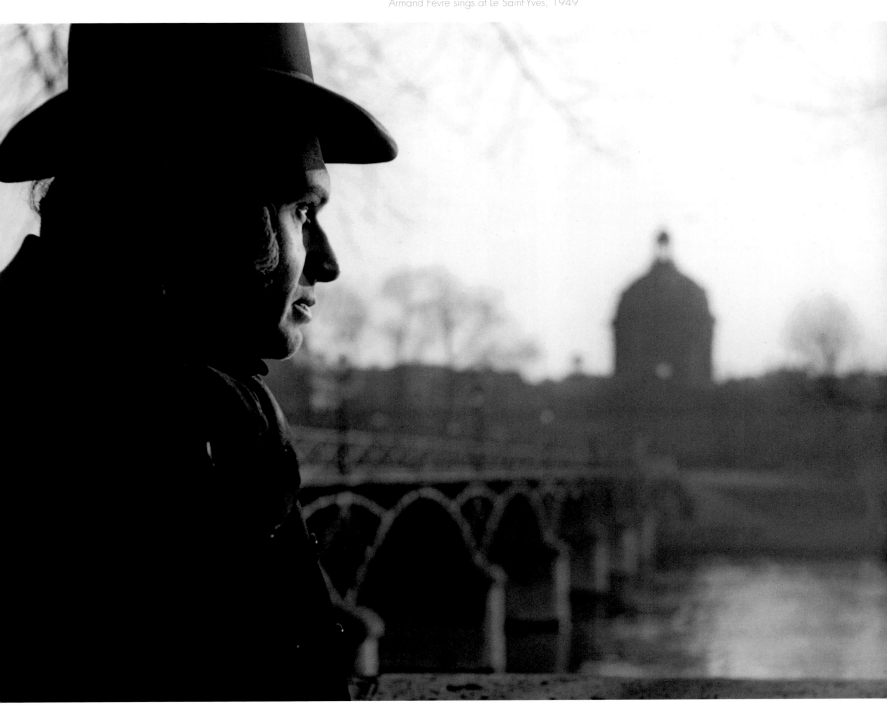

Pierre Dessau, 1950

Every evening in the streets of Saint-Germain-des-Prés, painter Pierre Dessau rides around on a "boneshaker" bedecked with balloons. By day he paints canvases of his nocturnal escapades.

Robert Giraud

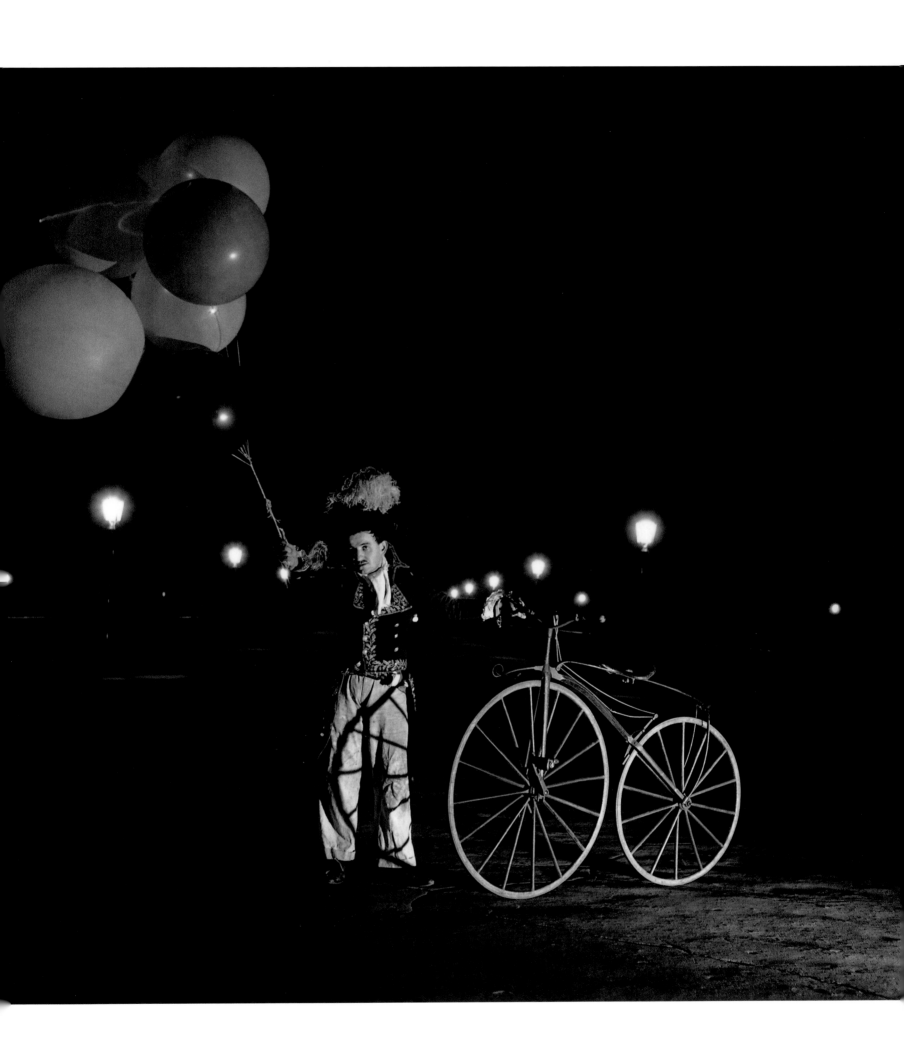

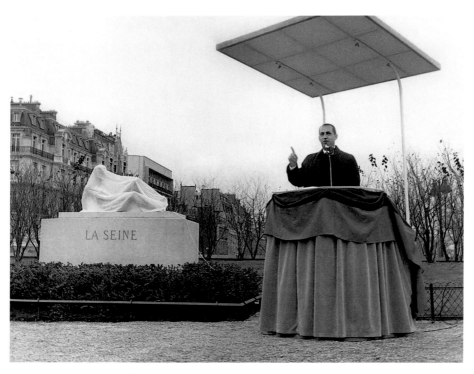

Monsieur Legaret Unveils La Seine, 1983

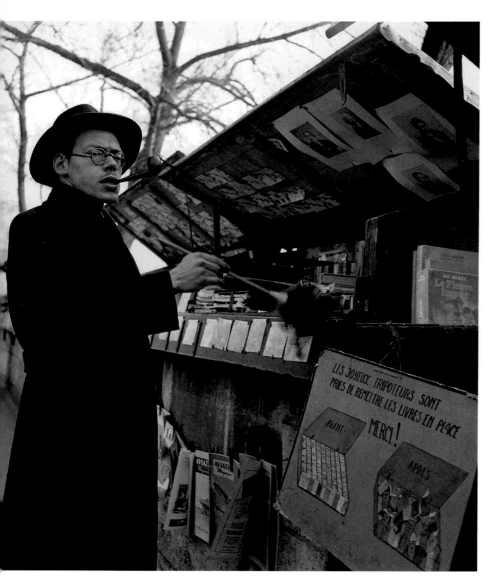

Bookstall Dealer with Duster, 1951

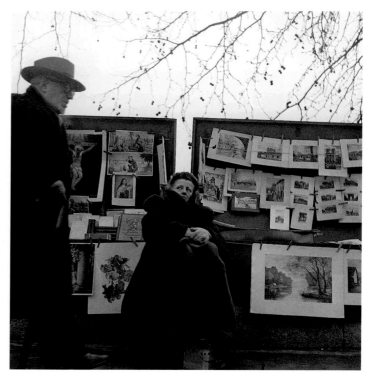

Bookstall Dealer Frozen to the Bone, 1951

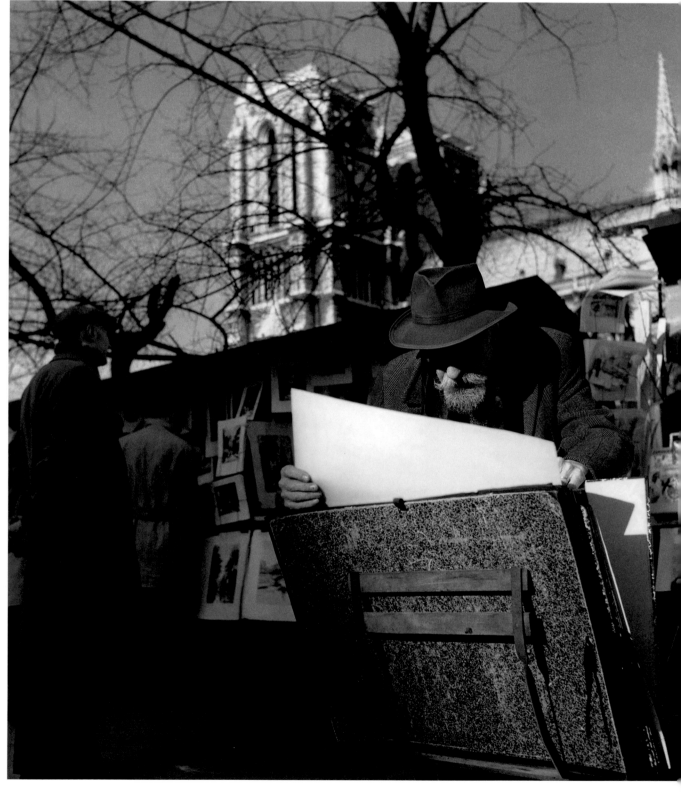

Quai de Montebello, 1960

RIVERSIDE GARDENING
SHOPS, 1946

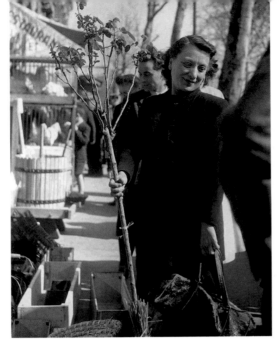
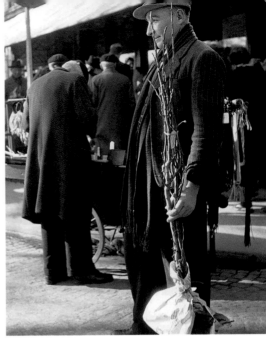

" Along quai de la Mégisserie on Saturdays in October and November, the grand parade of suburban gardeners is in full swing. They march off with their rosebushes and saplings in hand, like billiard cues, fishing rods, or rifles, heading for the suburban train lines on foot because the metro and buses are off-limits. Hard on the nylons. "

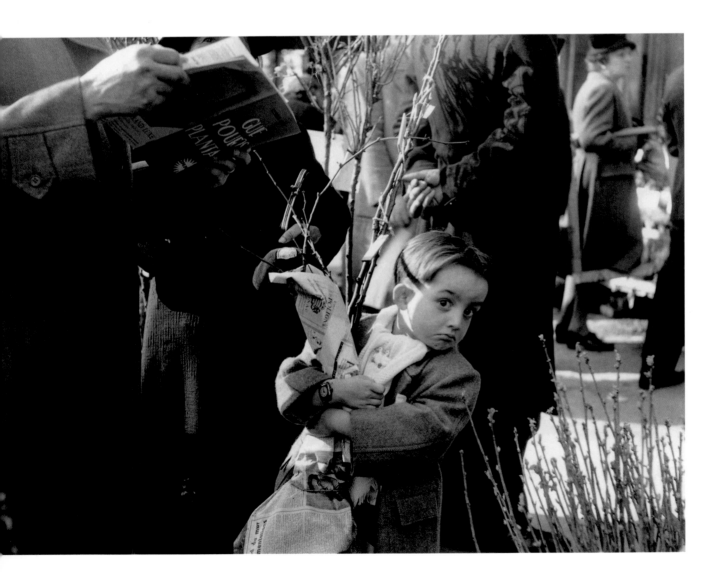

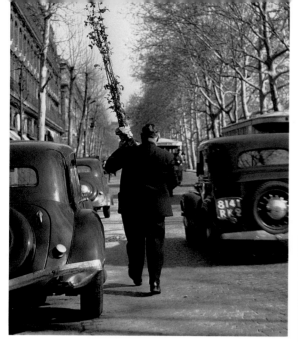

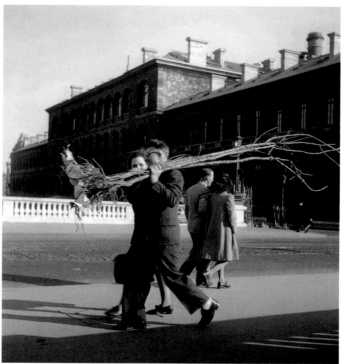

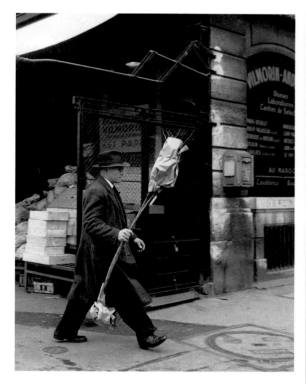

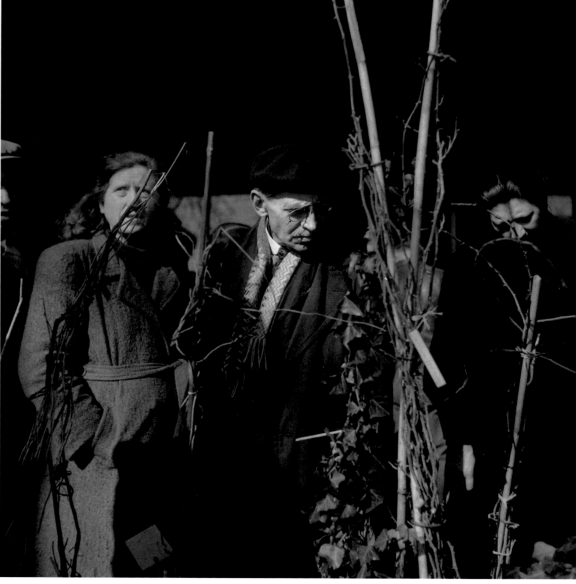

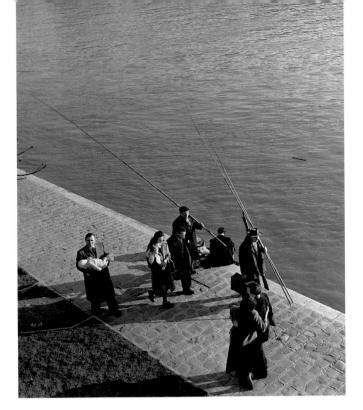

Quays along the Seine, March 1950

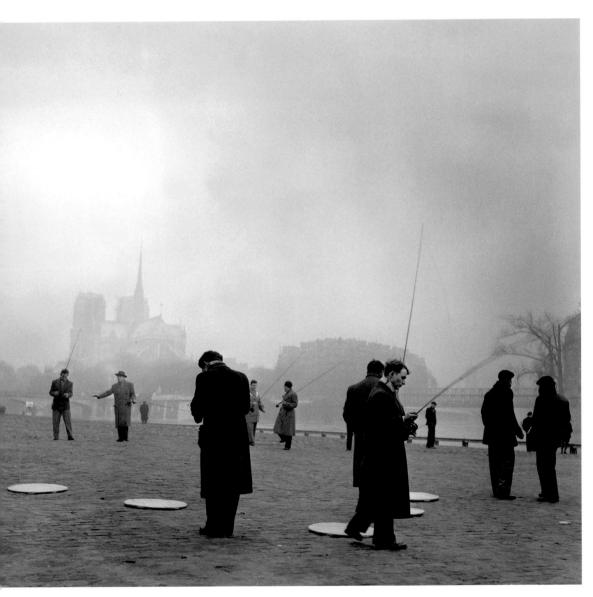

Fishing lessons, quai de la Tournelle, 1951

FACING PAGE: Pont de la Tournelle, 1951

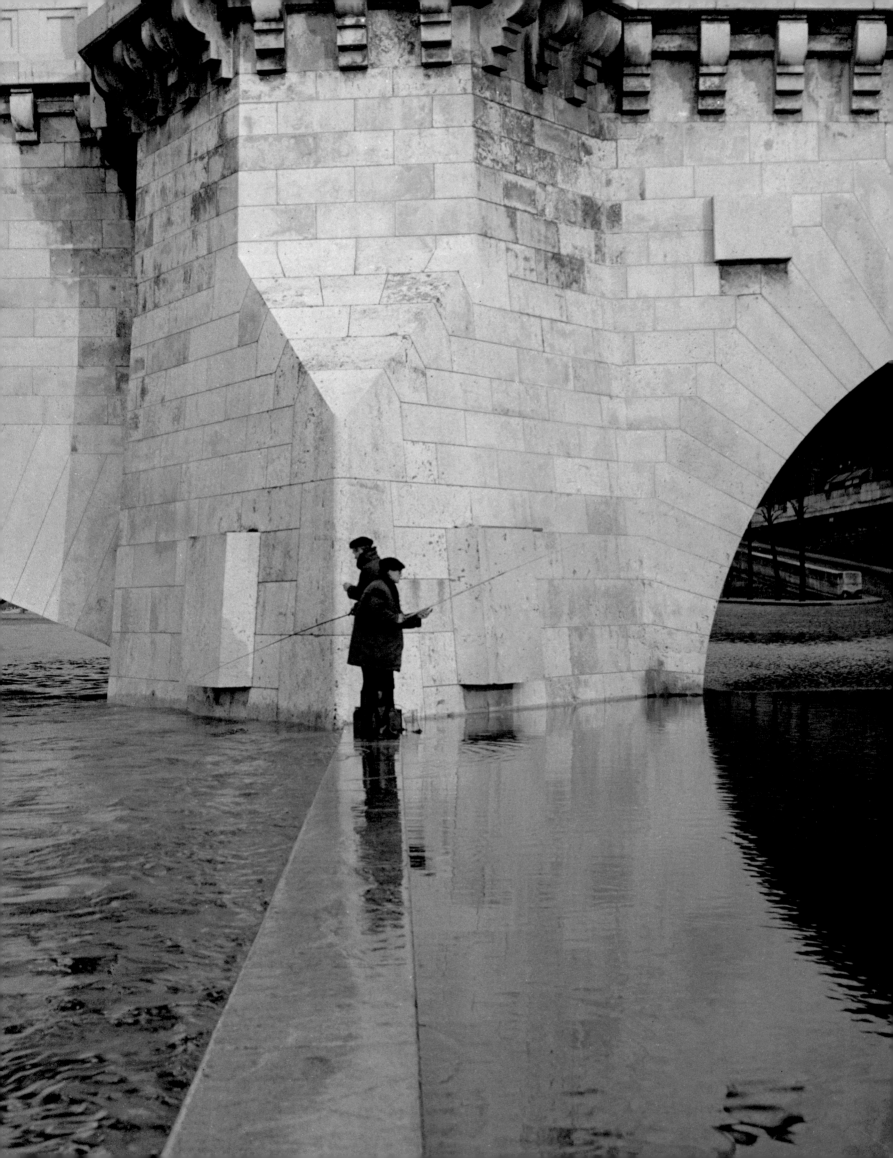

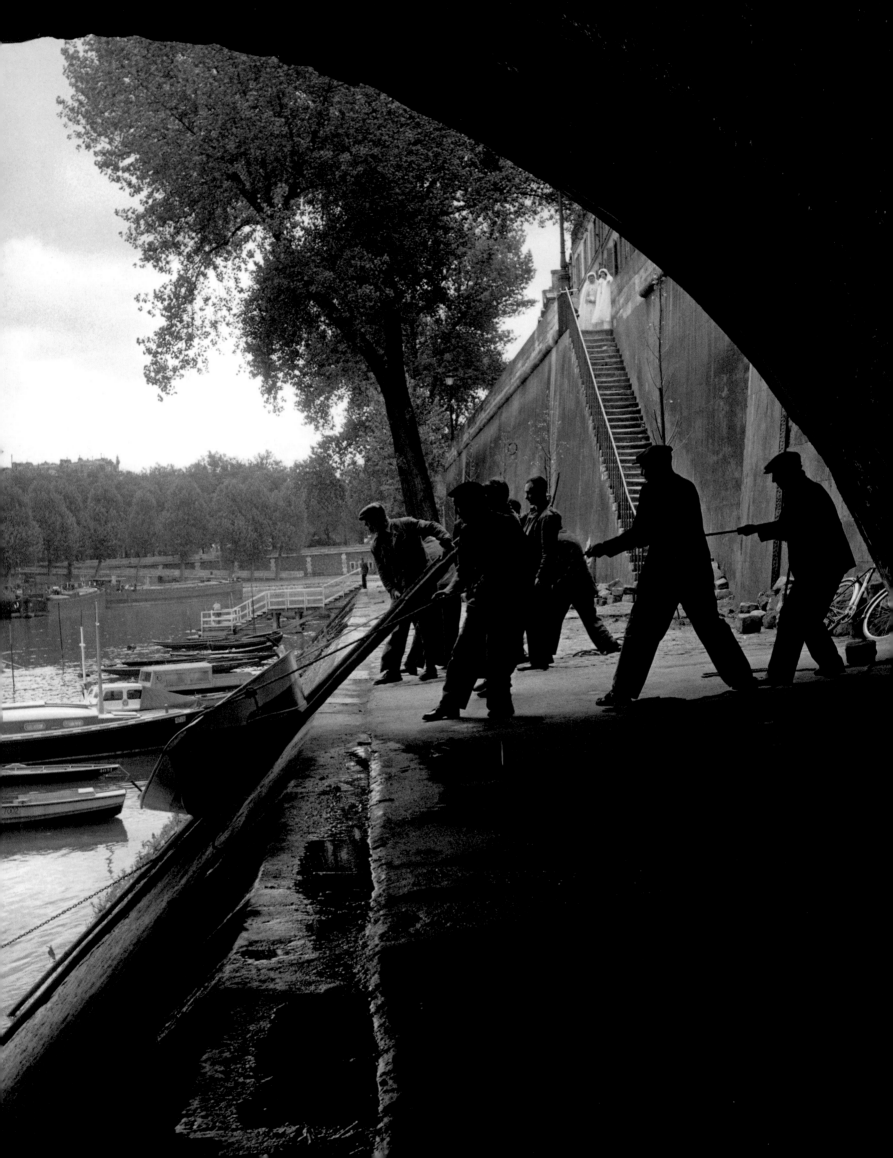

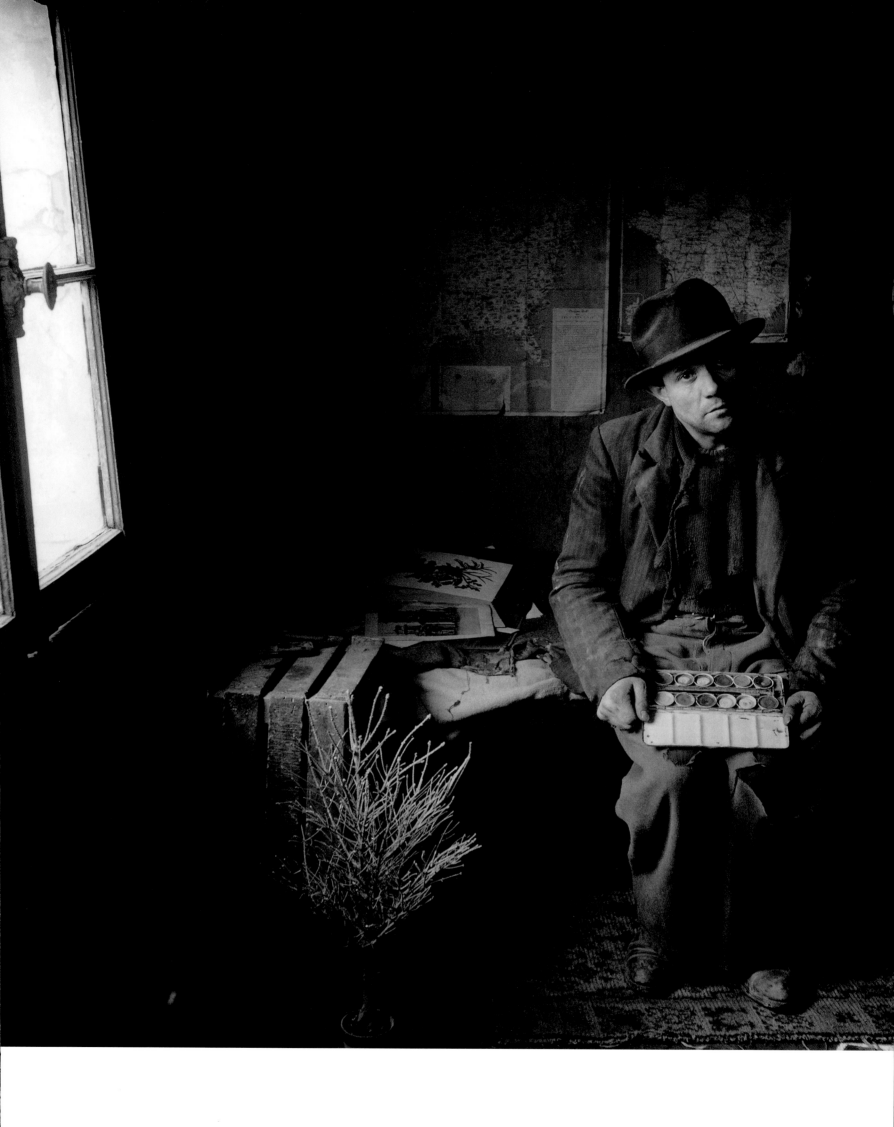

Julien Nollan

" In his ground-floor room on rue des Saint-Pères, he is the most courteous man in the world. He once knew Caroline 'La Belle' Otéro and Liane de Pougy. He says, 'I like to surround myself with pretty things, you see, so don't even mention those operating theaters they call modern apartments.' "

Doorman at a Montparnasse nightclub, Monsieur Nollan dresses in an admiral's uniform and collects everything that glitters.

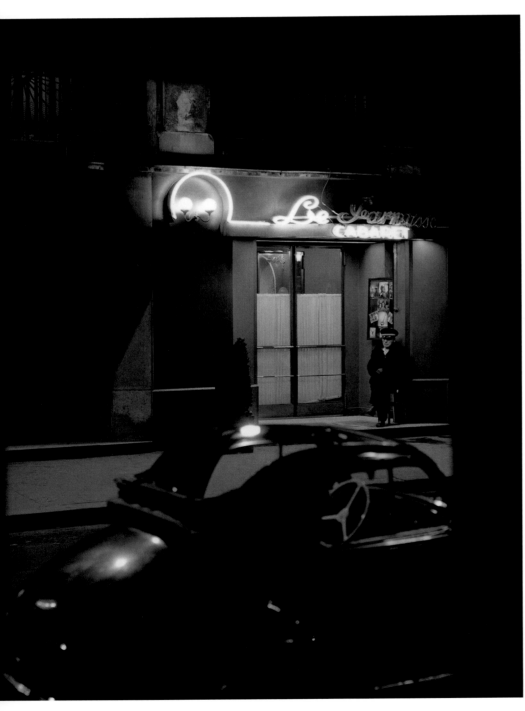

Monsieur Nollan, doorman, 1950

FACING PAGE: *The Admiral Among his Collections*, 1950

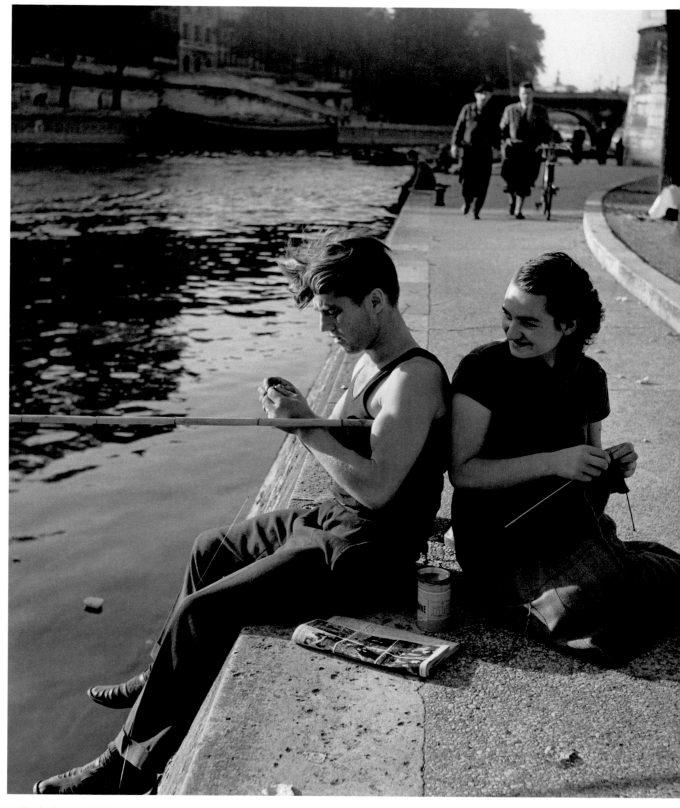

On the banks, 1951

Facing page: *The Boat*, 1951

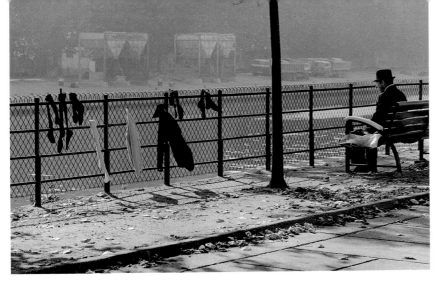

The Socks, 1972

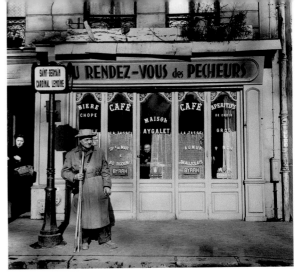

Paul Barabé with fishing rod, 1957

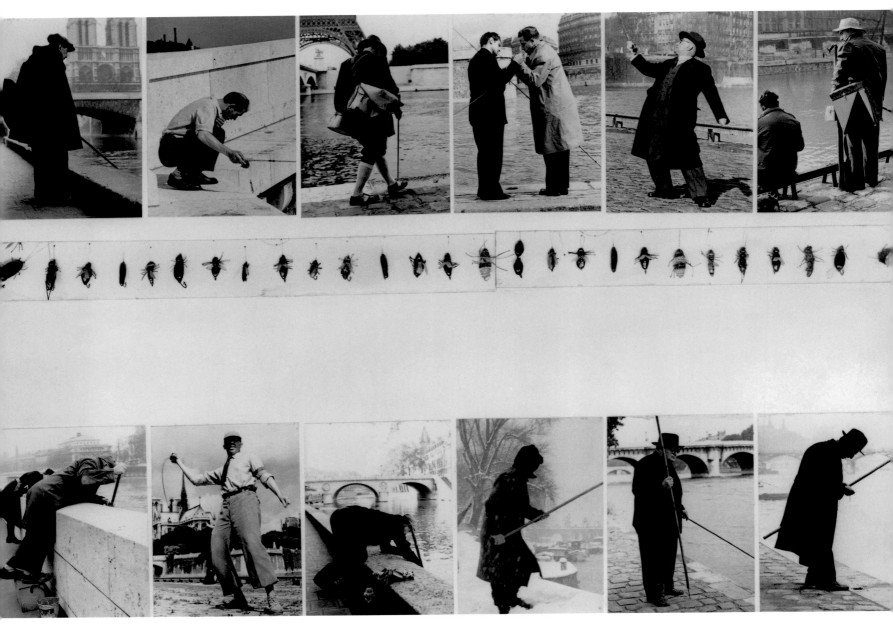

Photomontage of fishermen and flies, 1972

Sparrows on the canal, 1951

" There are days when the technique of an aimless stroll—without timetable or destination—works like a charm, flushing out pictures from the non-stop urban spectacle.

One lucky day like that produced this fellow fishing on canal Saint-Martin. 'Just look at them, they're eating my entire forty francs' worth of worms!' Once served, a sparrow would rest briefly on the footbridge then return to take its place again at the end of the line. Anglers and sparrows are both picturesque props welcome in any photo of Paris, so it's only normal they should team up. "

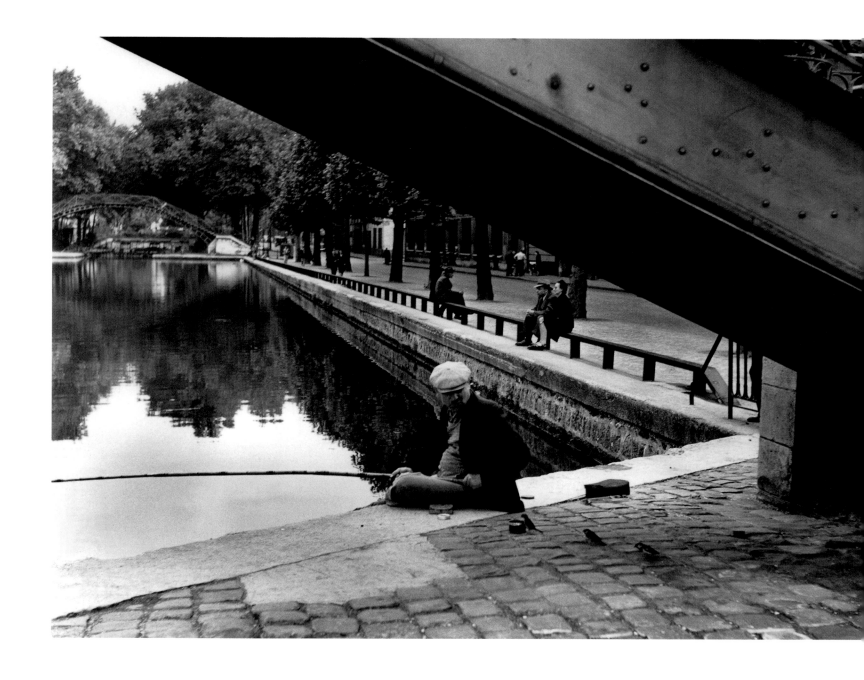

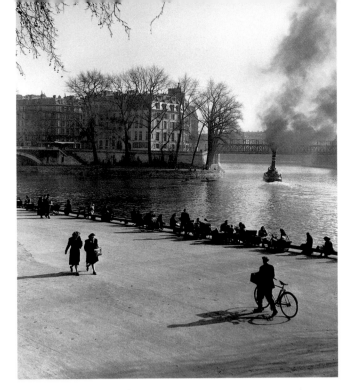

Quai de l'Hôtel de Ville, 1946

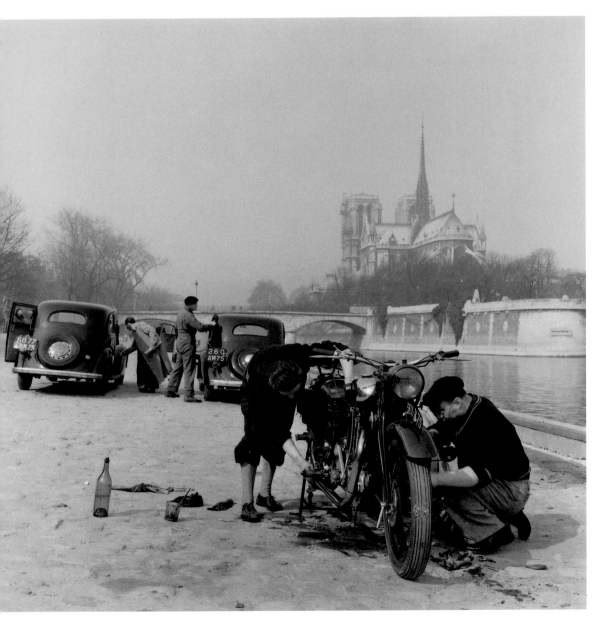

Quai de la Tournelle, 1953

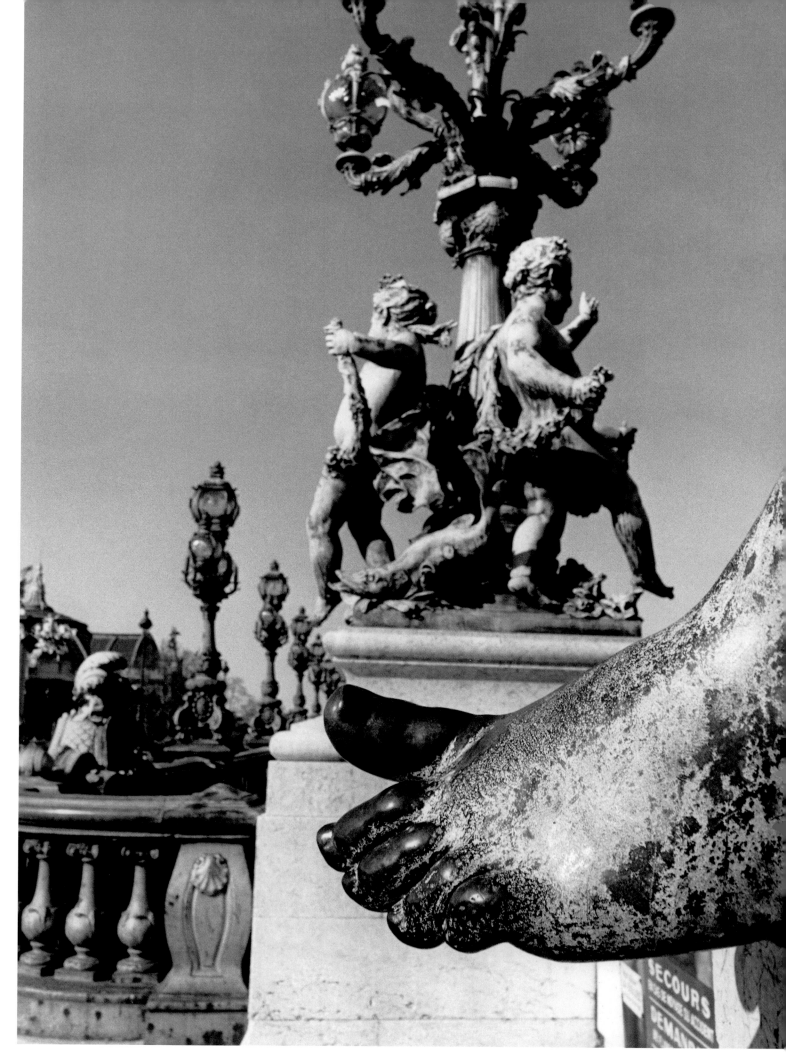

Pont Alexandre III, 1970

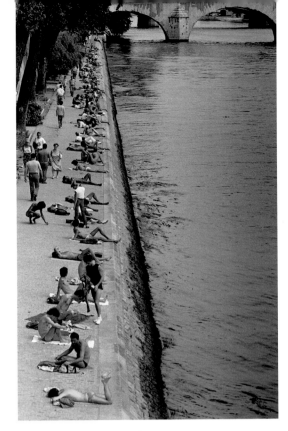

Sunbathing, quai des Tuileries, 1982

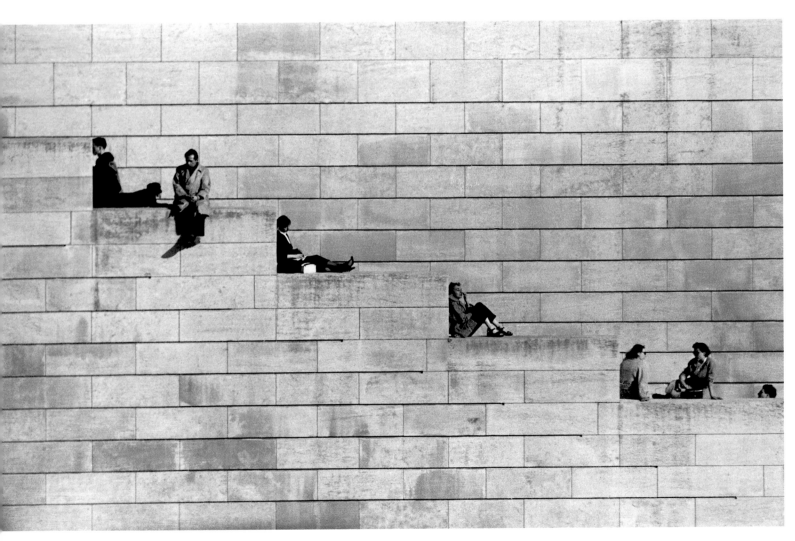

Diagonal Steps, 1953

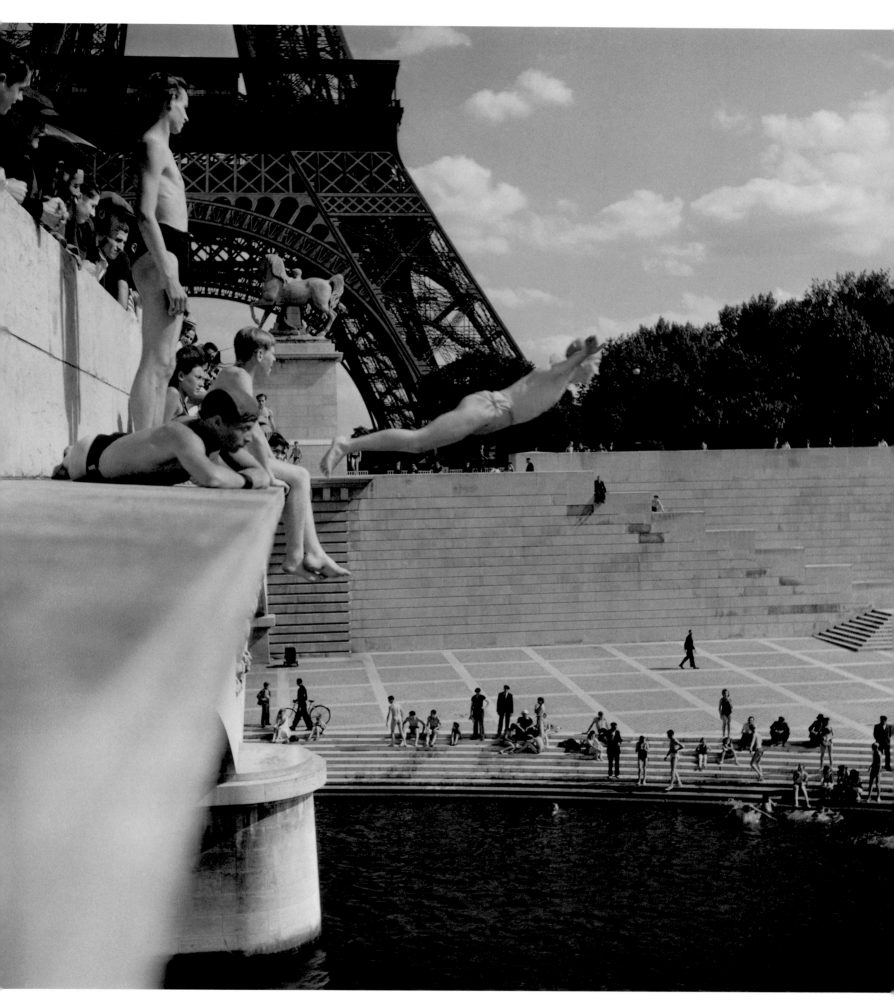

Pont d'Iéna, 1945

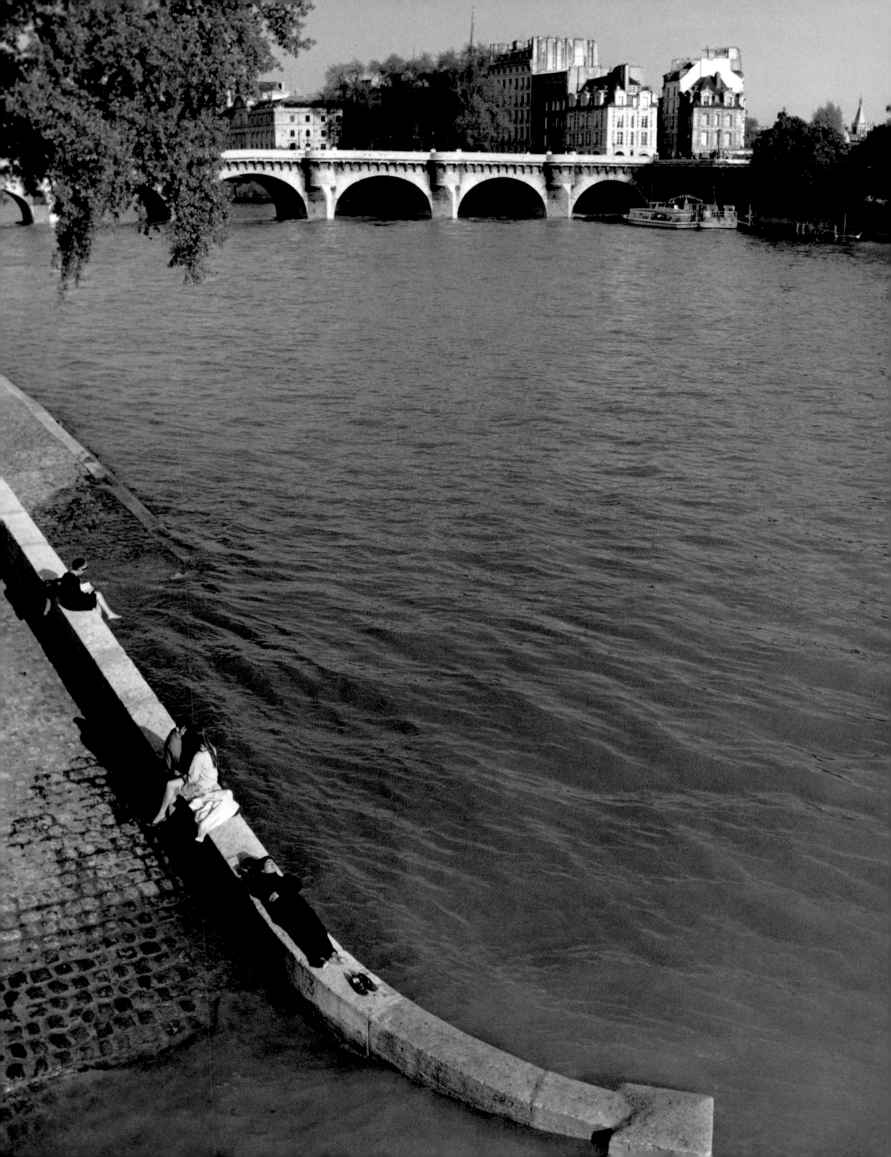

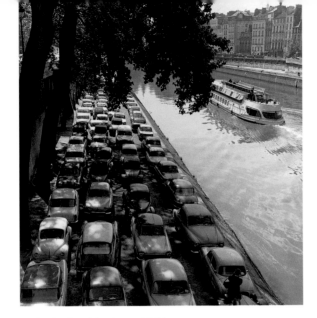

The banks of the Seine, 1954

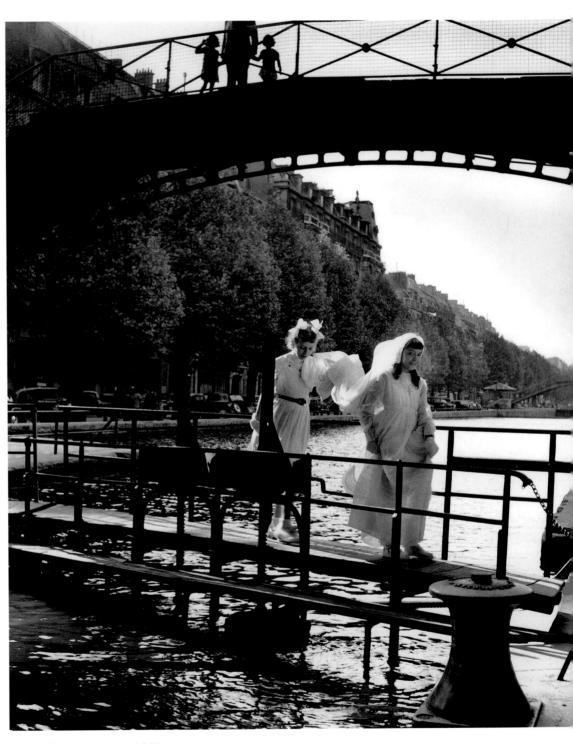

Canal Saint-Martin, June 1953

FACING PAGE: Flood, quai du Louvre, 1969

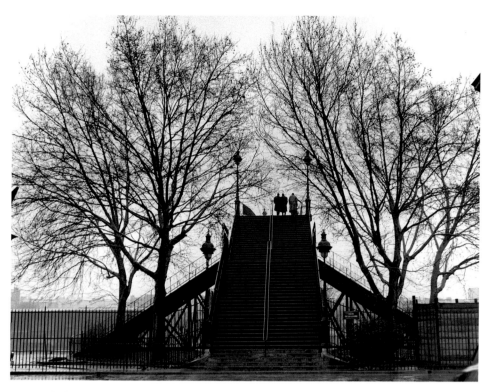

Quai de la Loire, 1957

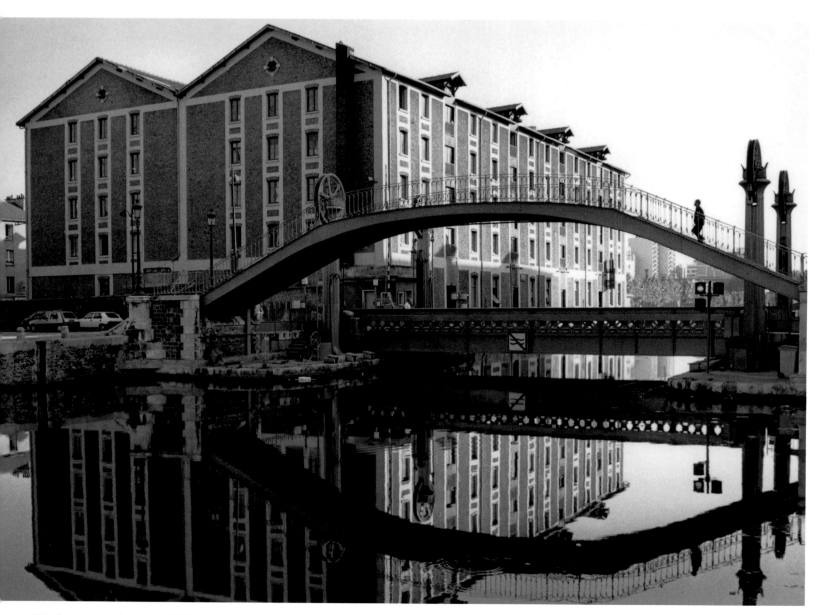

Warehouses, pont de Crimée, 1988

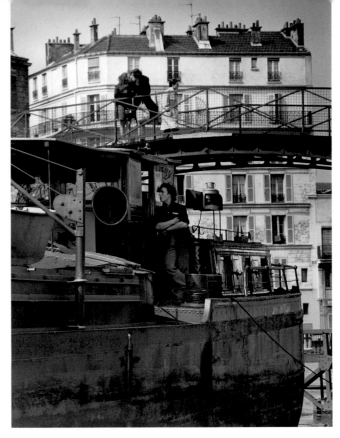

Quai de Jemmapes, 1969

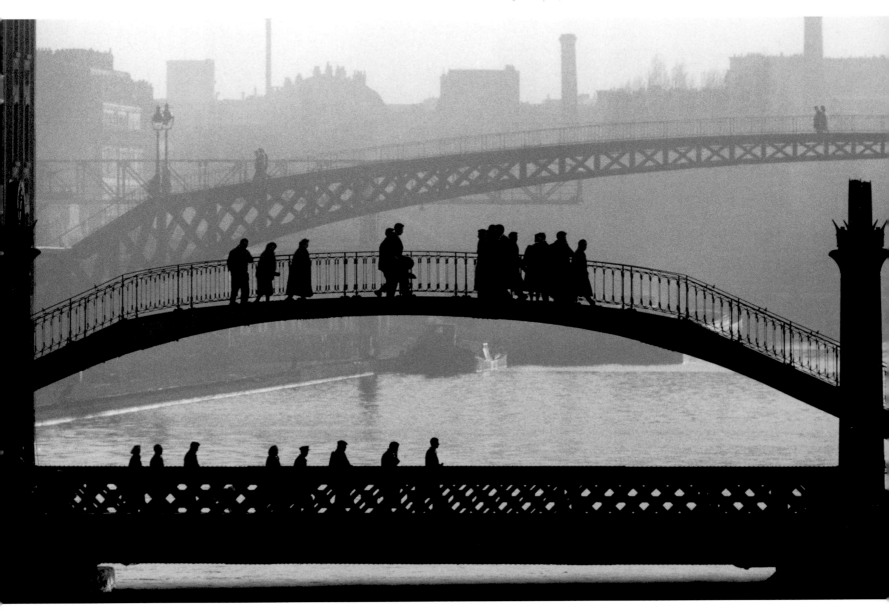

Canal de l'Ourcq, 1957

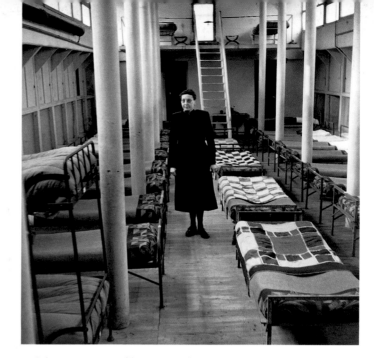

Salvation Army canal barge, March 1952

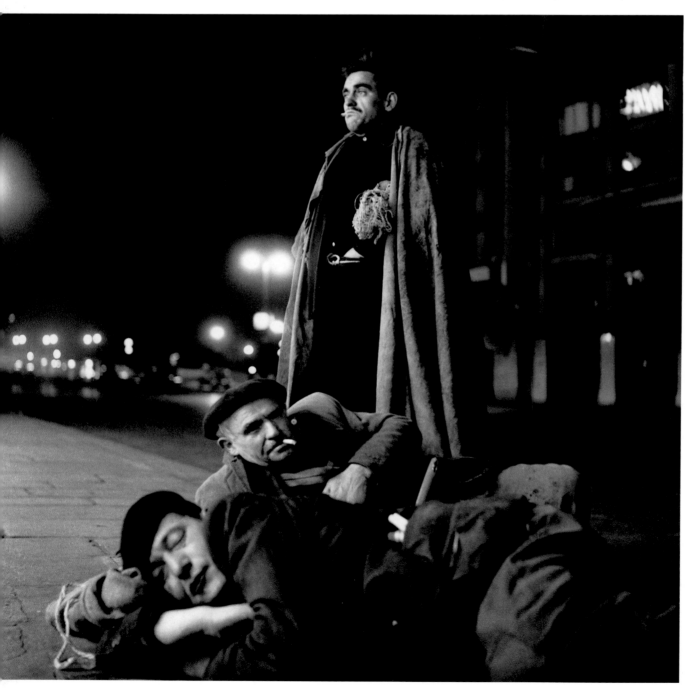

The Acrid Warmth of an Urban Heating Vent 1952

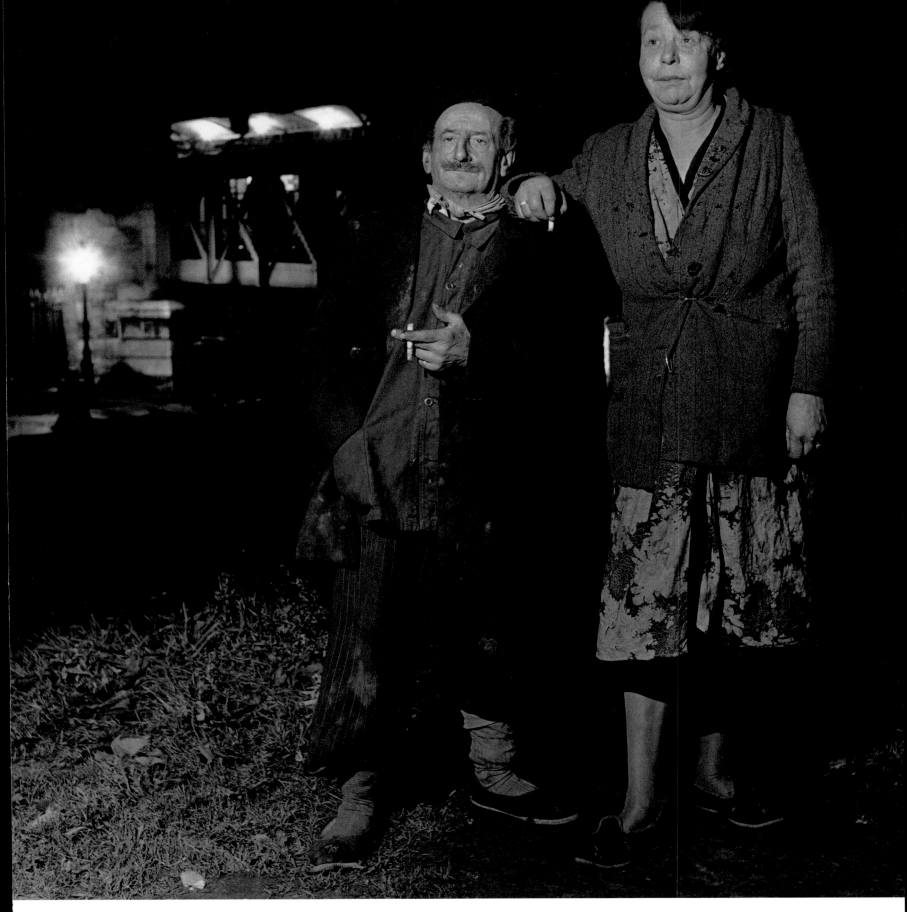

Couple, quai de la Rapée, 1951

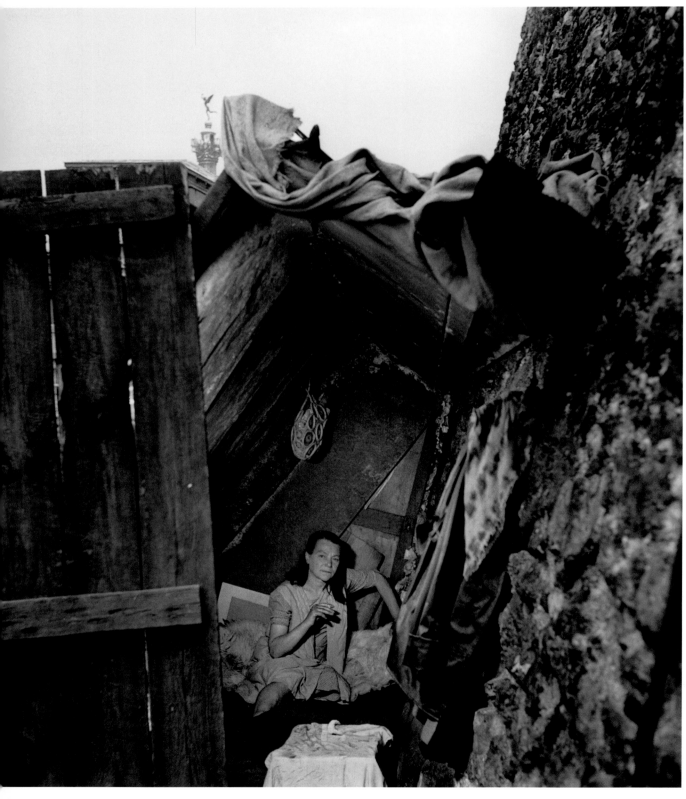

Madame Titine Camps on quai de l'Arsenal, 1950

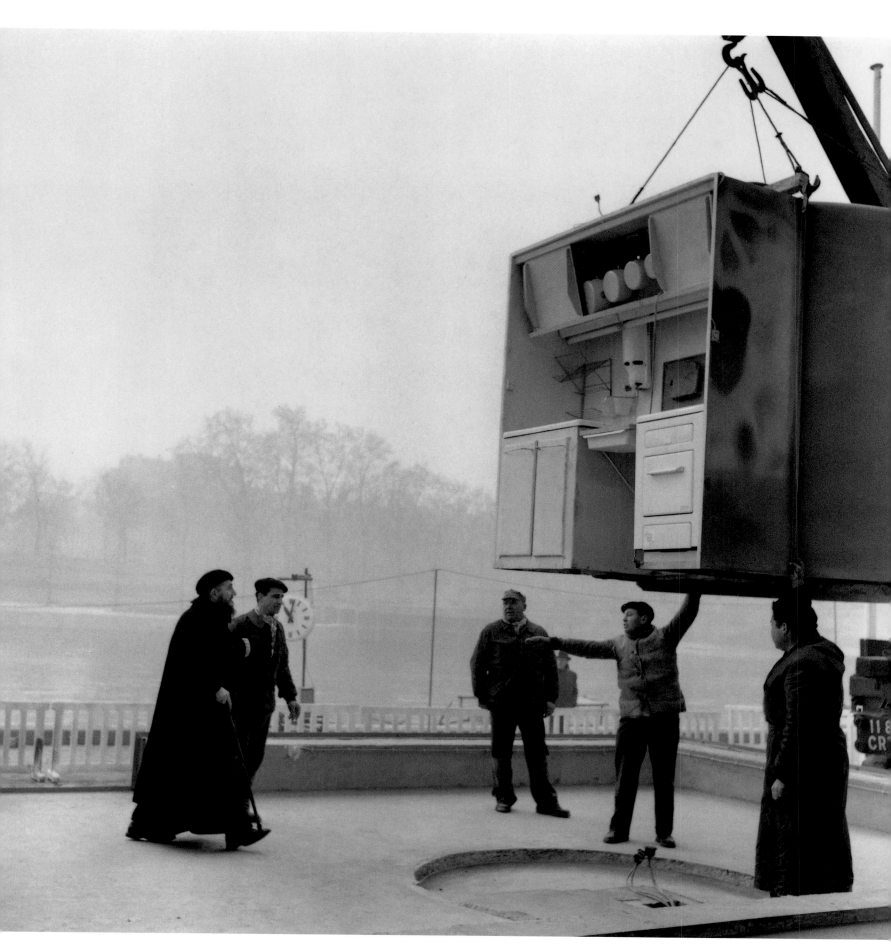

Abbé Pierre with Jean Prouvé's prefab housing units, February 1956

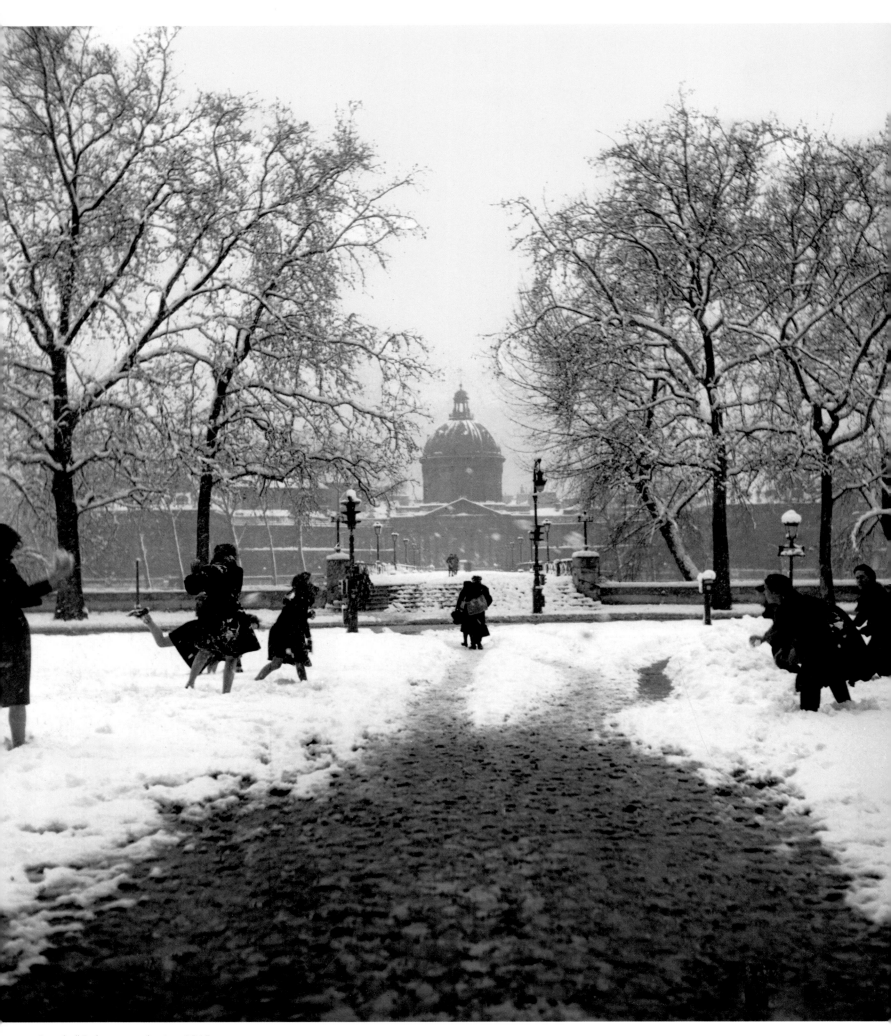

Snowball Fight on pont des Arts, 1945

Shoot the Artist, 1966

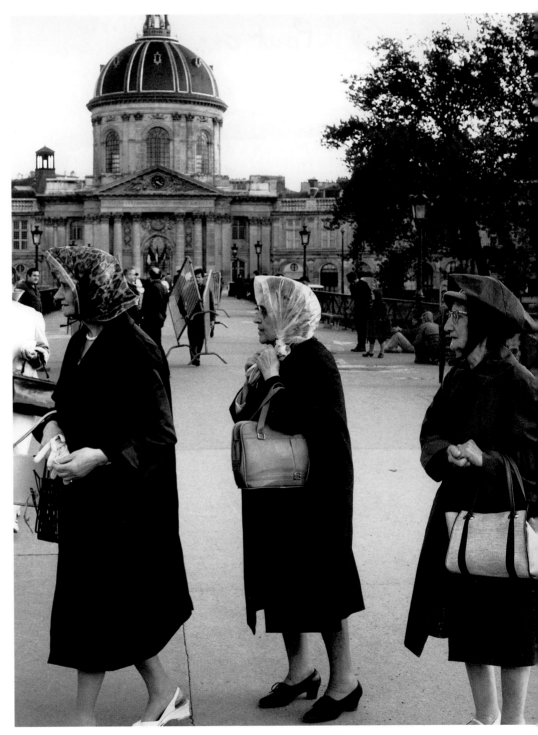

Raincoats, 1966

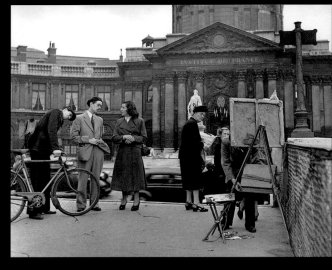

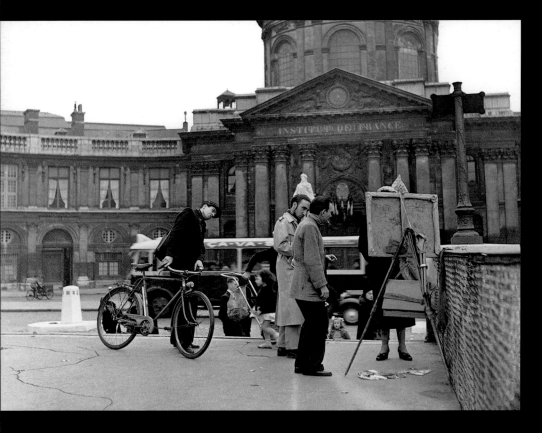

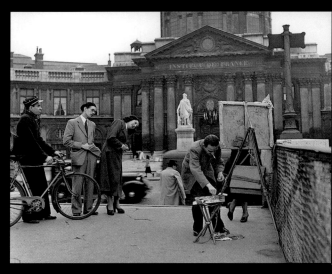

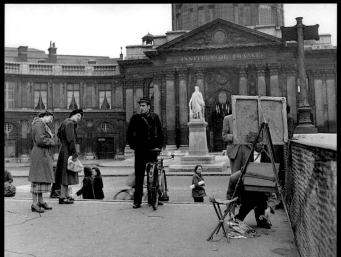

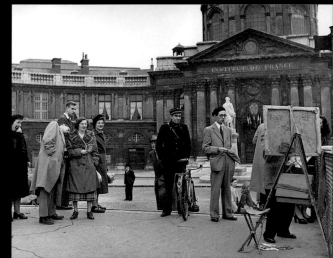

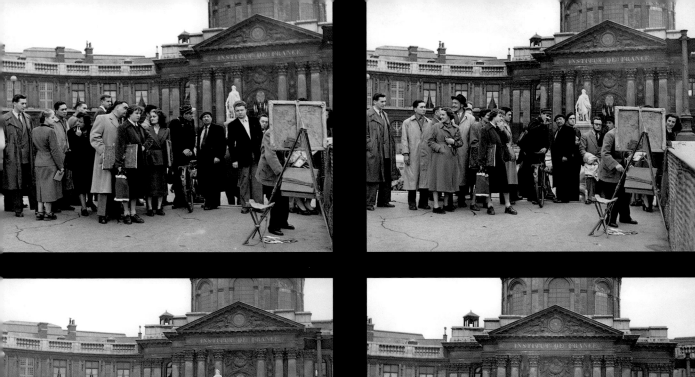

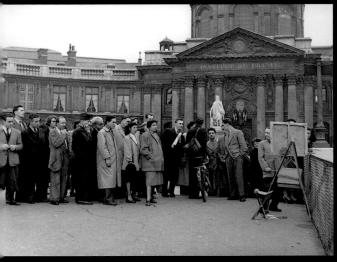

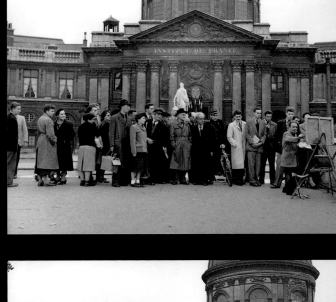

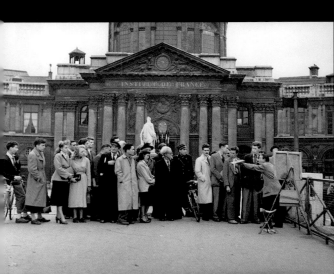

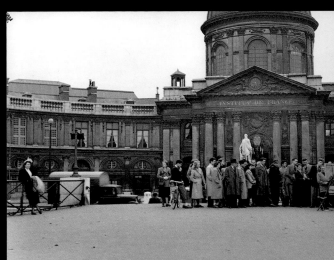

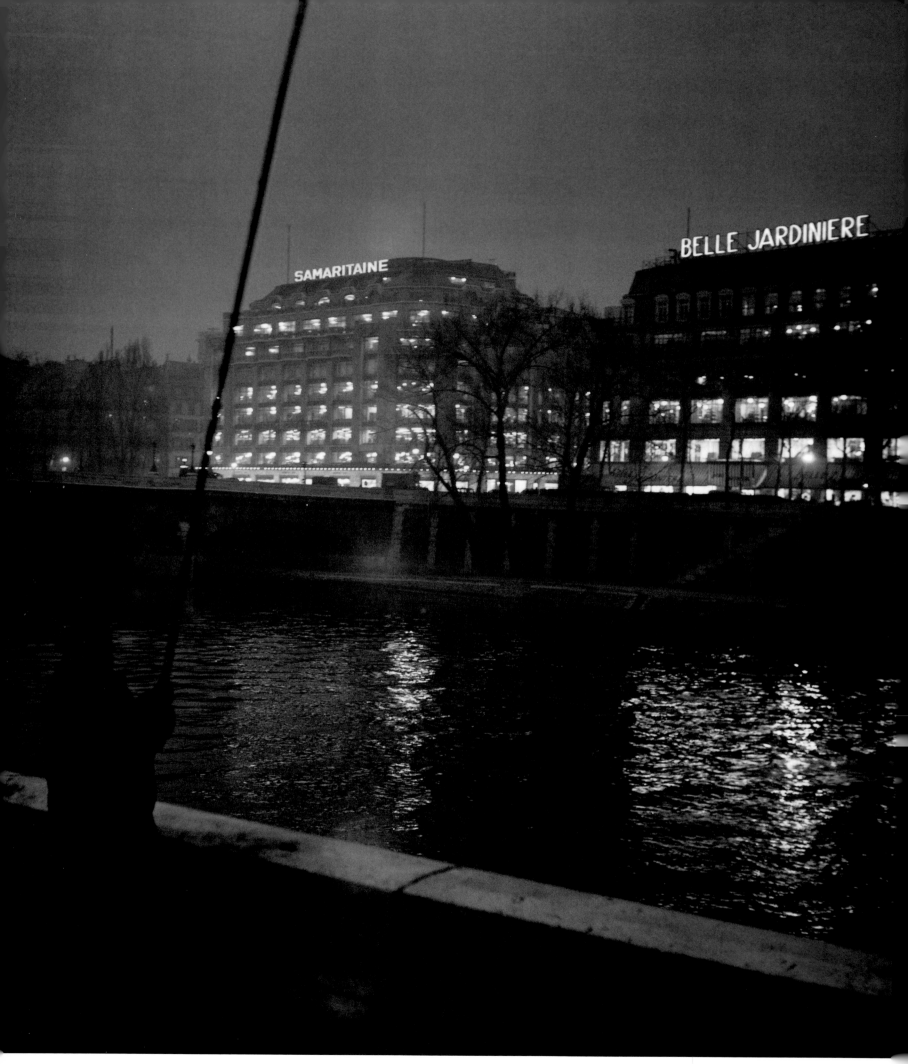

Night-time angler, 1953

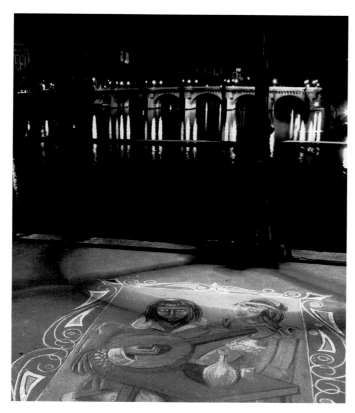

Pont des Arts at night, 1962

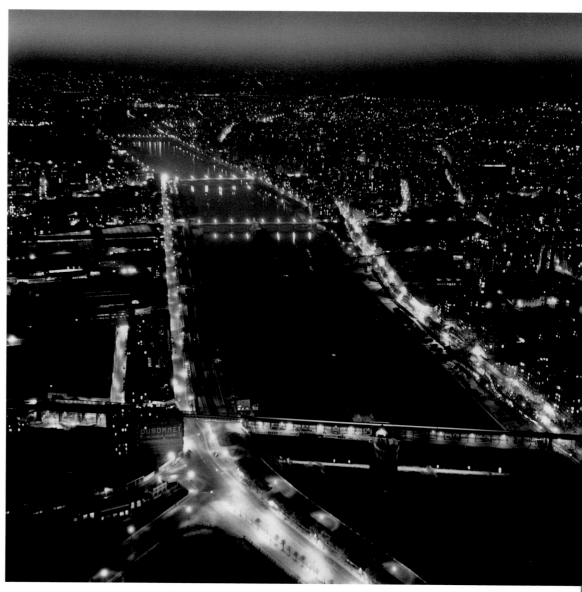

The Seine at night, 1955

[PARIS

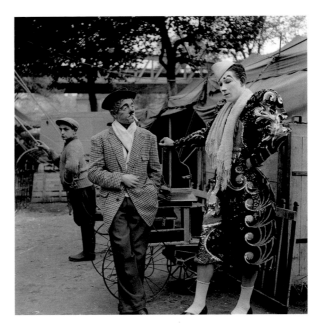

Maïs and Mimile, the Fanni Circus, 1951

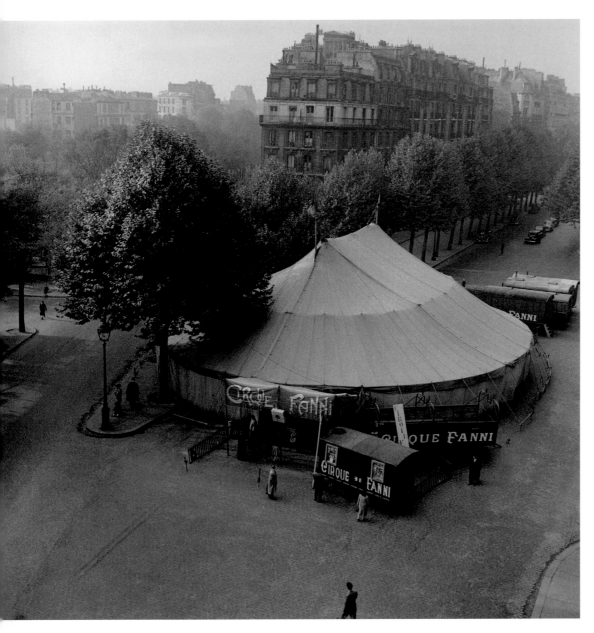

The Fanni Circus Tent, 1951

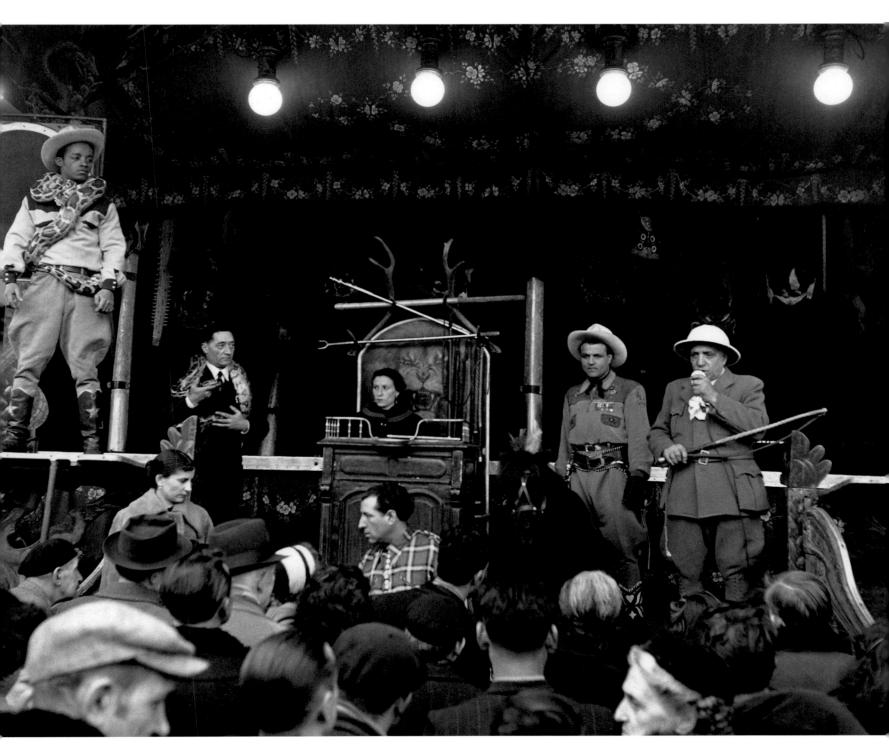

Lambert Carrousel, place Denfert-Rochereau, 1952

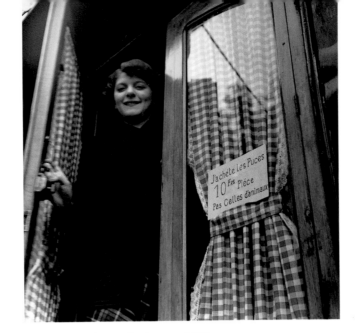

Mademoiselle Wagner, 1950

Flea circus, April 1950

In a theater scaled down to the size of the actors, the audience stood in a ring around a table. Given the strong lighting, Monsieur Wagner clapped a visor over his eyes, like the ones worn by croupiers and newspaper editors in American movies.

He swung a huge magnifying glass in a circular movement, so that people could clearly see a microscopic Roman chariot, a hearse, a canon, and I can't remember what else. The beasts of burden harnessed by brass threads showed signs of a certain independence as the parade advanced in jerks. Monsieur Wagner corrected the trajectory with a pair of tweezers, all the while delivering his spiel in a confidential tone. 'Just look at little Victor pulling the carriage all by himself, see how he has to yank to get going, look how strong he is, he can pull five hundred times his own weight. Now we have the flea funeral, tiny Victor follows behind—take it easy, little family. Step up, folks, no need to wait. Now here are the fleas in the country, working the land, it's good to see such healthy, strapping fleas. Now we have the fleas at a costume ball, isn't it strange and funny. Step up, no need to wait. The footballer who kicks the soccer ball on command is a lady, Louise. That a way, Louise! She's two years old. The other one is Françoise—but she doesn't kick the ball, she spins it round. All so entertaining, no need to wait.'

He had to keep his audience hooked. I didn't write it all down. But the concluding joke was always the same: 'Say, where's Victor gone? I seem to be missing a flea. Madam, perhaps you'd better search yourself . . .'

It was family entertainment.

After the final show, Monsieur Wagner turned off the spotlights, removed his visor and carried the jar into his caravan. On the door there was a sign: 'We buy fleas (no animal fleas, please).'

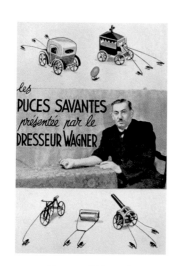

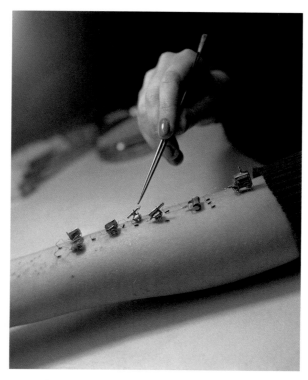

Monsieur Wagner's
advertising sticker

Fleas at work, 1950

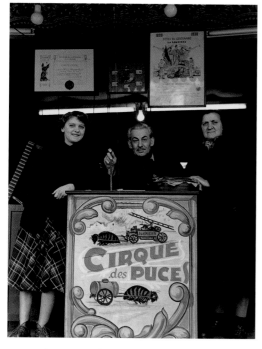

The Wagner family, 1950

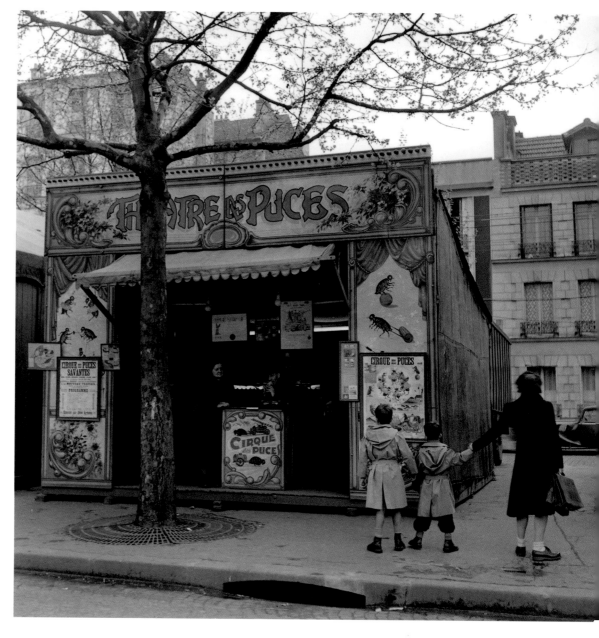

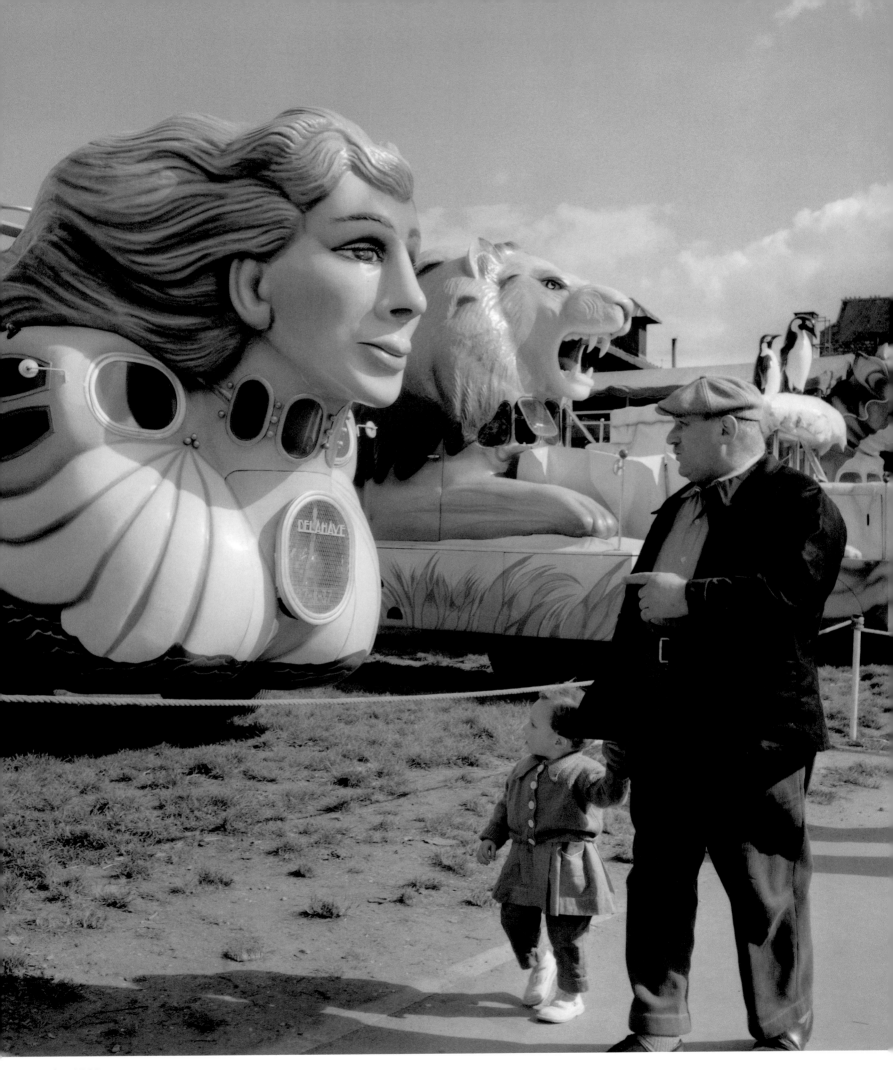

Fun fair, 1955

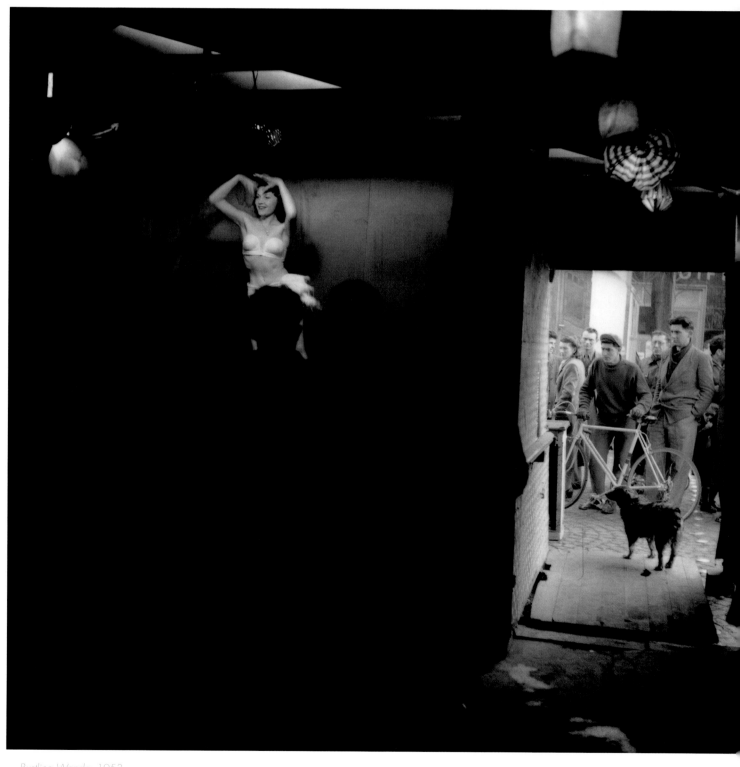

Bustling Wanda, 1953

Mountebanks, place de la Bastille, 1944

" The way a photographer composes an image is not unlike the rectangle that mountebanks and gypsies sketch around themselves in public places with their carpets and caravans, creating what urban theorists call 'leisure spaces.' "

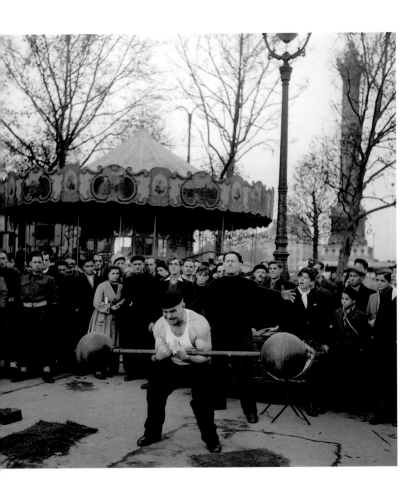

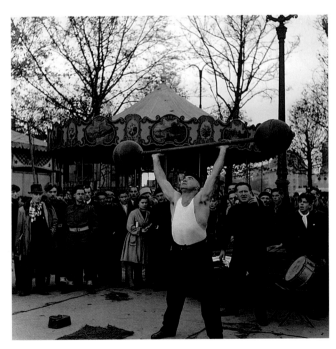

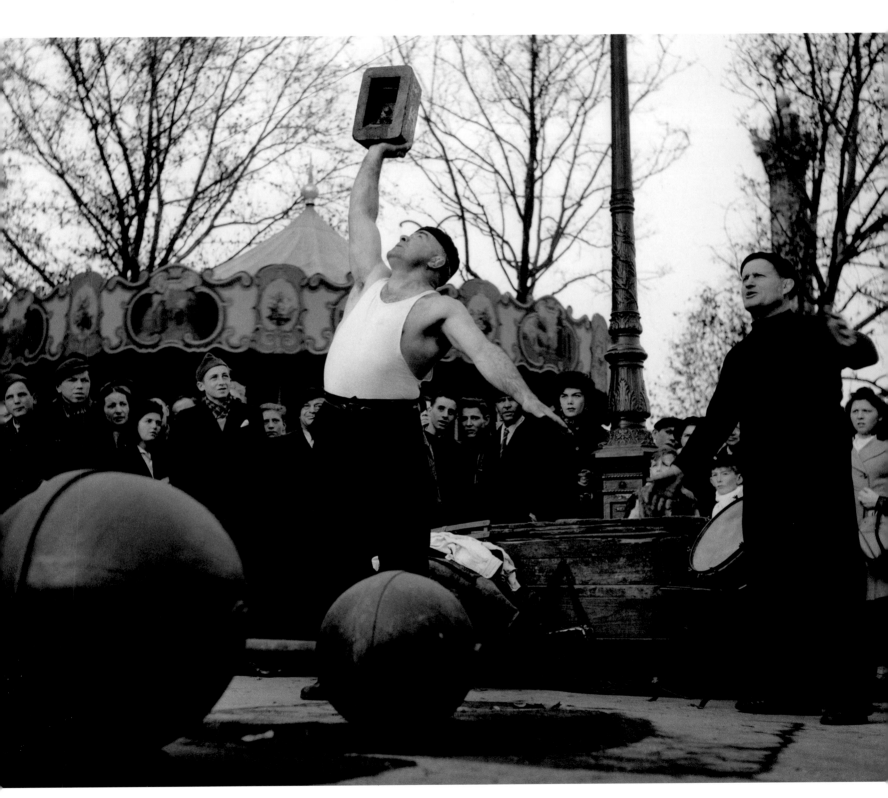

Following pages: Bumper cars, 1953

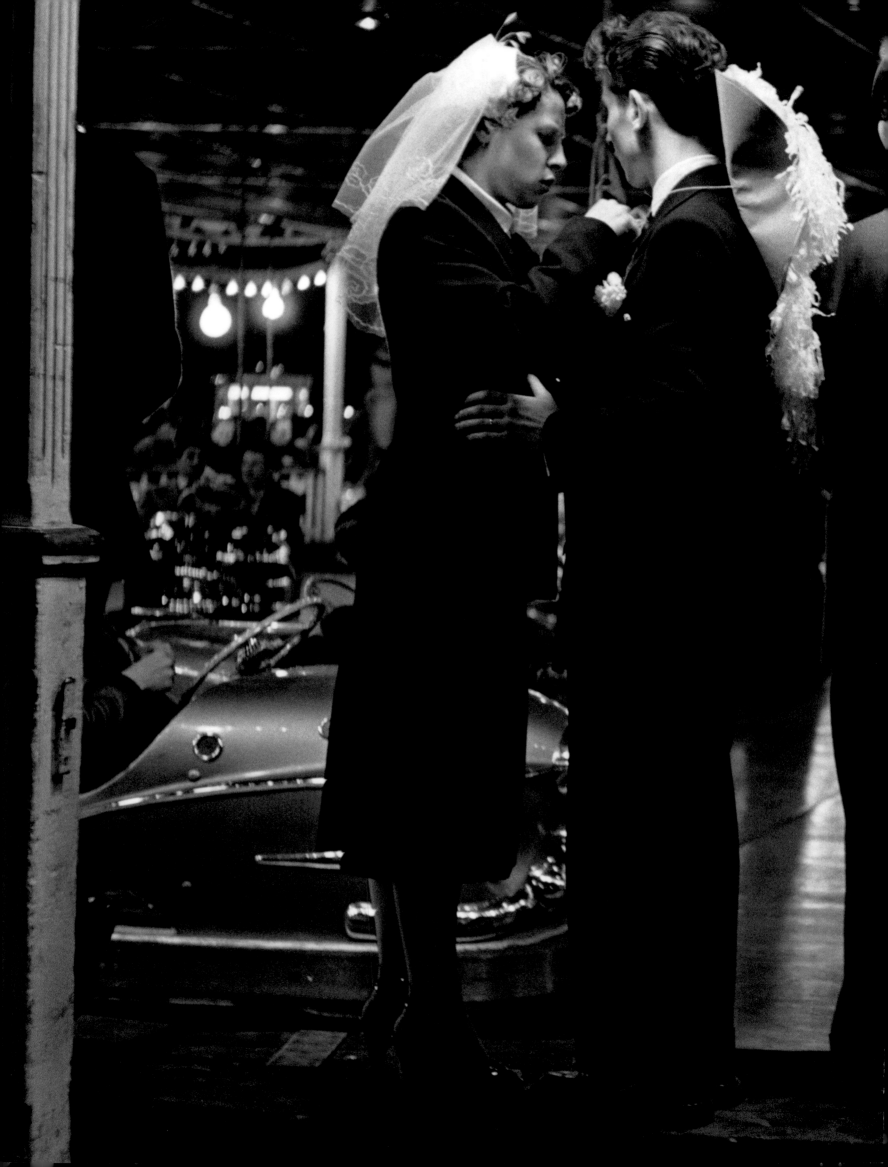

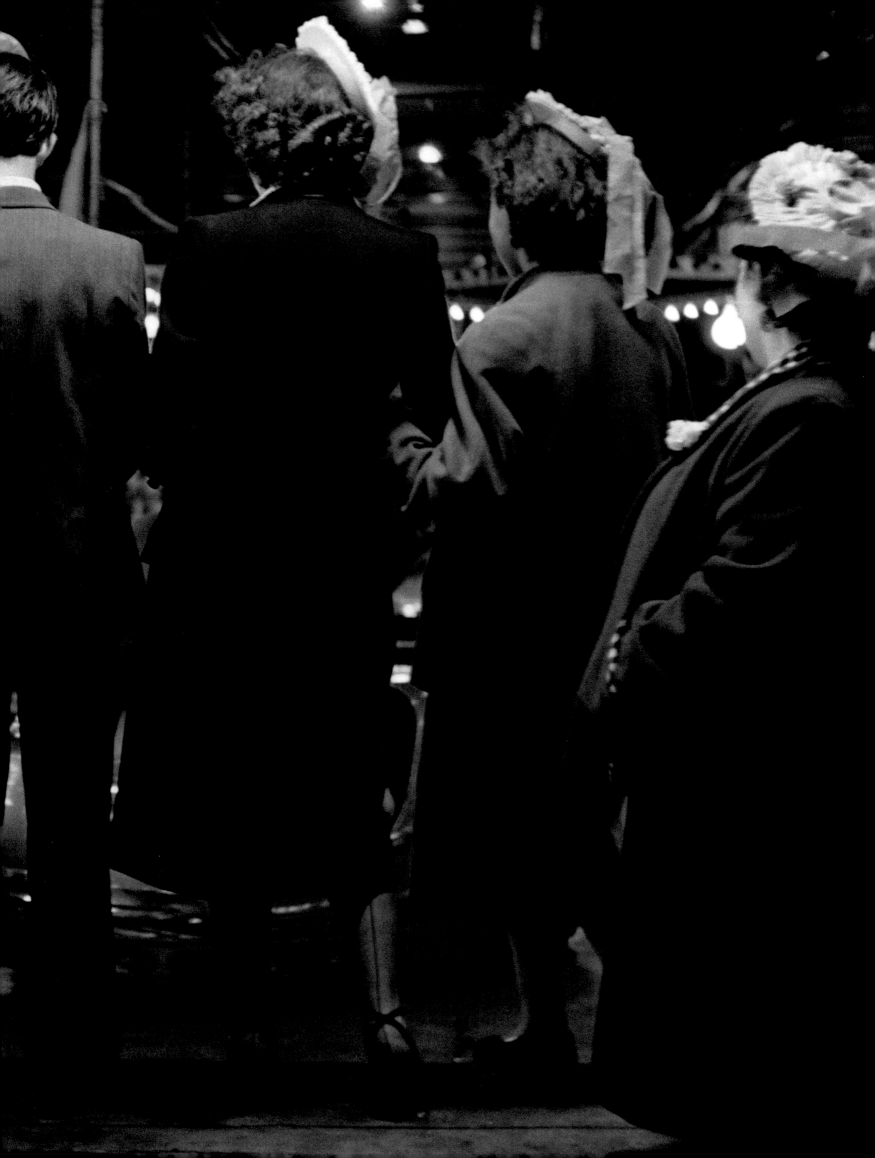

Ghost Train, 1953

" The Ghost Train at the annual Foire du Trône. The ride is noisily mechanical—from the outside, you can hear the screams, then suddenly: bang! The door opens and out comes a car with its terrified occupants. People pay good money to be scared out of their wits. "

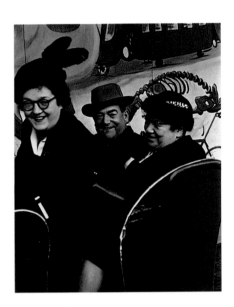

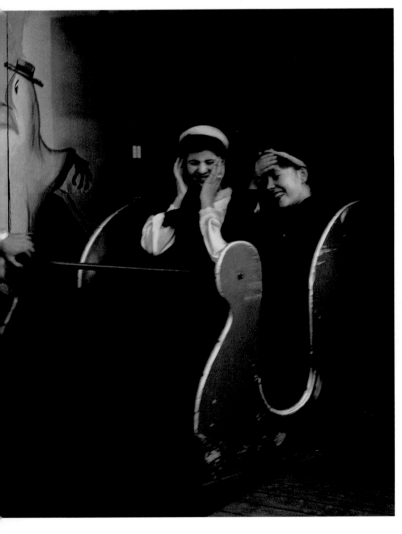

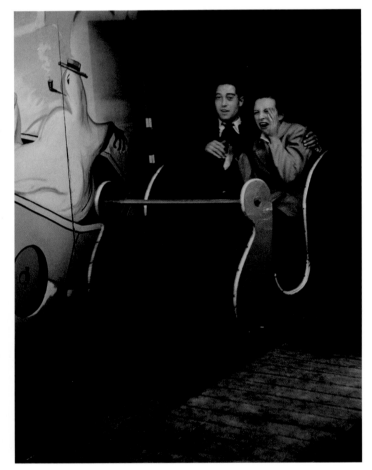

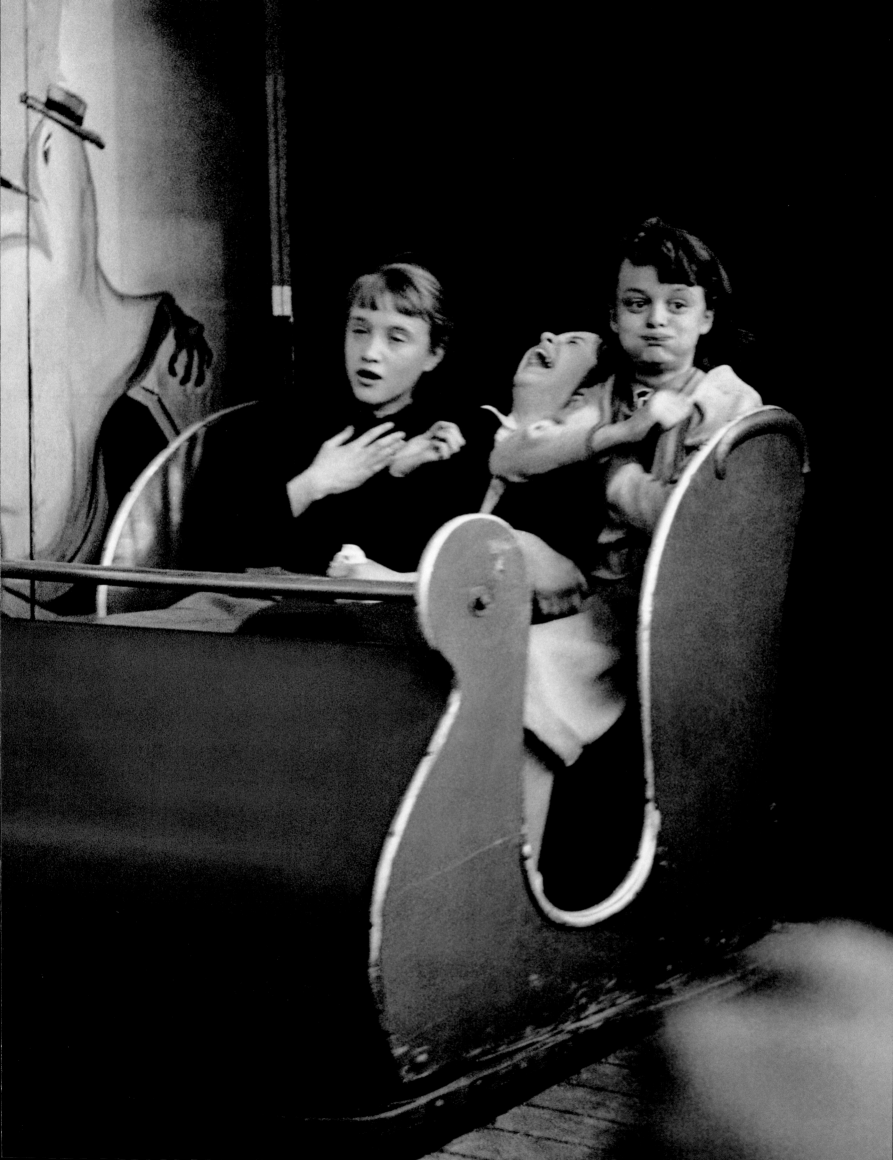

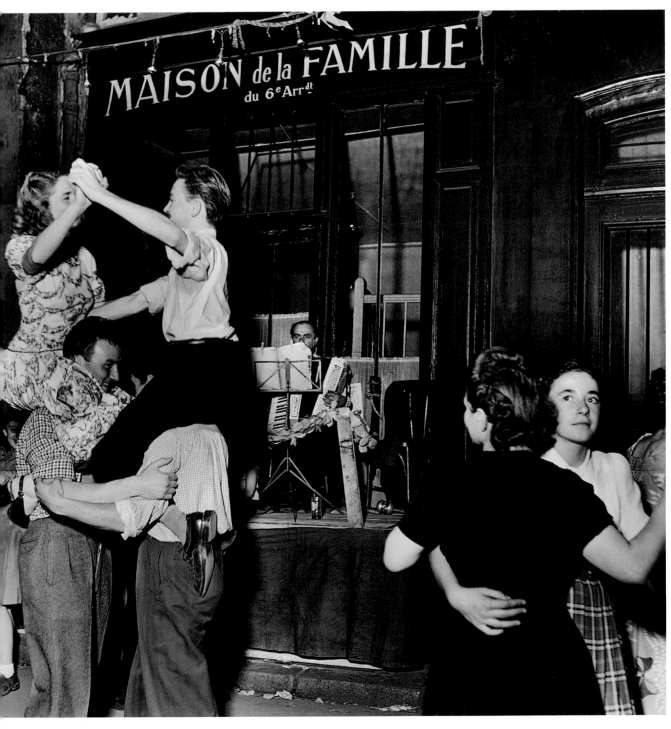

Bastille Day, 1949

FACING PAGE: *The Last Waltz on Bastille Day, 1949*

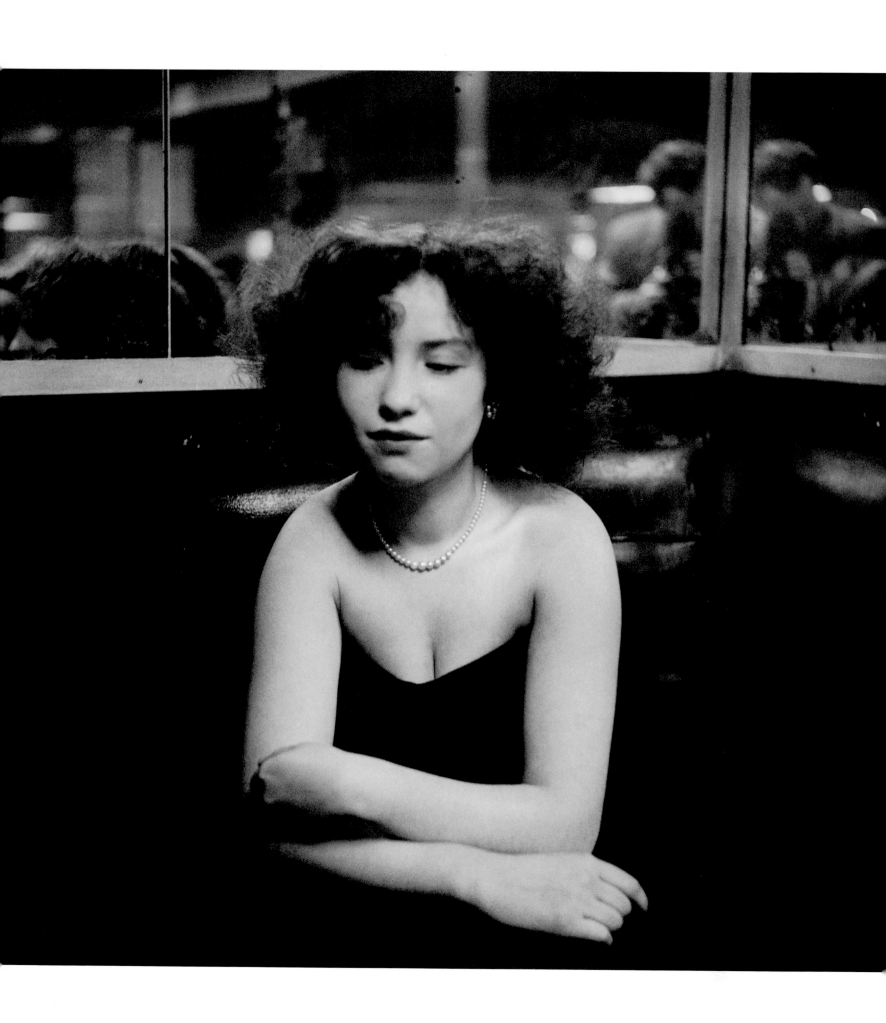

Mademoiselle Anita, 1951

" Aura is the name given to that kind of neon light that glows around certain people, setting them apart for a brief instant.

You have to snap it quick because movement can destroy it: 'Don't move, please, don't change anything, I'll explain later.'

She must have been aware of the effect she was creating, because she didn't even raise her eyes, she stuck to the pose of stubborn modesty that suited her so well.

She wanted to be a dancer. But a photographer approached her in 1951, and ever since that day Anita hasn't budged. "

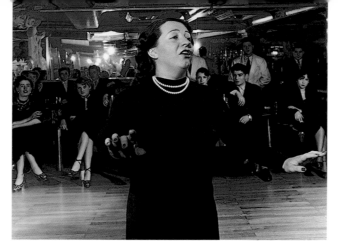

Jane Chacun at La Boule Rouge, 1951

" A memorable expedition to the dance halls on rue de Lappe. I was accompanying Emile Vacher and Péguri, hailed as kings of the accordion on every dance floor in town. While waiting for Jane Chacun to sing, I set my Rolleiflex on the floor in order to produce a souvenir of the prettiest legs in La Boule Rouge. "

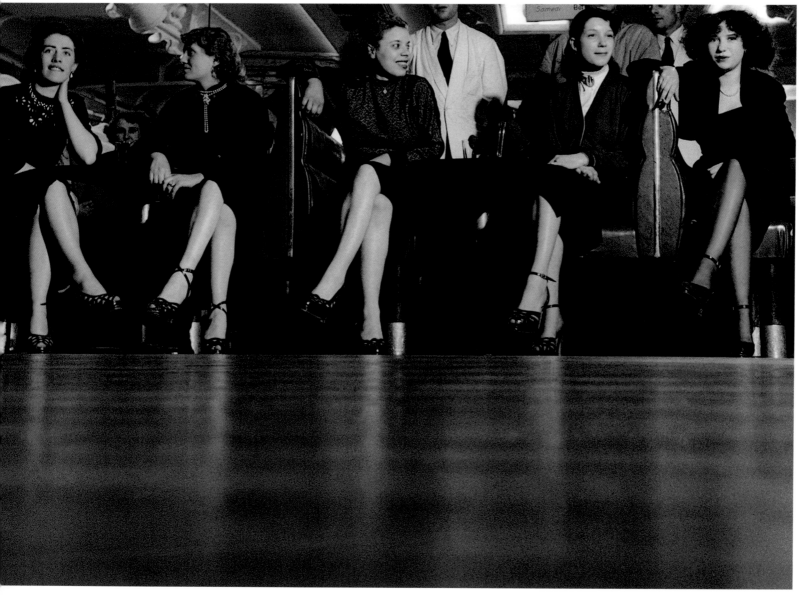

Nylon Stockings, La Boule Rouge, 1951

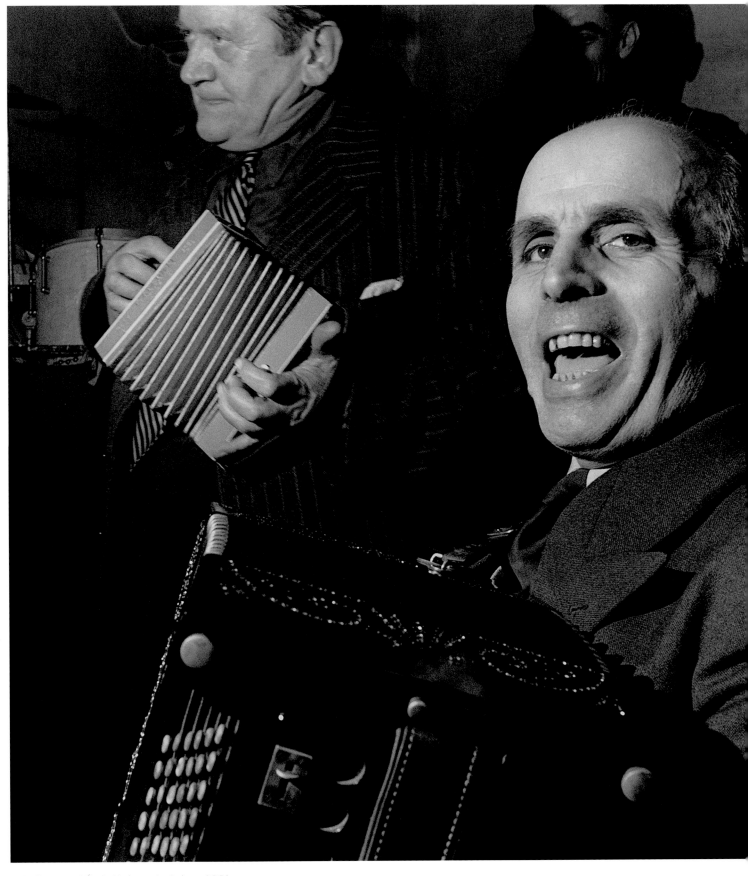

Jo Péguri and Émile Vacher at Le Balajo, 1951

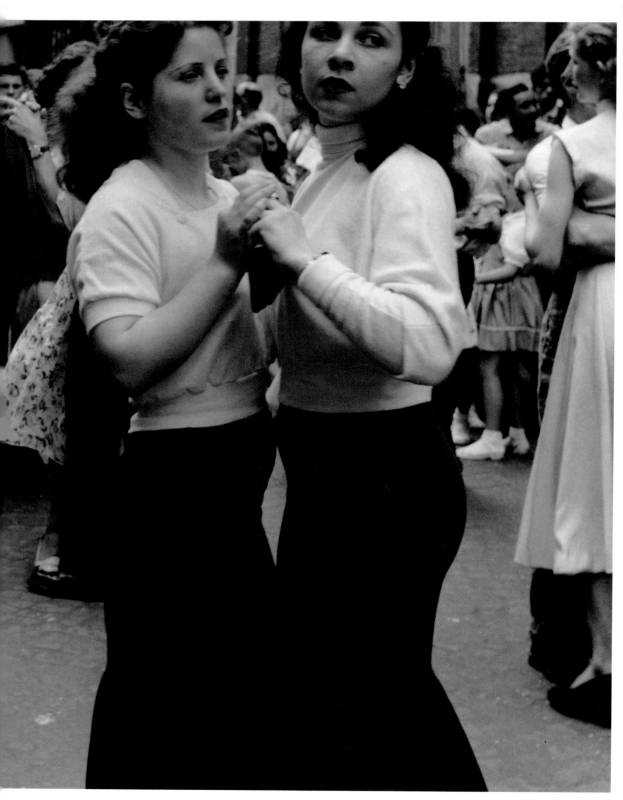

Bellies at Bastille Day Ball, 1955

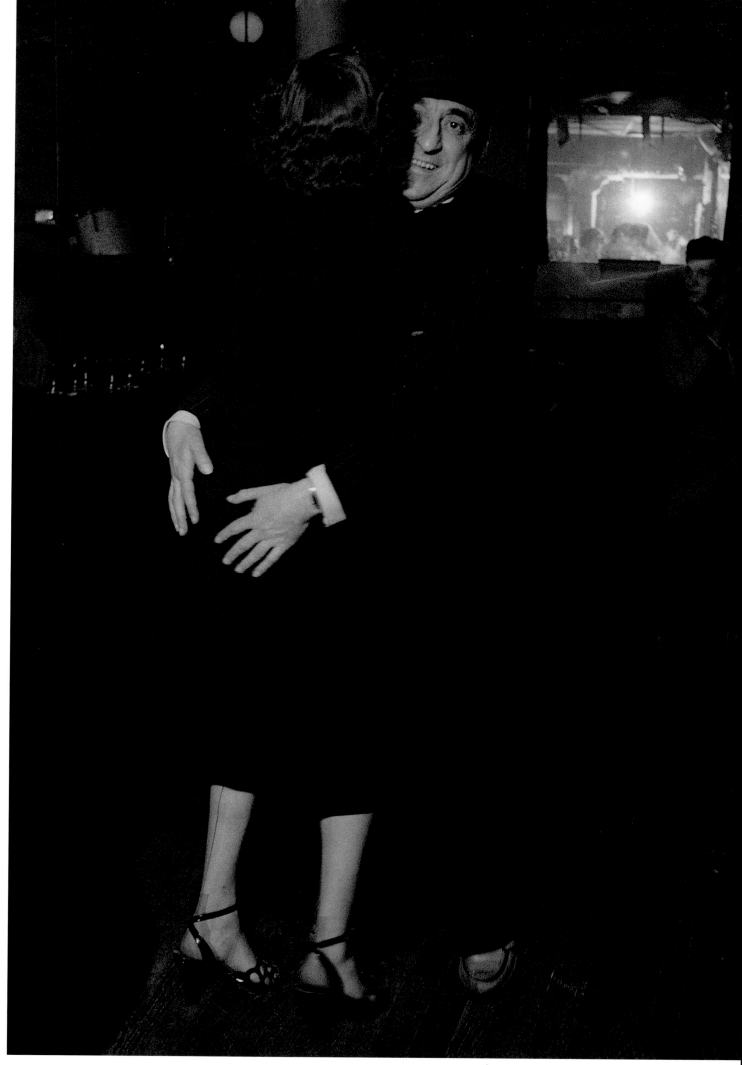

La Java, November 1951

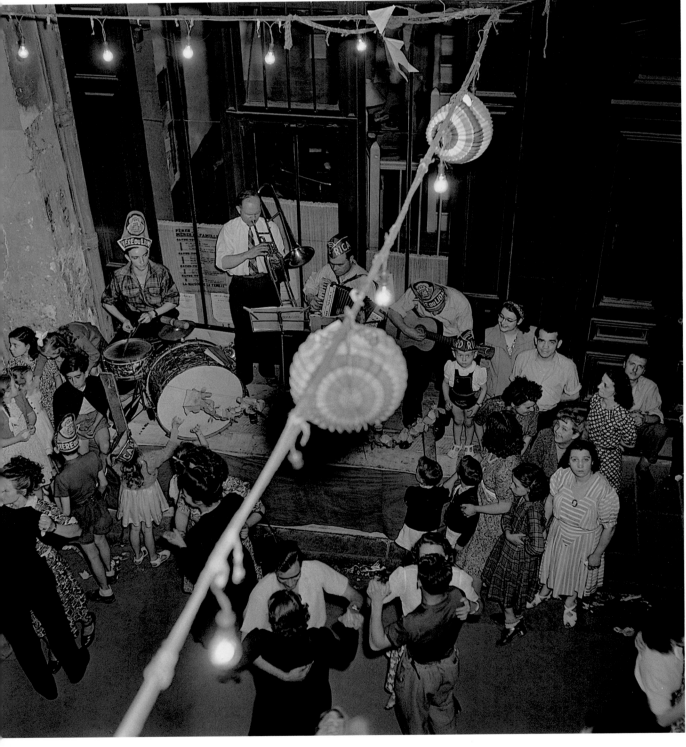

Bastille Day, rue des Canettes, 1949

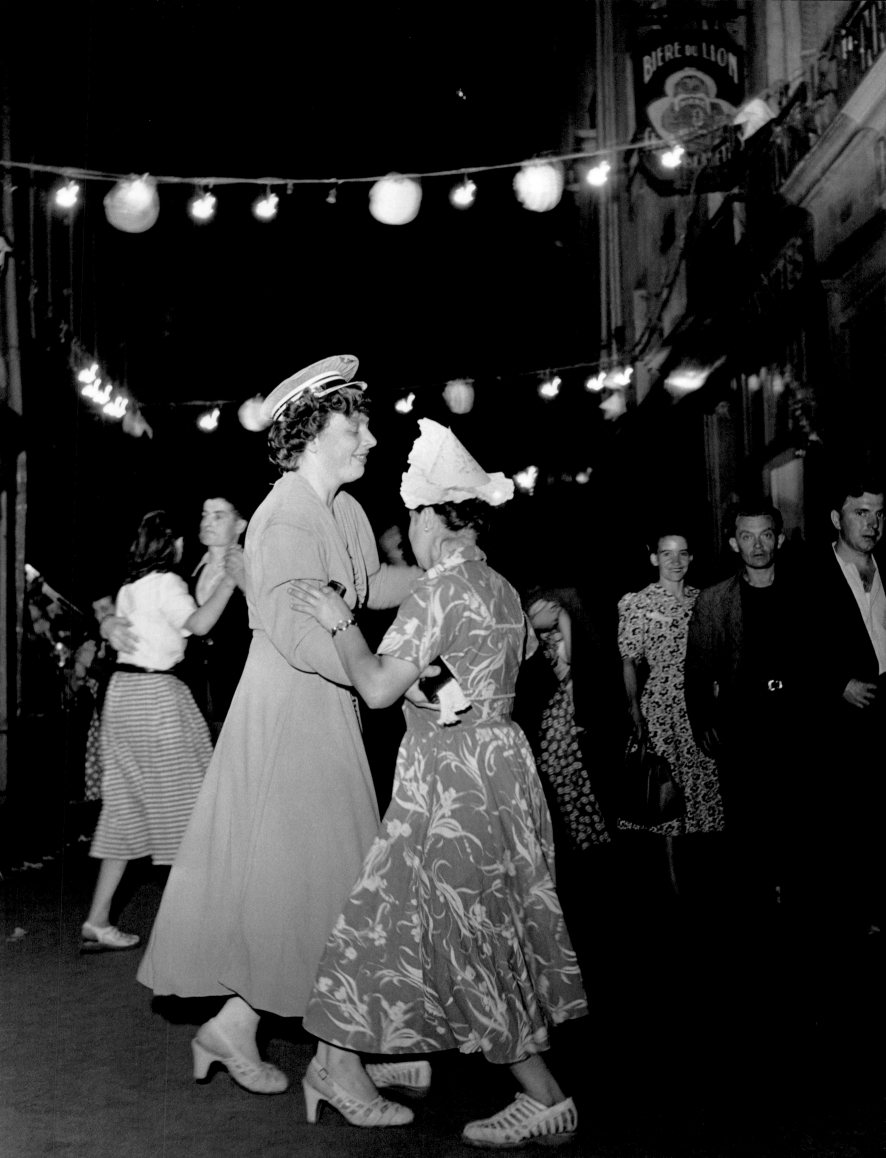

Laughing and dancing, 1945

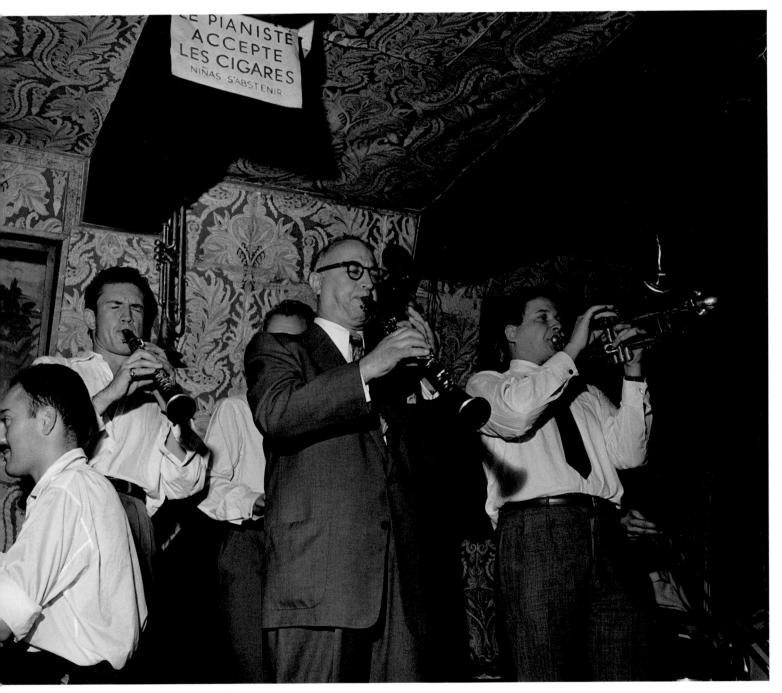

Claude Luter, Mezz Mezzrow, and Guy Lognon at Club du Vieux Colombier, October 1951

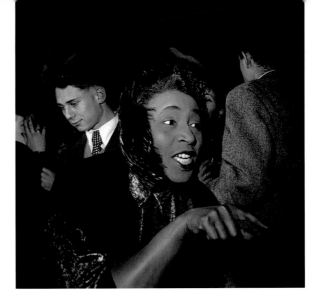

Inès, February 1949

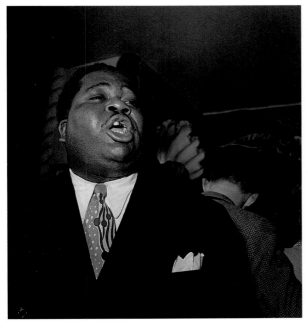

Fats Edwards, 1949

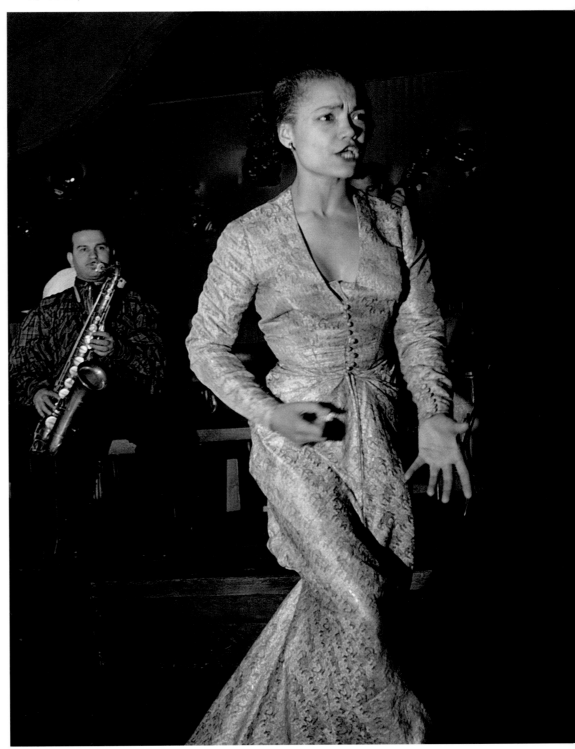

Eartha Kitt, 1950

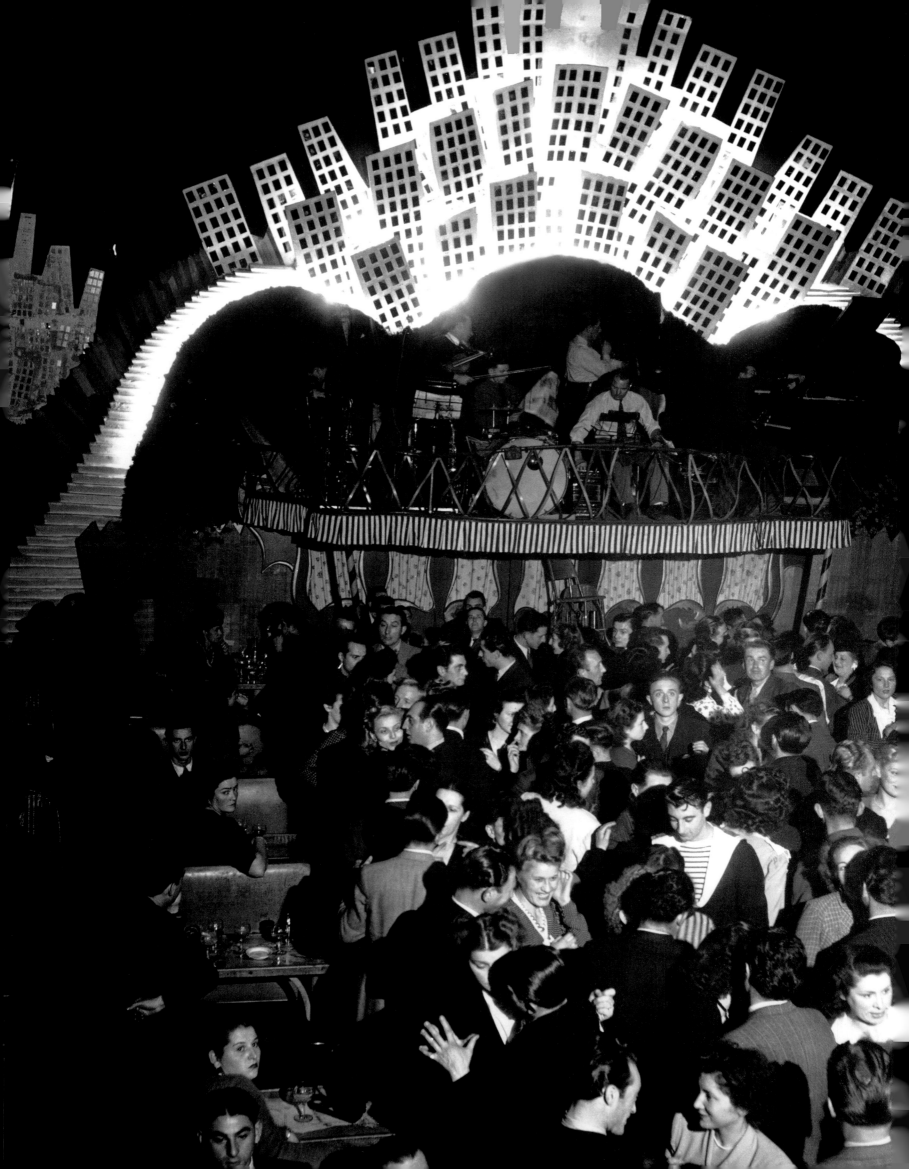

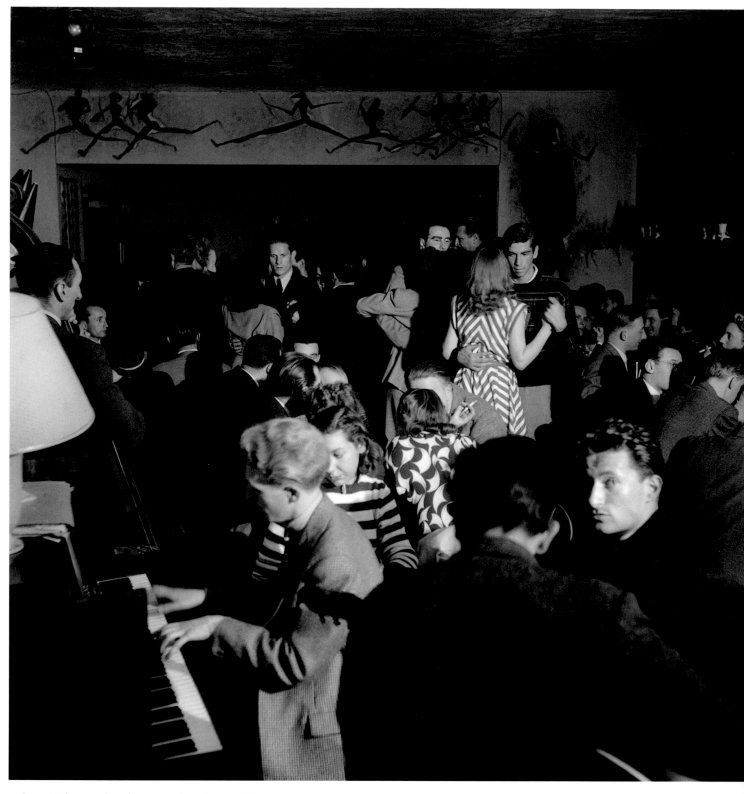

Roger Vadim in a slow dance at La Rose Rouge, 1947

Facing page: Le Balajo, rue de Lappe, 1945

Bebop in a club, 1951

" Claude Mocquery and James Campbell dancing to the music of Claude Luter—boogie-woogie or bebop—in the Club du Vieux Colombier. "

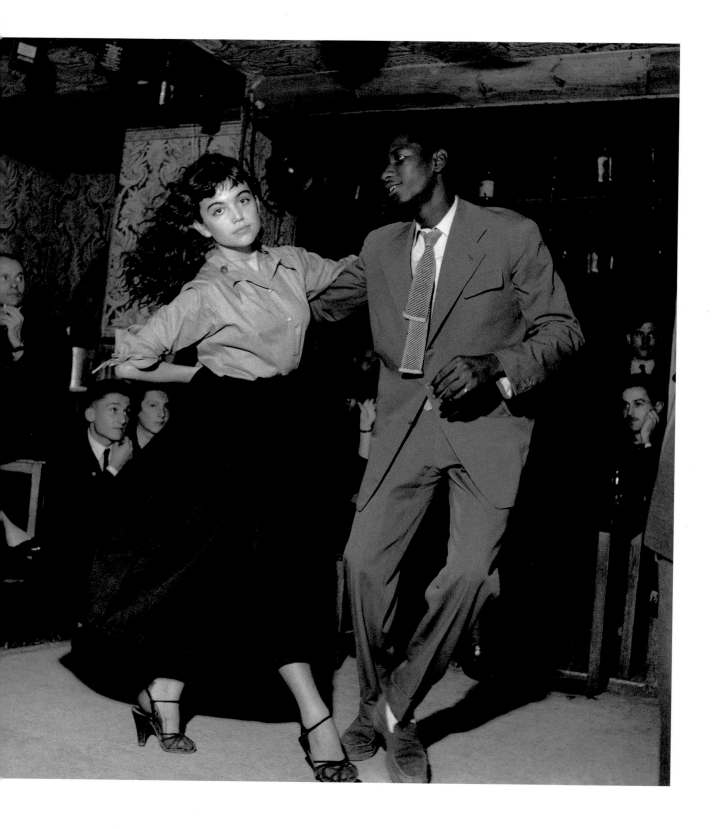

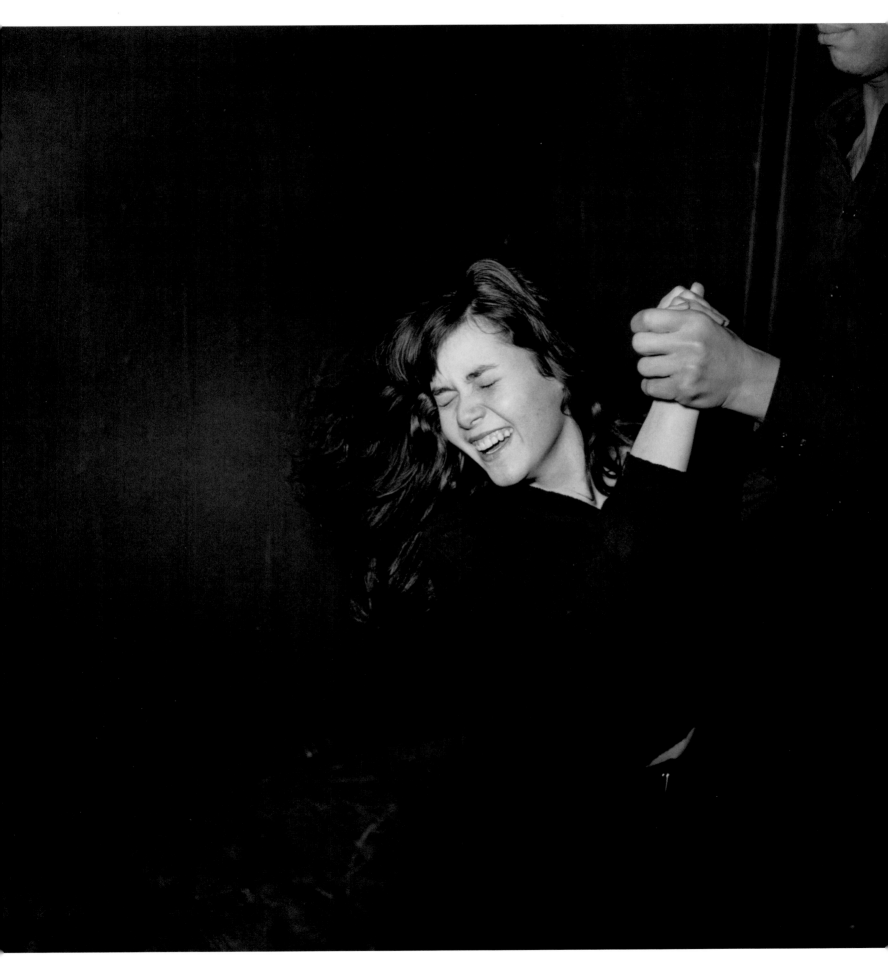

Bebop dancer, 1951

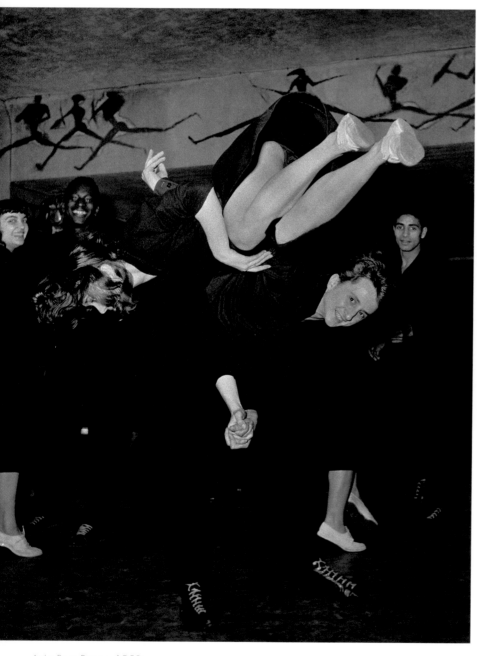

At La Rose Rouge, 1950

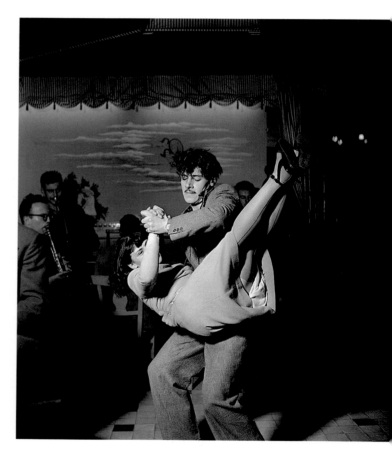

At Le Saint-Yves, 1948

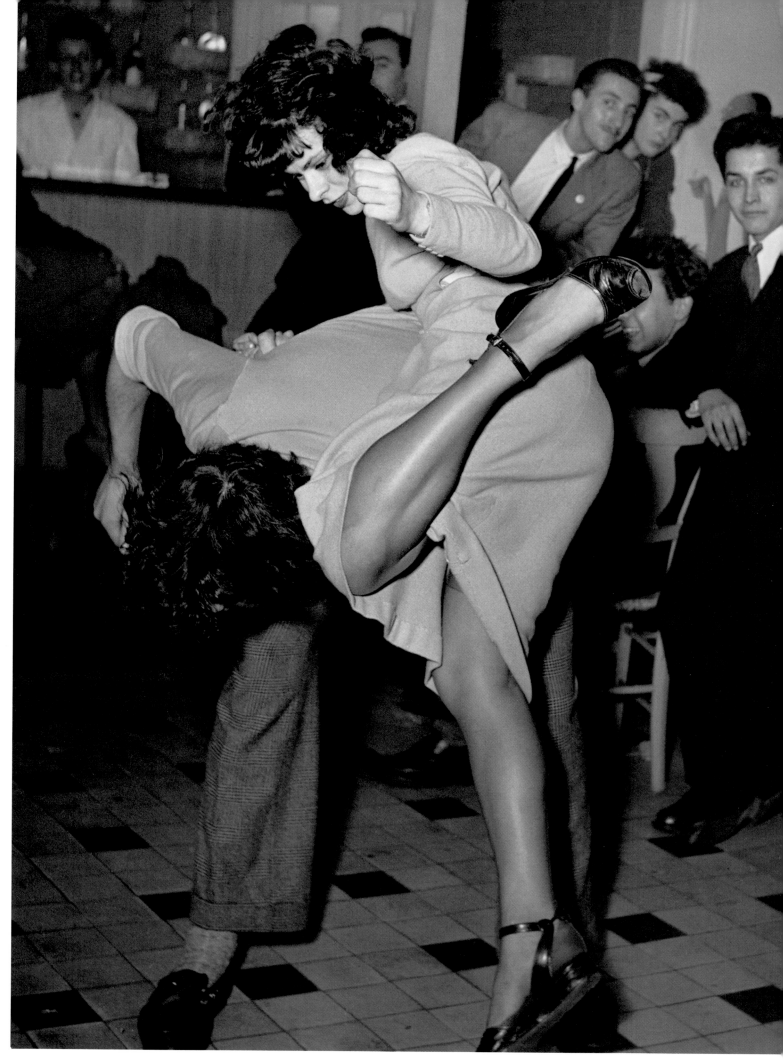

At Le Saint-Yves, 1948

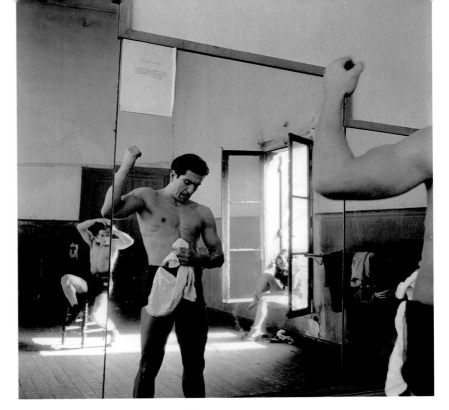

Performer at Rest, Constant Gym, 1946

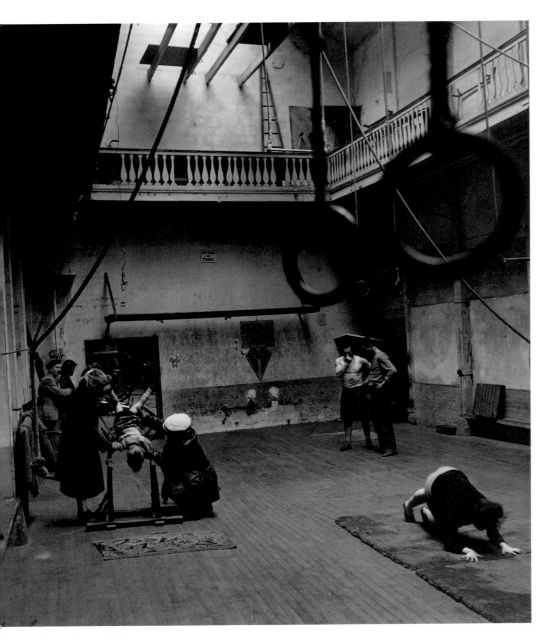

Enagg Gym, 1946

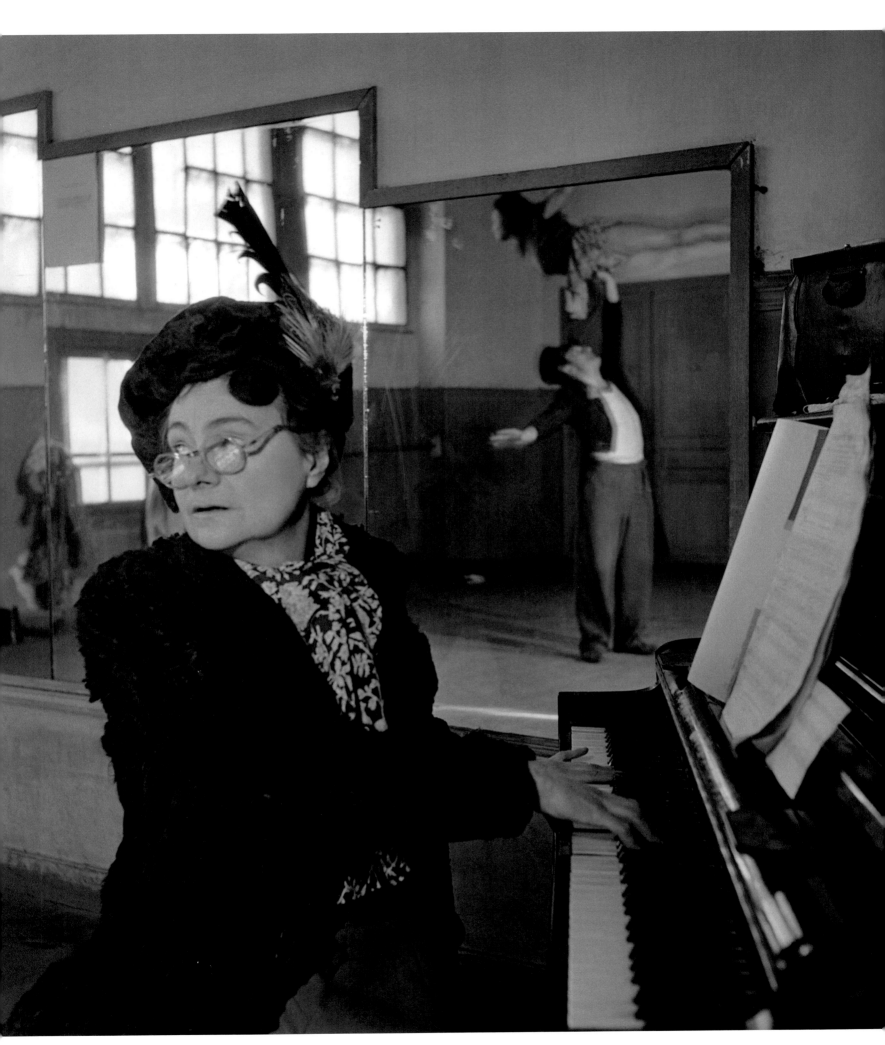

Pianist with Feather, 1946

Constant Gym, 1946

❝ The Constant Gym was subdivided into small studios.
 In each one, there were people training—a couple with a torture act, circus folk, cabaret dancers. The Clerans used to say, 'In order to succeed, you have to rehearse it as many times as there are hairs on your head.' ❞

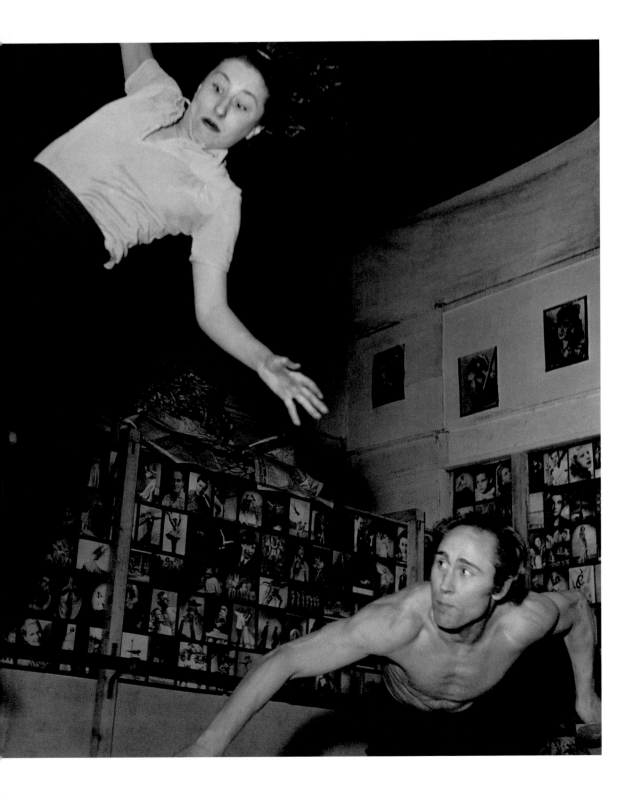

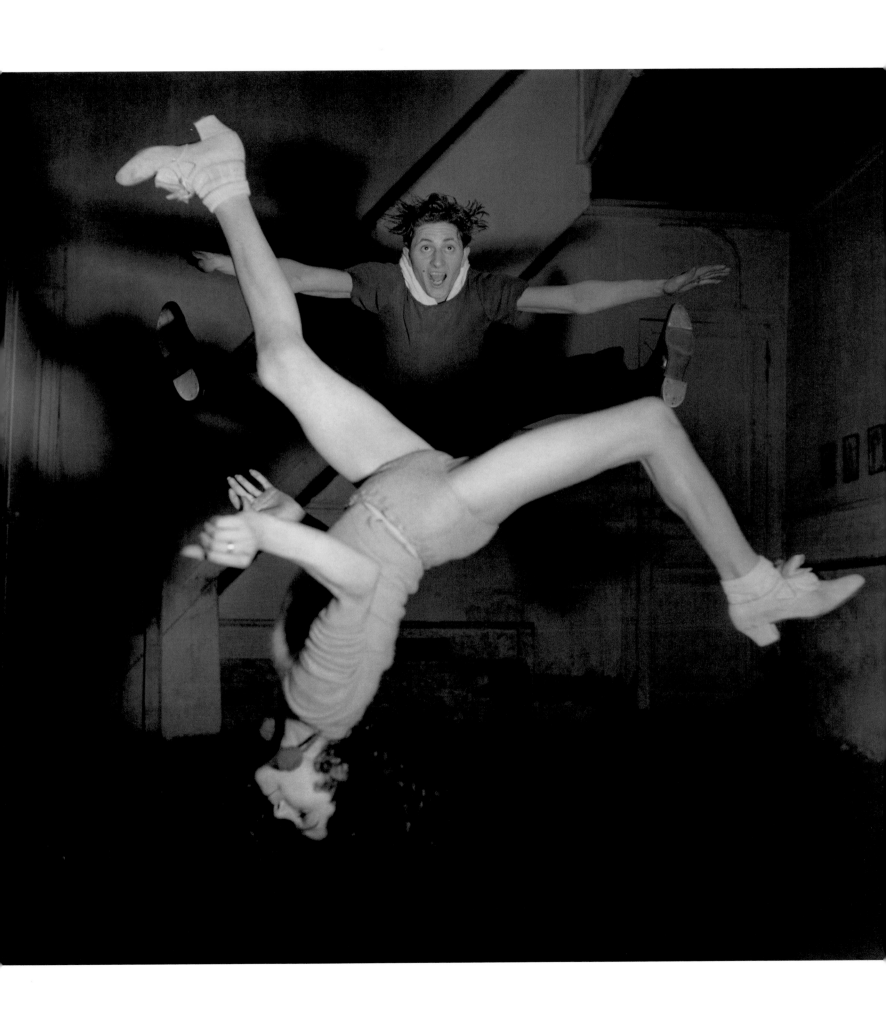

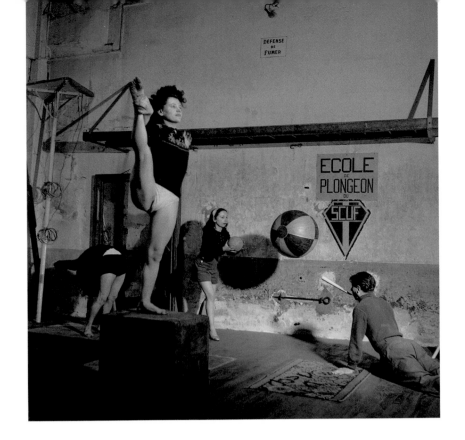

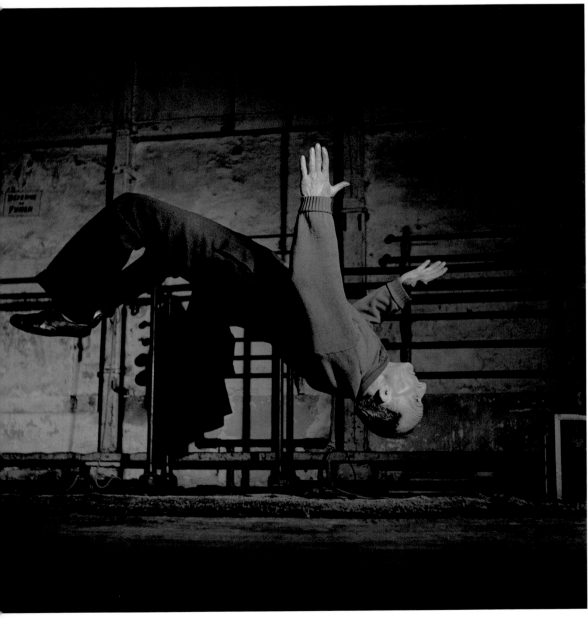

Enagg Gym, 1946

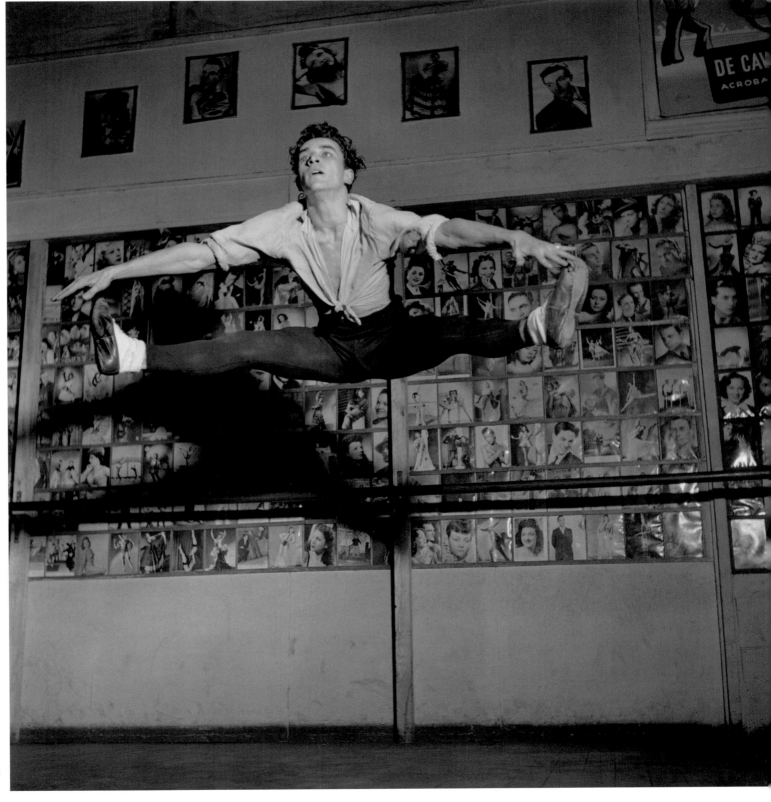

Leaping, Constant Gym, 1946

CONCERT MAYOL, 1952

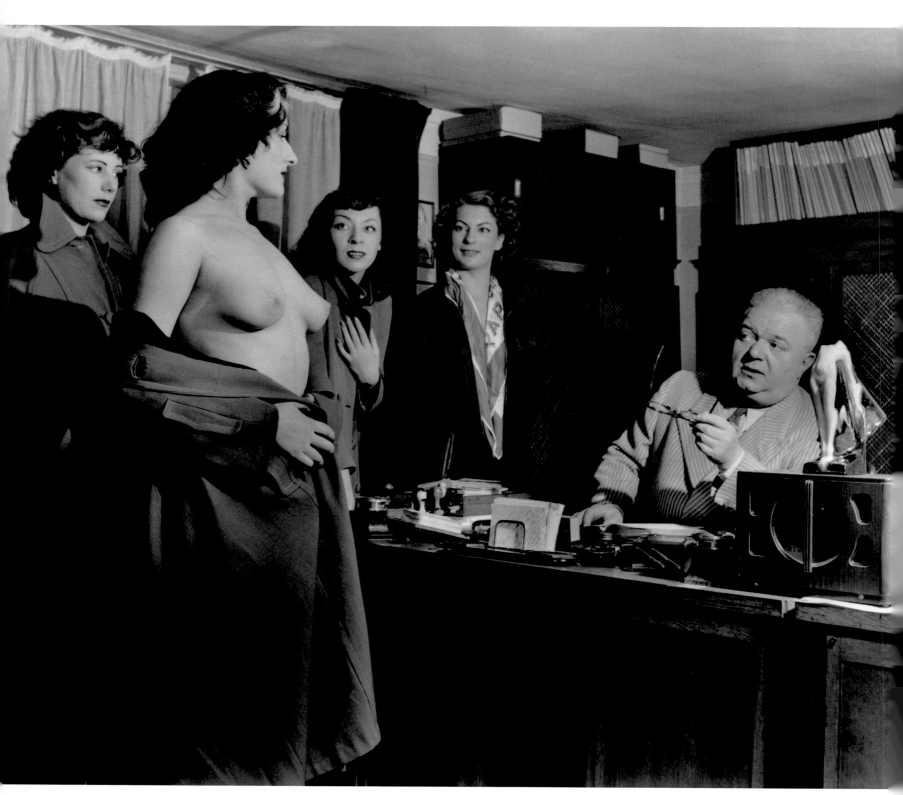

Selection for the Concert Mayol music hall

FACING PAGE: Backstage at the Concert Mayol music hall

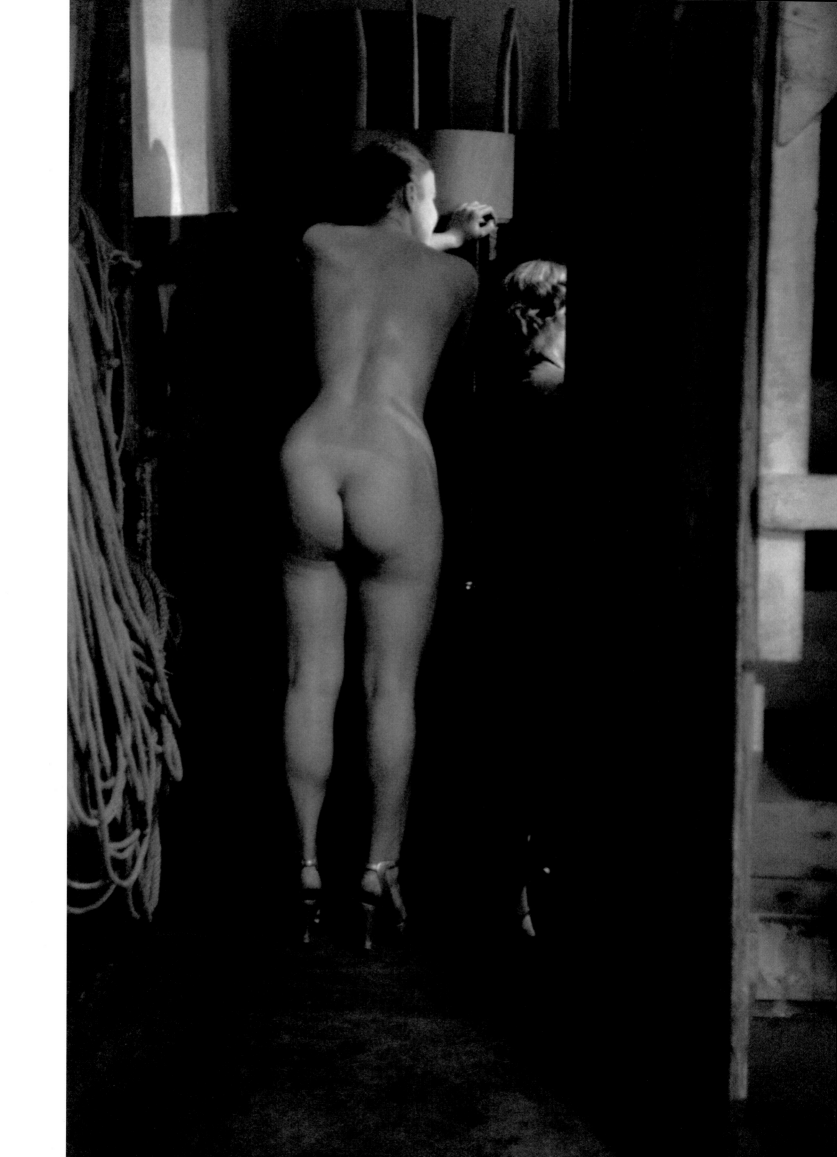

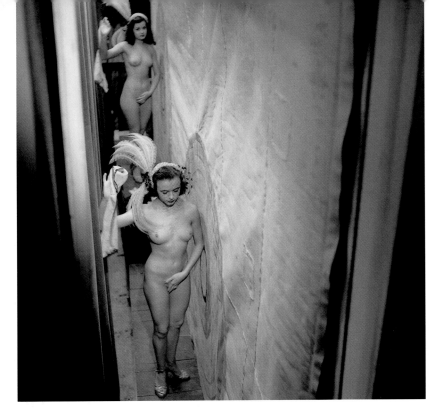

Nude dancer

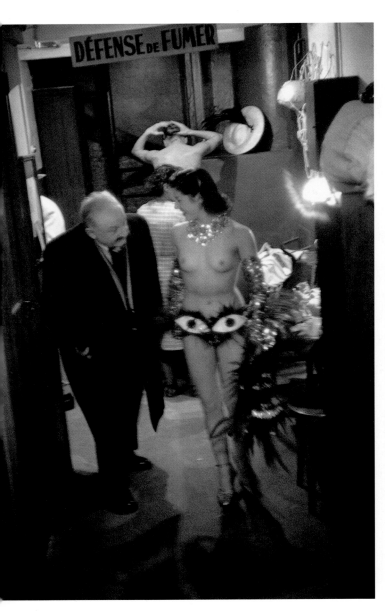

Respectful homage

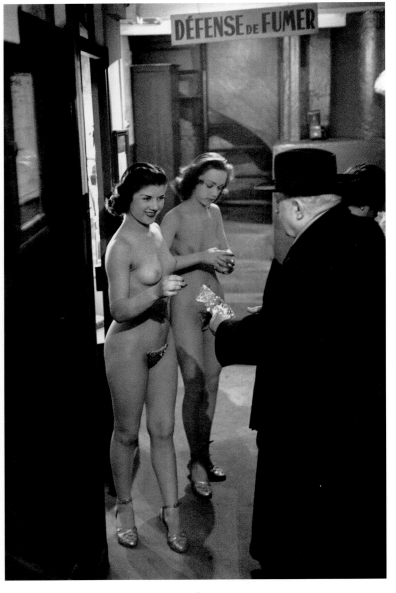

Sweeties at the Concert Mayol music hall

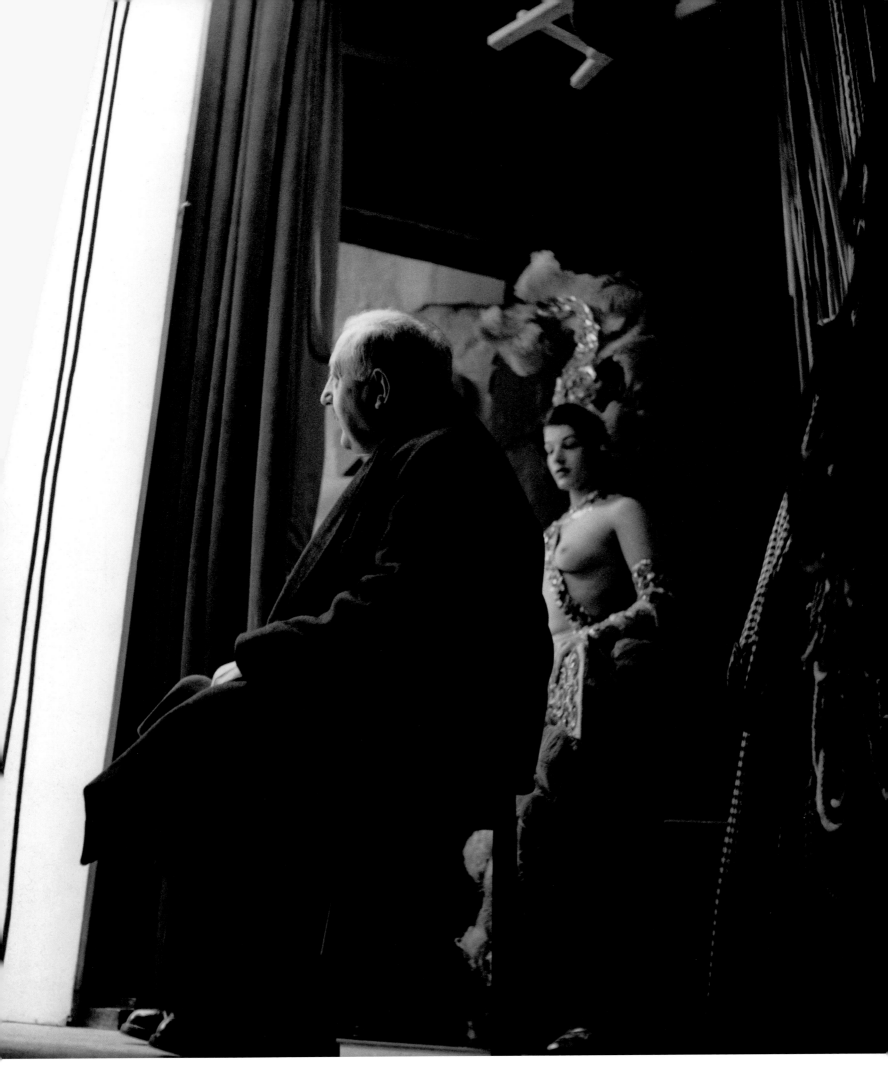
Spectator backstage

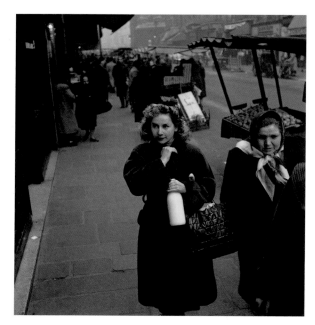

Mademoiselle Vivin, 1953

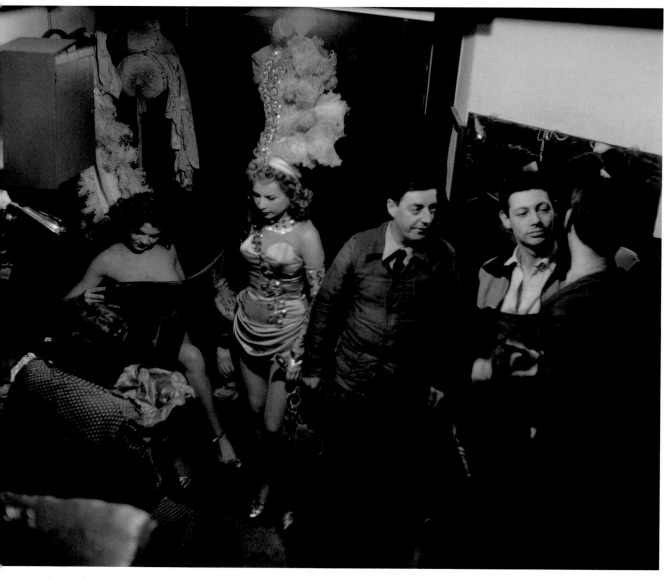

Mademoiselle Vivin's dressing room, 1953

Facing page: Mademoiselle Vivin greets, 1953

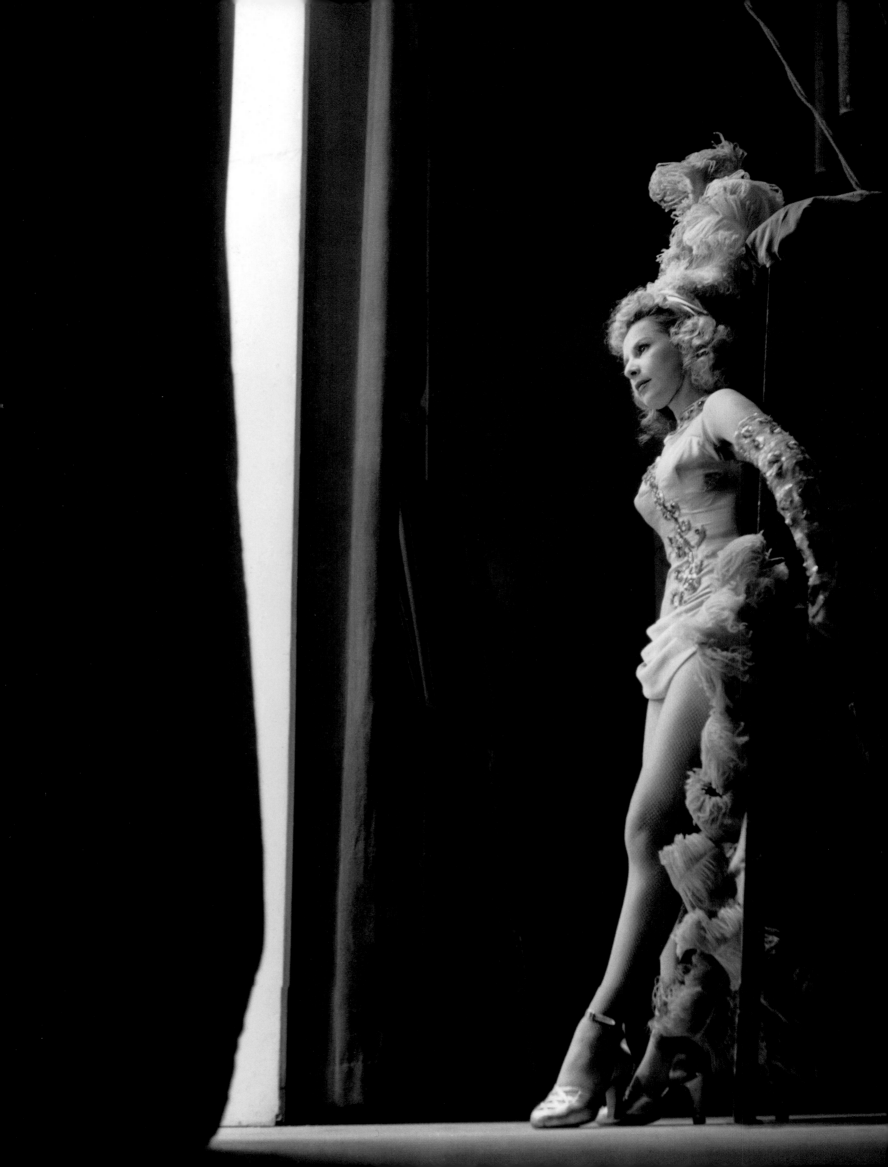

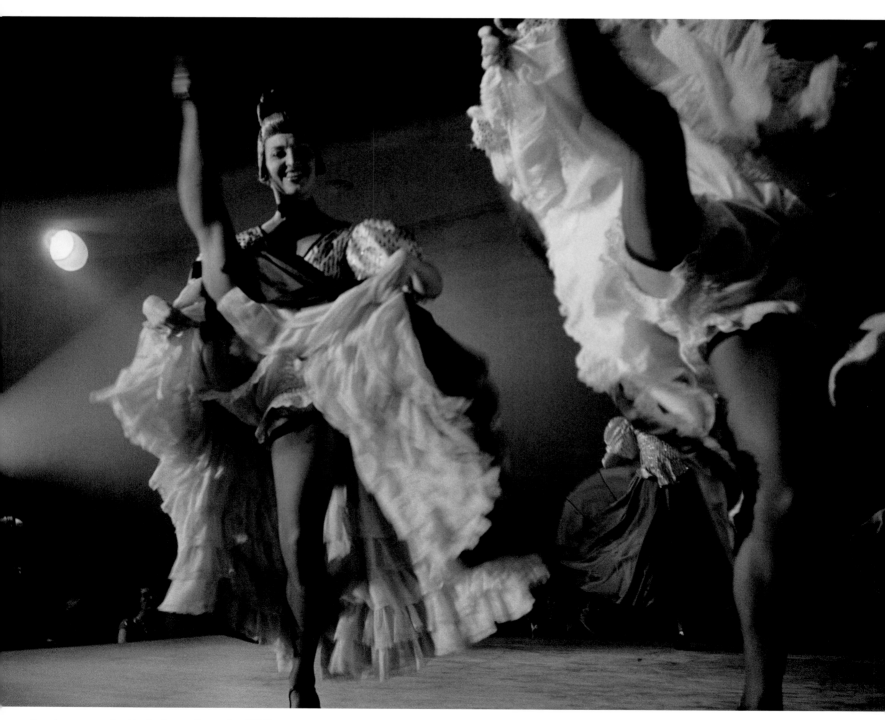

French cancan at the Moulin Rouge, September 1955

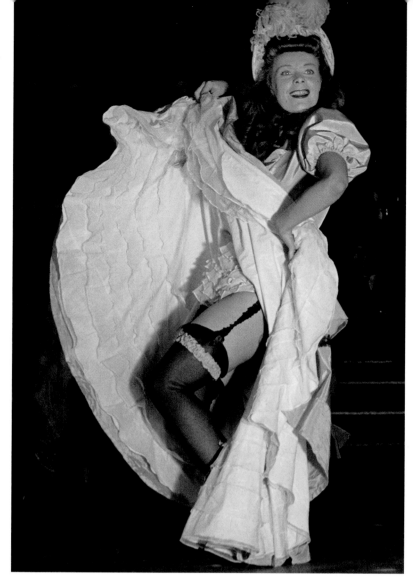

French cancan at Le Tabarin, 1949

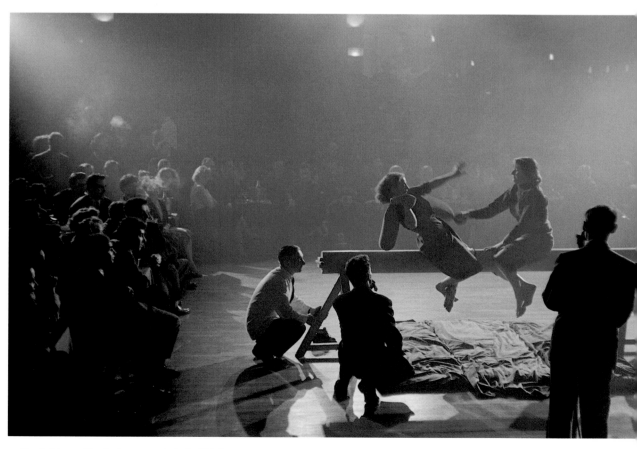

The Robinson Moulin Rouge music hall, 1953

FOLLOWING PAGES: The balcony, 1953

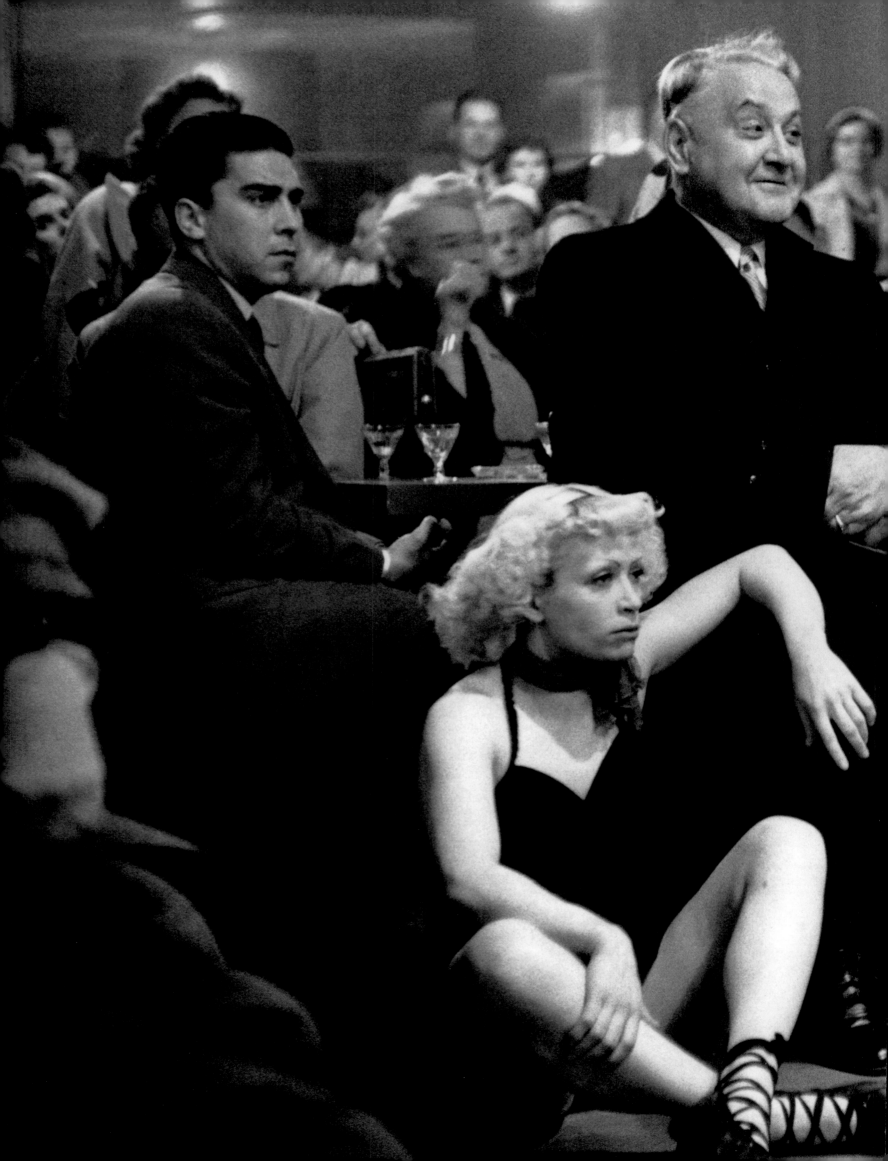

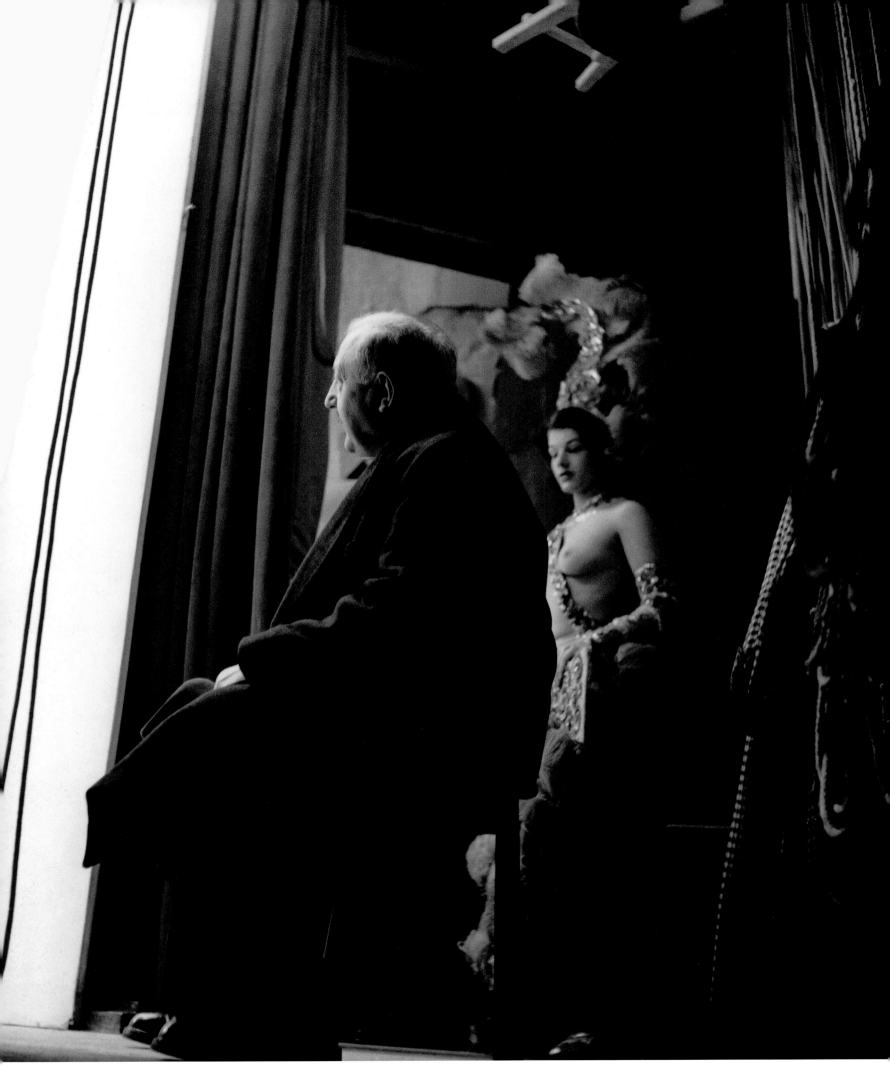

Spectator backstage

Mademoiselle Vivin, 1953

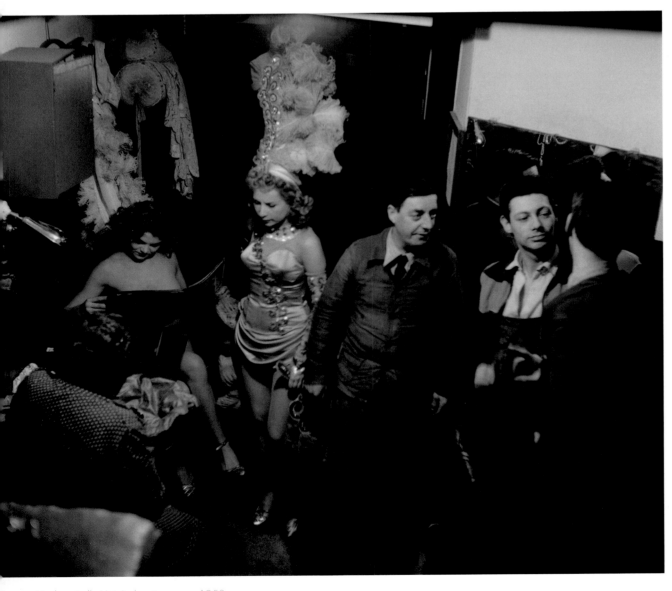

Mademoiselle Vivin's dressing room, 1953

FACING PAGE: Mademoiselle Vivin greets, 1953

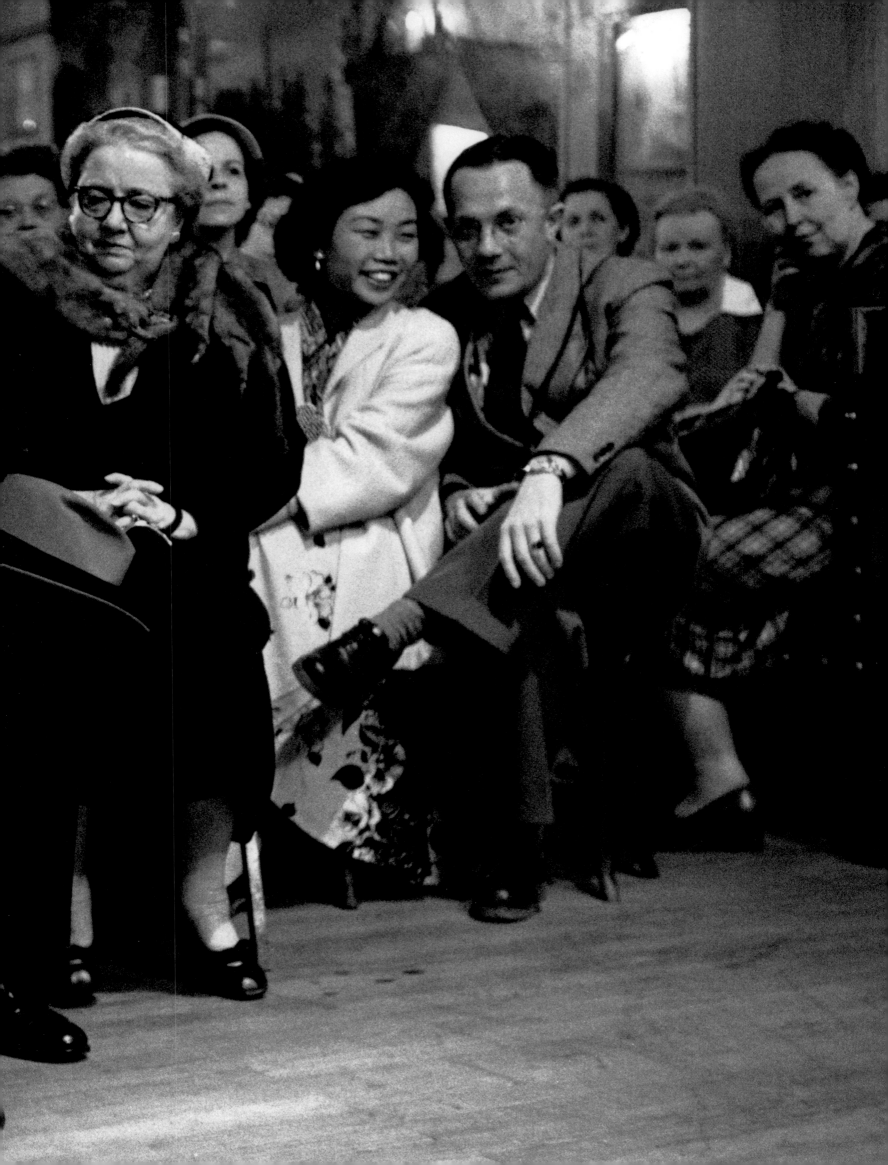

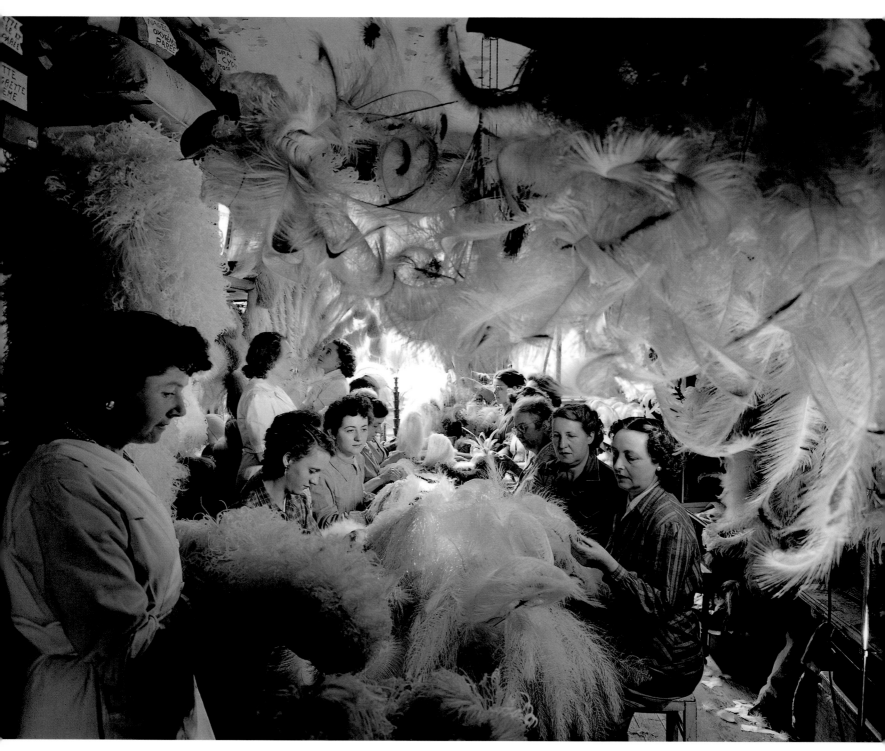

Plume-makers from the Ferier company, 1954

Airborne dancers, Casino de Paris 1970

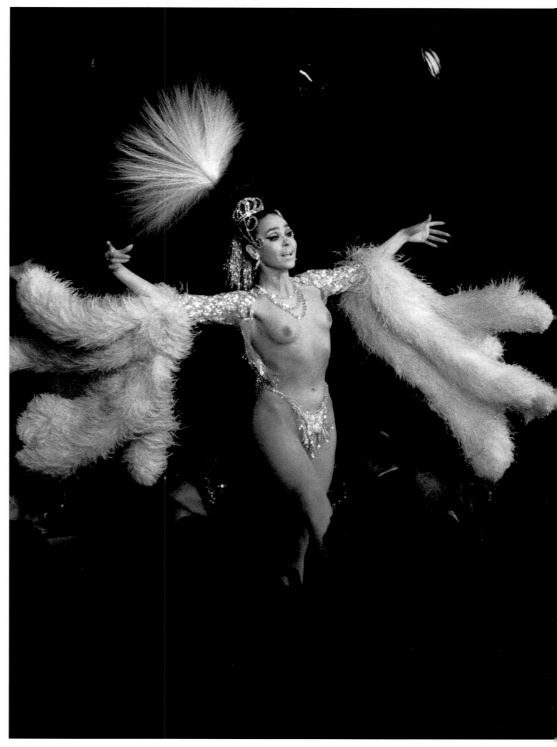

Lido, November 1969

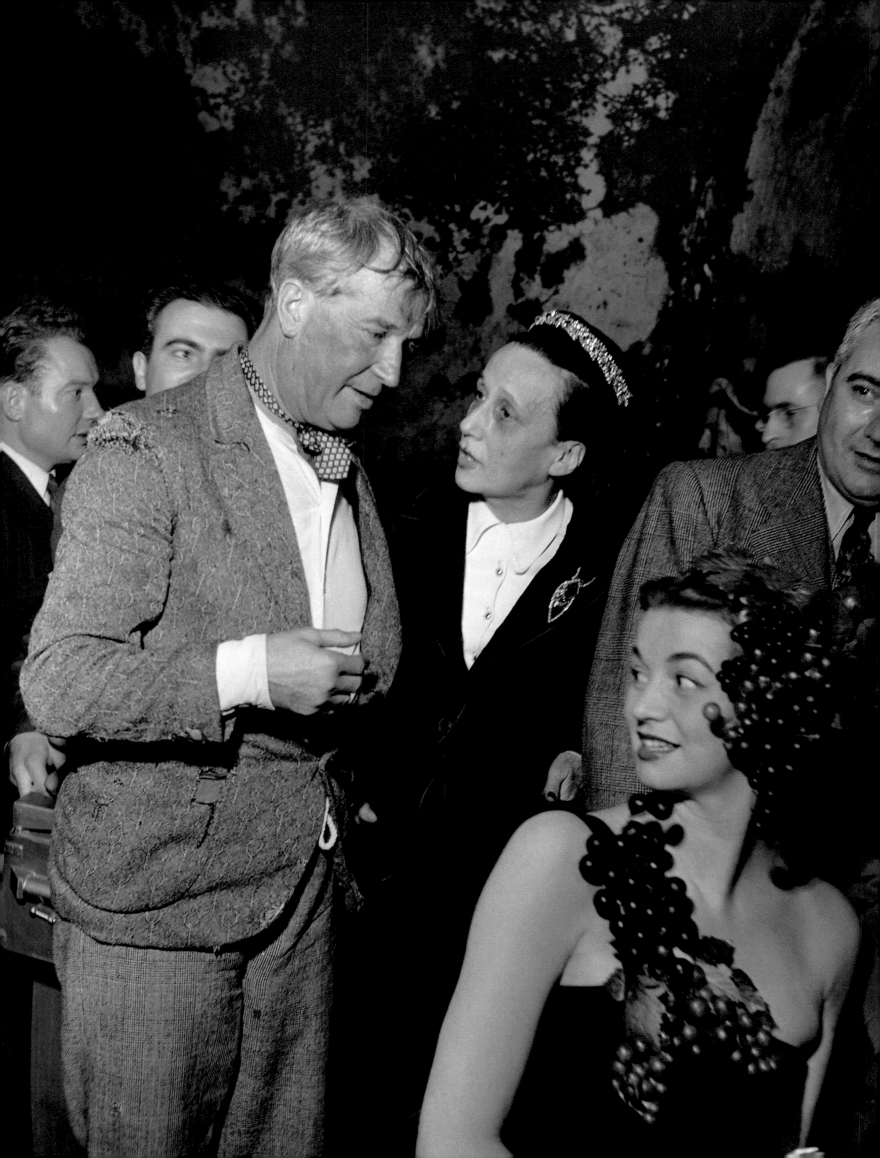

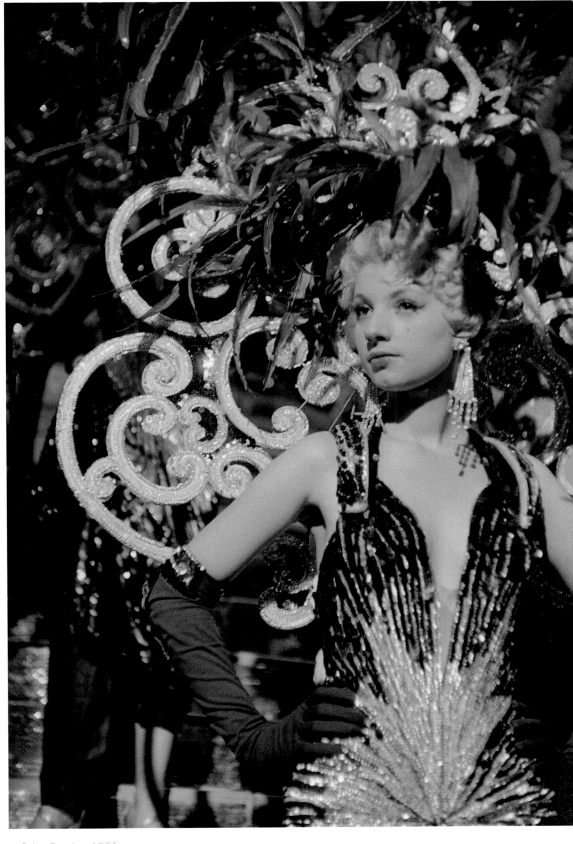

Folies Bergère, 1955

FACING PAGE: Maurice Chevalier, 1950

"Like moths, photographers are drawn to the lights of place de la Concorde. They circle around the splashing fountains, trying to get the perfect shot. This they will then foist on dinner guests back home."

 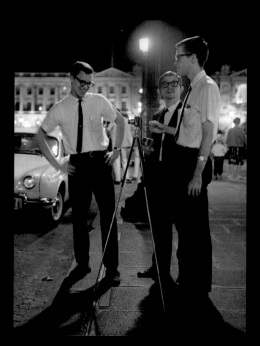

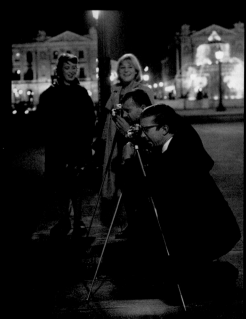 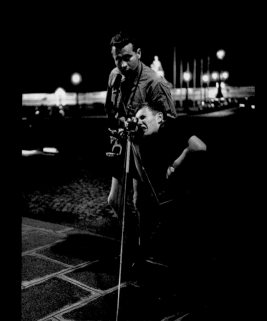 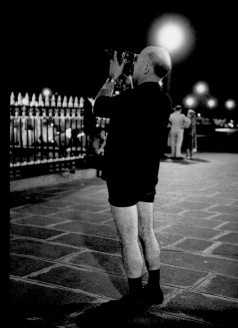

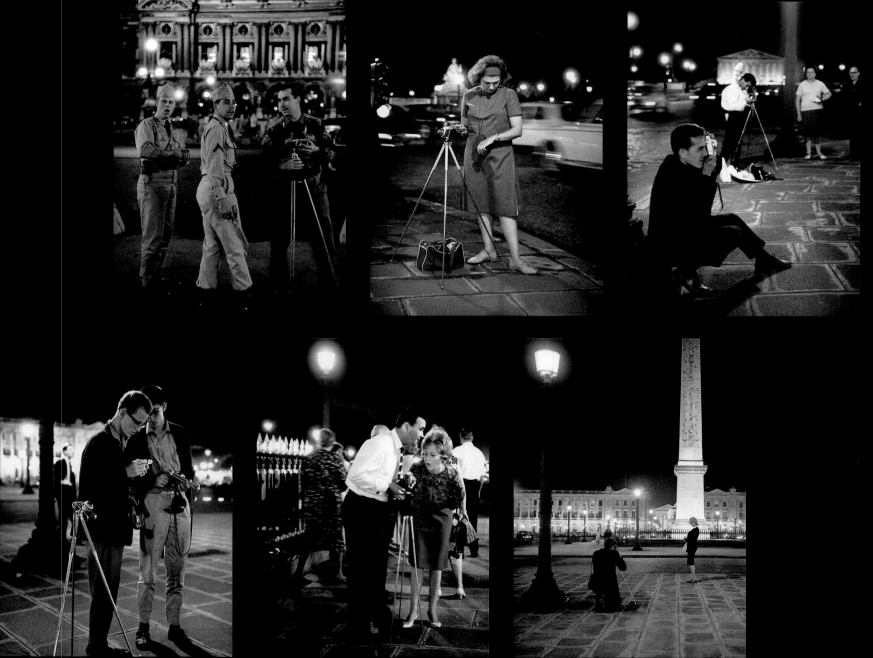

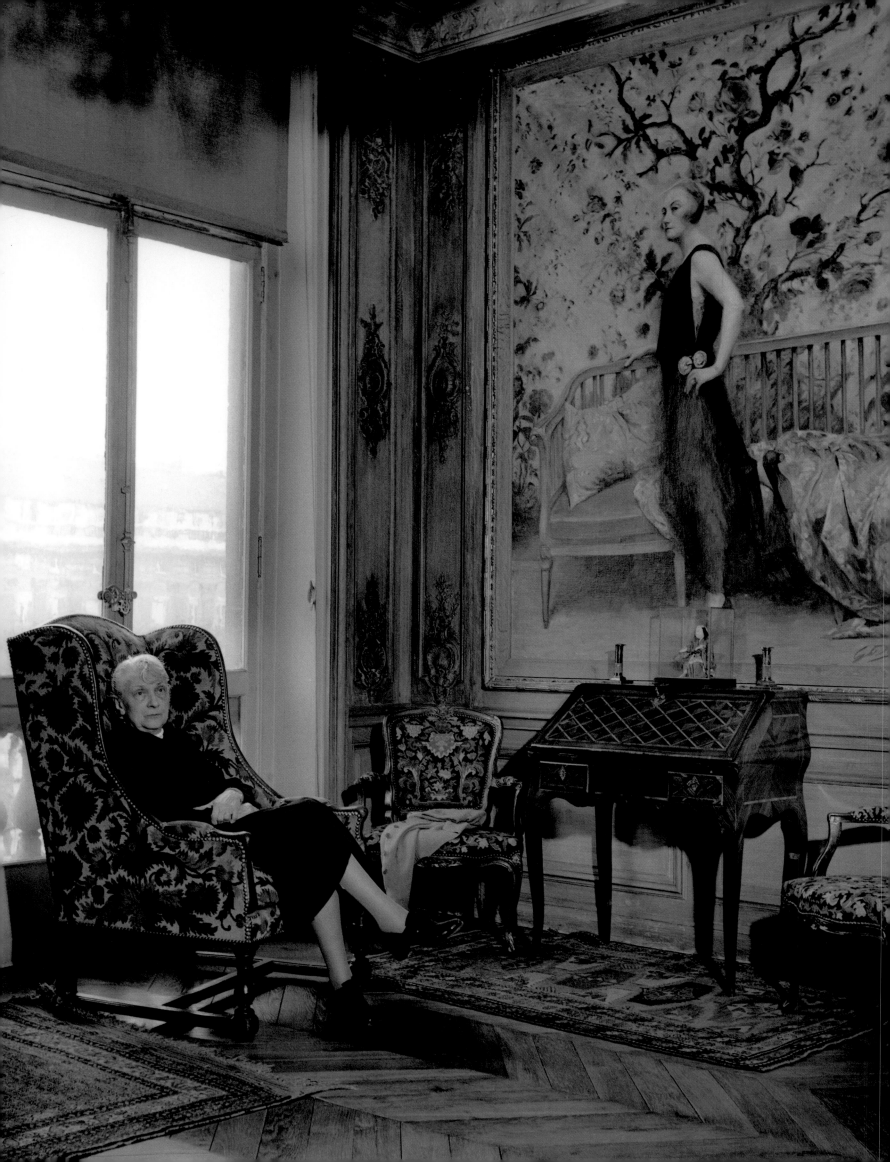

"The two, perhaps three, years I spent at *Vogue* left only a few vague memories, which are now fading with time. True enough, that was over a third of a century ago.

What remains are the pictures, which act as handrails to prevent the memory from slipping. Even when dealing with the power of images, only the dates are reliable, everything else depends on mood.

Sometimes they seem to show nothing other than the poses of a pointless world; but sometimes, in a better light, they seem to illustrate an extremely refined society.

With hindsight, I can say why Michel de Brunhoff offered me a contract. I was like a gardener's son invited to play with the children of the lord of the manor, welcome as long as he brought a new angle to things. In my case, the new angle was guaranteed, because I had never, I mean never, seen such sights—I'm thinking in particular of high-society events like weddings with twenty-foot trains and balls like nobody throws anymore.

In the end, I wasn't suited to the job. And today I think I know why.

Opening Night at the Charpentier Gallery, 1949

PRECEDING PAGE: *Time Rolls On, 1950*

The irresistible urge to create an image is dictated by a quest to recover the elements that originally provoked some intense feeling. From my childhood there remains, in a corner of my mind, a Grand Meaulnes-type château, but apart from that I experienced nothing that might have given me an obsession for luxury. So all I could rely on was my manual dexterity in handling a Rolleiflex, and a shrewd use of flashbulbs. Plus knowledge of a few basic rules of composition, for good measure.

In short, my work at *Vogue* could be divided into three parts.

First, life in Paris, a kind of photo album of those people whose names would be dropped in every conversation: artists, writers, creative people of all kinds.

Then photos of models in urban settings, or against the formidable white wall of a studio. (For fun, and to mask my lack of sensitivity to the studio setting, I often called upon natural elements and upon the aid of the Ruggieri firm—rain, snow, smoke bombs, sparklers, and Roman candles, thanks to which the studio shed some of its stiffness.)

Finally, the third part, society events, which left the most lasting memories.

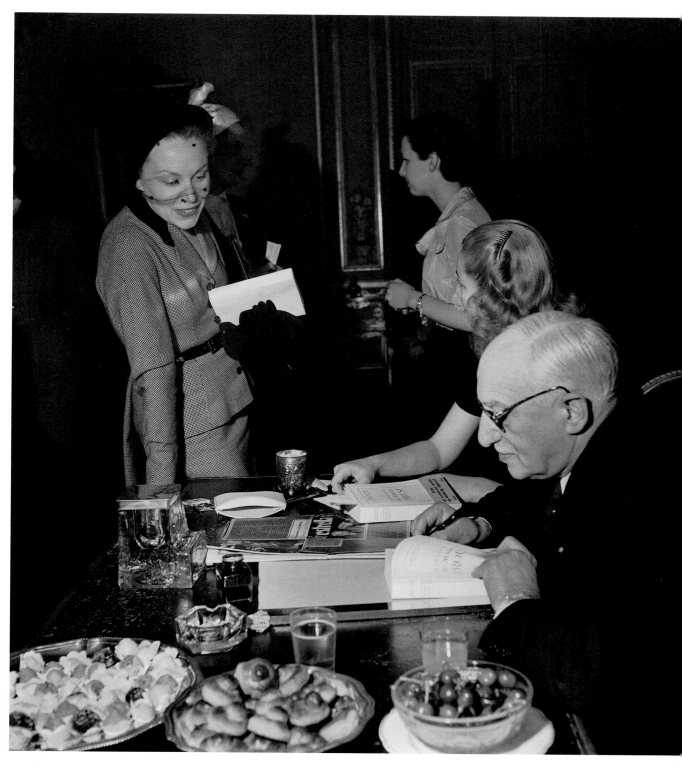

André Maurois dedicates his books, 1949

Mademoiselle d'Origny becomes Vicomtesse d'Harcourt, 1952

" I can do no better than to quote *Vogue*, for whom these photos were taken. 'As Viscountess d'Harcourt, the ravishing Miss d'Origny now bears one of France's grandest names.' "

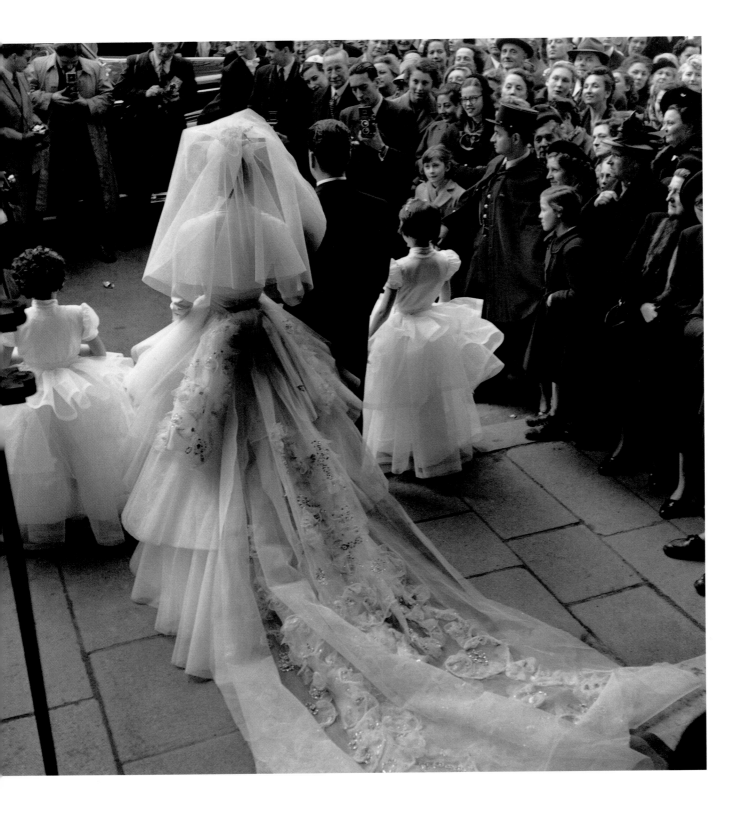

A grand wedding, 1949

66 Booming organs, towering servants, people in funny dress of all kinds. Please rise, pleased be seated, endless ceremonial . . . while a pack of photographers waits outside, crushing cigarette stubs underfoot. Nothing could be more boring for a little girl. 99

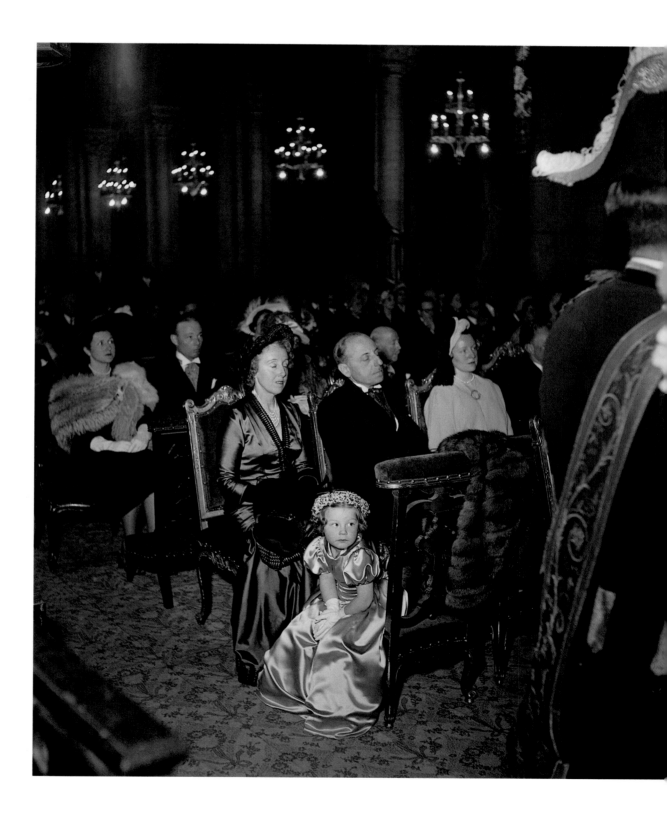

A woman passes, 1947

"Wide eyes peering over a newspaper, the flame of a lighter halted in its path to the cigarette, three blue-rinse ladies suddenly falling silent: when the woman in the velvet cloak crossed the lobby of the grand hotel there was the imperceptible rustle of her train on the carpet. Probably inspired by her plumage, she moved at the stately pace of a peacock.

The man with the gold keys, the very one who normally displayed his disdain for the world on his brow, never took his eyes off her."

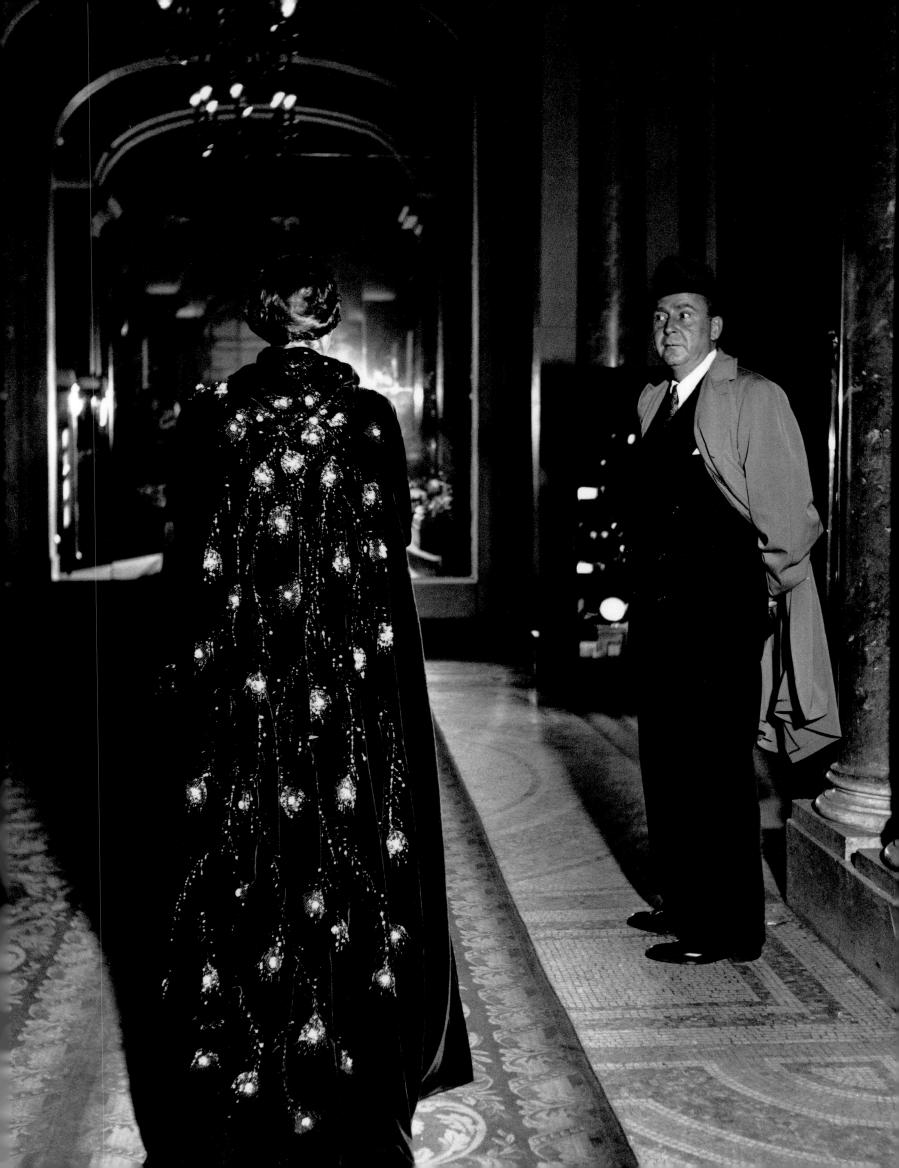

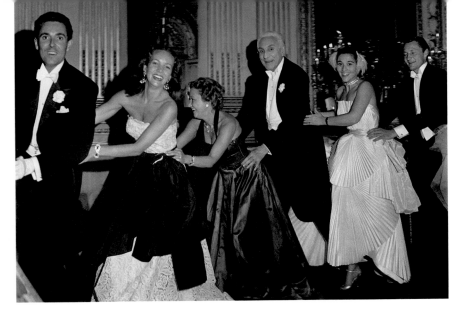

The Beaumonts' dance, 1950

At the home of Baron and Baroness de l'Espée, June 1949

“ Pictured left to right: Viscount and Viscountess de Ribes, Countess de Gourcuff, Viscount Hervé de Caradec, Countess Olivier de la Baume, and Count Jean de Gourcuff. ”

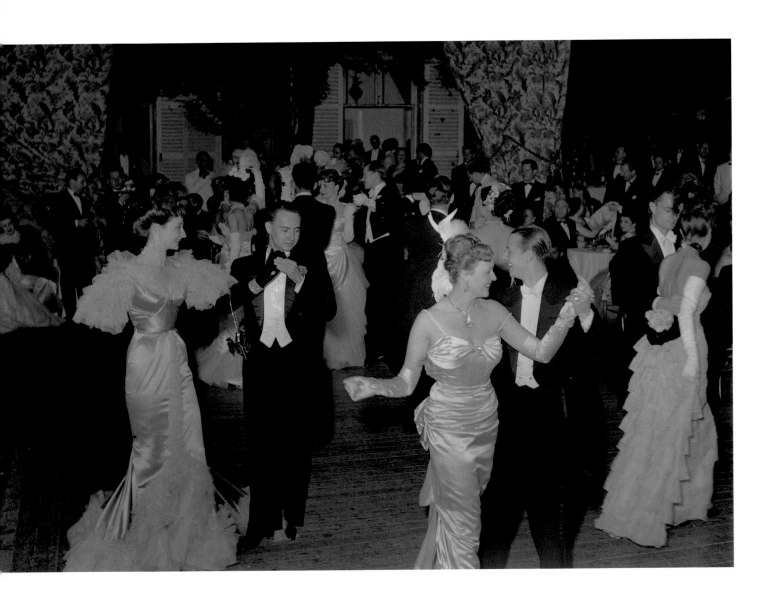

Ball at the Lambert residence, 1950

" People these days don't know about the events that drew everyone who was anyone in Paris, London, and New York. If you didn't receive an invitation you could consider yourself the lowest of the low. My faithful assistant, Maurice, and I were there to represent *Vogue*—in rented tuxedos altered to fit with a few safety pins, carrying four U.S. Army musette bags stuffed with flashbulbs. "

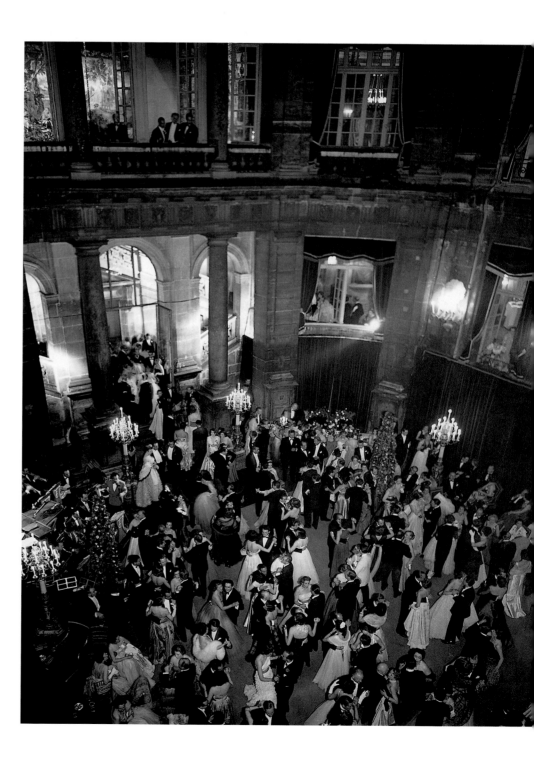

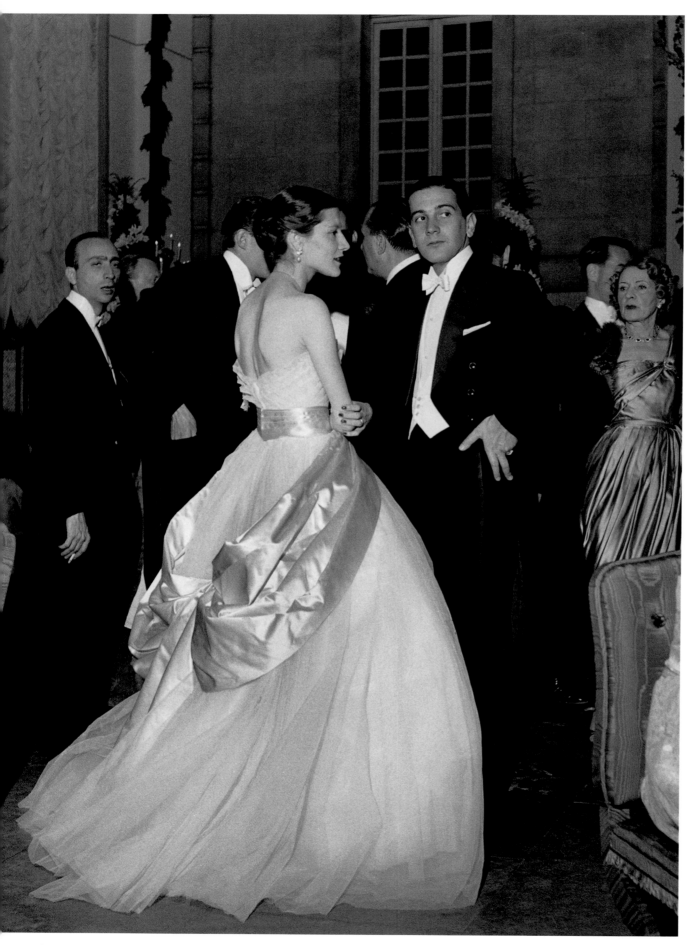

The Arturo Lopez Ball, June 1952

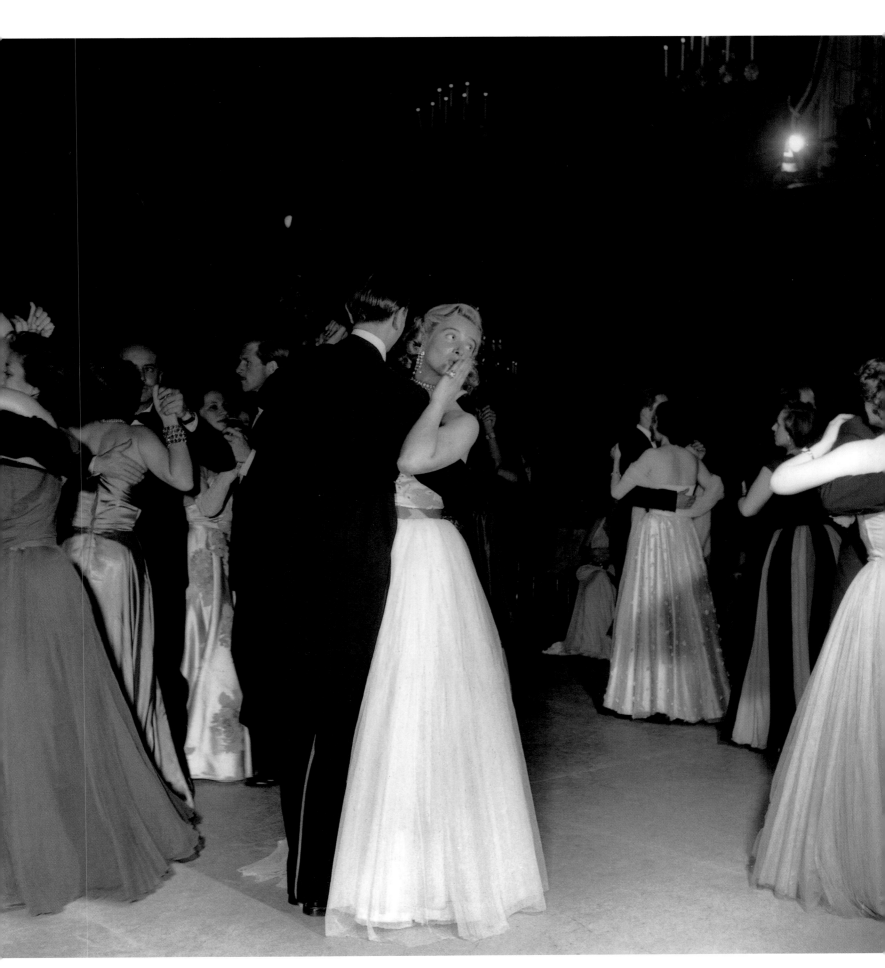

Waltzing Kiss, 1950

THE FATH BALL, CHÂTEAU DE CORBEVILLE, JUNE 15, 1951

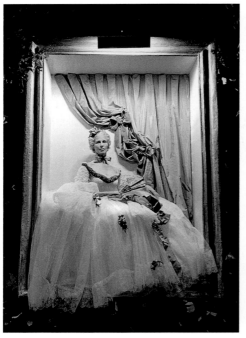

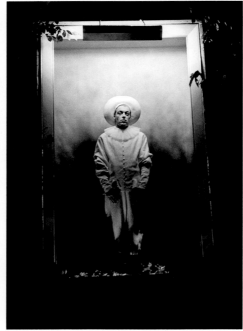

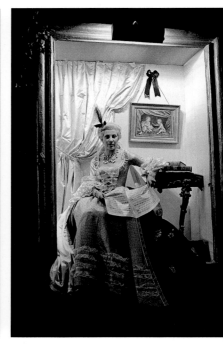

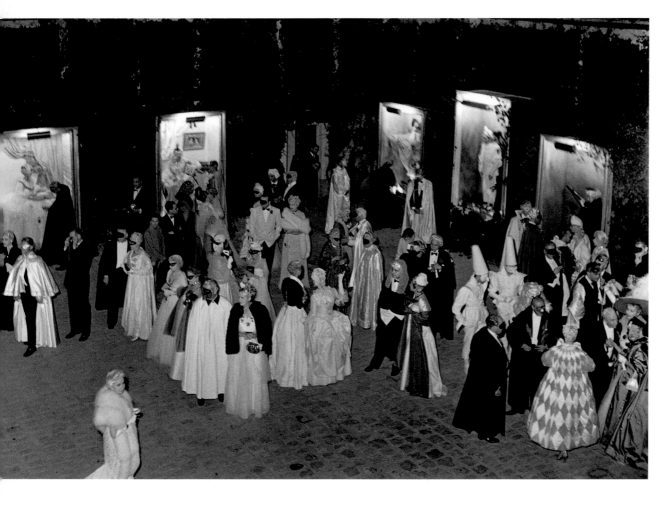

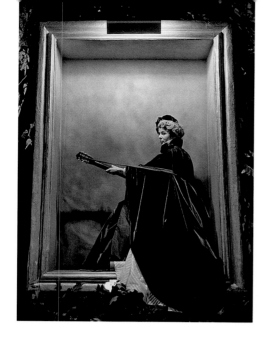

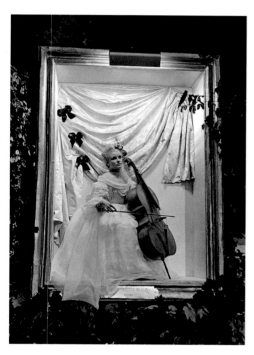

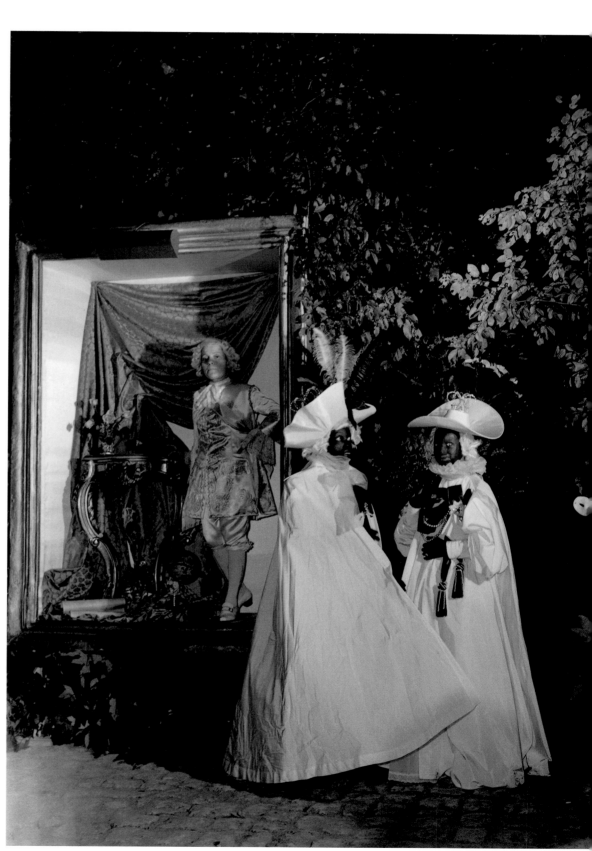

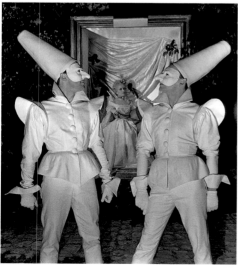

Barillet and Gredy at the Fath Ball, 1951

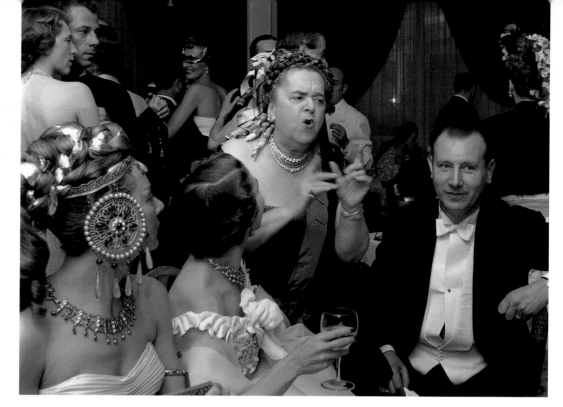

Elsa Maxwell's Gossip, 1949

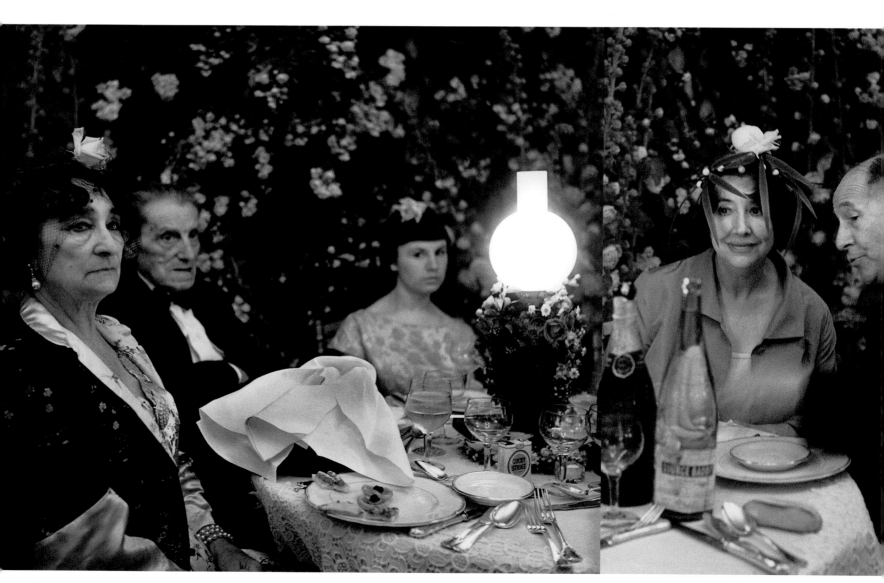

Photomontage of Marguerite Castaing and Monsieur Galvaine celebrating Carole Weisweiller's eighteenth birthday on June 14, 1960

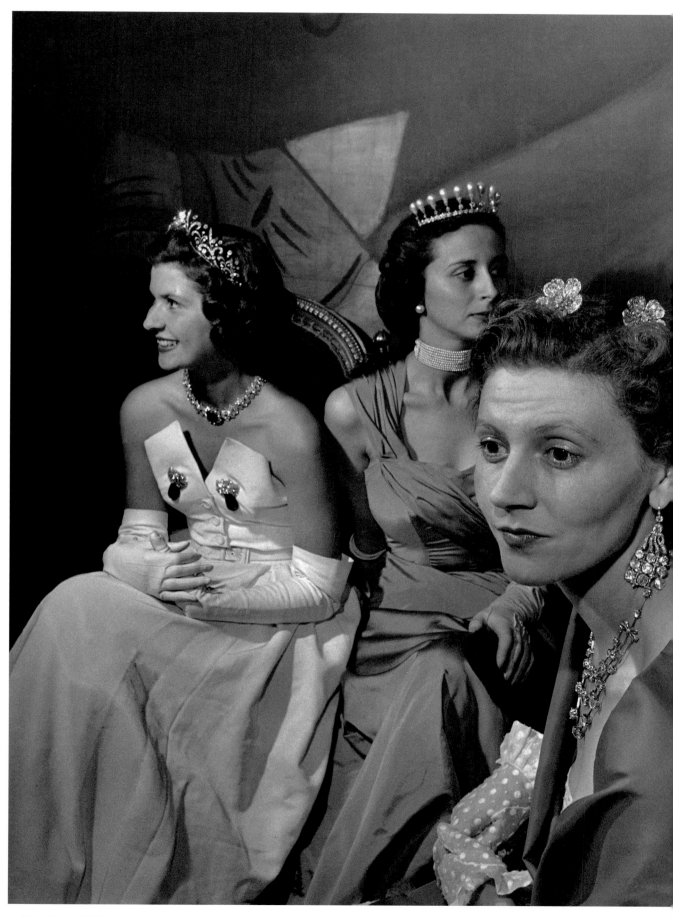

Three Tiaras, 1950

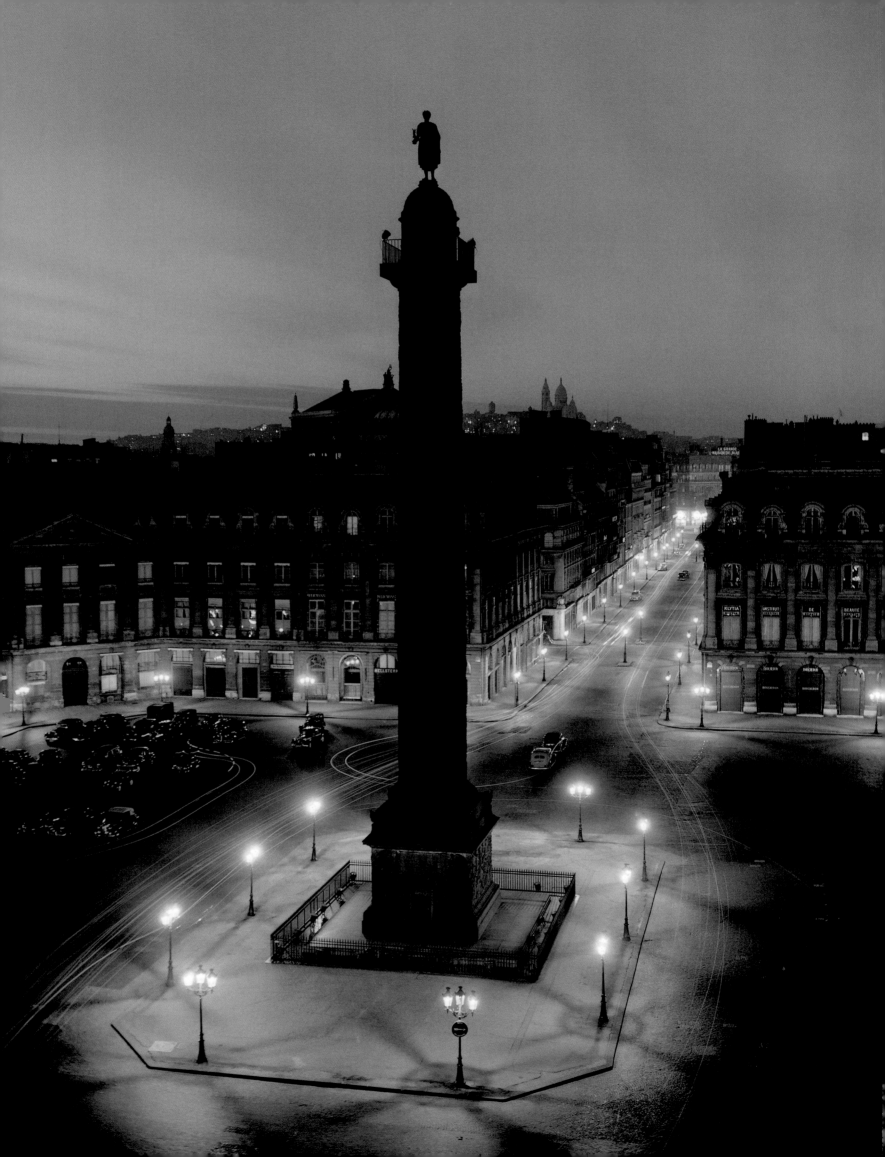

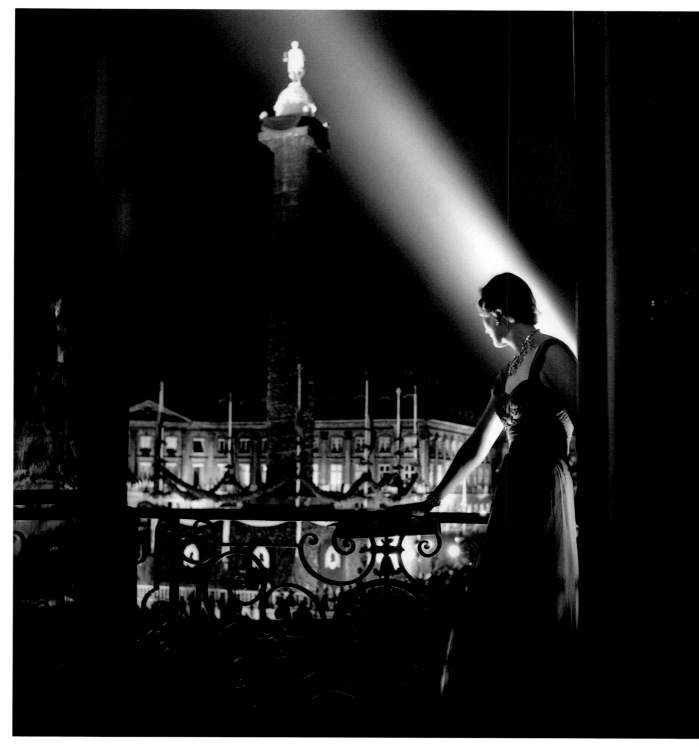

Place Vendôme from a balcony at night, 1950

Facing page: Place Vendôme at night, 1949

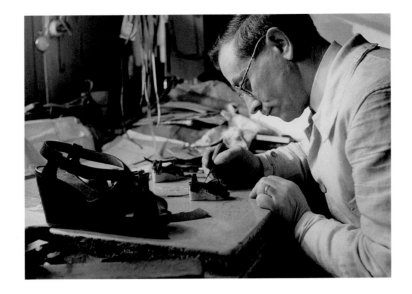

Saint-Martin, maker of wire figurines

Christian Bérard with a brush

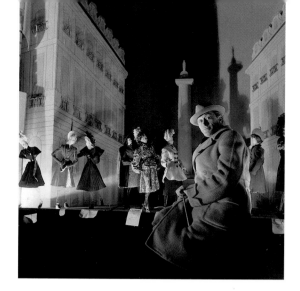

Touchagues in his element

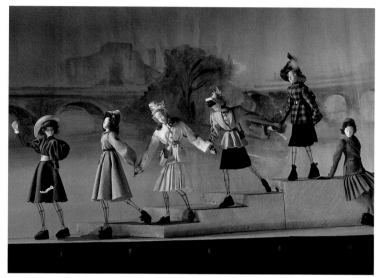

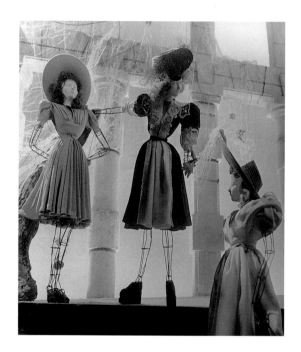

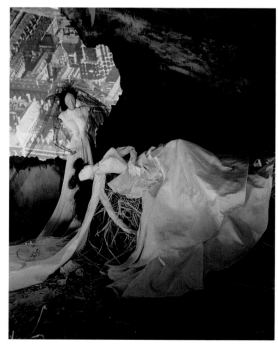

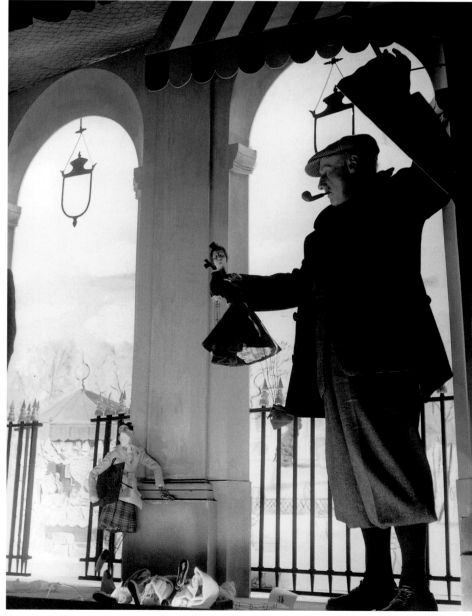

Dignimont and his "figurines" before the miniature grates
of his Palais Royal garden

Fashion sketches by Jean-Louis, 1947

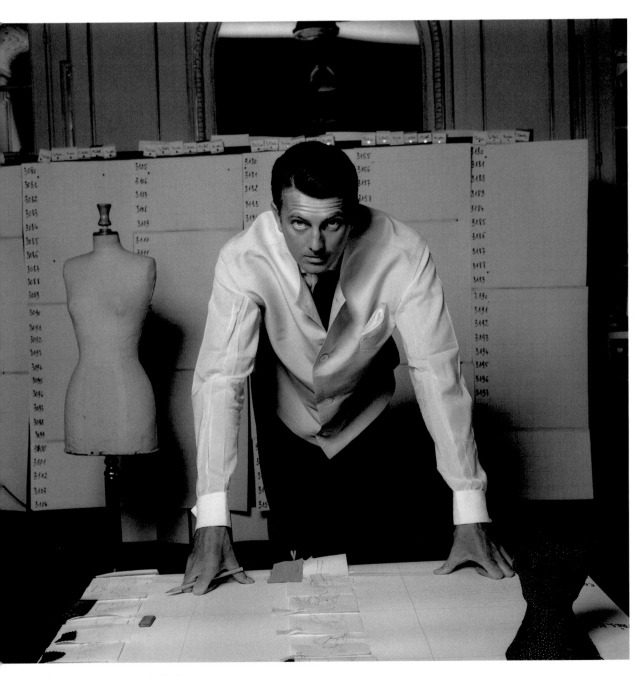

Hubert de Givenchy, April 1960

Façade of the Dior building, 1955

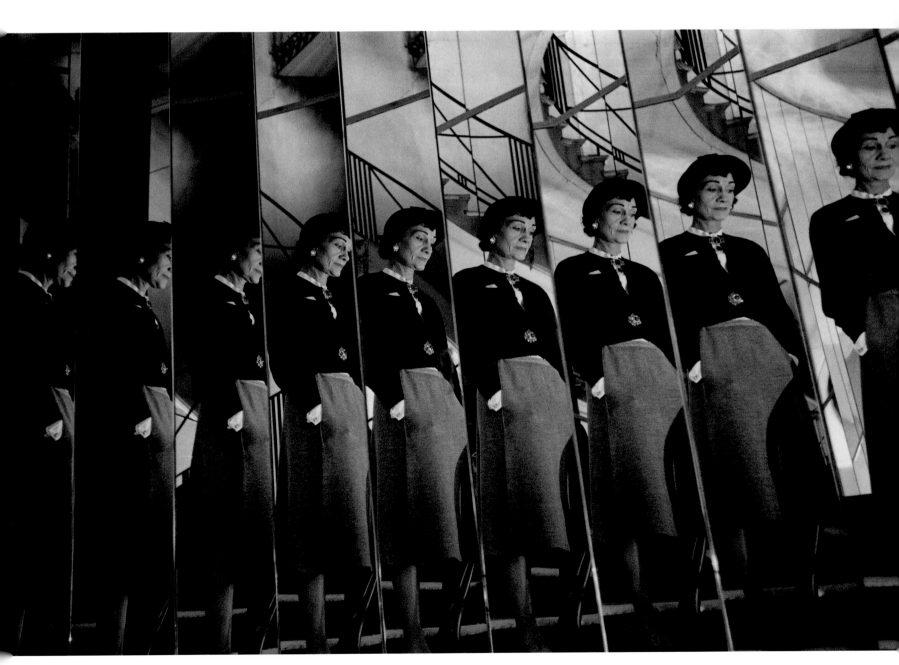

Coco Chanel at the mirror, 1953

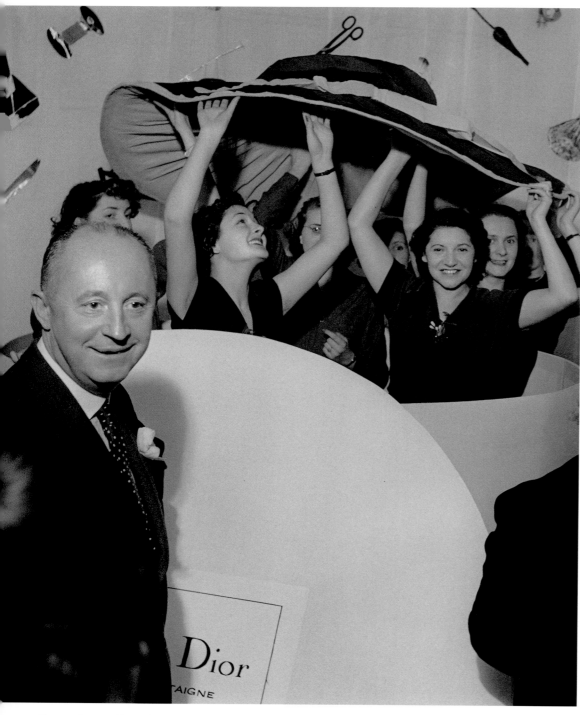

Christian Dior and his milliners, 1950

FACING PAGE: Yves Saint Laurent and Zizi Jeanmaire, a fitting for Carmen's costume, 1959

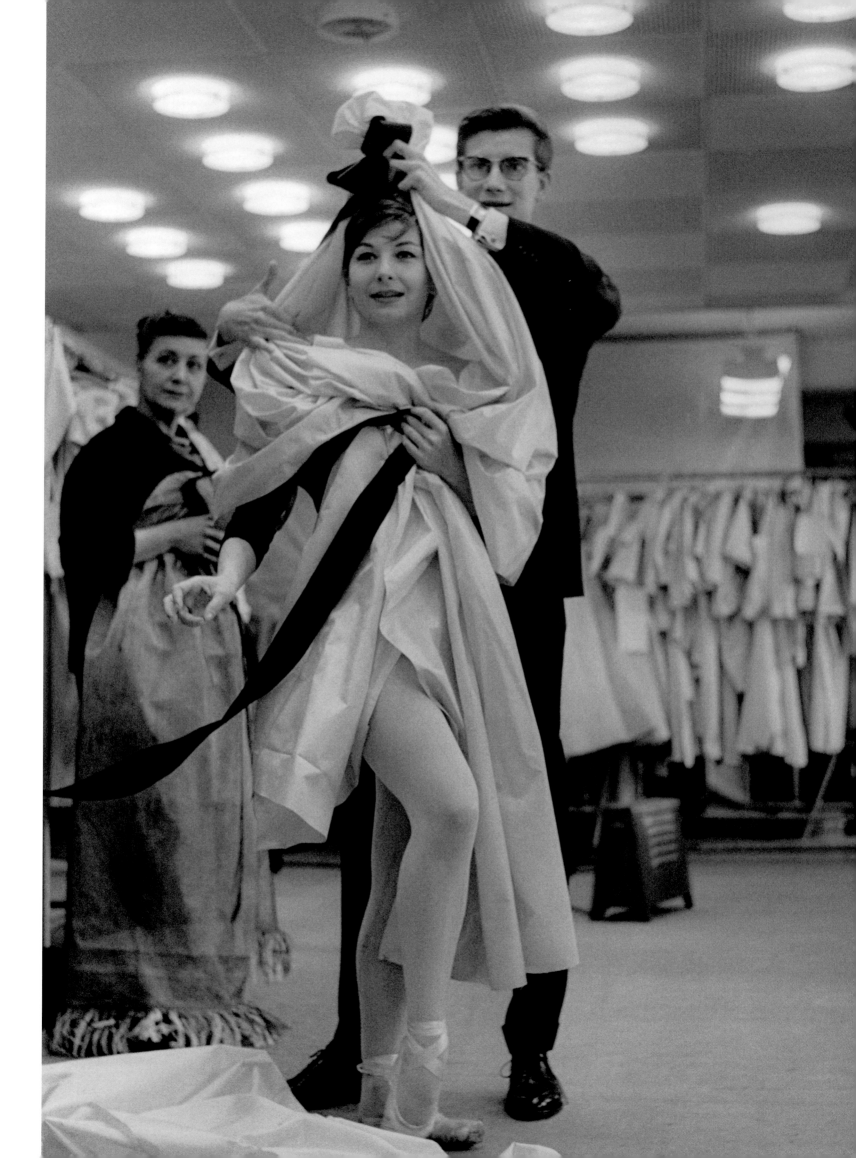

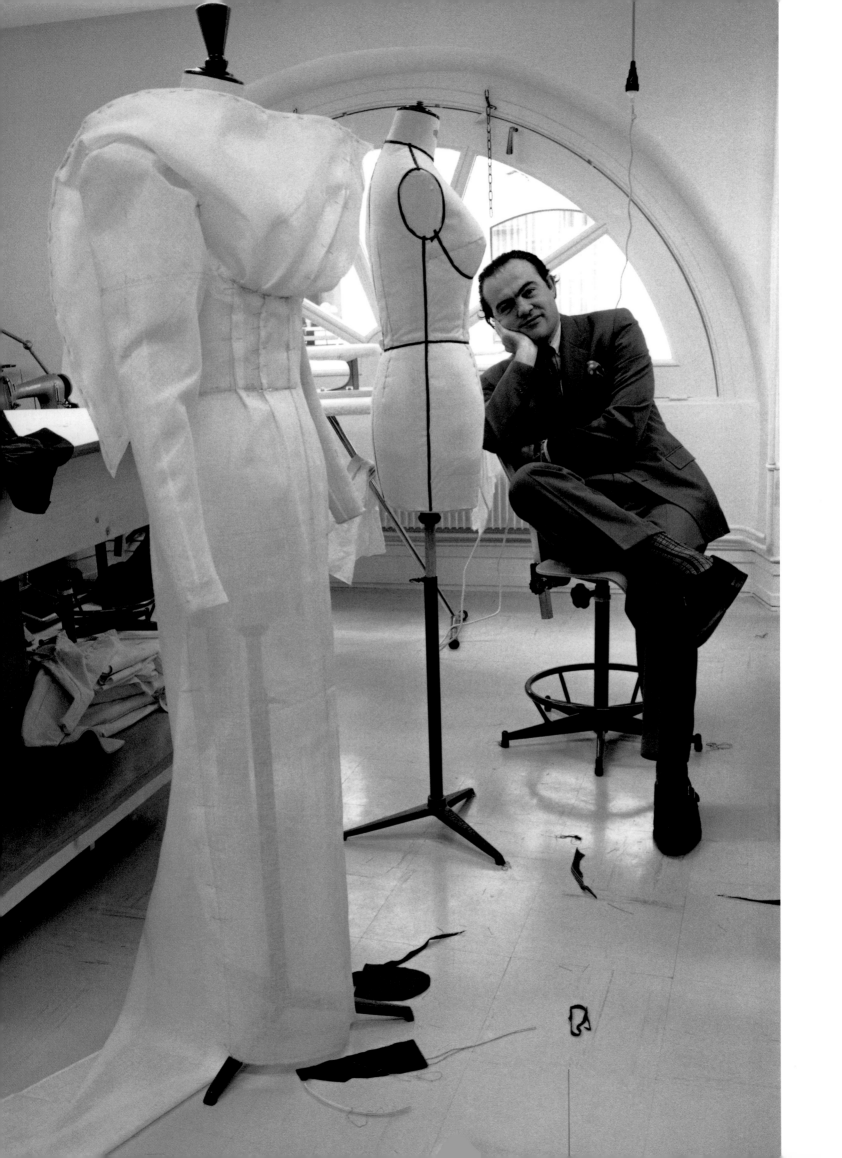

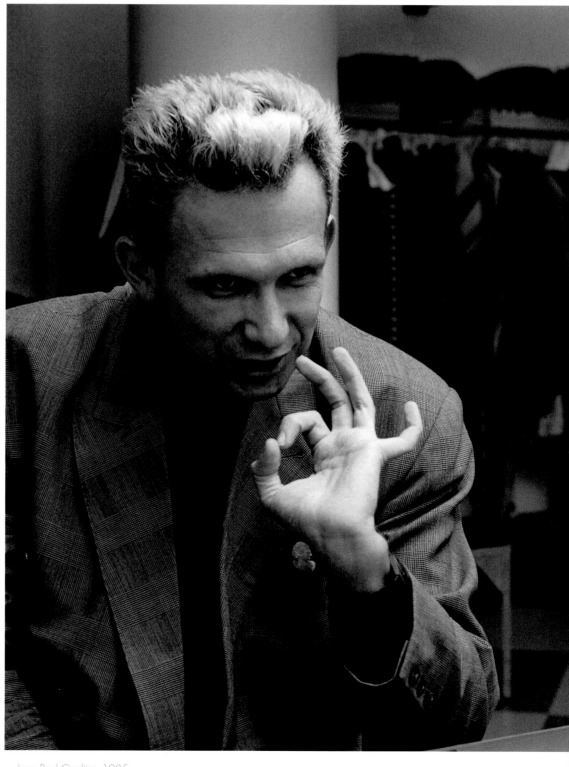

Jean Paul Gaultier, 1985

FACING PAGE: Christian Lacroix, 1987

" On such splendid women, light never travels in a straight line. These high priestesses of elegance are wreathed in a blossoming light. One hand on a hip or toying with a necklace, they remain disdainful and serious before their tall shadows. "

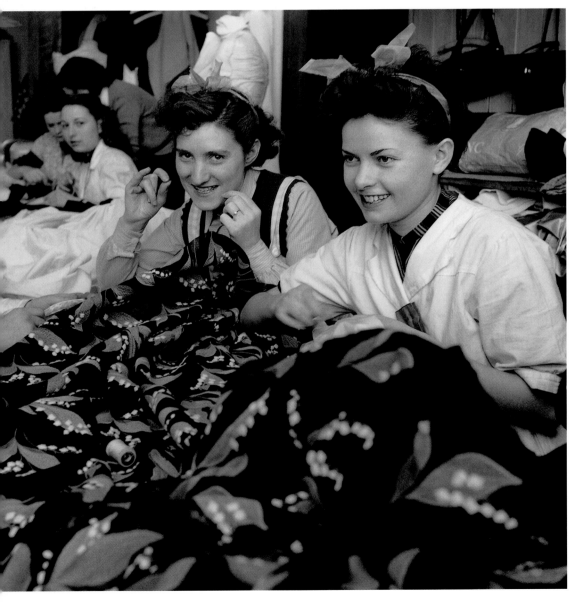

Assistant seamstresses, May 1953

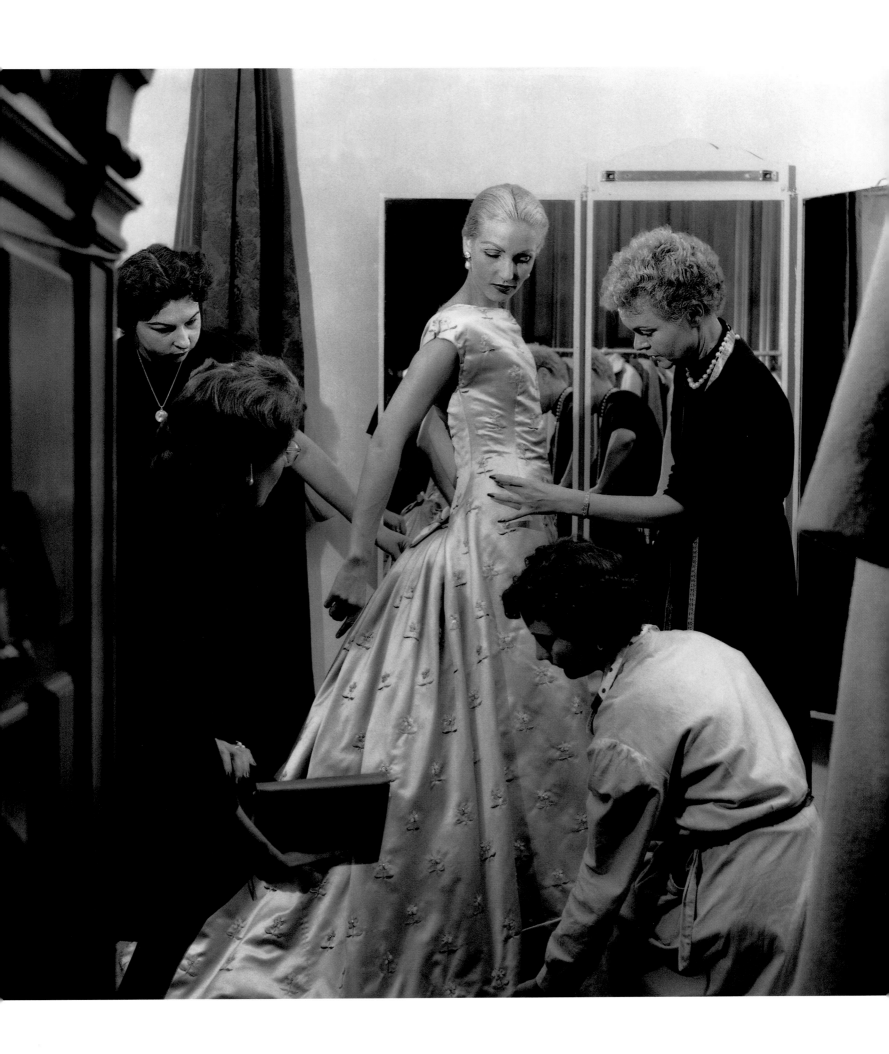

LANVIN DRESSING ROOM,
OCTOBER 1958

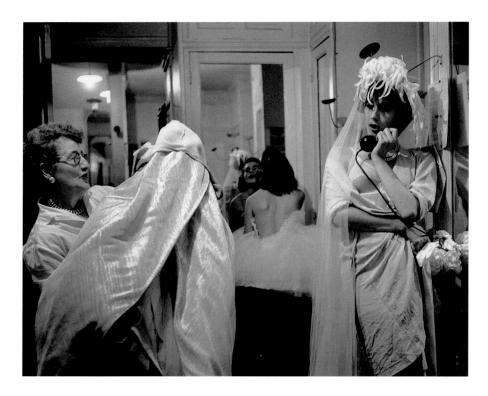

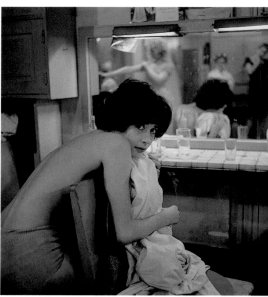

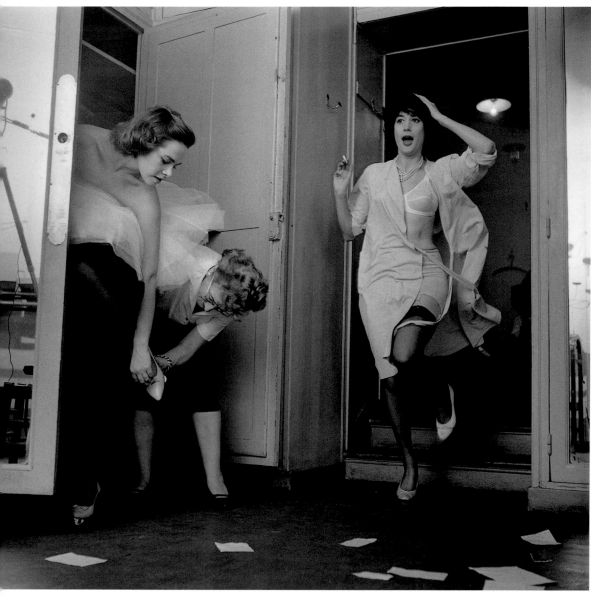

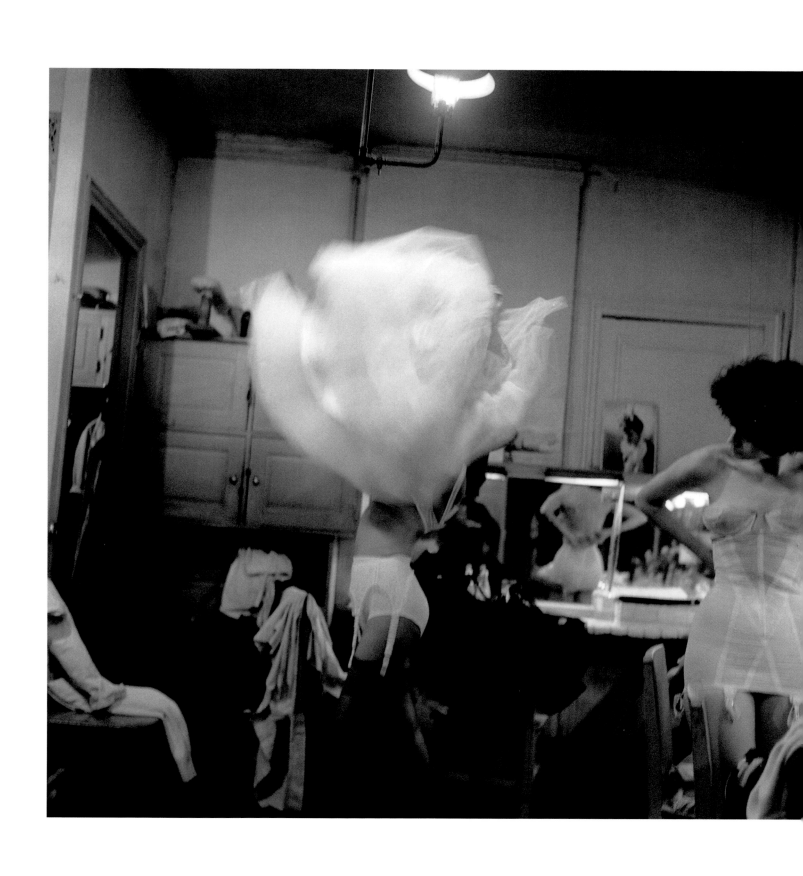

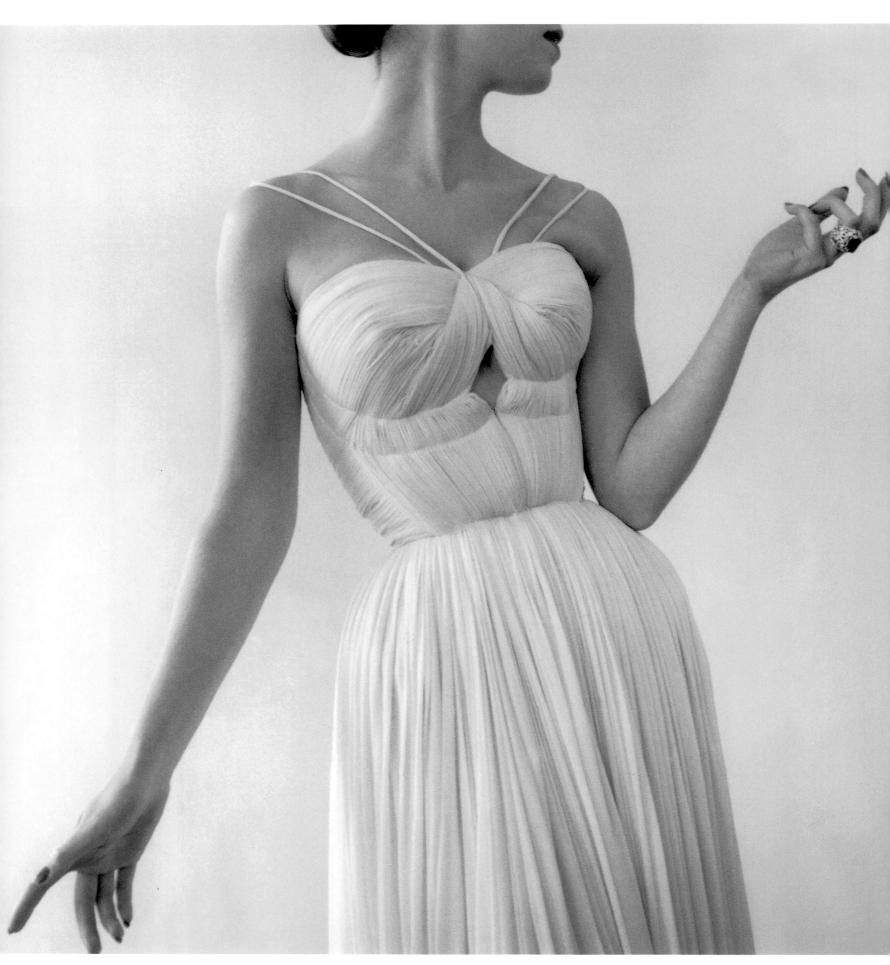

Madame Grès's Draped Fashion, 1955

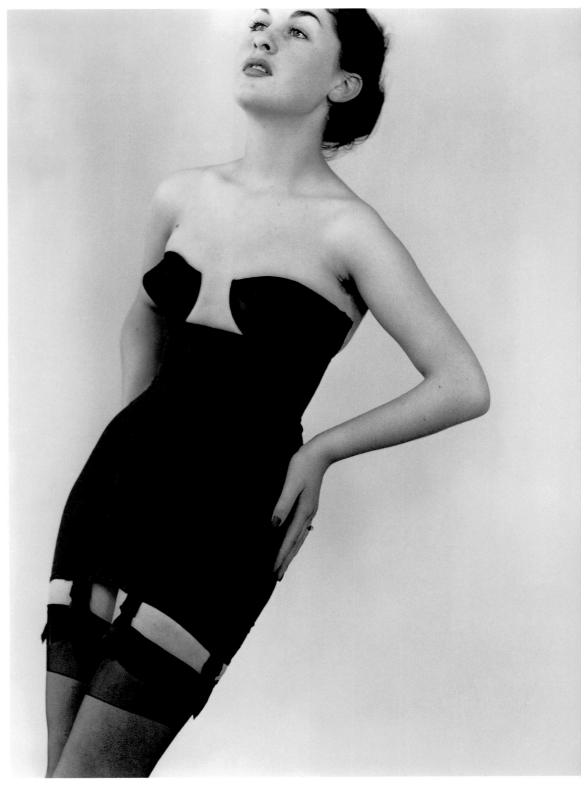

Black corset, 1950

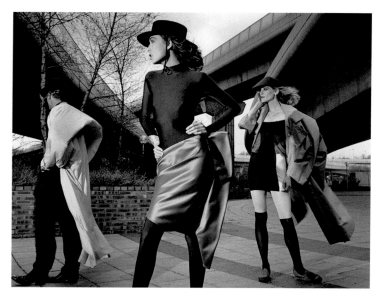

Beneath the Maisons Alfort interchange, February 1987

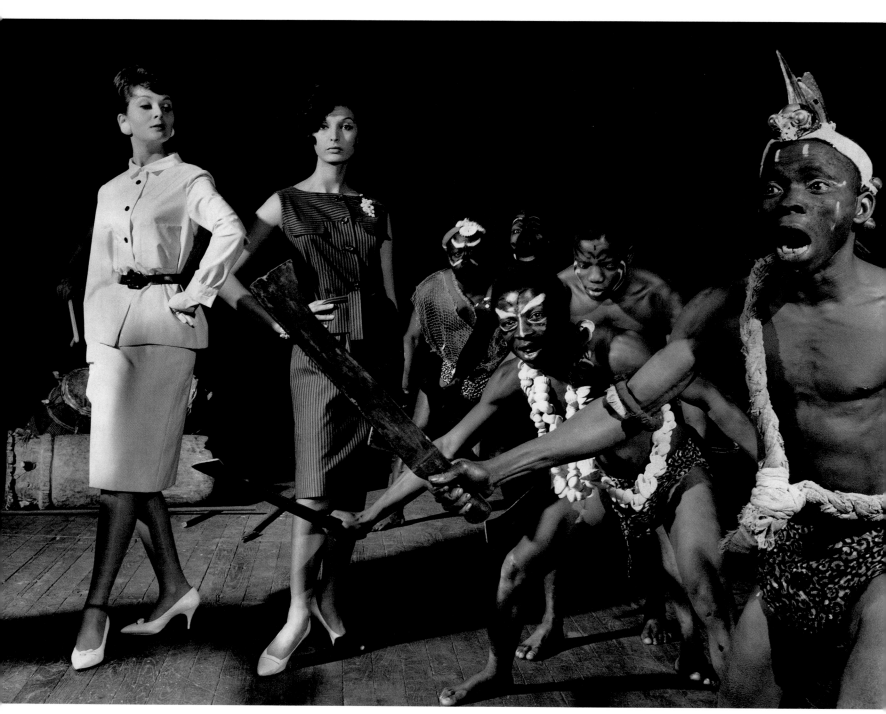

Les Ballets Africains, 1960

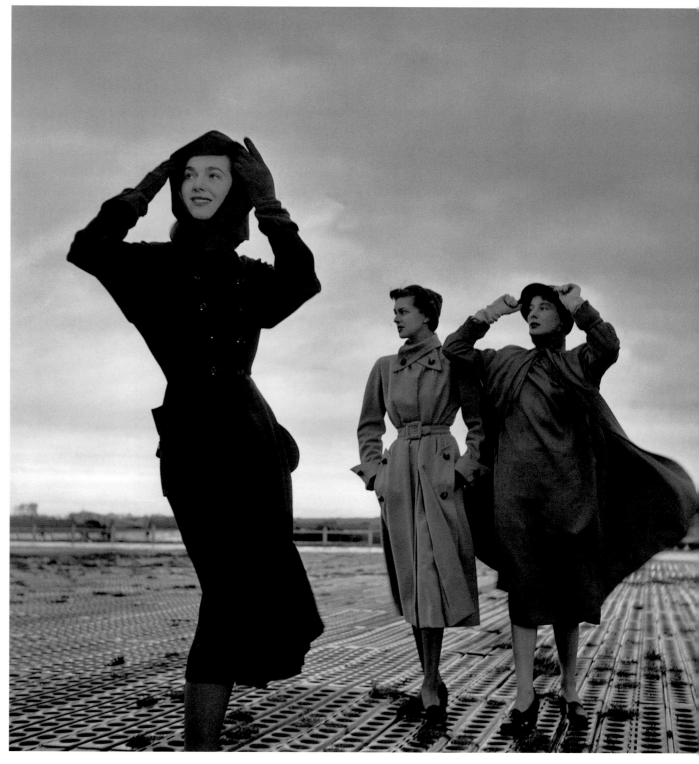

September 1949

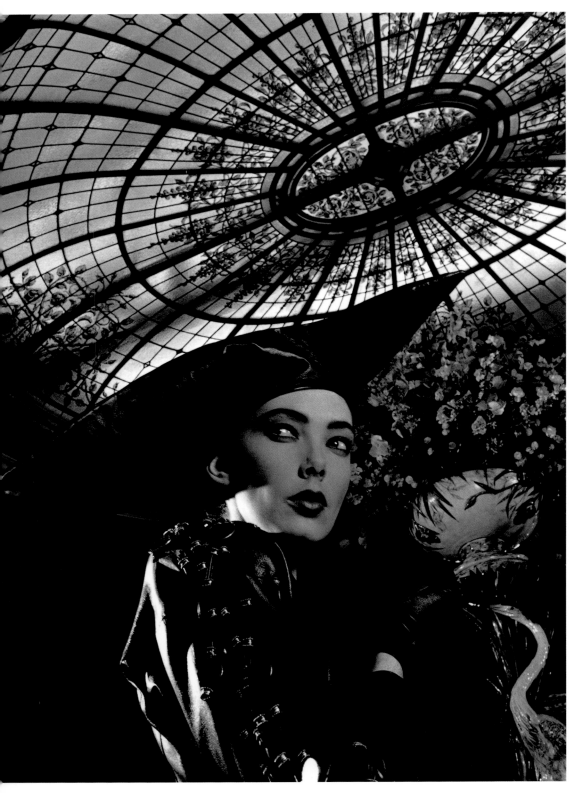

Bofinger's glass conservatory, 1987

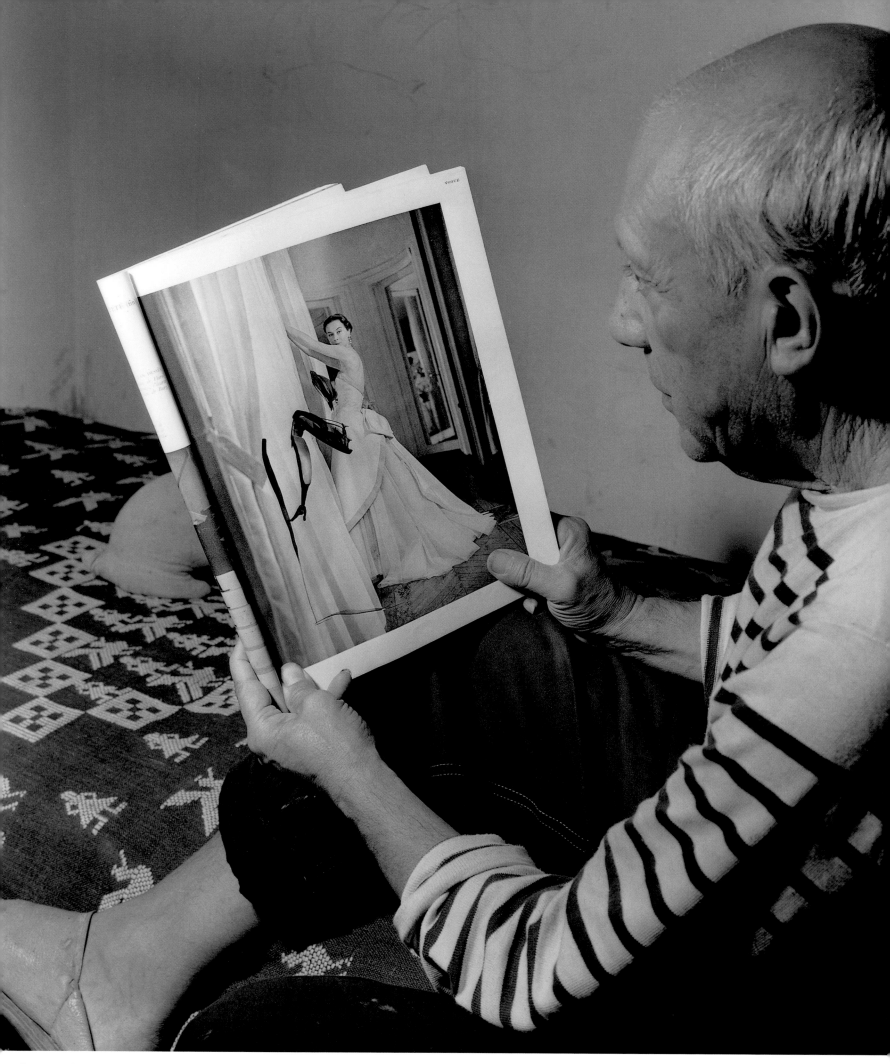

Picasso and *Vogue*, 1949

PARIS

IN CONCRETE

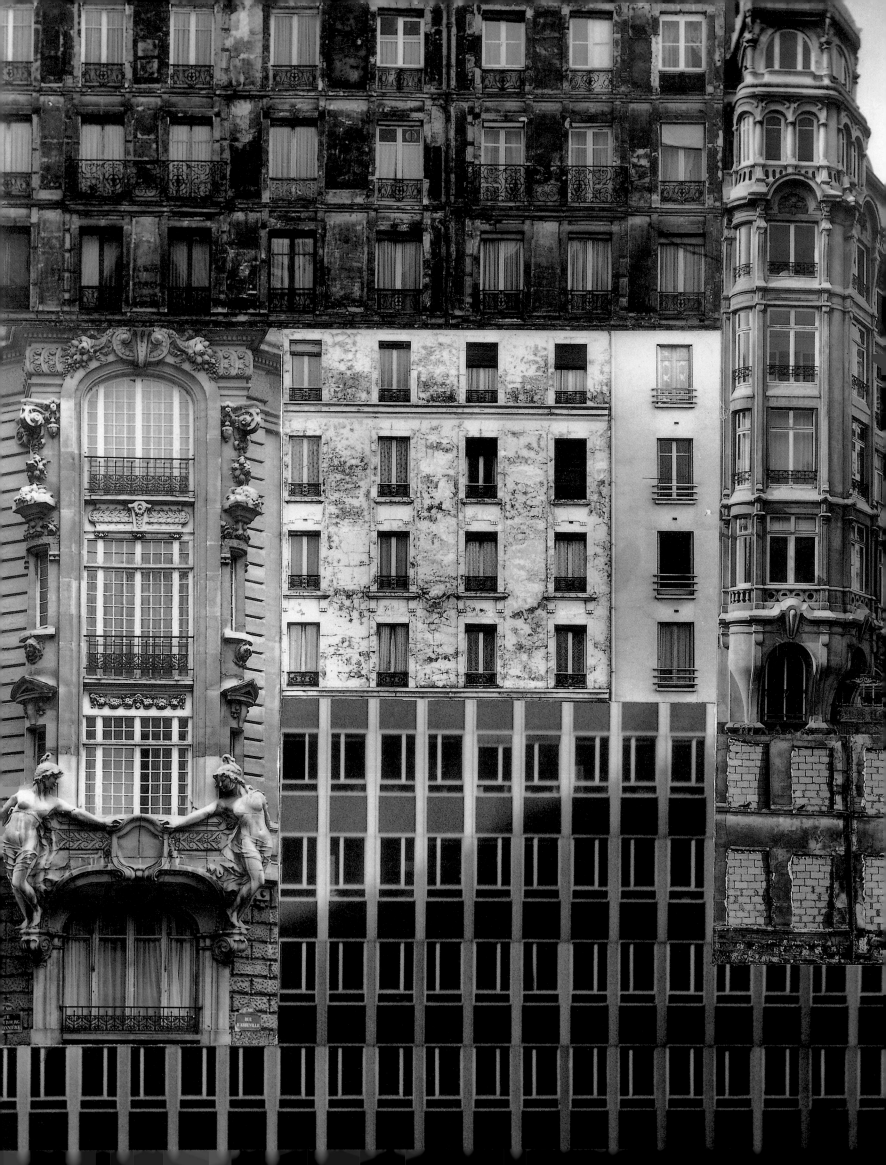

" The charm of a city, now we come to it, is not unlike the charm of flowers. It partly depends on seeing time creep across it. Charm needs to be fleeting. Nothing could be less palatable than a museum-city propped up by prosthetic devices of concrete.

Paris is not in danger of becoming a museum-city, thanks to the restlessness and greed of promoters. Yet their frenzy to demolish everything is less objectionable than their clumsy determination to raise housing projects that cannot function without the constant presence of an armed police force...

All these banks, all these glass buildings, all these mirrored façades are the mark of a reflected image. You can no longer see what's happening inside, you become afraid of shadows. The city becomes abstract, reflecting only itself. People almost seem out of place in this landscape. Before the war, there were nooks and crannies everywhere.

Now people are trying to eliminate shadows, straighten streets. You can't even put up a shed without the personal authorization of the minister of culture.

When I was growing up, my grandpa built a small house. Next door the youth club had some sheds, down the street the local painter stored his equipment under some stretched-out tarpaulin. Everybody added on. It was telescopic. A game. Life wasn't so expensive—ordinary people could live and work in Paris. You'd see masons in blue overalls, painters in white ones, carpenters in corduroys. Nowadays, just look at Faubourg Saint-Antoine—traditional craftsmen are being pushed out by advertising agencies and design galleries. Land is so expensive that only huge companies can build, and they have to build 'huge' in order to make it profitable. Cubes, squares, rectangles. Everything straight, everything even. Clutter has been outlawed. But a little disorder is a good thing. That's where poetry lurks. We never needed promoters to provide us, in their generosity, with 'leisure spaces.' We invented our own. Today there's no question of putting your own space together, the planning commission will shut it down. Spontaneity has been outlawed. People are afraid of life.
"

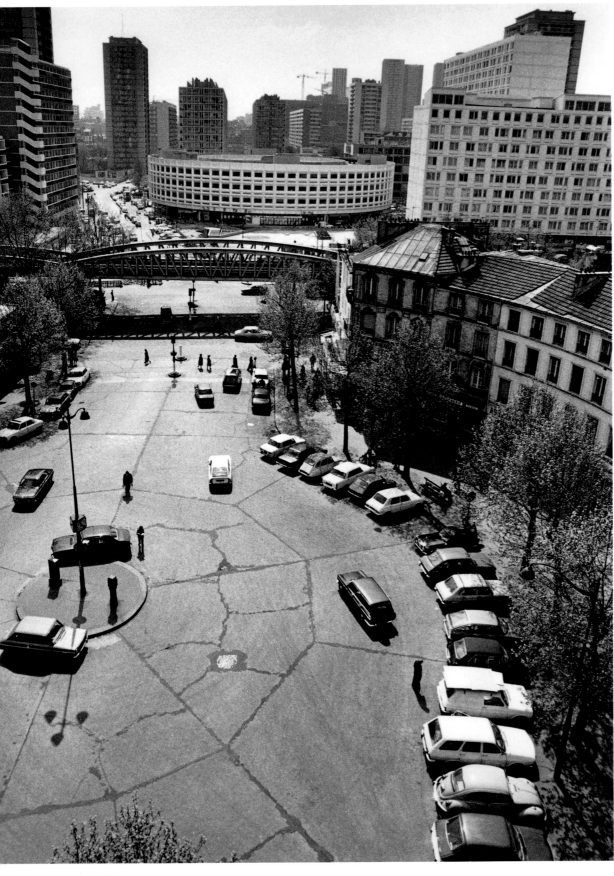

Place Pinel, 1975

Painted wall, boulevard de la Gare, 1975

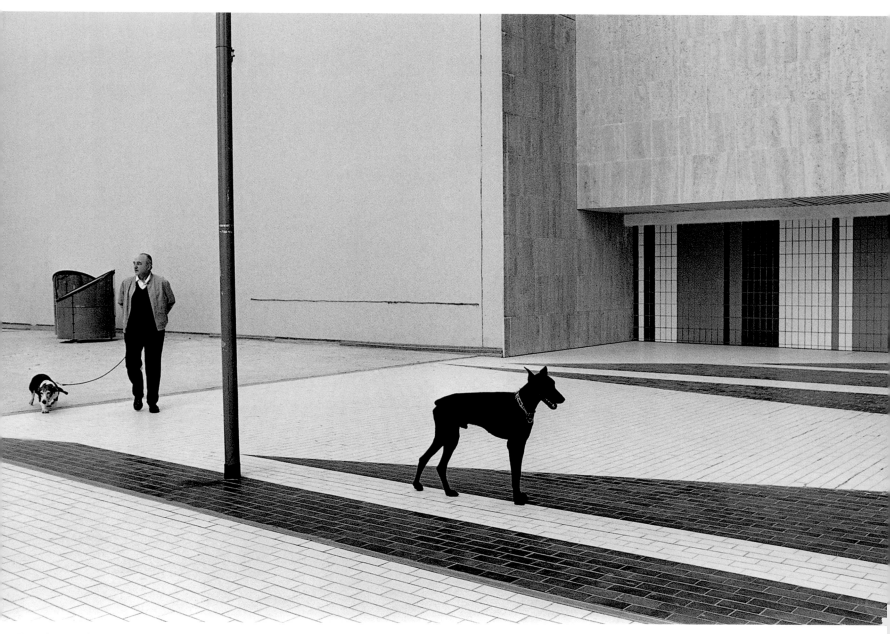

Front de Seine district, July 1978

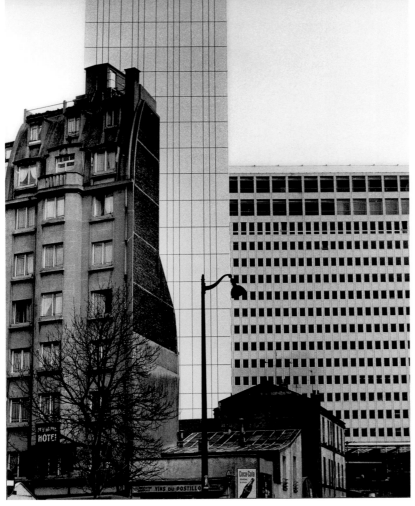

Anarchitecture, 1966

Montparnasse train station, 1966

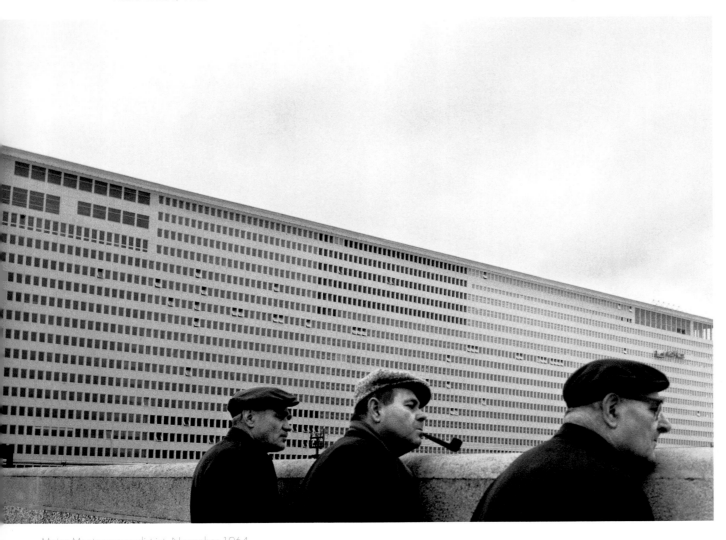

Maine-Montparnasse district, November 1964

FACING PAGE: Footbridge, La Défense district, 1975

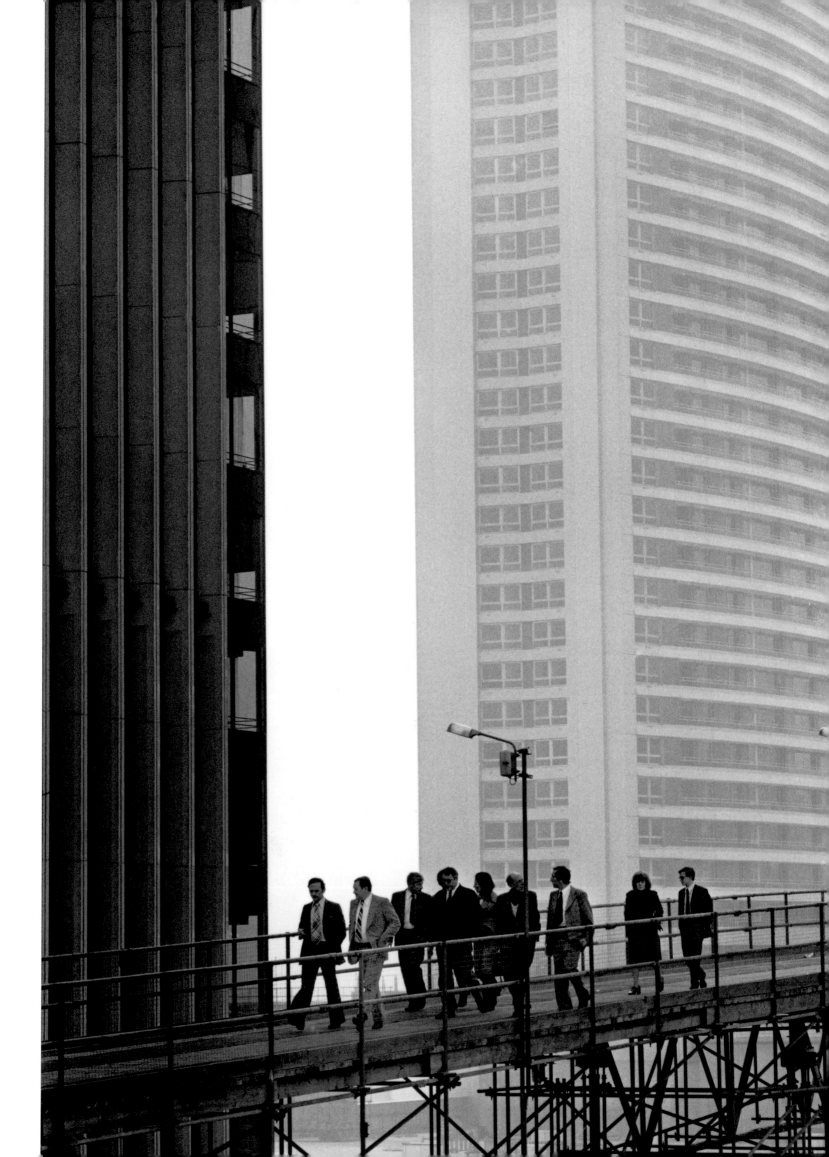

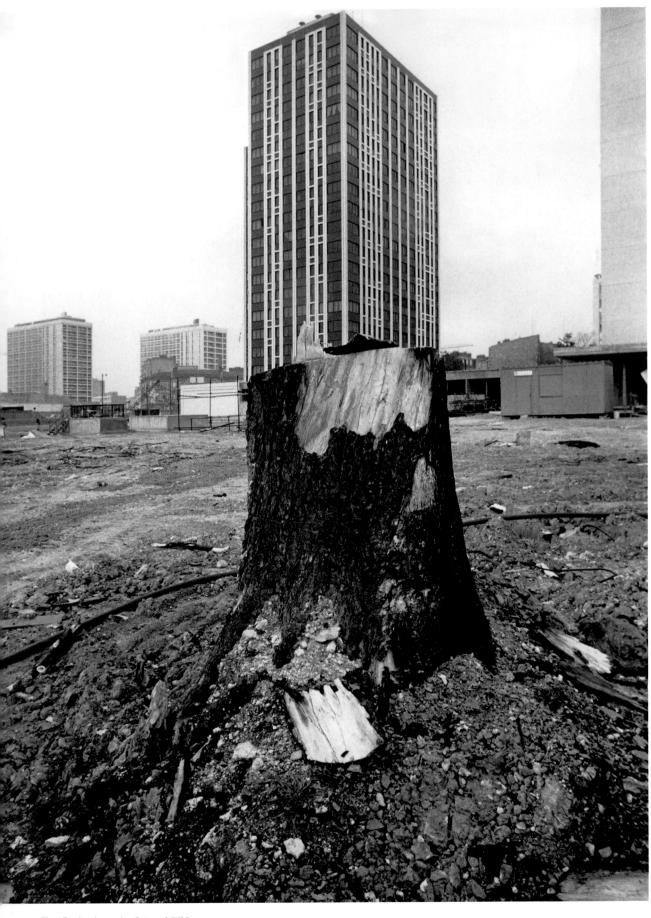

The Graft, place des Fêtes, 1975

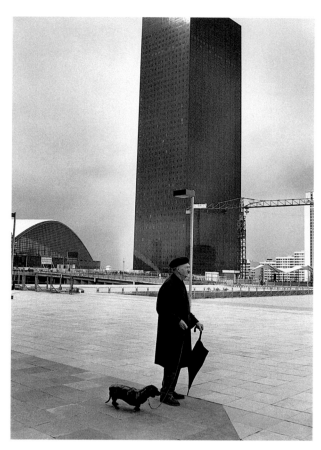

Basset Hound in Plaza, La Défense district, 1975

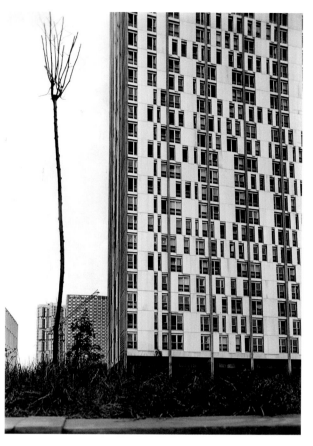

The New 15th Arrondissement, 1978

Signposts in the Front de Seine District, October 1977

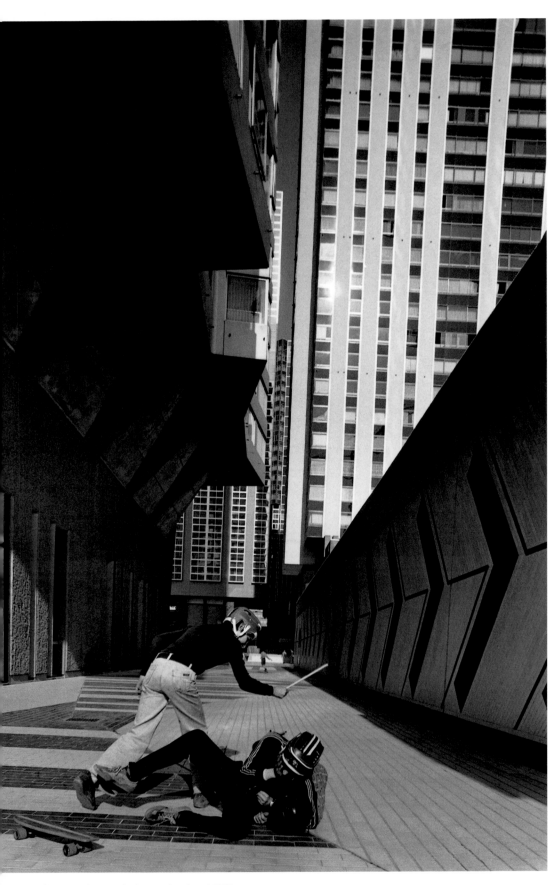

Playground, Front de Seine, October 1977

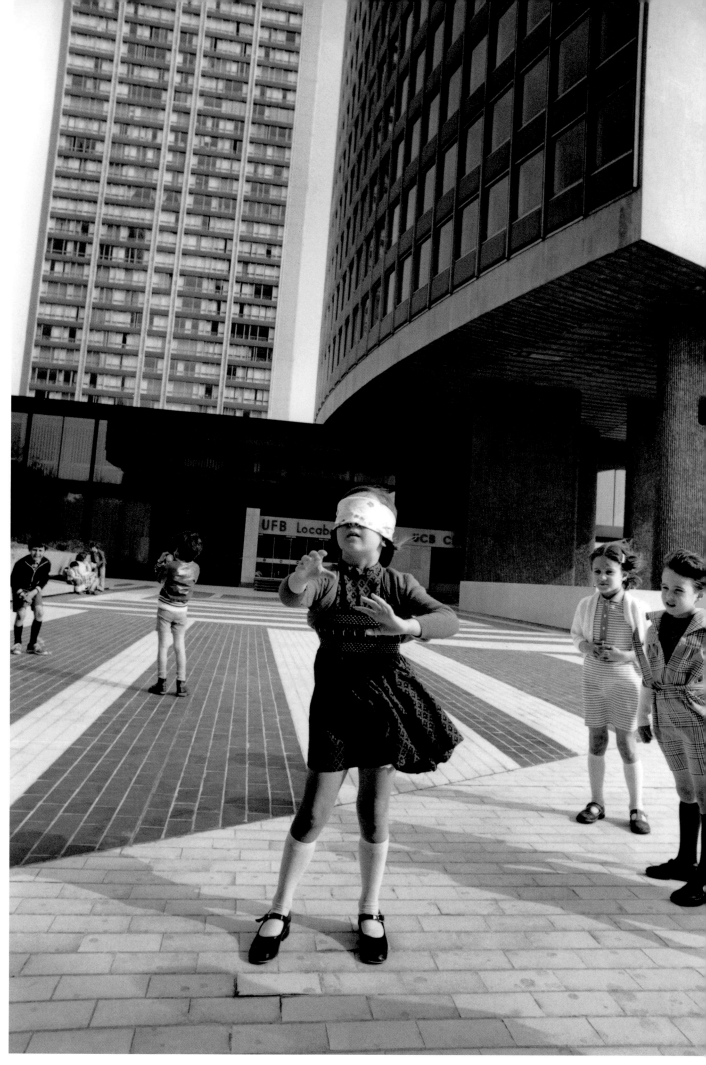

The Évasion 2000 building, Front de Seine district, 1975

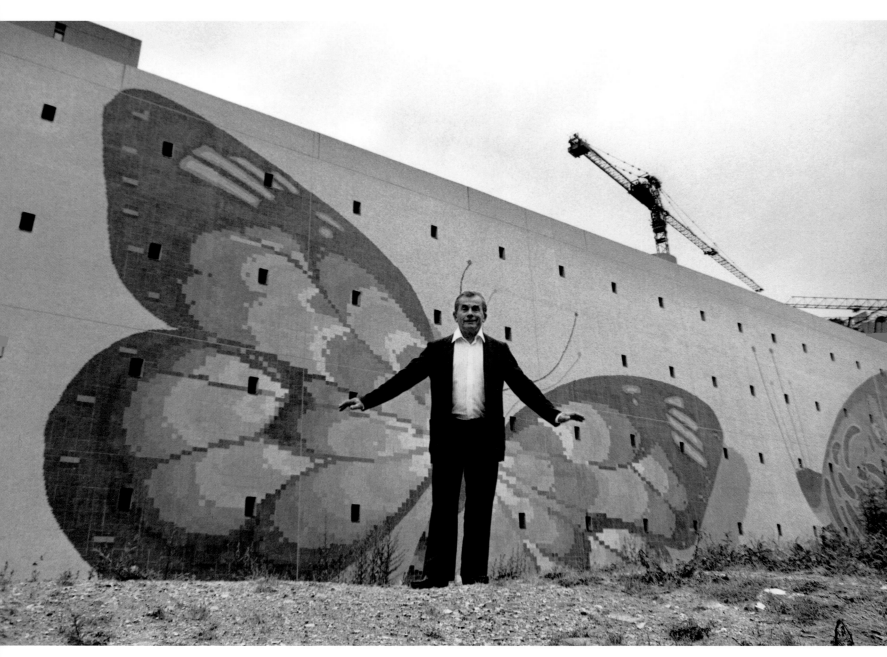

"Once our paths had crossed, I'd found the person who could teach me happiness." Maurice Baquet, Porte de Vanves, June 25, 1982

" There are days when the simple act of seeing feels like a simple joy. You're buoyant, so buoyant—cops halt the traffic to let you cross. You feel rich so you want to share your overflowing joy with others. 'It's Sunday every day!' as the song by Prévert goes.

The memory of such moments is the most precious thing I own.

Maybe because they're so rare. "

DOISNEAUBIOGRAPHY >

1912 Born in Gentilly, outside Paris, on April 14.

1926–29 Studies at the École Estienne, obtaining a diploma in lithography.

1931 Cameraman for André Vigneau.

1932 Sells first photo spread to the daily *L'Excelsior*.

1934 Marries Pierrette Chaumaison.

1934–39 Industrial photographer at the Renault car factory in Billancourt; fired for repeated lateness.
Meets Charles Rado, founder of the Agence Rapho. Becomes an independent photographer.

1942 Birth of daughter Annette.

1945 Begins working for Pierre Betz, publisher of the magazine *Le Point*.
Meets Blaise Cendrars in Aix-en-Provence.

1946 Returns to the Agence Rapho, run by Raymond Grosset, and continues to work for the agency for nearly fifty years.
Weekly photo spreads for the periodical *Action*.

1947 Meets Jacques Prévert and Robert Giraud.
Wins the Kodak award.
Birth of daughter Francine.

1949–51 Contract with *Vogue*.

1951 Exhibits with Brassaï, Ronis, and Izis at the Museum of Modern Art, New York.

1956 Wins the Nièpce award.

1960 Exhibits at the Museum of Modern Art in Chicago.

1971 'Tour de France' of regional museums with Roger Lecotté and Jacques Dubois.

1975 Invited to the Arles Photography Festival.

1979 Exhibition at the Musée d'Art Moderne de Paris, entitled *Paris, les Passants qui passent*.

1983 Exhibition at the Palace of Fine Arts in Beijing.
Exhibition of portraits in Tokyo.

1984 Participates in the French territorial administration's 'Photographic Mission.'

1986 Exhibition at the Crédit Foncier de France entitled *Un certain Robert Doisneau*.
Exhibition of portraits at the Maison de Balzac.

1987 Exhibition at museum in Kyoto.

1988 A show in tribute to Doisneau held at the Villa Médicis in Rome.
Exhibition titled *Doisneau-Renault* held in the Grande Halle de la Villette in Paris.

1990 Exhibition at the botanical gardens in Paris, entitled *La Science de Doisneau*.

1992 Retrospective exhibition at the Museum of Modern Art, Oxford, under the artistic direction of Peter Hamilton.
Short film, *Bonjour, Monsieur Doisneau*, by Sabine Azéma (Riff Production).

1993 Short film, *Doisneau des Villes et Doisneau des Champs*, by Patrick Cazals (FR3 TV).
Retrospective exhibition in Manchester and Montreal.

1994 Robert Doisneau dies on April 1.
Exhibition entitled *Doisneau 40–44* held at the Centre d'histoire de la Résistance et de la déportation in Lyon.

1995 Major exhibition in tribute to Doisneau held at the Musée Carnavalet in Paris.

1996 The exhibition *Hommage à Robert Doisneau*, hosted in Oxford and Paris, tours to Montpellier (March/April) and Japan (June/November).
Retrospective show in Milan.

1997 *Hommage à Robert Doisneau* travels to Dusseldorf, Germany.

2000 Reporters sans Frontières holds a Doisneau operation as part of its 'Freedom of the Press' campaign.
Show entitled *Gravités* held at the Galerie Fait et Cause in Paris, May 2–July 15.
Video/DVD, *Robert Doisneau tout simplement*, made by Patrick Jeudy.
Exhibition at Galerie Claude Bernard, Paris.

2002 Exhibition at the Museum of Fine Arts in Santiago, Chile, *Un tal Robert Doisneau*.

2003 Retrospective show of fifty-eight large prints in the streets of Bogota, Colombia.
Robert Doisneau tout court presented at the Centro Cultural Borges in Buenos Aires, Argentina.
Inauguration exhibition at Galerie Claude Bernard, Paris.

2005 *From the Fictional to the Real*, exhibition at the Bruce Silverstein Gallery, New York.
Exhibition entitled *Doisneau chez les Joliot-Curie, un Photographe au pays des physiciens*, held at the Conservatoire National des Arts et Métiers, Paris.

DOISNEAU BIBLIOGRAPHY >

Baquet, Maurice. *Ballade pour violoncelle et chambre noire*. Paris: Herscher, 1980.

Camilly, Jérôme. *Pour saluer Cendrars*. Arles: Actes Sud, 1987.

Caradec, François. *La Compagnie des zincs*. Paris: Seghers, 1991.

Cavanna, François. *Les Doigts pleins d'encre*. Paris: Hoëbeke, 1989.

Cendrars, Blaise. *La Banlieue de Paris*. Lausanne: La Guilde du livre / Paris: Seghers, 1949.

Cendrars, Blaise and Albert Plécy. *Instantanés de Paris*. Lausanne: Éditions Claire-Fontaine, 1955.

Delvaille, Bernard. *Passages et galeries du xixe siècle*. Paris: ACE, 1981.

Doisneau, Robert. *Compter en s'amusant*. Lausanne: Éditions Claire-Fontaine / La Guilde du livre, 1956.

Doisneau, Robert. *Épouvantables épouvantails*. Compiled by Jean-François Chabrun. Paris: Éditions Hors Mesure, 1965.

Doisneau, Robert. *La Loire*. Paris: Denoël, 1978.

Doisneau, Robert. *Trois secondes d'éternité*. Paris: Contrejour, 1979.

Doisneau, Robert. *Un certain Robert Doisneau*. Paris: Éditions du Chêne, 1986.

Doisneau, Robert. *Doisneau-Renault*. Paris: Hazan, 1988.

Doisneau, Robert. *La Science de Doisneau*. Paris: Hoëbeke, 1989.

Doisneau, Robert. *À l'imparfait de l'objectif, souvenirs et portraits*. Paris: Belfond, 1990.

Doisneau, Robert. *Portrait de Saint-Denis*. Paris: Calmann-Lévy, 1991.

Doisneau, Robert. *Mes gens de plume*. Texts selected by Yvonne Dubois. Paris: Éditions de La Martinière, 1992.

Doisneau, Robert. *Rue Jacques-Prévert*. Paris: Hoëbeke, 1992.

Doisneau, Robert. *J'attends toujours le printemps, lettres à Maurice Baquet*. Arles: Actes Sud, 1996.

Doisneau, Robert. *Mes Parisiens*. Paris: Nathan, 1997.

Doisneau, Robert. *La Transhumance de Robert Doisneau*. Arles: Actes Sud, 1998.

Doisneau, Robert. *Doisneau en Limousin*. Limoges: Éditions Culture et Patrimoine en Limousin, 1999.

Doisneau, Robert. *Tous les jours dimanche, entretiens avec Claude Villers*. Paris: Hors Collection, 2001.

Doisneau, Robert. *Doisneau chez les Joliot-Curie, un photographe au pays des physiciens*. Paris: Conservatoire national des arts et métiers / Romain Pages Éditions, 2005.

Donguès, Jean. *Gosses de Paris*. Paris: Éditions Jeheber, 1956.

Dubois, Jacques. *Les Auvergnats*. Paris: Nathan Images, 1990.

Fouchet, Max-Pol. *Le Paris de Robert Doisneau et Max-Pol Fouchet*. Paris: Les Éditeurs français réunis, 1974.

Gautrand, Jean-Claude. *Robert Doisneau*. Cologne: Taschen, 2003.

Giraud, Robert. *Le vin des rues*. Paris: Denoël, 1983.

Giraud, Robert and Michel Ragon. *Les Parisiens tels qu'ils sont*. Paris: Éditions Delpire, 1954.

Hamilton, Peter. *Robert Doisneau, A Photographer's Life*. New York: Abbeville Press, 1995.

Ollier, Brigitte. *Robert Doisneau*. Paris: Hazan, 1996.

Ory, Pascal. *Doisneau 40/44*. Paris: Hoëbeke, 1994.

Pennac, Daniel. *Les Grandes Vacances*. Paris: Hoëbeke, 1991.

Pennac, Daniel. *La Vie de famille*. Paris: Hoëbeke, 1993.

Renard, Jean-Claude. *Travailleurs*. Paris: Éditions du Chêne, 2003.

Romano, Lalla. *Robert Doisneau*. Milan: Motta Fotografia, 1997.

Roumette, Sylvain. *Robert Doisneau*. Paris: Centre national de la photographie, 1982.

Roumette, Sylvain. *Lettre à un aveugle sur des photographies de Robert Doisneau*. Paris: Éditions Le Tout sur le Tout / Cognac: Le Temps qu'il fait, 1990.

Sage, James. *L'Enfant et la Colombe*. Paris: Éditions du Chêne, 1978.

Soubeyran, Charles. *Les Révoltés du merveilleux*. Cognac: Le Temps qu'il fait, 2004.

Triolet, Elsa. *Pour que Paris soit*. Paris: Le Cercle d'Art, 1956.

I mustn't forget to acknowledge the author as prime begetter—he who begot the photographs, the text, and my own good self. From him I have inherited not only 400,000 negatives, but also a desire to look through them again and thus prolong my promenade in his company.

So thank you for these glowing vignettes of everyday life that continue to light my path.

And thank you to all the skilled and talented people who helped to breathe new life into these pictures and allowed their stories to unfold. I particularly thank Jean Yves, Hervé, Kristina, and Gaëlle.

Thanks also to Anita, Claude, Pierrette, Bob, Wanda, and all the others, thanks for having nurtured the dream. . . .

Francine Deroudille

To a wonderfully unique father.
Quite simply, thank you.

Annette Doisneau

The texts in this book have been taken either from Robert
Doisneau's private notebooks or one of the following works:

Chevrier, Jean-François. *Doisneau.*
Paris: Belfond, 1983.
Cendrars, Blaise. *Instantanés de Paris.*
Paris: Arthaud, 1955.
Doisneau, Robert. *Trois secondes d'éternité.*
Paris: Contrejour, 1979.
Doisneau, Robert. *Un certain Robert Doisneau.*
Paris: Éditions du Chêne, 1986.
Doisneau, Robert. *À l'imparfait de l'objectif.*
Paris: Belfond, 1995. Arles: Actes Sud, 1989.
Ory, Pascal. *De la Résistance à la Libération.*
Val de Marne: Musée de la Résistance nationale /
Paris: Hoëbeke, 1994.

"The Simple Tale of a Paris Street Urchin and Dutiful
Soldier" was first published as "La simple histoire d'un
gamin de Paris, bon fils et bon soldat," *Point de vue,*
February 19, 1971.

Quotations from Robert Giraud were taken from articles
published in 1950 in *Paris-presse l'intransigeant.*

The caption to the photograph of Colette in Palais Royal
was written by Claude Brulé for *L'Album du Figaro,*
December 1954.

Translated from the French by Deke Dusinberre
Copyediting: Philippa Richmond
Typesetting: Thomas Gravemaker
Proofreading: Chrisoula Petridis
Color Separation: Les Artisans du Regard

Distributed in North America by Rizzoli International
Publications, Inc.

Simultaneously published in French as *Doisneau Paris*
© Éditions Flammarion, 2005
English-language edition
© Éditions Flammarion, 2005
© Atelier Robert Doisneau, 2005

www.editions.flammarion.com

05 06 07 4 3 2 1

FC0491-05-IX
ISBN: 2-0803-0491-7
EAN : 978280304919
Dépôt légal: 09/2005

Printed in France by le Govic